THE COMPLETE BOOK OF
PAINTING
and
DRAWING

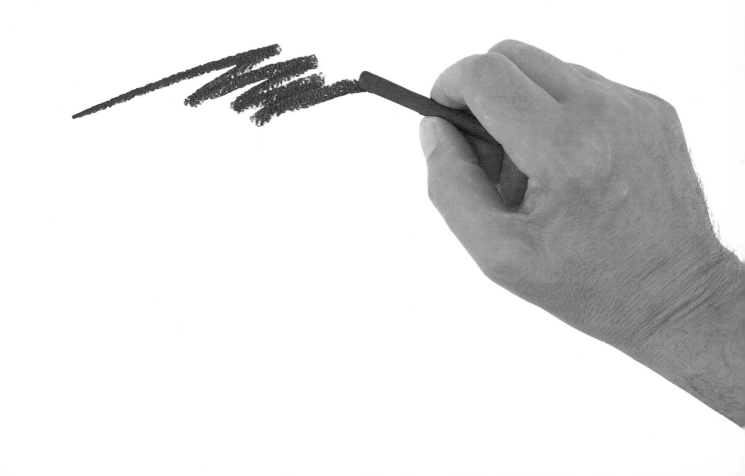

This edition first published in the United States by
Courage Books, an imprint of Running Press Book Publishers.

CLB 5017

9 8 7 6 5 4 3 2 1
Digit on the right indicates the number of this printing.

Library of Congress Cataloging-in-Publication Number 97-77962

ISBN 0-7624-0290-3

Originally designed and created by
The Bridgewater Book Company Ltd.
and produced by
Quadrillion Publishing Ltd., Godalming, Surrey, England
Designers Peter Bridgewater / Annie Moss
Editor Viv Croot
Managing Editor Anna Clarkson
Photographers Zul Mukhida / Jeremy Thomas
Typesetters Vanessa Good / Kirsty Wall

This revised edition edited by Joseph F Ryan, PhD

Acknowledgements
We would like to thank the following artist
for his contribution to this book:
Harold Cohen pages 42-3

Color separation by Scantrans PTE Ltd., Singapore
Printed and bound in Spain by Graficromo

Published by Courage Books, an imprint of
Running Press Book Publishers
125 South Twenty-second Street
Philadelphia, Pennsylvania 19103-4399

THE COMPLETE BOOK OF
PAINTING
and
DRAWING

by Gerald Woods

COURAGE
BOOKS

AN IMPRINT OF RUNNING PRESS
PHILADELPHIA • LONDON

Contents

PRACTICAL OIL PAINTING

Introduction

All forms of drawing and painting are part of an ongoing tradition. Initially, an interest in art might be awakened by visiting an exhibition, seeing paintings reproduced in books or, more often than not, by observing a friend or relative sketching or painting. Perhaps a teacher or fellow student found qualities in your work of which you had been unaware and, encouraged by their interest, you resolved to find out more. At first it is rather like learning a new language – drawing is the language of the eye. With a spoken language, it is necessary to get to grips with the grammar and then to enlarge one's vocabulary. Similarly, with drawing one must first learn how to represent an object in three dimensions, then to relate that object to its background and to show how objects relate to one another in space.

People learn by imitation. By looking at drawings and paintings that have been done in the past, it is possible to see our own artistic development more clearly. For example, the French Impressionists wanted to render in paint the actual experience of the way that their subject, or selected view, impressed on the senses and, in doing so, they were able to produce paintings which aroused interest by the unexpectedness of the viewpoint, the translation of light into simplified areas of color, and the economy in the handling of technique. Using a variety of media, they tried to awaken in others their experience of working directly from nature. Today, an exhibition of the work of Degas, Monet or Van Gogh will attract huge crowds of people who are prepared to queue for hours to see the original paintings at close quarters. Indeed, the Impressionists are undoubtedly still the largest single influence on the work of those contemporary artists who work from direct observation.

The main aim of this book is to demonstrate in a practical way how techniques can be harnessed to give account — in landscapes, portraits, still life and so on – of those aspects of the visible world which have aroused our interest, allowing us to share with others something of the experience in which our perceptions and thoughts are rooted.

In the first few pages of this volume, the text covers topics which are fundamental to anyone about to start a course in the visual arts and includes information on perspective, composition, scale and proportion, color and tone, and the use of sketchbooks for gathering ideas. There are four main sections to the book: drawing, pastels, watercolor and oil painting. At the beginning of each section there is a summary of the materials required when working in a particular technique, and information on the preparation of working surfaces and the handling of materials to produce qualities which are characteristic of each medium. There is advice on the best ways of working from direct observation, and how to use different sources of reference. Also, there are suggested ways of dealing with specific problems, such as form and structure, mood and atmosphere, and rhythm and movement.

In the latter part of each main section, there are five projects which have been carried out by three different artists using the same medium and reference sources, but often producing results which are strikingly different. In the introduction to each project, the kind of problems that are specific to the subject have been identified. There is also a critique of the finished work which highlights the weaknesses and strengths of each drawing or painting. By involving the reader in every aspect of the work, it is hoped to dispel any fear of failure: the biggest mistake that you can make is to be continually afraid that you will make one! As the great French artist Delacroix said: "One always has to spoil a picture a little bit in order to finish it."

Perspective

We see things in depth – that is, we see objects spaced at different intervals from each other and from where we are standing. When we talk about drawing "in perspective," we are describing a means of creating the illusion of depth on the flat surface of the drawing paper or canvas.

If your eye is sufficiently well trained, it is perfectly possible to do this accurately, without any knowledge of the theories of perspective. On the other hand, a basic knowledge of perspective will free you from needless and unproductive anxiety when you are tackling difficult subjects, such as a street scene or an undulating landscape.

The whole idea of creating the illusion of three dimensions in drawing is attributed to the architect and sculptor Brunelleschi in the early 15th century (Filippo Brunelleschi's theories were described by Leon Battista Alberti in his treatise *Della Pittura*, written in 1436). Perspective is based on the assumption that all parallel lines going in any one direction appear to meet at a single point on the horizon known as the vanishing point.

The principles of perspective can be tested quite simply by tracing an outline of the objects that you can see through your window directly onto the surface of the window pane (using the kind of fiber-tip pen that adheres to slippery surfaces). When you have traced the outline, you will notice how everything appears to be deployed in depth: the more distant things are, the smaller they become.

THE PICTURE PLANE

Another concept that helps to explain perspective is the picture plane. This is an imaginary vertical plane that is set on the ground at the distance from the artist where the picture is intended to begin. The true size of any object can be found by projecting it forward onto the picture plane (see the diagram below).

All horizontal lines at 45° to the picture plane meet at a point on the horizon line that is the same distance from the vanishing point as the vanishing point is from the eye of the observer (see diagram on page 9).

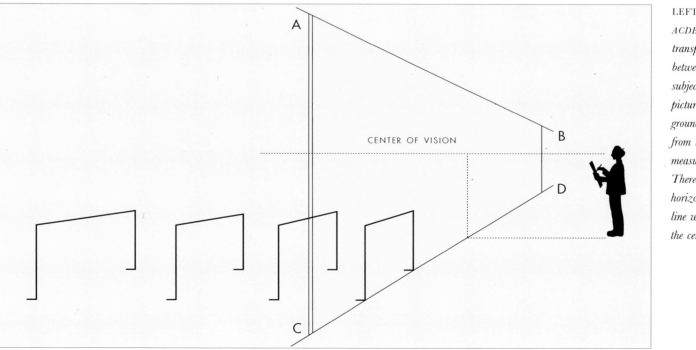

A

CENTER OF VISION

B

D

C

LEFT *The picture plane* ACDB *is an imaginary, transparent, vertical plane between artist and subject. The base of the picture plane is called the ground line and it is from this line that measurements are taken. There is a point on the horizon immediately in line with the eye that is the center of vision.*

EYE LEVEL

This is the term we use to describe the position of the eye in relation to the horizon. If, for example, you are standing on a flat surface and your eye is level with the top of a fence, then that is the eye level. If you then move some distance from the fence and sit down your eye level will, as a consequence, also shift to a lower level.

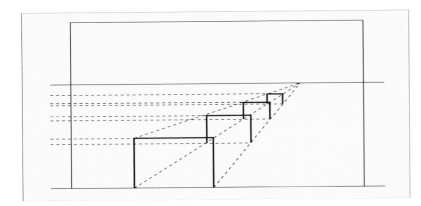

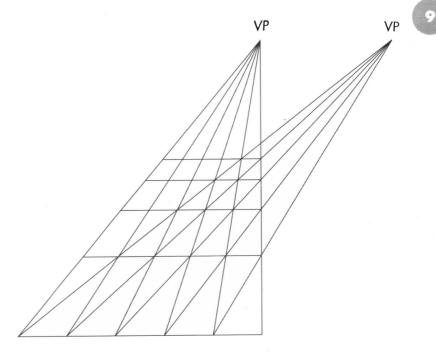

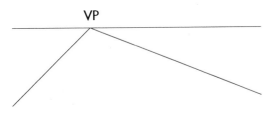

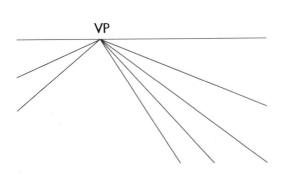

ABOVE Objects of the same size appear to diminish in size as they get nearer to the horizontal line.

LEFT Lines that are parallel to each other converge at the vanishing point VP.

ABOVE RIGHT Each set of parallels has a separate vanishing point.

THE VANISHING POINT

Having established your eye level on the horizon line, you will find that all lines that are parallel to each other are drawn to the same point – the vanishing point. Lines that are parallel to the ground and above your eye level are drawn down to the horizon eye level. Conversely, parallel lines below the horizon are drawn upwards to the eye level. Each set of parallels has a separate vanishing point. Objects of the same size will appear to diminish in size as they recede from us and the smaller they get, the nearer they will seem to be to the horizon line.

AERIAL PERSPECTIVE

As objects begin to recede from the spectator, there are observable changes in color and tone. In landscape, particularly in northern Europe, the density of the atmosphere causes tones and colors to be more muted. Colors tend towards blue in proportion to their distance from the observer. One of the main concerns of the French Impressionists was to register such changes as they occurred when painting outdoors.

Composition

> *An arrangement of the parts of a work of art so as to form a unified, harmonious whole.*

A musical score, a painting and a gourmet dish are all the products of someone consciously putting together something from related parts. In just the same way, a drawing or painting that is well composed is one whose parts have been skilfully brought into a satisfactory visual whole. In great classical paintings, all the constituent parts form a harmony which is pleasing to the eye.

The process of composing begins from the moment you select a particular viewpoint, before you have made any marks on the paper. Objects in nature are never isolated – they are relative. Though a single feature might command your attention – a solitary church on a hillside, for instance – it is seen in relation to the broader view of surrounding hills and sky, roads, trees and footpaths. If it was your intention to convey this sense of isolation in your watercolor painting, then scale would be critical, and you would paint the church from a greater distance. If, on the other hand, you were more interested in saying something about the architectural detail of the same church, then you would have to move much closer to your subject. Composition, in this sense, is determined by your intentions.

Landscape is without a doubt the most popular subject for watercolorists, yet it is potentially the most difficult to handle in terms of composition. Landscape is indeterminate and orderless – you need to have a strong sense of design to be able to visually harness all the random elements which are positioned at different levels and recede into the distance. One advantage that you have over the photographer is that you can simply leave out any detail which you feel might spoil the balance of your composition. The composition of seascapes is very much dependent on where the line of horizon is placed. Supposing, for example, you wanted to make a dramatic stormy sky the main feature of your painting, then you would place the

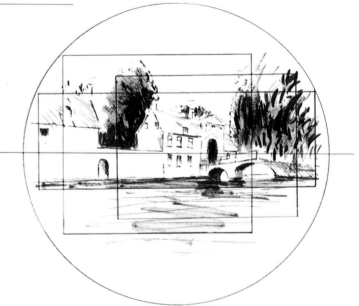

This diagram represents the circle of vision.
The different rectangles suggest the choices available in terms of composition.

horizon line low in your composition in order to provide the right emphasis. Conversely, if you were painting a "Turneresque" sea study, then the horizon line would either be high in your composition or would disappear altogether.

Classical painters, such as Poussin (1594-1665), often used pictorial devices to lead the eye towards the most important part of their composition. Paths, lines of trees, rivers and bridges were carefully positioned to draw the eye towards the groups of figures which were the focal point of the composition.

The "acid-test" of a well-composed painting, however, is that the viewer should be unaware that the artist has imposed any kind of pre-determined plan on his work. A painting in which the composition is too self-conscious will distract attention from the subject itself. The artist needs to be something of a tightrope walker and a dancer – the basic framework of the composition supporting the free expression of the brushwork.

When painting a still life subject you will find that you have much greater control over the composition since the objects you are painting can be arranged at will. We know that Cézanne used to spend hours arranging his still life groups – changing

11

folds in cloth, moving bottles, jugs and bowls of fruit until he felt instinctively the relationship to be right.

Whatever subject you decide to draw, whether it be a landscape, life model, portrait or still life, you should consider beforehand how the composition might work. Begin by asking yourself a number of questions. Will the house you have seen on a hillside look more dramatic if drawn from a greater distance? Would the pose of the life model look better by working from a higher vantage point, thus changing the eye-level? Will the features of the model who is posing for a portrait work best against a light or dark background? Should you allow more space between the objects you have selected for your still life? All of these considerations might help to improve your composition.

THE GOLDEN SECTION

Also known as the Golden Mean, this is the name given to a means of dividing space harmoniously, and has been known since the time of the Greek mathematician Euclid (300 BC). The basic premise is that the proportion of the smaller to the larger is the same as the larger to the whole. (See Golden Section rectangle diagram, right.) In practice, this works out as a proportion of 8:13 and is the underlying division of many great works of art.

ABOVE *Two transcriptive studies from a painting by Pieter de Hooch (1629–1684),* The courtyard of a house in Delft, *29 x 24 inches. A striking feature of this composition is the orange shutter opened at a window we do not see. Notice how all related elements are linked together.*

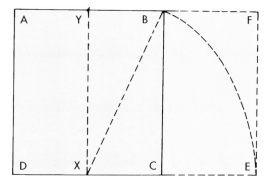

ABOVE *Underpinning the composition of most great drawings or paintings is a variant on the Golden Section rectangle. To help yourself understand the way this works, create a Golden Section rectangle on paper. Start with a square ABCD. Divide the square in half with line YX. Place a* compass point on X and, using B as a radius, describe an arc cutting the extension of line DC at E. Raise an upright from E to meet the extension of the line AB at F. The Golden Section rectangle is AFED. The line BC indicates the Golden Section division.*

Scale and Proportion

here are a number of simple devices for dividing the picture plane that have been used by painters since the Renaissance. The best known of these divisions is called the Golden Section. The basic premise of the Golden Section is that the proportion of the smaller to the larger is the same as that of the larger is to the whole.

The Fibonacci Series is another method of establishing related proportions, based on the idea that each succeeding number is the sum of the two preceding numbers, i.e., 1.1.2.3.5.8.13.21 and so on. Examples of its use can be found in the work of Piero della Francesca and other Renaissance masters.

LEARNING FROM THE MASTERS

One can gain a much better understanding of composition by making transcriptions from master painters such as Piero della Francesca, Poussin, Jan Vermeer, Pieter de Hooch and Georges Seurat. In the study of Vermeer's painting, *Young Woman In Blue* (1662–64, 21 x 19 inches), I began by marking the exact dimensions of the original onto a primed piece of plywood 23 x 24 inches, thus allowing a border all round the image. Because I was working from a reproduction that had been scaled down to half size, I had to make the necessary adjustment in my preliminary measurements to get back to the size of the original painting. Working in a soft pencil, I first noted the essential divisions of the picture-plane. When working on a transcription of this kind, you are concerned not with simply making a copy of the painting, but rather with trying to uncover through analysis how it was constructed.

The underpainting was done in a bister of Sepia. As the work progressed I became very conscious of Vermeer's superb sense

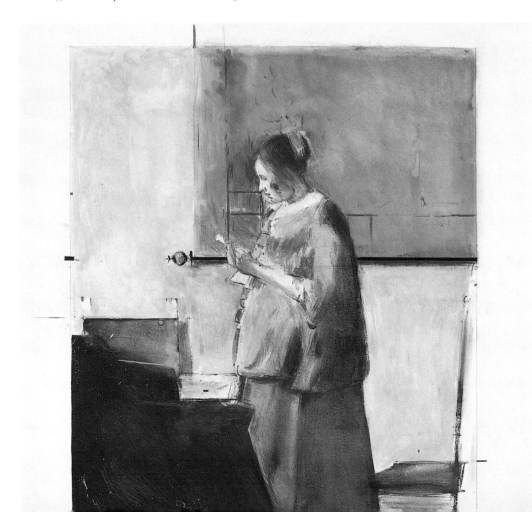

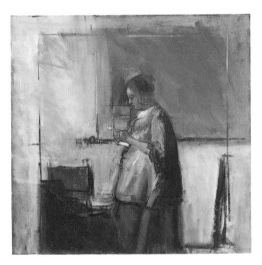

LEFT *Transcriptions from Vermeer's* Young Woman in Blue. *The first study is the same size as the original.* ABOVE *The second study attempts to uncover the relationship between* the standing figure and the background. OPPOSITE *Transcription from Vermeer's* A Woman Weighing Gold *adapting the proportions to a square canvas.*

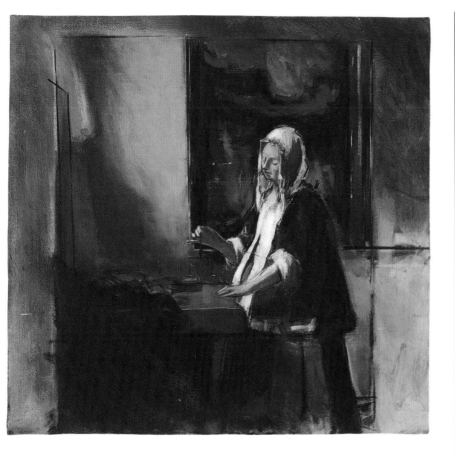

of composition – the exquisite placement and how every element was related to an underlying abstract structure. I became very aware of the negative shapes between objects – the subtle shape created between the back of the figure and the chair on the extreme right, for example. The particular angle of the head is based on a diagonal line that runs from the bottom left-hand corner to a point that marks the Golden Section.

The second study, *A Woman Weighing Gold* (1662–64, 17 x 14 inches), was painted onto a square canvas of a different proportion to the original. Here, I was concerned more with extracting the main elements than with making a precise transcription. The woman holding a balance in her right hand maintains her own posture by touching the table with her left hand.

THE GOLDEN SECTION

To divide a rectangle using the Golden Section theory, start with a square ABCD. Divide the square in half with line YX. Place a compass point on X and, using B as a radius, describe an arc cutting the extension of line DC at E. Raise an upright from E to meet the extension of the line AB at F. The Golden Section rectangle is AFED. The line BC indicates the Golden Section division.

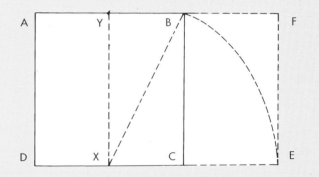

A simple formula can be used to discover the Golden Section point on any line. Take the line AB and raise an upright from it, BD, which is equal to half the distance from A to B. (The point C on AB indicates the halfway point.) Draw a line to join A to D.

Now, place a compass point on D and, using B as a radius, describe an arc from B to cut AD at X. Next, place the compass point on A and, using X as a radius, describe another arc to cut AB at GS. This is the Golden Section point.

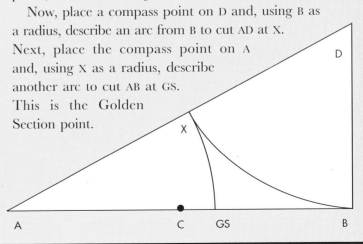

Color

In the course of teaching art students over the last 30 years, I have on occasion found that certain individuals do possess a kind of intuitive color sense. Most of us, however, must necessarily learn the hard way – through seeing, understanding, and experiencing. In my view, a complete and thorough understanding of color accrues gradually over the years, and is not something that can be acquired by reading a few books on color theory. A proper understanding of color theory is of course important, but my own appreciation of color has been achieved primarily by painting directly from nature and by studying the work of master colorists such as Titian, Jean-Baptiste Corot, Turner, Delacroix, Claude Monet, Jean Vuillard, James Abbotte McNeill Whistler, Gwen John and others. Moreover, I have become increasingly aware of the fact that color is always interpretative and, as such, dependent on the individual's emotional response to the subject at the time of painting.

We know from the experiments of Isaac Newton (1642–1727) that a ray of sunlight passing through a prism produces seven colored rays: violet, indigo, blue, green, yellow, orange, and red. We call this the spectrum, and we see color in objects that reflect or absorb these rays to a greater or lesser extent. If, for example, white light – which is a mixture of all the colors of the spectrum – is shining directly onto a flat surface that is red, it will reflect mainly red. If, on the other hand, the light falls onto a red ball or apple, which is three-dimensional, it will reflect a variety of other colors as the light is deflected by the curvature of the form. The area of shadow might be tinged with blue or violet.

Color exists only in relation to other colors. Bright primary colors, for instance, can change the value of a dull opaque color, simply by being placed in juxtaposition. We call this phenomenon "simultaneous contrast." For this reason, the colors we use in painting must always be considered in relation to one another.

PRIMARY COLORS

The three primary pigment colors are red, yellow, and blue. They are called "primary" colors because it is not possible to mix them from other colors on the palette, and they are also the base colors for secondary and tertiary colors.

ABOVE *A color wheel of softly merging primary, secondary, and tertiary colors.*

SECONDARY AND TERTIARY COLORS

Secondary colors are those mixed from the three primaries: orange from red and yellow, green from yellow and blue, and violet from red and blue.

Tertiary colors are produced by adding proportionally larger amounts of one primary color to another.

COMPLEMENTARY COLORS

The colors that appear opposite each other on the color wheel are known as "complementary colors." The complementary color of each of the primaries, for instance, is a mixture of the remaining two primaries. Thus green (blue and yellow) is the complementary color of red, blue is the complementary color of orange (red and yellow) and yellow is the complementary color of violet (red and blue).

Complementary colors are contrasted from light to dark, and from warm to cool. If they are mixed together, however, they cancel each other out – turning to gray or near black.

RIGHT *A color exercise exploring complementary color contrasts.*

Tone

> *The contrasts and connections of tones — there you have the secret of drawing and modeling* – Paul Cézanne (1839–1906)

Cézanne observed that everything in nature is based on the sphere, the cone and the cylinder, and he believed that if one could only draw these simple forms correctly, it would be possible to attempt more complex subjects.

A white teacup placed on the table before me as I write is a cylindrical form which I could draw in line, for instance, but to express the form of the cup, I would need to use tone. By tone, we refer to the gradations of lightness to darkness which can be seen in any solid object which reflects light. In drawings, we use tones to create the illusion of depth and three dimensions. We use tone to describe the anatomy of the human figure and, in landscape, to suggest atmosphere and distance.

Tone can also be used to describe color. If you were wearing a pink T-shirt with blue jeans, for example, I would notice that, apart from the difference in color, the T-shirt is lighter in tone than the jeans. Tonal values are also dependent on local color (the actual color of the object). A dark object in light may actually be lighter tonally than the shadow on a light object. The local tone of an oak tree, for example, might be dark brown, but if strong sunlight were to illuminate part of the trunk, it would appear much lighter in tone (on that part of the trunk) than on the rest. This may sound obvious, but because we often expect a particular object to be darker or lighter in tone, we sometimes fail to observe exactly what is happening when an object is seen under certain conditions of light.

The texture of an object can affect its tonal value; generally, the heavier the texture, the darker the tone.

It is, of course, impossible to reproduce all the subtleties of tone we see in nature, but even with a 2B graphite pencil, you would be able to translate what you see in terms of transitional tones from pale gray to near black.

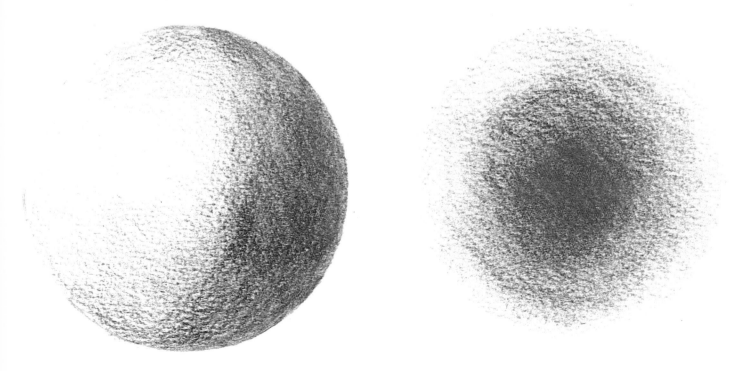

Tone expresses form. In this exercise, light and shade follow the form of the sphere on the far left. The circular area of tone increasing in the center (left) creates a different form.

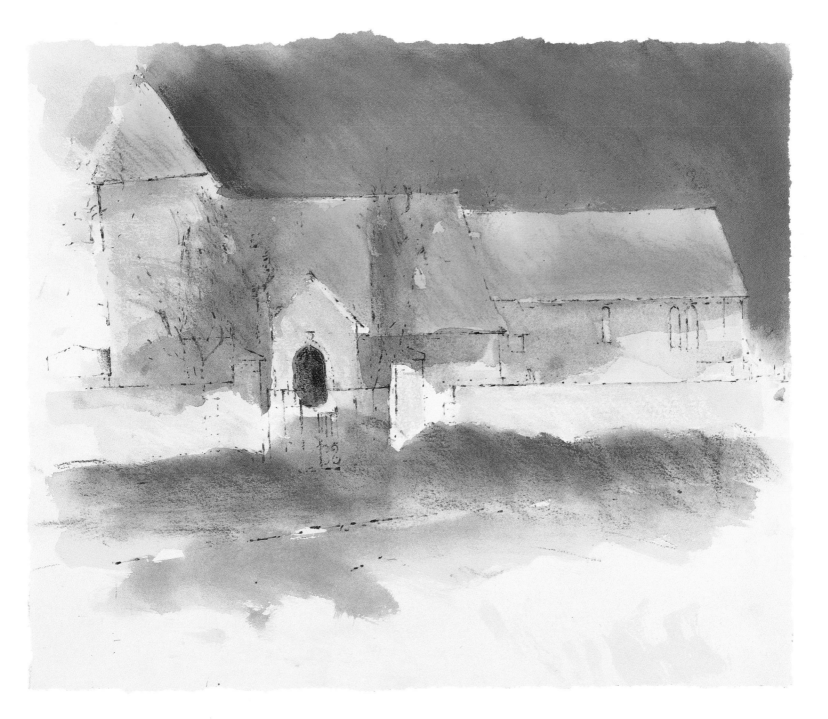

Keeping a Sketchbook

Deciding what to draw and how to find subjects that reflect our own interests can be frustrating if we do not allow ourselves to be alert to a wide range of possibilities. If you can get into the habit of carrying a sketchbook around, you will be better prepared to make drawings of things that unexpectedly beckon your attention.

It sometimes happens that you stumble across a subject that you feel you must respond to there and then, only to discover that you have left your sketchbook and drawing materials somewhere else! This kind of disappointment is compounded when, visiting the same place again, it has for one reason or another changed completely. Sketchbooks are useful for those occasions when you feel the need to draw on impulse. You can take risks when drawing in a sketchbook that you might feel more inhibited about if working on an expensive sheet of paper.

You might find it useful to keep several sketchbooks in varying sizes for different themes – museum studies, landscape, figure studies, and so on, building up your own sources of reference. If you are traveling abroad, you might fill a number of sketchbooks as a kind of visual record of your journey. This is exactly what Turner did, producing on average 17 sketches a day when he traveled through France, Germany, and over the Swiss Alps to Italy during his Grand Tour of Europe.

My own feeling is that a sketchbook should be used both for making shorthand visual notes and for more prolonged studies when working from direct observation. An artist's sketchbook will reveal his or her first impressions, and also record particular interests and obsessions.

Sketchbooks are manu-factured in a variety of shapes and sizes. Paper ranges from smooth, inexpensive cartridge to heavily textured surfaces.

Sketchbooks are produced in many shapes and sizes, but all too often their dimensions conform to accepted standards of measure-ment. It is difficult, for instance, to find a square sketchbook!

The "A" series of sketchbooks range from the smallest A5 (5.83 x 8.27 inches) to the largest A1 (23.39 x 33.11 inches). The quality of paper varies from inexpensive cartridge paper to heavier mold-made paper in H.P., NOT, and ROUGH surfaces. I generally use a sketchbook with a wire spiral binding so that the pages can be folded back easily for drawing.

If you have access to bookbinding facilities, you could have your own selection of paper made up into a sketch-book, with the added advantage of having it made any dimension – even square.

How the Projects Work

The first part of this book has dealt with some basic elements, including perspective, composition, scale and proportion, color, tone, and keeping a sketchbook.

Subsequent chapters cover the essential techniques used in drawing, pastels, watercolor and oil painting. Learning how to handle these techniques and understanding the particular characteristics of the chosen medium is, of course, terribly important. Just as the novice pianist must necessarily practice the scales and learn chords, so the artist must be able to use a medium with fluency.

Nothing, however, should deter the artist from starting to work from observation as soon as possible, and to do this you must be able to use techniques expressly to say what you have to say about a particular subject. If you concentrate too much on technique, you will never arrive at precision – if you concentrate on precision, you will arrive at technique.

Many artists are initially fearful of making mistakes, but the greatest mistake you can make in life is to be continuously feeling you will make one! Almost all our faults are more pardonable than the methods we resort to hide them.

In the project sections, which follow the description of techniques for each medium, you will see how three artists have approached the same subjects in terms of their own personal vision and technique. I believe that an artist should be judged by what he or she does with the subject, not by what the subjects are. It sometimes happens, however, that the subject itself will determine the technique used.

Although the artists have worked simultaneously from the same sources of reference, they have sometimes produced very different interpretations of the same subject. At the end of each project, therefore, there is a critique that offers a brief appraisal of the work done, including both the positive and negative aspects. My hope is that in considering what we may have achieved – or lost – you will feel sufficiently encouraged to put this book to one side, and begin to produce works of art which reflect your own response to similar problems and subject matter.

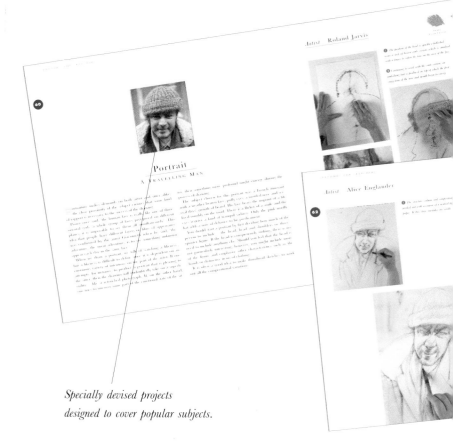

Specially devised projects designed to cover popular subjects.

You may find yourself disagreeing with some of the comments or you might have some criticisms of your own. You might even feel that you could produce something better. If this is so, I will leave you with the following thought from Johann Wolfgang von Goethe: "We should talk less and draw more. Personally, I would like to renounce speech altogether and, like organic nature, communicate everything I have to say in sketches."

*Techniques and methods
explained clearly and precisely
with easy-to-follow text.*

*Color palettes presented
with every project.*

*Each project is
painted by three different
professional artists.*

*Inspiring "critique"
spreads compare
different approaches
and interpretations.*

*Practical problems
highlighted by the author.*

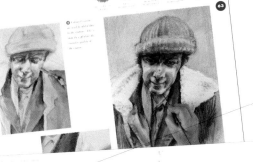

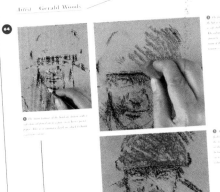

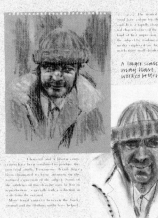

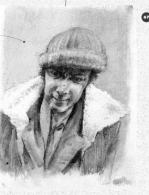

*Helpful tips and
advice given by top
professional artists.*

*Results judged by the
author, based on sound
visual judgement and
practical good sense.*

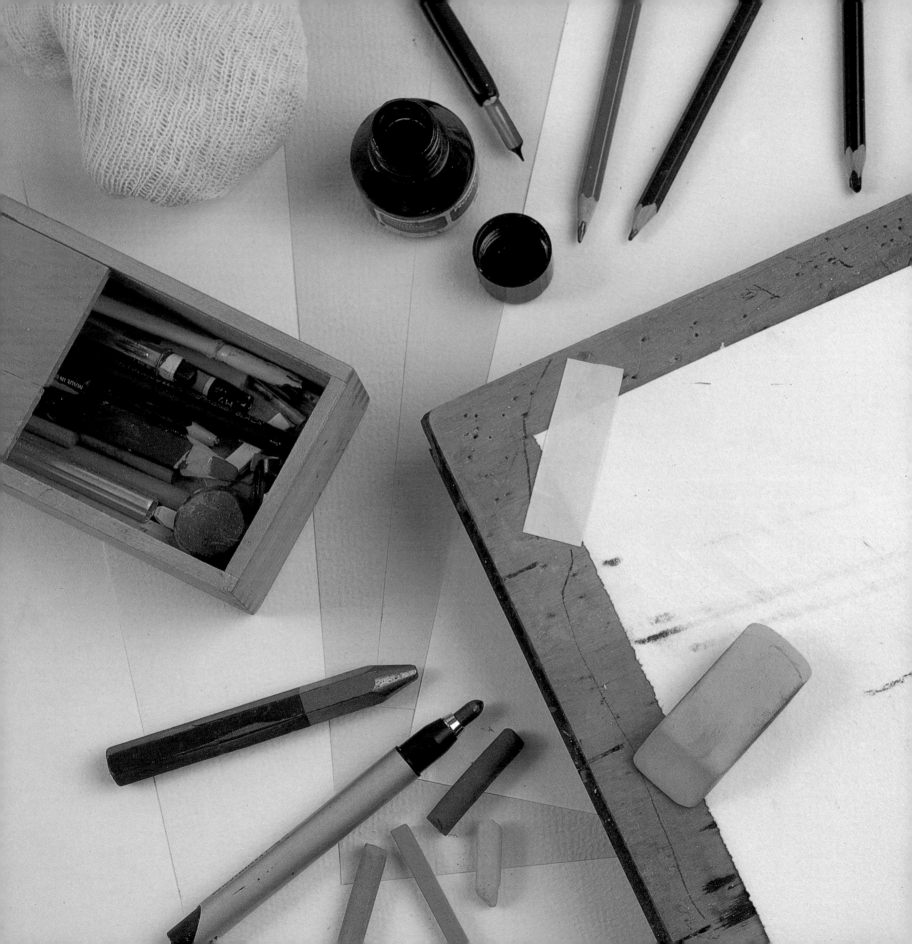

MATERIALS
AND
TECHNIQUES

Pencils

Michelangelo said that it should be possible to distinguish one artist's work from another by the way he or she drew a single straight line. The quality of line is critical in drawing, since it bears the imprint of an emotional response to the subject. When an artist develops an affection for a particular person, object, or place, his or her feelings are intimately transmitted through his or her drawings.

Most artists, in fact, tend to pick up a pencil without noticing whether it is of a hard or soft grade, in an effort to capture an idea spontaneously before the impression fades. It is precisely this kind of response that can invest a drawing with the vital resonance that separates it from a technically competent but otherwise stilted drawing.

Wood-encased graphite pencils range from the softest, 9B, to the hardest, 9H. In the manufacture of pencils, the graphite forms the pigment and the clay the binder. The larger the proportion of graphite, the softer and blacker the pencil. Hard pencils have a higher proportion of clay. The materials are finely ground, pressed and fired before being inserted into their casing, usually made from cedar wood.

The soft, B-grade pencils allow for a greater sensitivity of line and are capable of rendering rich gradations of tone. The darkest B grades produce an intense, gritty black that is best used on textured drawing paper. Some artists successfully combine hard and soft grades of pencil in a single drawing, the hard lines being employed as a kind of underdrawing and the softer lines overlaid to emphasize the main accents.

Colored pencils are useful for producing half-tones in contrast to darker tones made with a graphite pencil.

The color and tonal range of a drawing can be extended by using different types of pencil.

Aquarelle pencils can be used dry, or can be partially dissolved with a brush loaded with water to produce a grainy wash.

A pure graphite pencil is useful for rapid, broad work.

A soft charcoal pencil wrapped in a paper cylinder with a pull-thread for self-sharpening.

A red pencil can be used tentatively to hint at warmth in a drawing.

A 9B pencil is capable of producing a range of tone from silvery grays to intense blacks.

A 3B pencil is ideal for drawing figures — and for producing a broad scale of tone.

A white pencil can be used to suggest highlights and mute other colors.

Artists' pencils are usually either round or hexagonal in cross-section. The latter are easier to grip.

Try to avoid dropping pencils onto a hard surface, as this can easily fracture the lead. Clutch-pencils are particularly useful for sketching, as you can keep a variety of leads that can be interchanged as required. Use a pencil-holder to extend the life of a pencil when, after much sharpening, it becomes too small to hold comfortably.

Inevitably, you will develop your own predilection for certain types of pencil. In the first instance, however, you should try everything at your disposal.

Colored drawing pencils are produced in a range of closely related shades of gray and earth colors, such as ocher and terra cotta. These work well in combination with soft grades of graphite pencils.

Charcoal

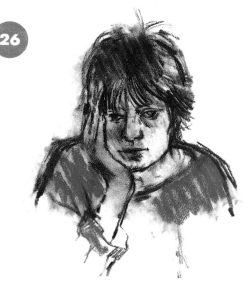

ABOVE *A 30-minute study using willow charcoal and chalk pastel.* BELOW *A study in charcoal and chalk pastel of Michelangelo's* Bozzetto the Slave.

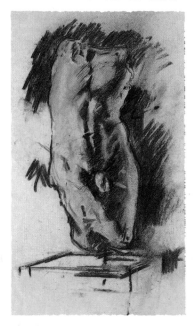

Charcoal drawing is an ancient medium still very much in use today. Unfortunately, the characteristically soft mark charcoal leaves on the paper has the disadvantage of being generally unstable, which is why so few examples produced by the early masters survive.

The best charcoal is produced from slow-burning sticks of willow. The supply of air during firing is restricted, allowing the sticks to retain their individual shape. Artists' charcoal is produced in four different thicknesses: thin, medium, thick, and scene-painters'. The thin and medium sticks are best sharpened by breaking the stem. Thicker pieces can be rubbed against a sandpaper block to produce a sharper edge.

It is a medium capable of producing drawings of great sensitivity, responding, as it does, to the slightest pressure. You will discover, for instance, that as your drawing progresses, you will tend to disperse the first marks you have made as your hand brushes against the surface of the paper. This means that you are constantly having to restate the drawing in order to achieve the right tonal balance. Alternatively, the drawing can be fixed in stages (see page 32).

Thin papers with a slight grain such as Japanese paper or Ingres are best for charcoal drawing. It is, in my view, a good medium for the beginner in that it is easily corrected and helps to build up confidence in a way that would prove more difficult with a sharper instrument. There is a tendency, however, for some artists to deliberately smudge the charcoal in a dramatic way that only serves to conceal what may well be an underlying weak drawing or indifferent composition.

I often tell students that they should try to work in terms of the medium. This is especially true in charcoal drawing. It is no good, for example, trying to produce the kind of detail that you would expect from the sharpened point of an HB pencil. Use charcoal for working broadly on large sheets of paper.

Compressed charcoal is more consistent in texture and is produced both in stick form and as a range of graded pencils. When fixing charcoal drawings, hold the spray at the correct angle and recommended distance from the drawing. If you spray too closely, you will disperse the pigment.

Full-length figure study using charcoal.

Pencils and Crayons

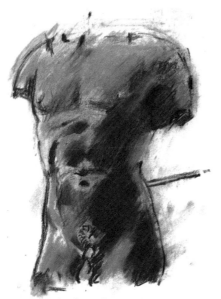

*Study in charcoal
and chalk pastel
of Michelangelo's
model for David.*

olored pencils are now produced in a range of more than a hundred colors. They blend together easily to produce rich tonal qualities. They can be sharpened to a fine point like graphite pencils, or used bluntly to cover larger areas.

Aquarelle pencils can be partially diluted with a paintbrush dipped in water, producing a kind of mixed-media effect of pencil and watercolor. A certain amount of premeditation is required to get the best use out of these pencils. There is no point in diluting the pencil mark, for instance, if it simply destroys the tonal value of the drawing.

CONTÉ CRAYONS

Conté crayons produce an even line that is more intense than charcoal but more difficult to erase. It is, however, a more stable medium and is particularly useful for working on location. Sanguine conté is, as the name suggests, a red ocher and can be used effectively on a toned paper or in combination with black and white conté.

ABOVE *A tentative
drawing using blended
tones of colored pencils
and graphite.*
BELOW *A rapid life
study drawn with a
Burnt Umber crayon.*

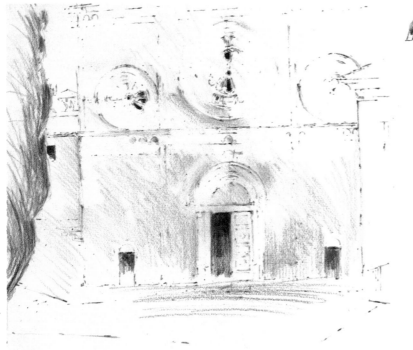

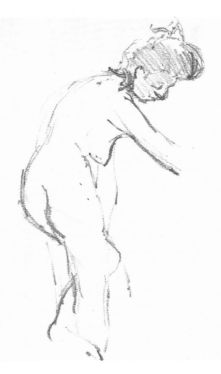

ABOVE *A 5-minute
study using colored
pencils and graphite.*
LEFT *Study of a church
façade using colored
crayons and graphite.*

Brushes for Drawing

He painted and wrote with joy. The Chinese artist Wu Chen (1280–1350) always added this inscription as a footnote to his own work.

To draw with a brush and ink on a soft rag paper is one of the most sensuous and expressive techniques available to the artist. One has only to explore the rich tradition of Chinese and Japanese brush drawings to appreciate the full potential of the medium. The landscape brush drawings of Hiroshige (1797–1858), for example, clearly influenced the work of the Impressionists.

The quality of a line drawn with a brush bears the imprint of the shape of the brush and the texture of the hair itself. It is important, therefore, to use good quality brushes. Any brush that does not hold its shape when wet is useless. The best sable brushes retain their shape in such a way that the natural curve of the hair forms the flexible rounded tip. Brushes made from synthetic hair, however, have greatly improved in quality and are less expensive than sable brushes. Chinese brushes are also generally less expensive and produce a beautiful calligraphic line.

The action of drawing with a brush demands a degree of swiftness in order to keep the essential character of the brushstroke. It is therefore worthwhile to consider spending some time on preliminary mark-making exercises. Try holding the brush in different ways, and use different sizes and shapes of brush, until you feel sufficiently confident to begin working directly from observation. The best brush drawings are done without any underdrawing with pen or pencil. The more diluted the ink or watercolor that is loaded onto the brush, the softer and paler the line will be. A brush that is almost dry produces an irregular broken line that is enhanced by using rough-textured watercolor paper. Try drawing contours with Indian ink and, when dry, overlaying washes of watercolor. Chinese ink is particularly good for producing gradated washes and for intense blacks.

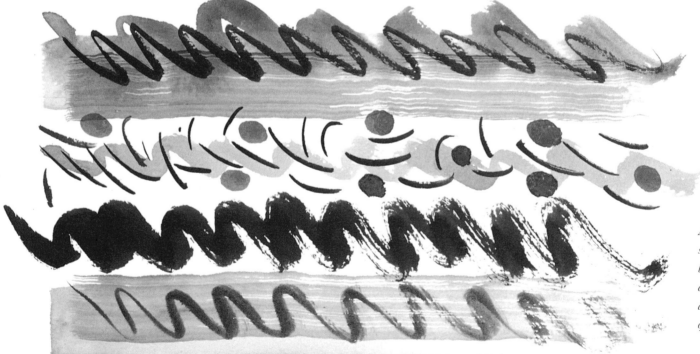

An exercise using fine sable and broader mop brushes. Notice how the character of the stroke is determined by the shape of the brush.

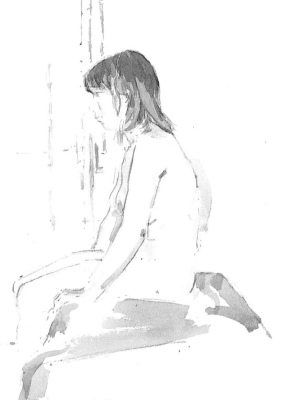

LEFT *Life study drawn with a No. 3 sable brush and watercolor.*

ABOVE *Life study in Raw Umber and fountain pen ink wet-in-wet.*

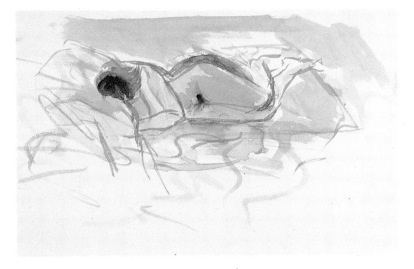

LEFT *A rapid life study notation with a No. 6 sable brush and watercolor.*

RIGHT *A rapid study of Anna Sophie Mutter made during rehearsal with a No. 4 sable brush and pre-mixed washes of watercolor.*

Paper

The paper you work on can contribute to the success or failure of a drawing. The strongly atmospheric conté drawings produced by Seurat (1859–1891), for instance, are enhanced by the texture of the "laid" paper he used.

One can sometimes feel inhibited when working on expensive paper. It is not always necessary to use expensive handmade or moldmade papers. When drawing in pencil or charcoal, any machine-made cartridge paper will be perfectly adequate.

There are three main paper surfaces: H.P., NOT, and ROUGH. H.P. (hot-pressed) is the smoothest and well suited to all kinds of graphite pencil, pen, and brush drawing. When drawing in pencil, however, I prefer a NOT surface, which has a slight "tooth." A paper such as Saunders Waterford, for instance, is made from 100% cotton fiber that is sized internally for greater strength. As a result, the surface can withstand multiple erasions when using pencil or charcoal.

Buff Ingres mouldmade paper, 90 gsm

Gray Ingres moldmade pastel paper, 90 gsm

ROUGH surface papers take on the texture of the rough paper-making felt. They are most suited to pastel drawing and broad-brush drawings. For charcoal drawing, my own preference would be either a Japanese paper such as HOSHO or one of the Indian Mulberry papers. Most handmade and moldmade papers are manufactured in different weights and sizes. The weight is calculated in pounds (lb) per ream (500 sheets) or grams per square meter (gsm). For most drawing purposes, a paper weight of 185 gsm/90 lb is ideal. Try to ensure that the paper you buy is acid-free to avoid discoloration at a later stage.

In the end, your choice of paper will no doubt be influenced by your own needs. Most paper merchants produce sample books that will enable you to test the suitability for your own requirements. Degas produced many of his best pastel drawings on tracing paper because his work method (tracing one drawing over another) demanded a transparent paper.

Cream cartridge, 96 gsm

*Acid-free white
cartridge, 96 gsm*

*Bockingford cylinder
moldmade watercolor
paper, 425 gsm*

*"Crisbrook" Barcham
Green handmade paper,
unsized, 535 gsm*

Erasing and Fixing

It is important to use an eraser of good quality that will eliminate unwanted lines and marks without damaging the surface of the paper.

For charcoal drawings and pastels, a kneadable putty eraser can be shaped with the fingers to lift out fine detail. Charcoal drawings can also be erased effectively with fresh bread that has been kneaded slightly.

The wedge-shaped soft pencil eraser and some plastic erasers are sufficiently pliable for most purposes. A soft gum eraser is the least likely to damage the surface of the paper.

FIXATIVE

All drawings produced with graphite pencils, charcoal, conté, and chalk pastels require fixing. Fixative liquid is applied by means of an atomized spray held approximately 12 inches from the drawing. For the purpose of fixing, the drawing should be laid on a flat surface and the spray moved back and forth to provide even coverage. Additionally, the back of the paper can also be sprayed to ensure complete saturation and protection. Always use the spray in a well ventilated room, and use a face mask. For charcoal and graphite pencil drawings, skim milk makes a cheap and effective alternative, particularly useful if you are allergic to fixative spray. On graphite pencil work, simply paint the milk on with a brush. On charcoal drawings, use a diffuser spray (available in art supply shops). Put the milk in a jar and insert the diffuser tube in the liquid. Using the L-shaped diffuser mouthpiece, suck the milk up through the tube and then blow to spray it over the drawing.

There are a number of recipes for fixative, but most are based on a combination of shellac, resin and alcohol. Pastels should be fixed in stages to avoid neutralising the brilliance of the color.

A diffuser spray can be used with standard fixative or skim milk.

Erasers are just as useful as pencils. They can make a positive contribution to a drawing. By taking out or lightening areas of tone, form can be altered or restated.

A chunky, soft eraser is useful for general erasing.

A putty eraser can be shaped to lift out fine detail.

A paper torchon is used to blend and smudge.

LEFT *A slightly harder eraser is good for erasing on robust grounds.*
BELOW *A plastic eraser can be used for general work.*

OTHER USEFUL EQUIPMENT

STOOLS AND CHAIRS

An investment in a folding stool or tubular steel chair is one I feel sure you will never regret. My Maclaren "Gadabout" chair has provided me with great comfort in various difficult locations, from the Swiss Alps to the hill towns of Italy. This is the smallest and lightest stool generally available in most countries and is an aluminum and canvas folding stool often favored by fishermen. This type of stool does not provide much back support, however, and is too low to the ground. The three-legged French stools are well made, of good quality, and easy to carry. The "shooting-stick" type of seat, with a small folding seat attached to the end of a walking stick, provides some support, but is not much use for prolonged periods of concentrated drawing.

HARDWARE

A good pocketknife, such as a Swiss Army knife, is essential. There are also a number of knives with retractable, "snap-off" blades.

Fold-back spring clips are practical when working outside to keep paper in place when it is windy.

A good lightweight shoulderbag, preferably made from waterproof material, will enable you to carry all your equipment when you are working outdoors.

Line and Tone

34

One of the most difficult problems you must confront when learning to draw is how to use line and tone together. When I first attended life-drawing classes, for example, I was expected to draw the contours of the figure with a needle-sharp pencil and then fill in the tones as a completely separate action. The resulting drawings were always artificial and contrived. It was some time before I found the confidence to fuse line and tone as a single entity.

The balance between the weight of line and tone needs careful consideration. If the tonal strength is too intense, the value of the line will be lost. If, on the other hand, the tone is under-stated, the line will appear too dominant. In order to avoid this false division between line and tone, begin by working with a soft line – a 3B pencil will do. Make sure that the point of the pencil is round and blunt. Let the tonal quality develop from the softness of the line itself as you begin to construct your drawing. Indicate light and dark tones by keeping your lines in the same direction. Try to unify tones by checking the overall relationship between the pattern of light and dark areas.

Lithographic crayons produce a soft, grainy tone rather than a sharp line, and artists such as Camille Pissarro (1830–1903) and Pierre Bonnard (1867–1947) produced some of their most sensitive drawings in this medium. If you are using charcoal, you can dust off surplus pigment with a soft cloth to produce more delicate tones. When drawing with pen and wash, use the brush as well as the pen for the linear aspects of the drawing. Lines drawn with non-waterproof inks will dissolve when a wash is laid over, producing a fluid, irregular line.

LEFT *Study of the conductor Paul Sacher at rehearsal using a 3B pencil on cartridge.*
RIGHT *Portrait drawn in a 3B pencil on Bockingford paper.*

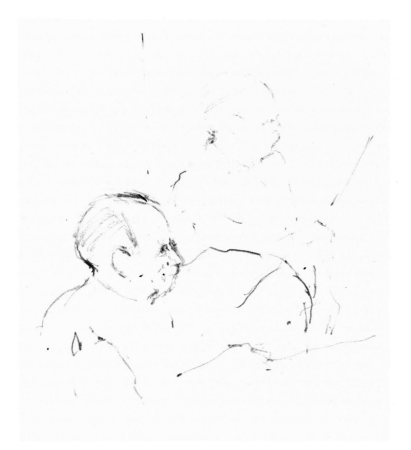

RIGHT *In this life study in 4B pencil, lines are heavily impressed into the soft, handmade, toned paper.* FAR RIGHT *Costume life study. The wide range of tone in this drawing is produced with a 6B pencil on toned, handmade paper.* BELOW *Sketchbook life study using a 3B pencil and an added wash of Burnt Umber.*

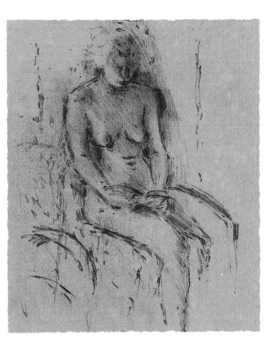

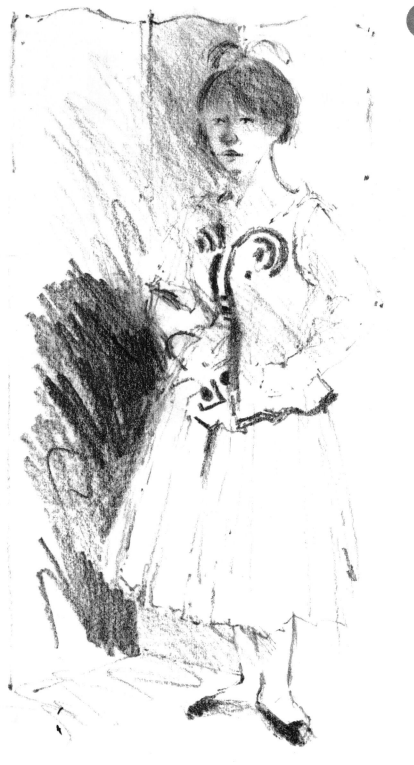

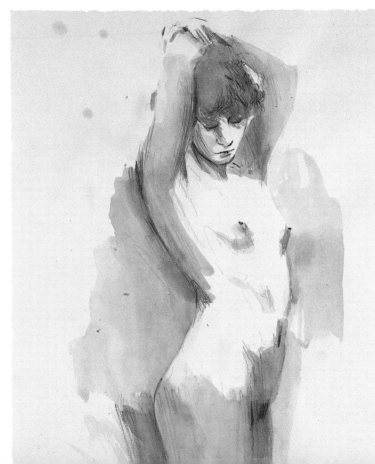

Drawing from Observation

Two elements are needed to form a truth – a fact and an abstraction.
Rémy de Gourmont (1858–1915)

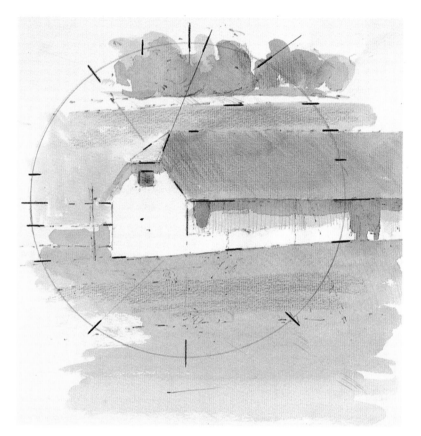

Because the reproduction or exact copy of nature is an impossible pursuit, we tend to abstract what we see. The artist never draws things as they are but as he or she sees them. And what we see, we commit to memory and try to register the main elements on paper with a pencil or some other drawing instrument. Drawing is the most direct and spontaneous medium available to the artist. The pencil becomes an extension of the hand through which the impulses of your sensory experience are translated into marks which symbolize what you have observed.

The artist Walter Richard Sickert (1860–1942) once gave what I believe to be the best description of the process of drawing from observation, and I feel it would be helpful to quote it in full:

All lines in nature, if you come to reflect on it, are located somewhere in radiants, with the 360° of four right angles. All straight lines absolutely, and all curves, can be considered as tangents to such lines. In other words, there is no line in nature which does not go in the direction of one of the little ticks that mark the minutes on the face of a watch. Given the limits of exactness needed for aesthetic purposes, if you could put on paper by sight the place, that is to say the minute of every line you see, you could draw.

You can test the truth of this statement for yourself by looking out of the window (it doesn't matter whether you live in town or country). You will see how the specific angles of various elements conform to the idea of the minute marks on a clock.

Try to make a drawing simply by marking some of the main angles you can see – perhaps the acute angle of a rooftop, the upright of a telegraph pole, the slope of the land, and so on. Do not worry at this stage about producing a finished drawing: think of what you are doing purely as an exercise in observation.

The 19th-century art critic John Ruskin once said that if you want to draw, you must forget what you know and only look. It

is difficult to do this in practice, but when you are drawing from observation you are trying to uncover things that might normally escape your attention. You will want to discover, through drawing, how natural and man-made forms are linked together, how one form overlaps another on different planes and how things change their appearance in different conditions of light.

If you are persistent in drawing from observation, you will eventually discover what all great artists know – that everything has its own shape, that nature is a harmony of opposites and that all forms are relative to one another.

Try to concentrate on seeing, rather than on "self-expression." The line drawn by the artist will, of necessity, bear the imprint of his or her emotional state. The gesture made by an impatient person will be different from the gesture made by someone who is by nature placid, gentle, or contemplative.

OPPOSITE *The outline of a clock superimposed on a drawing of a barn illustrates Sickert's ideas about radiants and linked angles.*

TOP RIGHT *A study from direct observation of Zamora cathedral, Spain. The photograph was taken at the same time from the same viewpoint. Notice how extraneous details have been left out in the drawing.*

MIDDLE RIGHT *In this distant view of Segovia, Spain, the artist is seemingly able to project himself forward to focus on detail that seems lost in a photograph taken from the same viewpoint.*

BOTTOM RIGHT *A rapid sketchbook notation of a country church in Spain that evokes the atmosphere of the place more directly than the photograph.*

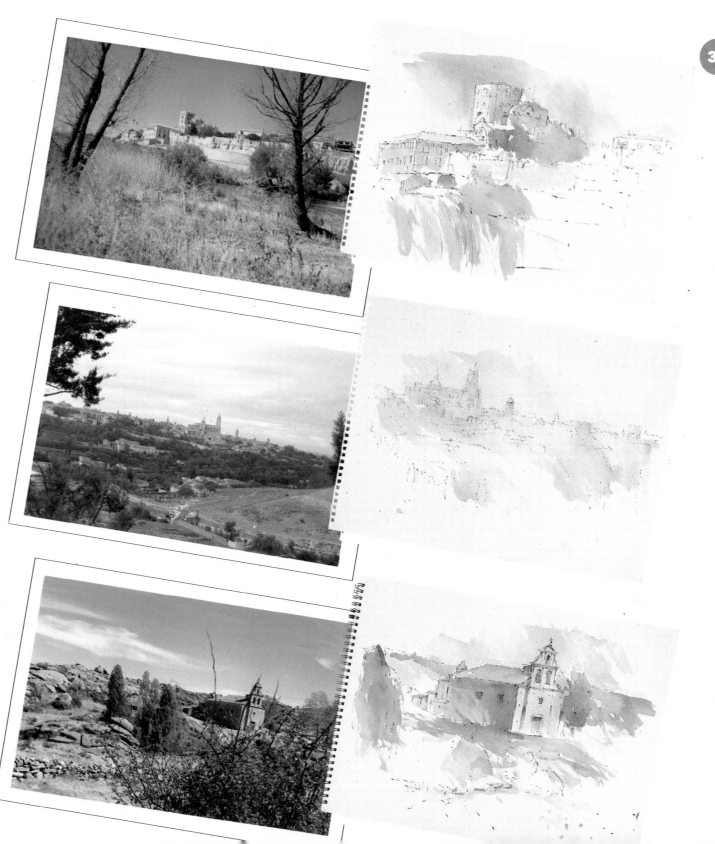

Measured Drawing

LEFT *Portrait. A drawing that bears the imprint of carefully judged intervals.*

BELOW *Life study. Notice how background and adjacent structures have been used as a means of checking the proportion of the figure.*

The marks that an artist makes when he or she is constantly searching for probity are an intrinsic part of the drawing. In Michelangelo's crucifixion drawings, for example, it is the multiple contours that reveal the artist's acute sensitivity to the subject. When beginning a drawing, do not allow the problem of measurement to inhibit or distract you.

When drawing from observation, no system of measurement is strictly accurate – a reasonable probability is the only certainty. According to Heisenberg's Uncertainty Principle, it is impossible to determine simultaneously, with any certainty, the position and momentum of a particle: the more accurately the investigator determines one, the less accurately he or she can know the other.

Some artists adopt a system of measurement and continue to use it all their working lives. Others simply use their sense of visual judgement intuitively, and make continual corrections as the drawing progresses.

STANDARD MEASUREMENT

Imagine you are drawing a standing figure, and you want to determine the number of head-lengths that can be fitted into the total length of the figure. Hold your pencil vertically with your arm fully extended between one eye (the other closed) and the figure. Mark off the length of the head between the tip of your thumbnail and the top of the pencil. Then lower your arm with the fixed measurement to see how many times that same distance will go into the total length of the figure. If, for example, you discover that the length of the figure is equal to seven and a quarter head-lengths, you can then register the distance with nodal marks on your paper. You will then be able to work out other proportions in the same way.

There are a number of devices you can use to make it easier to assess distance and proportion. Try, for instance, taping colored drinking straws to the model at main intersections of the body, or make marks with red greasepaint.

When I am drawing a life model, I use surrounding furniture and fixtures as a means of cross-checking the proportions of the figure. The length of an arm or leg can be checked against adjacent chairs, tables, fireplaces, baseboards, and so on.

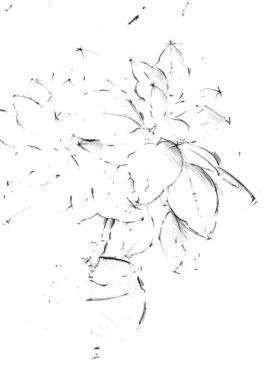

ABOVE *Life study.*
The measurements here
are left as an inherent
part of the drawing.

RIGHT *Plant study.*
The related leaf forms
have been measured
by holding the pencil
at arm's length and
fixing the position
on the paper.

USING A GRID FOR STILL LIFE

Take an ordinary object, such as a jug or teapot, and place it against a previously drawn background grid of 2-inch squares. The size of the squares can be reduced or enlarged according to the size of the object. Then draw a grid of the same number of squares on your drawing paper.

As you begin to draw the outline of the jug or teapot, note the position of the object against the squares on the background grid. Try to relate this position to the corresponding squares of the grid on your drawing paper.

Figure Studies

40

When we start to draw, our expectations are often too high. Intent on producing the "perfect drawing," we run into difficulty from the first lapse in concentration. Sometimes it is better to settle for less in the hope of gaining ground. Figure drawing is probably the most challenging subject to confront any artist. Faced with a life pose of two hours or more, a beginner might feel a sense of trepidation bordering on panic!

Lack of confidence can be dealt with in a number of ways: begin with a series of short poses that leave no time for second thoughts. By drawing more rapidly, you will tend to produce figure studies that are more resolute. In my experience, students doing figure drawing often position themselves too closely to the easel. Working thus, they shield themselves from the model and disrupt the process of hand and eye coordination.

To overcome this problem, try the following experiment. Into one end of a stick of bamboo (about 1 yard long and 1 inch in diameter), cut two slits so that you can insert a piece of charcoal that is slightly larger in diameter. Make sure that the charcoal is gripped tightly in the end of the stick, and, if necessary, bind it with thread. Now, stand well back from the easel, holding your bamboo stick like a fencing rapier, and begin to draw from the model. At first, you will find that this way of drawing is disconcerting, because you will have less control. However, you will have a much better view of the model and you will soon discover that your drawing will be ruled by what you see, and not dictated by technique.

Short poses might be staggered in time limits from, say, 30 minutes to 20, 15, 10, and 5 minutes, The sequence could, for instance, be a series of arrested movements from stooping and kneeling to stretching and standing.

Consider where the central axis lies in terms of weight and balance. By going after the structure first, the drawing can be made simpler. If time allows, you can give further consideration to the modeling of the form by introducing tone. The sense of solidity can also be expressed in terms of "lost" and "found" contours. When a line is broken, it suggests light at the edge of the form; corresponding contours will be more intense in tone to emphasize the amplitude of the figure.

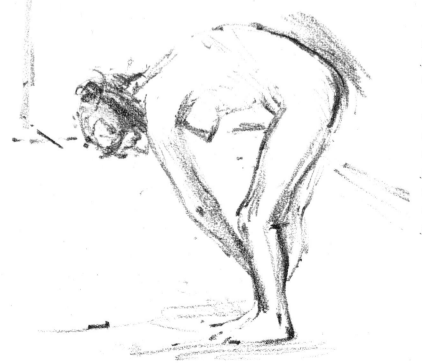

Drawing from quick poses is good practice for loosening up hand and eye coordination. The five- and ten-minute poses (LEFT and RIGHT respectively) only allow time for an instant response to the figure, giving more of an overview than a finished study.

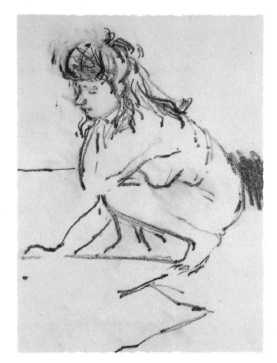

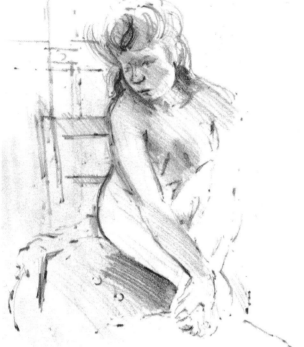

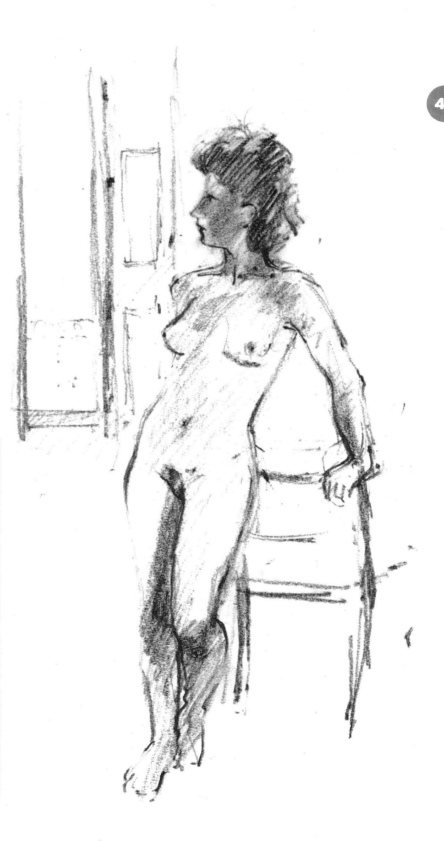

FAR RIGHT *A 15-minute pose allows time to register a response to the effects of strong light and shade and to explore tonal relationships.*

ABOVE AND RIGHT *Longer studies give scope for a more measured account of spatial relationships. The space around the model becomes more important.*

Landscape

42

The artist approaching a landscape subject for the first time will no doubt be overawed by the immensity of the view with which he or she is confronted. Landscape is indeterminate, allowing the eye to select freely and to group and compose various elements. Each of us is faced with the task of attempting to rediscover the landscape we inhabit through our own stream of consciousness. To do this, a series of senses are necessary. We need a sense of scale and proportion, rhythm and movement (nature is never still), a sense of the spatial immensity of landscape, of advancing and receding forms, of structure and of the organic nature of growth.

Landscape drawing is essentially, then, about the art of relationships. The artist sees everything in terms of his or her own emotional response to a place, regrouping all the various elements in view. There is a need to observe the particular disposition of buildings, rivers, trees, bridges, and so on, and be able to put them together in such a way that a kind of drama is released. By describing in his or her work the emotions attached to specific objects in the landscape, the artist is able to express something about the spirit of a place.

Places that inspire one artist may alienate another; much depends on the kind of images an artist stores in his or her own mind. There is a temptation, for instance, to make drawings in locations that may have elicited fine work from admired and respected artists. Paul Nash (1889–1946) felt that an artist usually works best in "his own backyard," but that sometimes he or she

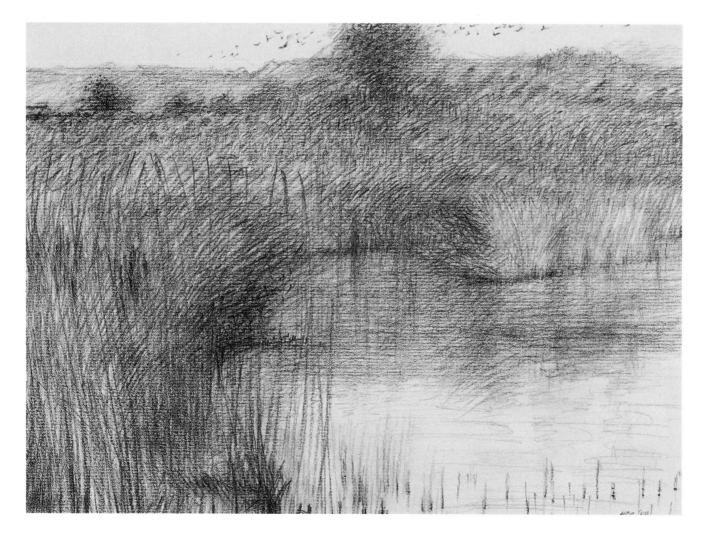

LEFT *The intricate pattern of reeds in this wetland scene demonstrates the artist's skill in seeking and translating the subject in a purely tonal way.*

OPPOSITE RIGHT *Notice how the artist has accentuated the structure of the rocks seen against background foliage in this study of a stone quarry in Scotland.*

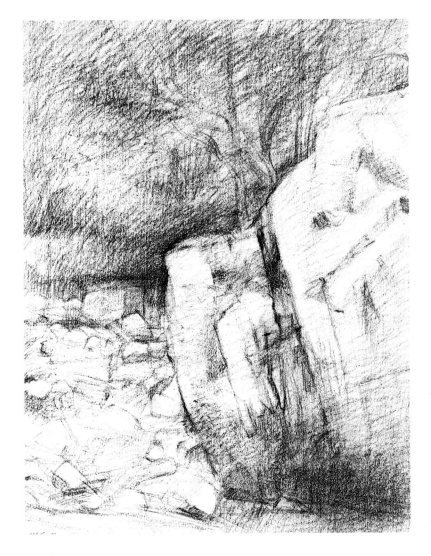

nine hundred and ninety-nine times, you are perfectly safe; if you look at it for the thousandth time, you are in frightful danger of seeing it for the first time."

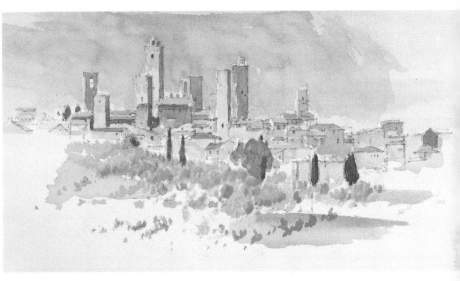

had to travel around the world to discover that simple fact.

I usually look for landscape subjects where there is some kind of "incident" – some feature that significantly transforms an otherwise tedious view. Begin with the places you know best. If, however, you find that your senses have become dulled by familiarity, plan a journey somewhere you have not been before. It's a tall order, but you should try to look beyond the picturesque to uncover those things that you see but do not fully understand. As the writer G. K. Chesterton once said, "If you look at a thing

ABOVE The distant towers and olive grove are seen in brilliant sunlight in this pencil and watercolor of San Gimignano, Italy. There is an interesting relationship between the predominantly horizontal landscape form and the strong verticality of the towers and cypress trees.

LEFT The suggestion of filtered light in this drawing of a garden scene is achieved by carefully controlled tones.

Architecture

44

Our awareness of a particular building, seen either in isolation or in a town or city, is usually dependent on the quality of the light. The extravagant detail of a baroque cathedral might go almost unnoticed on a gray, overcast day, but a humble farm cottage caught in a shaft of sunlight on a hillside can command our attention instantaneously. The season and time of day can, therefore, be particularly important. The whole mood and atmosphere of an architectural subject can change dramatically with the movement of the sun. A gaunt Gothic cathedral might look very inspiring when silhouetted against the pale sun of a wintry afternoon. The white architecture of a Spanish or Greek town, on the other hand, might be best seen when strong sunlight produces sharp tonal contrasts.

Time is an important factor when planning to draw architecture. You can, of course, make a perfectly good rapid summary statement in a few minutes, but that would leave you with very little understanding of the values of proportion. I only began to understand the exquisite symmetry of Palladian architecture, for example, after I had spent a day trying to register the proportions of the Redentore church in Venice.

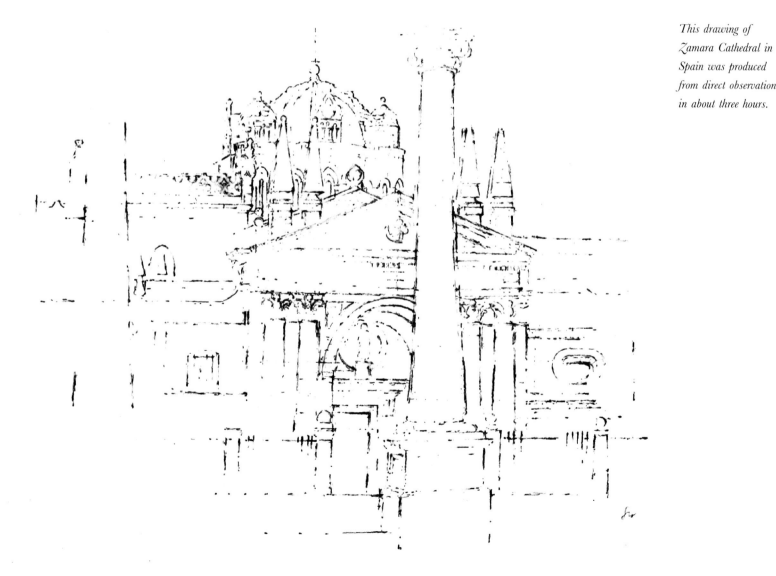

This drawing of Zamara Cathedral in Spain was produced from direct observation in about three hours.

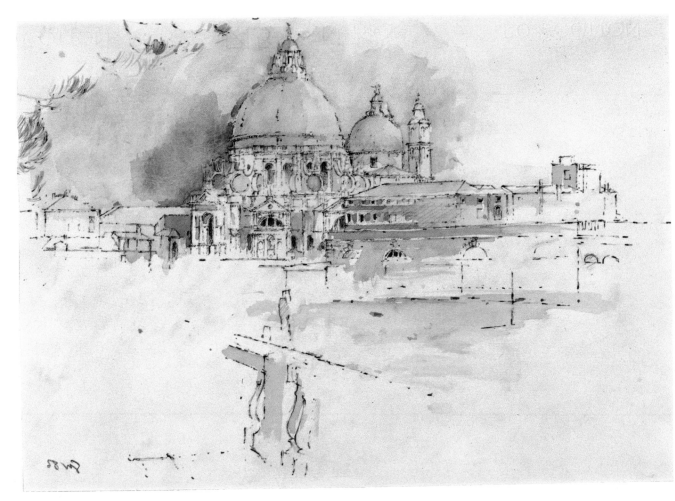

LEFT *Santa Maria Della Salute, Venice, drawn in pencil and watercolor at midday. Watercolor is used sparingly, leaving undrawn areas of white to suggest the intensity of light.*

BELOW *Alte Kirche, Fluelen, Switzerland. In this drawing the artist was mainly interested in seeing the church in relation to the structures of overhead power lines from the adjacent railway.*

Whatever style of building you are drawing, you should first make sure that it will fit on your pad or paper. This may sound obvious, but all too often in our haste to get started, we tend to overlook such fundamental calculations.

Once you have indicated external dimensions in your drawing, consider all the internal divisions between windows, doors, buttresses, and so on. The width of the building might, for example, be determined by the way you judge visually the spaces between windows. Some artists prefer to make an initial drawing using a hard pencil, sorting out the main structural details before restating and developing the drawing with a softer pencil. You might try this if you are uncertain of your initial judgements.

Washes of watercolor, used sparingly, can add an extra dimension to the drawing by enhancing contrasts.

THE
PROJECTS

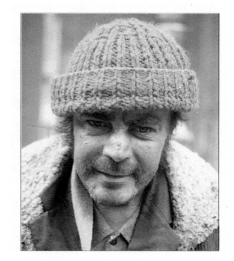

Portrait

A TRAVELING MAN

Portraiture makes demands on both artist and sitter alike; the close proximity of the subject makes some kind of rapport necessary to the success of the drawing.

Proust once said, "The human face is really like one of those oriental gods: a whole group of faces juxtaposed on different planes; it is impossible to see them all simultaneously." This idea that people have different layers or films of appearance was confirmed by the artist Giacometti when he said, "The adventure, the great adventure, is to see something unknown appear each day in the same face."

When we draw a portrait, we talk of "capturing a likeness," but a likeness is difficult to define because it is dependent on an enormous variety of intentions on the part of the artist. If one attempts, for instance, to produce a portrait that is pleasing to the sitter, then the drawing will undoubtedly take on a superficiality – like a touched-up photograph. If, on the other hand, one tries to uncover some part of the emotional state of the sitter, then something more profound might emerge during the process of drawing.

The subject chosen for this portrait was a French itinerant with a weather-beaten face, puffy eyes, a mottled nose, and several days' growth of beard. His face bears the imprint of a life lived roughly on the road. There is a flicker of a smile and the eyes register a kind of tranquil sadness. Only the pink woolen hat adds a note of defiance to his predicament.

You should start a portrait by first deciding how much of the person to include – the head, head and shoulders, or three-quarter figure. If the head is conspicuously striking, there is no need to include anything else. Should you feel that the head is not particularly interesting, however, you might include more of the figure and emphasize other characteristics, such as the hands or distinctive items of clothing.

It is often a good idea to make thumbnail sketches to work out all the compositional variations.

Artist · Roland Jarvis

OCHER
CONTÉ CRAYON

TERRA COTTA
CONTÉ CRAYON

CHARCOAL

6B PENCIL

1 *The position of the head is quickly established using a stick of brown conté crayon, which is smudged with a finger to soften the tone on the area of the face.*

2 *Continuing to work with the conté crayon, an underlying tint is produced, on top of which the first suggestion of the nose and mouth begin to emerge.*

3 *Charcoal is introduced at this stage to establish the form. Highlights are erased from the underlying tint.*

4 *After fixing the drawing at this point, the features of the face are more carefully defined with a soft pencil. The texture and pattern of the hat is briefly stated with alternate strokes of charcoal and brown conté crayon.*

5 *A darker tone is applied with compressed charcoal to consolidate the sense of relief and depth of shadow.*

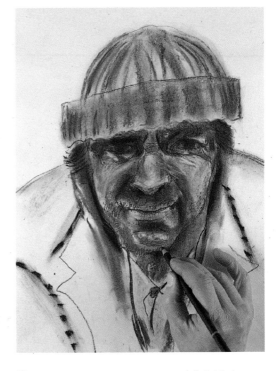

6 *Details such as the eyes, nose, and facial hair are rendered with a sharpened 6B pencil.*

Artist · Alice Englander

50

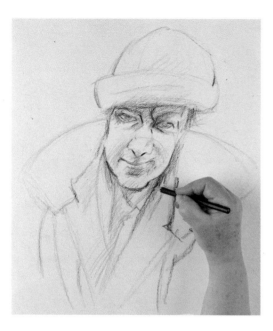

❶ *The structure, volume, and composition are initially worked out with a crayon of a neutral tint on cartridge paper. At this stage, mistakes are easily corrected.*

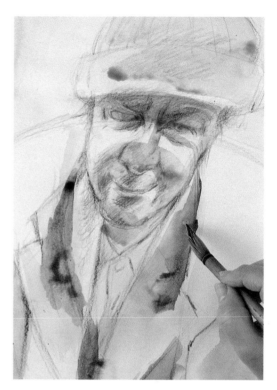

❷ *A gray tint of watercolor is added using a Chinese brush. This helps to define the basic components of the drawing at the beginning.*

❸ *Darker washes provide more tonal contrast. Always look at the subject to decide which parts are of a middle tone. Try to avoid starting the darkest tones too soon, because they are harder to change later.*

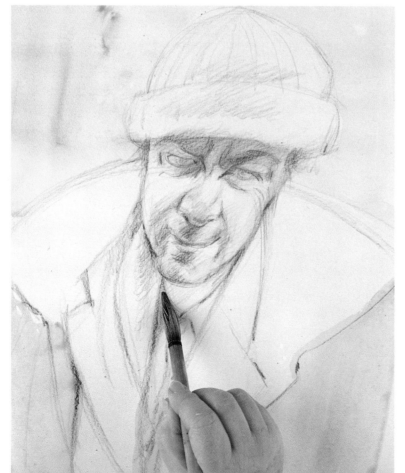

MAUVE CRAYON
LIGHT

GRAY
WATERCOLOR

DARK GRAY
WATERCOLOR

GERANIUM
WATERCOLOR

RAW UMBER
CRAYON

51

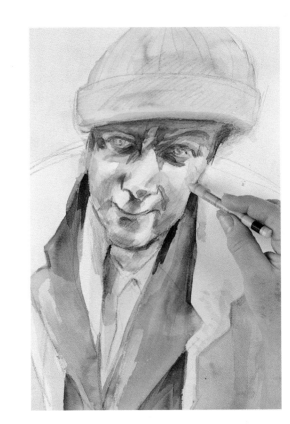

4 *Colored crayons are used to add texture to the clothing. This is done by exploiting the granular quality of the crayon.*

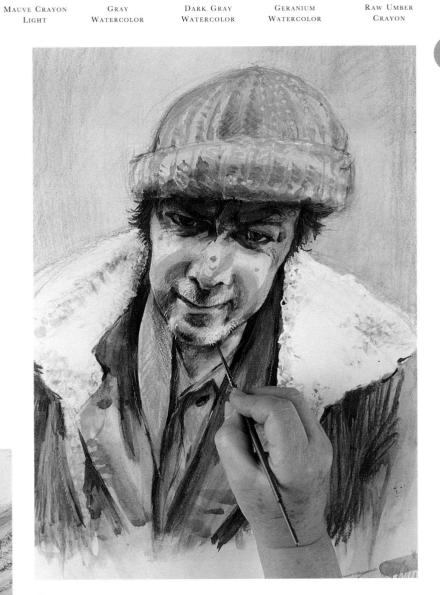

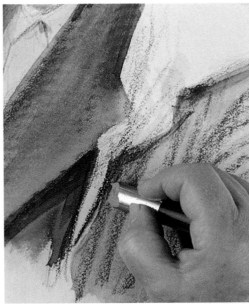

6 *Final details are added using a fine sable brush with watercolor. It is important at this stage not to overwork the drawing and, in so doing, cancel out the marks made more spontaneously at an earlier stage.*

5 *A water-soluble crayon is used to fill in flesh tints.*

Artist · Gerald Woods

52

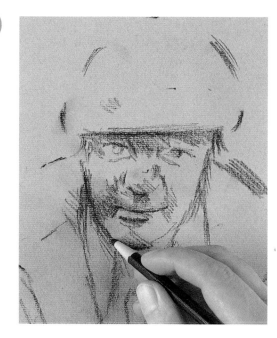

1 *The main features of the head are drawn with a soft charcoal pencil on to pale green Ingres pastel paper. This is a summary sketch on which to build overlaying colors.*

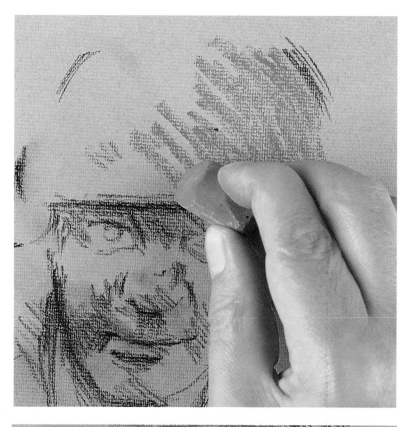

2 *The pinkish-red of the hat is drawn with a soft chalk pastel. The color is added sparingly so that the grain of the paper remains evident.*

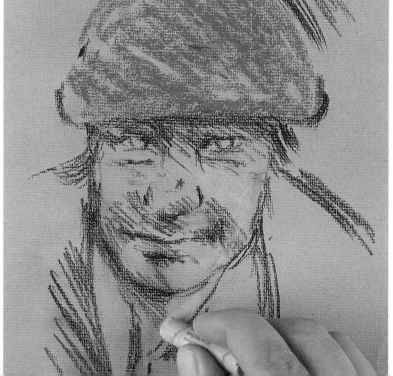

3 *A few strokes of flesh tint are added to the face. It is important at this stage to begin to look at the drawing in terms of related color and tone.*

CHARCOAL PENCIL PALE BRIGHT PINK PASTEL DULL CRIMSON PASTEL DEEP SHADOW PASTEL TERRA COTTA PASTEL PALE EARTH PASTEL

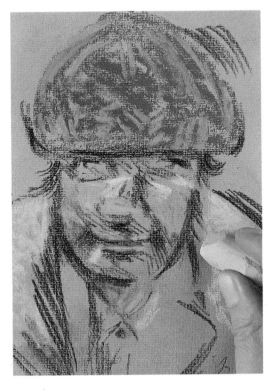

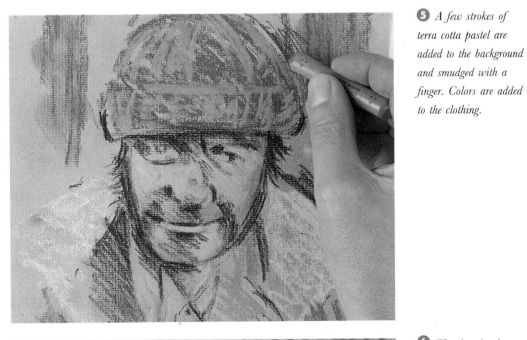

5 *A few strokes of terra cotta pastel are added to the background and smudged with a finger. Colors are added to the clothing.*

4 *A lighter pink is used to render the woolen texture of the hat. The fleecy collar of the coat is suggested by rapid strokes of a pale blue-gray pastel. More flesh tints are added to the face.*

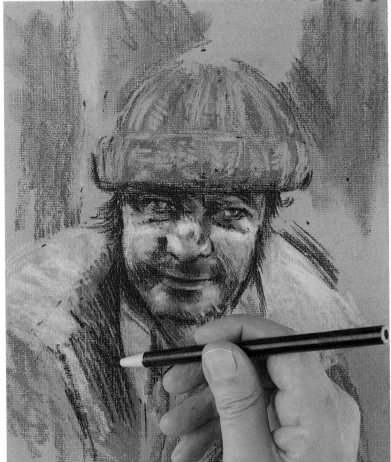

6 *The drawing is now more carefully defined and colors are blended with the fingers to unite disparate parts of the work. When finished, the drawing is laid flat and fixed.*

Portrait · *Critique*

GERALD The neutral tone of the Ingres paper provides a good base color for this drawing in chalk, pastel, and charcoal. It is a rapidly drawn statement that registers the essential characteristics of the subject. While the drawing works as a kind of first impression, the artist might have gotten more from the subject by working on a larger scale, particularly since the media employed are better exploited making broad, gestural marks than small, detailed sketches.

A larger scale may have worked better

Unnecessary detail has been eliminated to focus attention on the subject

ROLAND Charcoal and a brown conté crayon have been combined to produce this powerful study. Extraneous details have been eliminated to focus attention on the tortured expression of the subject. Some of the subtleties of this drawing may be lost in reproduction – especially with a reduction in scale from the original.

More tonal contrast between the background and the clothing might have helped.

Could be more contrast between the background and the clothing

Drawing
works as
a single
statement

ALICE Looking at this drawing one has the feeling that the artist has experienced a great deal of empathy with the subject. Like all good portraits, it has that compelling presence which hints at something deeper than that which is visible on the surface.

The mixed media are handled in a unified way so that the drawing works as a single statement. It might have been more interesting to provide better contrast by setting the figure against a darker background.

could be
more contrast
between the
subject and
the background

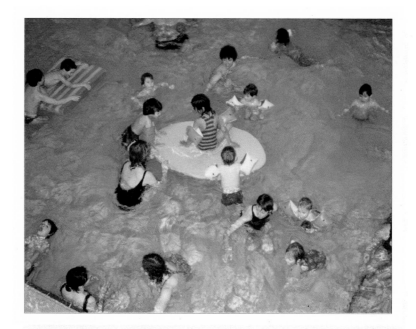

Interior

SWIMMING POOL

For this project it was necessary for the artists to use photographic reference for their drawings, instead of working directly from the subject. Because none of the shapes and forms are ever constant, there is a need to get some kind of fixed reference.

Photographic reference, however, should be used in the right way; it is important not to slavishly reproduce the smooth, silvery tones of the print, but to use the information as a starting point. The shapes made when people splash around in water are difficult to render in terms of drawing techniques. It can help to restrict the range of tones in a monochromatic way or, if using color, to use colors of the same hue. It is interesting to see how the human form is distorted and deflected by immersion in water, producing abstracted shapes which force one to consider the subject in an entirely objective way.

Artist • Roland Jarvis

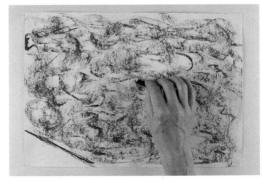

1 *The overall effect of water is achieved by drawing with a wedge-shaped piece of charcoal.*

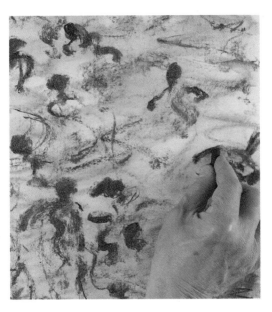

2 *The relative position of individual swimmers is roughly indicated.*

3 *Patches of light on the water and on the figures are picked out from the existing tone with the edge of a putty eraser.*

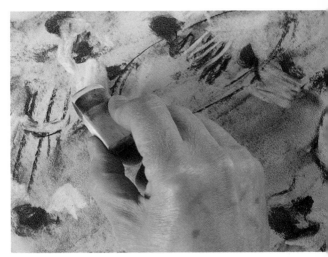

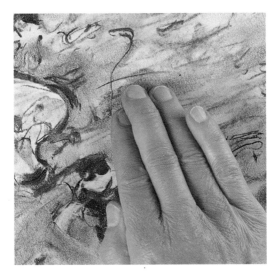

4 *Tones are blended with a finger and the drawing is developed while at the same time the artist tries to maintain spontaneity and a sense of movement.*

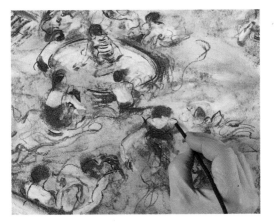

5 *Working with a stem of charcoal, the tonal pattern is consolidated to evoke the atmosphere of the swimming pool by varying the pressure on the paper.*

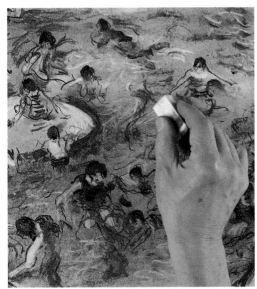

6 *Highlights are lifted out of the overall tone with the edge of a putty eraser.*

Artist • Alice Englander

58

1 *Drawing with an HB pencil, the exact action and placement of the figures is established within the overall composition.*

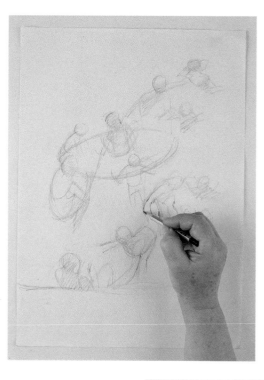

2 *Using a dip pen and waterproof Indian ink, the drawing is restated.*

3 *The ink drawing is allowed to dry and the under-lying pencil lines are erased. The pen provides a key-line on which to lay further washes of color and to build up the drawing generally.*

HB PENCIL	PEN AND INK	COBALT BLUE WATERCOLOR	LEMON YELLOW WATERCOLOR	ALIZARIN CRIMSON WATERCOLOR	PRUSSIAN BLUE CRAYON	LITHO CRAYON

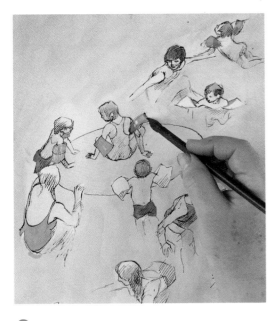

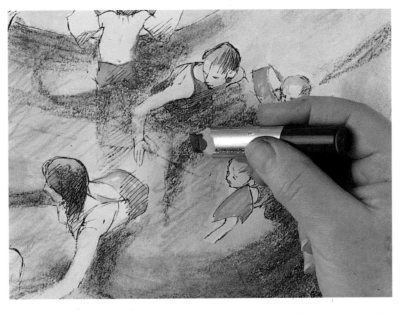

5 *The broken texture of a dark blue-gray crayon is used broadly to emphasize the rhythm and oscillation of the water.*

4 *The general areas of surface color are introduced with pale washes of watercolor applied loosely with a Chinese brush.*

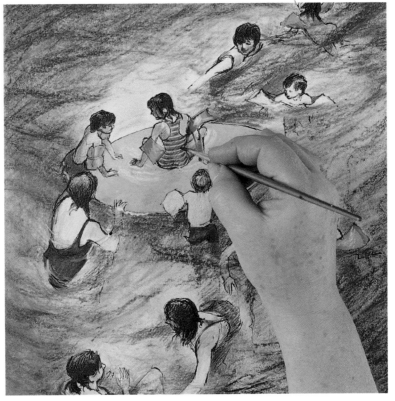

6 *Details are added to the figures and the primary colors of floats, armbands, and bathing suits with a fine brush, watercolor, and colored crayons.*

Artist · Gerald Woods

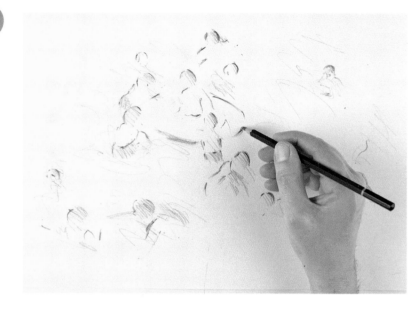

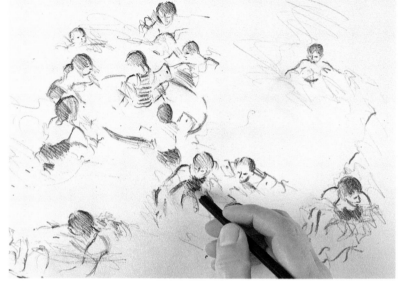

1 *The relative position of the fifteen swimmers is roughly drawn with a 3B pencil on buff-colored cartridge paper.*

2 *The drawing is further consolidated with a softer 6B pencil.*

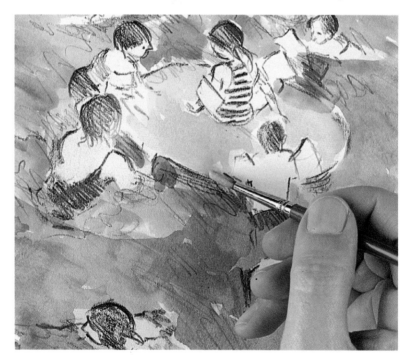

3 *A freely applied wash of Monastral Blue is laid over the drawing, isolating and defining the swimmers and those parts of their bodies above and below the surface of the water.*

3B PENCIL 6B PENCIL MONASTRAL BLUE LEMON YELLOW TURQUOISE PRUSSIAN BLUE
WATERCOLOR

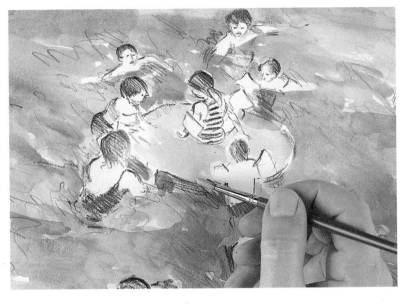

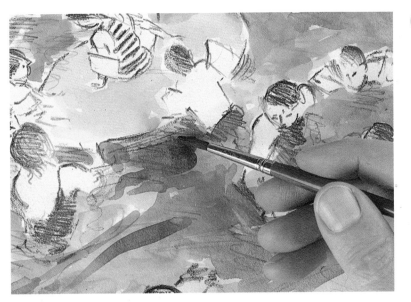

4 *A full wash of
Lemon Yellow defines
the shape of the
inflatable raft.*

5 *Further washes of
turquoise and French
Ultramarine are overlaid
wet-in-wet to create the
effect of dappled water.*

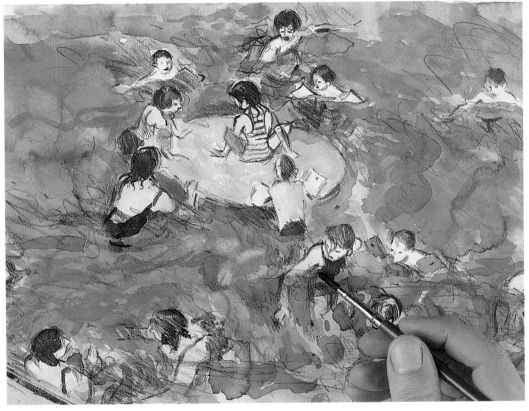

6 *Parts of the
drawing are given more
definition with a wash
of Prussian Blue using a
No. 4 sable brush.*

Interior · *Critique*

62

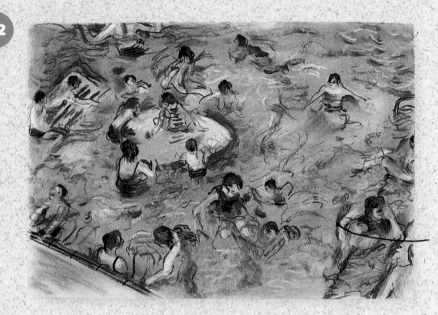

ROLAND This lively drawing suggests color even though it is produced in monochrome. The rhythm and spontaneity has been maintained throughout the various stages of development. One senses that the artist was particularly engaged in the early stages with the intrinsic movement of half-submerged figures and he has used charcoal in a very dynamic way. Something of this is lost, I feel, in the final stage of the drawing.

Sustained rhythm and spontaneity throughout

Effective use of watercolor

Too many points of focus

GERALD Watercolor has been used effectively in this drawing to convey the quality of opalescence of the pool. Additionally, the transparency of the medium helps to reinforce the impression of the buoyancy of the swimmers. In terms of composition, however, the displacement of the figures could have been more interesting, since in the existing drawing there are too many different points of focus.

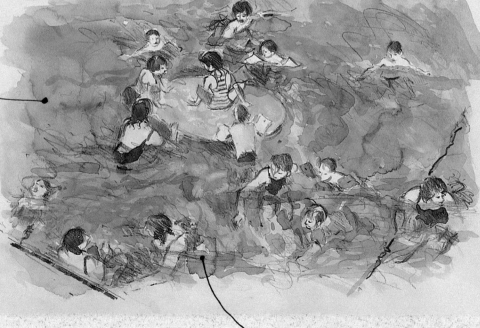

Displacement of figures not very interesting

Good
composition

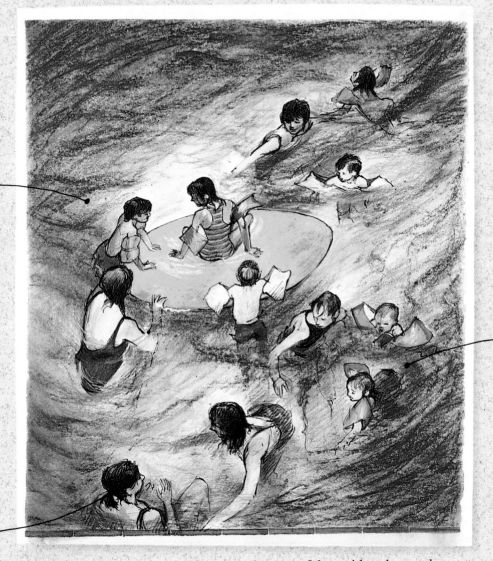

Fluent
use of
pen & ink

Rhythmic
water
movement

ALICE In this drawing, the artist has given careful consideration to the composition. Notice, for instance, the diagonal link of arm movements from the figure in the bottom left-hand corner to the figure in the top right-hand corner.

Drawing figures in movement calls for economy of line and the artist has used pen and ink with considerable fluency.

In the final stage of the drawing, she has used colored crayons to create a rhythmic movement of the water, and, while this is convincing, it is more reminiscent of the choppy texture of the open sea than of a swimming pool.

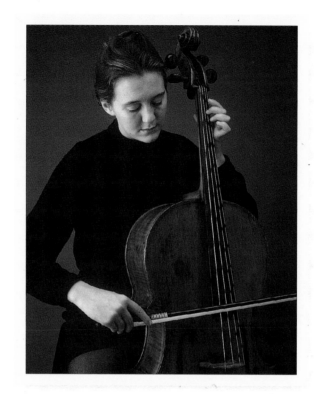

Unposed Figure

YOUNG CELLO PLAYER

I find that drawing someone who is engaged in some occupation or other is often more inspiring than drawing someone who is posing specially for a portrait. The subject is relaxed and unselfconscious, absorbed in whatever he or she is doing, rather than uncomfortably aware of the artist. Some of the most interesting drawings produced by the French Impressionists were their inconsequential studies of men, women, and children idly engaged in casual pursuits – cooking, sewing, reading, and so on. Edward Vuillard (1868–1940) spent most of his life drawing and painting such scenes of domesticity, as did Berthe Morisot (1841–1895) and Mary Cassatt (1844–1926).

Drawing musicians requires the ability to produce settled images from things that move a little. I was once invited to make a series of drawings at rehearsals for the annual music festival in Luzern, Switzerland. I remember that at first I found it difficult to come to terms with the need to draw rapidly, in an almost automatic way. It was only some hours after the rehearsals were over that I could look at my sketches and evaluate what had been achieved.

The young cellist selected for our drawing is seen concentrating on the action of drawing the bow across the instrument, while making finger movements instinctively with her left hand. Musician and instrument appear to be inextricably linked.

CHARCOAL PENCIL (2B)

Artist ⋅ Roland Jarvis

❶ *The artist begins by making a rapid "shorthand" analysis with charcoal, indicating the main rhythms and proportions of the subject. An advantage of working in this way is that you get rid of the blankness of the paper immediately – thus providing a framework for the whole drawing.*

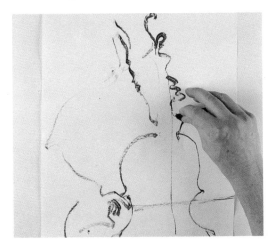

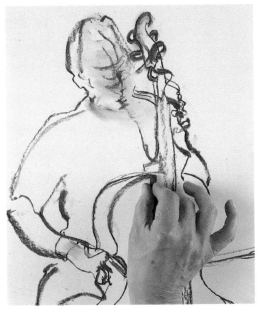

❷ *A linear rendering of the form continues with charcoal, applying strokes of varying pressure and intensity.*

❸ *Some redrawing may be necessary at this stage as tones are broadly established.*

❹ *The eraser is used as a drawing tool to produce lighter patches.*

❺ *Details on the face, hands, and instrument are drawn with a 2B pencil.*

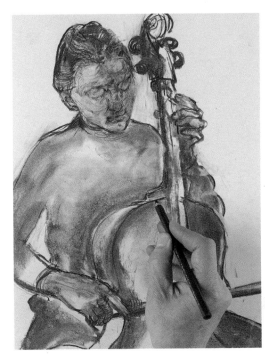

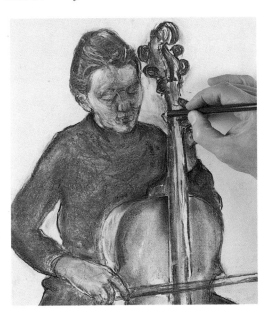

❻ *The drawing is tonally balanced, and final detail is added with a sharp 2B pencil.*

Artist • Alice Englander

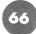

1 *The figure and instrument are drawn using a neutral tint of colored crayon on cartridge paper. Gradations of tone are added selectively with the same crayon.*

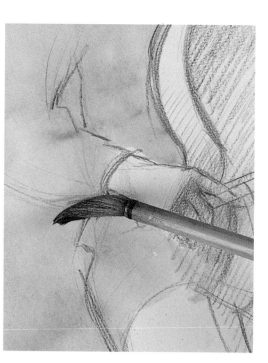

2 *A wash of Payne's Gray is painted over both figure and background with a Chinese brush to produce a unified tone.*

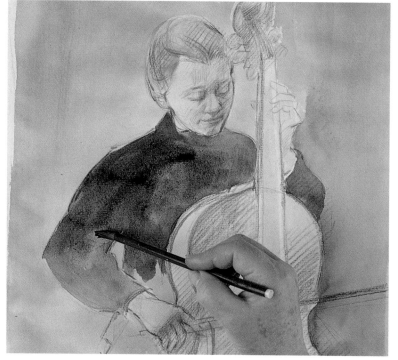

3 *Color is added to the hair, clothing, and cello with broadly laid washes of watercolor. The drawing is built up gradually by giving consideration to all the related elements.*

PURPLE CRAYON PAYNE'S GRAY WASH YELLOW OCHER BURNT UMBER LAMP BLACK BLACK LUMBER CRAYON

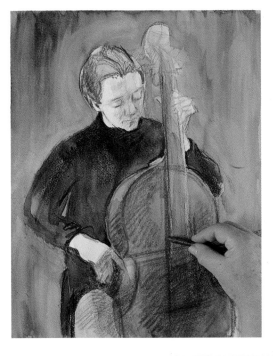

4 *A brown wax crayon produces tones that suggest the patina of the polished surface of the cello.*

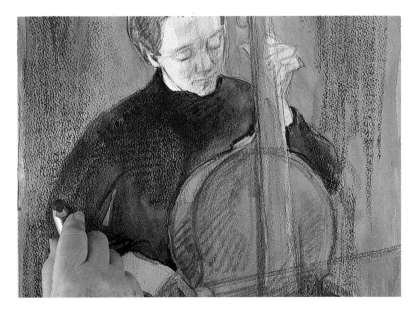

5 *Tones are further modulated using a combination of watercolor, colored crayons, and a black lumber crayon.*

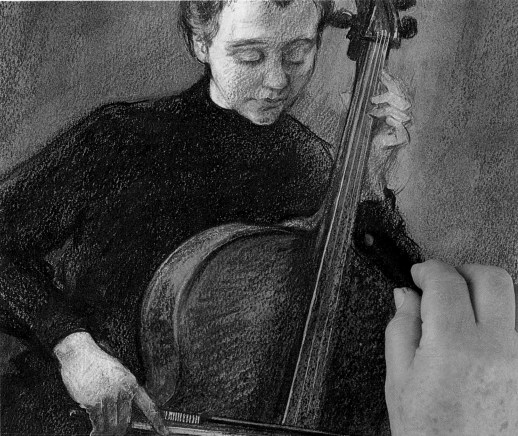

6 *The previously laid black washes are given greater intensity by drawing on top with a soft wax crayon. More detail is added to face, hair, hands, and cello.*

Artist · Gerald Woods

68

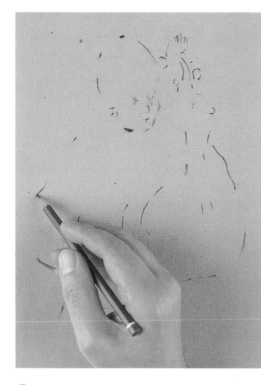

① *A few marks with a soft pencil on gray Ingres paper register the main corresponding angles of the figure and instrument.*

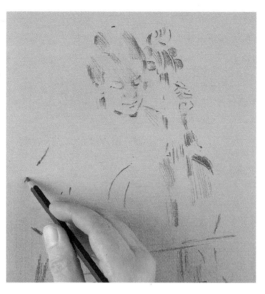

② *Shading with a softer graphite pencil follows the rounded forms of the figure and cello.*

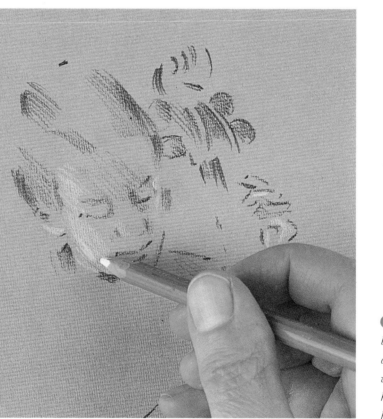

③ *Tones are intensified but the drawing remains deliberately understated. A white crayon is used for highlights on the face, hands, strings, and bow.*

2B PENCIL

6B PENCIL

GRAY CRAYON

BROWN CRAYON

9B PENCIL

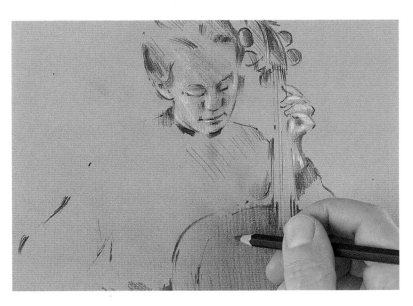

5 *Brown shading is added to the surface of the cello, but color is hinted at rather than overstated.*

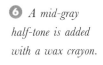

4 *At this stage the artist gives careful consideration to the corresponding arcs and angles of both the figure and the instrument, intensifying the tone as necessary with a 9B pencil.*

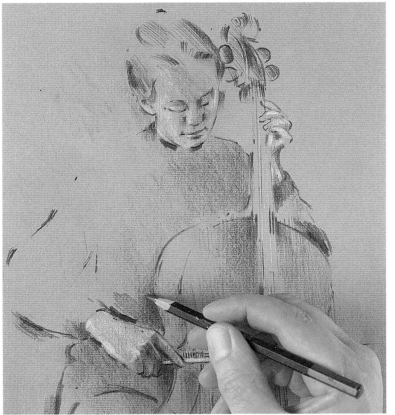

6 *A mid-gray half-tone is added with a wax crayon.*

Unposed Figure • *Critique*

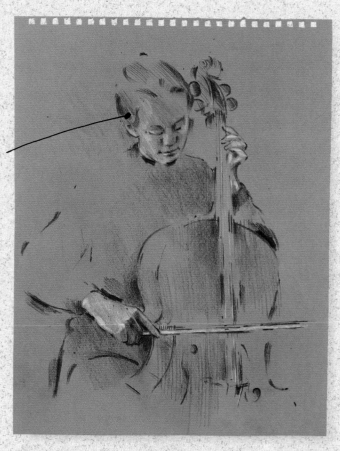

Deliberate under-statement

GERALD In this drawing, the artist has consciously aimed at the understatement, registering only those aspects of the pose that are necessary to communicate what is happening. Such a drawing calls for a certain amount of premeditation on the part of the artist, since one is concerned with evaluating just how much can be left out. The success or failure of the drawing is dependent upon the assumption that the viewer will make the necessary connections from memory and from the information provided.

Fingering of the instrument well observed

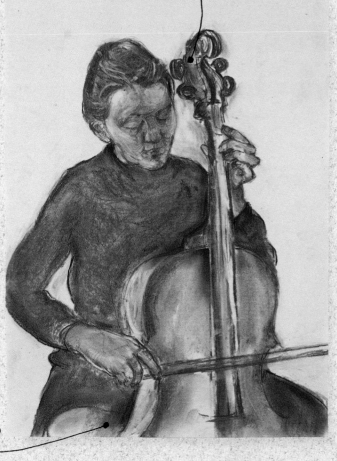

ROLAND The arabesque-like marks made in the early stage of the drawing are analogous to musical notations. This overriding sense of rhythmicity is maintained in the final stage particularly in the way that the fingering of the instrument has been depicted. The tonality of the drawing also evokes the idea of a melodic fugue.

This is a good example of a drawing that is concerned more with interpretative values than with exactitude. My own feeling, however, is that the drawing would have had even more resonance if the artist had worked to the same scale on a much larger sheet of paper.

Good interpretation of the subject

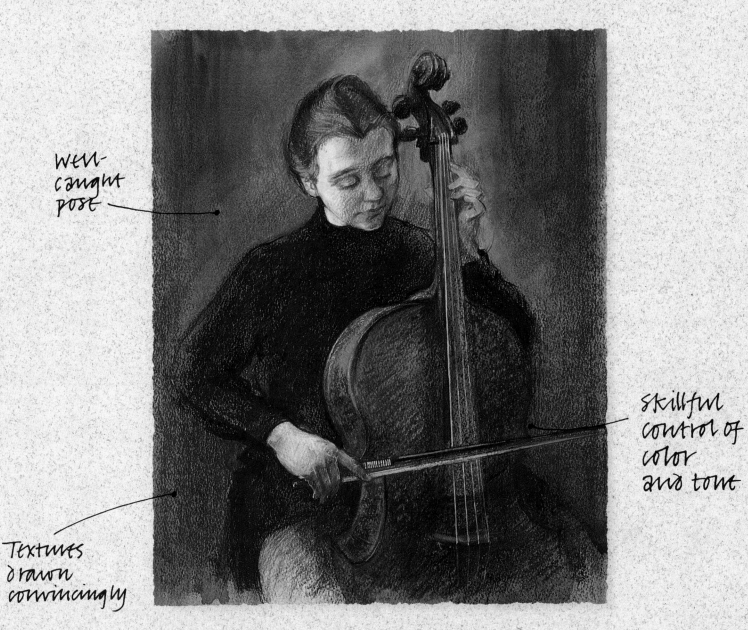

well-
caught
pose

Textures
drawn
convincingly

skillful
control of
color
and tone

ALICE In the first stage of the drawing, the artist has captured the essence of the pose. All the concentrated effort that is evident when a musician is at one with her instrument is made manifest in this drawing. In the final stage, color and tone have been skillfully controlled to retain the intentness of the perfor-mance. The dark tone of the background serves to enhance the isolated patches of light on the face and hands.

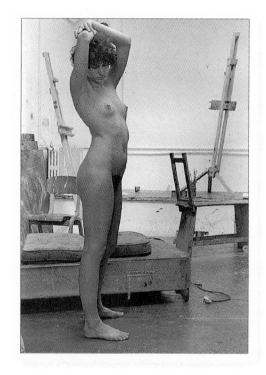

Life Study

STANDING NUDE

Life study or life drawing are terms that are traditionally used to refer to any drawing or painting of the naked form. Drawing the naked form is a demanding exercise but essential in learning to see the subtleties of light and tone.

Standing poses can sometimes prove difficult for both artist and model. The sense of weight becomes more critical, one leg usually bearing more weight than the other, so that there is a need to establish right away the vertical axis that is supportive to the rest of the body. The strongly vertical stance was achieved gradually. A number of alternative positions were tried out before the artists in the session settled for this final pose and in this it was helpful that the model participated fully.

It is interesting to note the relationship between the model and the displacement of other objects in the room. All the horizontal and vertical structures provide a link to the composition as a whole. Additionally, they provide a useful means of cross-reference when trying to establish the proportions of the figure. Keep this in mind when setting a pose.

Degas once said, "Drawing is not the imitation of the form, it is the manner of seeing the form." The task facing the artists responding to this pose is to create the right balance between a detached objectivity and a subjective sense of heightened reality. This will ultimately emphasize the strongly rhythmic elements of the pose.

SOFT PENCIL CHARCOAL

Artist · Roland Jarvis

1 *Using a broken stem of willow charcoal, the basic rhythm of the pose is rapidly drawn.*

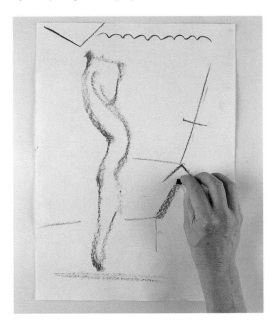

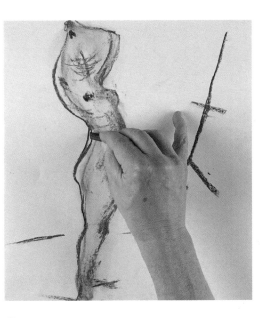

2 *The main accents of corresponding arcs of the figure are indicated, and parts of the drawn line are wiped softly to produce a flat tone over the whole figure.*

3 *The curvature of the torso is emphasized with directional strokes of charcoal. The modeling of the form is developed as a single statement.*

73

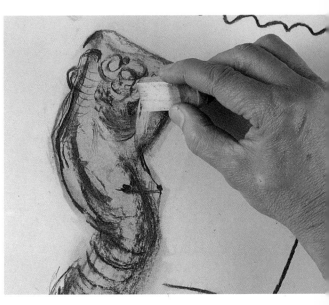

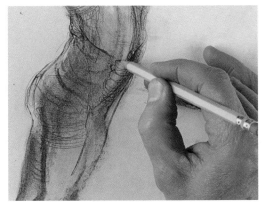

4 *Highlights are erased with a putty eraser and the main forms are restated with a medium grade pencil without being too precise at this stage.*

5 *With a softer pencil, the artist now works from the larger forms towards the smaller with a sensitive, more tentative line, producing rich tonal variations.*

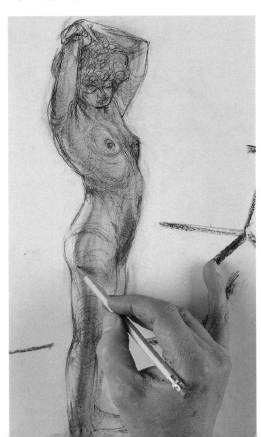

6 *The main compositional elements in the background are now linked to the figure with charcoal to produce a sense of space and to give the figure a context.*

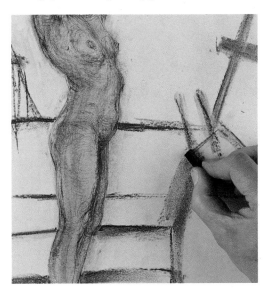

Artist · Alice Englander

74

① *The structure of the figure and the movement of the pose is registered lightly with a soft graphite pencil on cream-colored laid paper.*

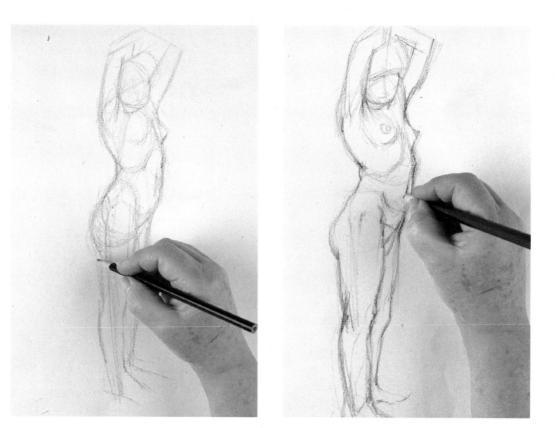

② *More tone is added tenuously with a lithographic pencil to express the volume of the form on the broken texture of the paper.*

③ *Earlier detail is now lost as broader tones are overlaid with a lumber crayon.*

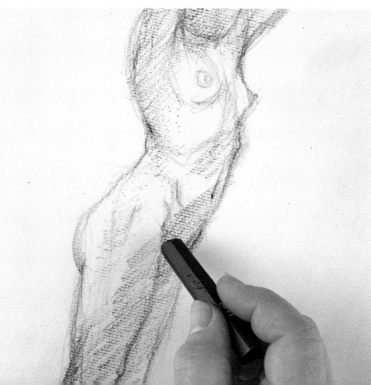

3B PENCIL LITHO CRAYON LUMBER CRAYON MID-GRAY WASH

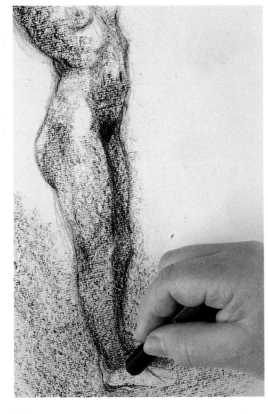

4 *Tonal development continues with the lumber crayon. The artist needs considerable visual judgment to evaluate the tonal balance at this stage.*

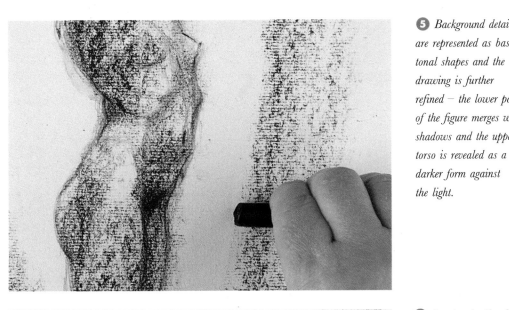

5 *Background details are represented as basic tonal shapes and the drawing is further refined – the lower part of the figure merges with shadows and the upper torso is revealed as a darker form against the light.*

6 *Interior details of the studio are hinted at with a gray wash applied with a fine brush.*

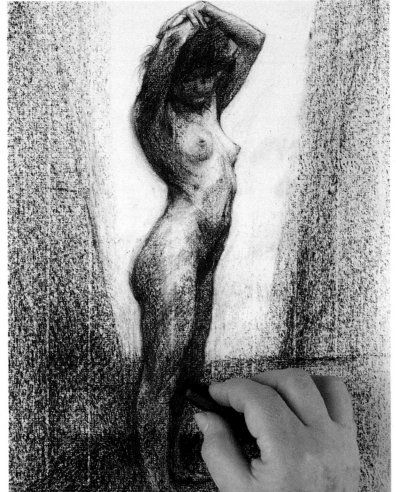

Artist · Gerald Woods

76

❶ *The main forms of the figure are rapidly stated with a 3B pencil on the smooth surface of cream cartridge paper.*

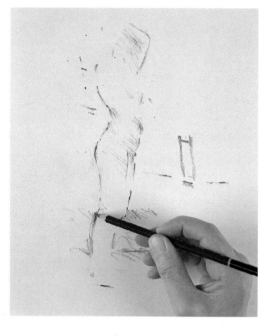

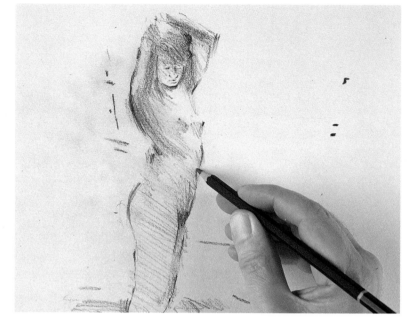

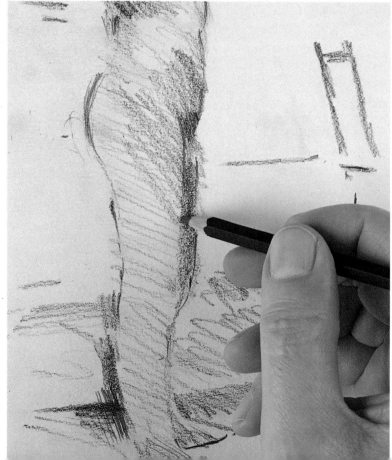

❷ *The figure is now more firmly established as further shading is added to emphasize the curvature of the arms, rib cage, and torso.*

❸ *Modeling of the form continues with a softer 9B pencil; the tones are softened slightly with a finger.*

3B Pencil

9B Pencil BLUE-GRAY PASTEL FLESH-TINT PASTEL

4 *A blue-gray pastel provides a neutral background tone.*

5 *A flesh tone is added to parts of the figure with a soft chalk pastel.*

77

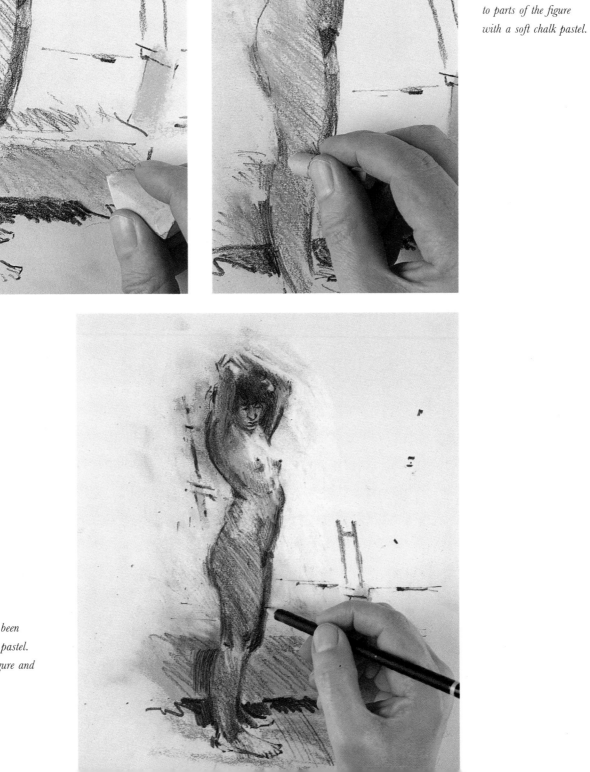

6 *At this stage, parts of the drawing have been erased, redrawn, and overlaid with smudged pastel. A white wax crayon is used to isolate the figure and cancel out unwanted tone.*

Life Study • *Critique*

Sculptural treatment

Some contrast lost in final stage

ROLAND This drawing has been interpreted in a very sculptural way. One has the sense that the artist has used his materials to "carve out" forms in terms of physical gesture and bodily space. There is nothing static about the drawing; surrounding studio furniture is used as a kind of armature to support the figure in space. The tones have perhaps been leveled out too much in the final stage of the drawing, losing some of the contrast of earlier stages.

Angularity of pose well observed

Background details reduced

ALICE The way that the artist has used a soft wax crayon on a textured, laid paper to produce this sensitive and strongly atmospheric life study recalls the drawings of Seurat. She has captured the angularity and physical presence of the model convincingly. Background details have been reduced to basic, barely perceptible abstract shapes, producing a harmonious tonal relationship.

In relation to the drawings produced by the other artists, the figure appears different in proportion.

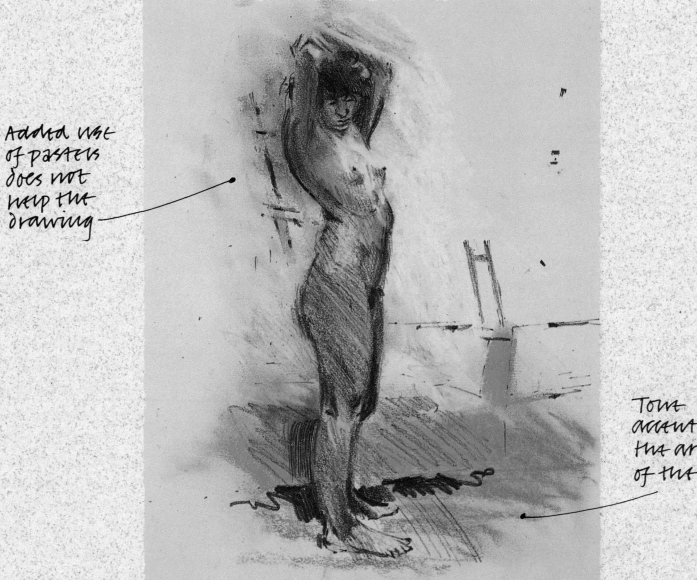

Added use of pastels does not help the drawing

Tone accentuates the articulation of the pose

GERALD This drawing bears the imprint of the artist's constant search for form in a tentative way, rather than with any degree of certainty in the quality of line. Tone has been used to accentuate the articulation of the pose. There is also the sense of balance and distribution of weight, from the curvature of the spine to the feet firmly planted on the studio floor.

I am not sure that the additional use of pastel helps the drawing at all, although a white crayon has been used effectively to cancel out contours that had become too prominent.

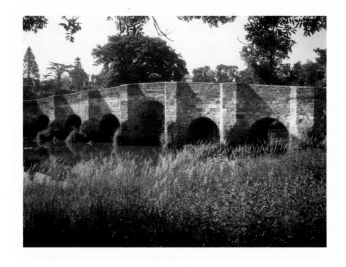

Landscape

STOPHAM BRIDGE

In every country the best examples of historic architecture usually incorporate locally quarried stone and clay. The timber used for building is also cut from nearby forests. This ensures a visual affinity with the surrounding landscape, as in the case of the bridge selected for this project.

Stopham Bridge in West Sussex, England, was originally built in 1423, although the raised center arch dates from 1822. The other six arches provide a rhythmic link from one side of the river to the other, which is visually satisfying. In this scene, the bridge makes a bold horizontal statement relieved only by the gently contrasting reeds and grasses in the foreground and the hazy green tracery of distant trees.

Texture is an important aspect of this subject. We are sometimes so preoccupied with representing what we see in terms of line and tonal contrast that we tend to overlook the rich texture of various substances which have become weathered and burnished by centuries of exposure to the elements.

Artist · Roland Jarvis

BURNT SIENNA
CONTÉ

BURNT SIENNA
WASH

BURNT SIENNA
DARK WASH

GRAY WASH

BLACK CONTÉ

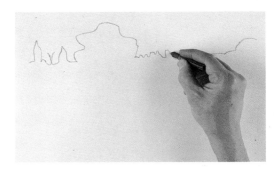

1 *A lucid outline of the distant trees is drawn with a Burnt Sienna crayon.*

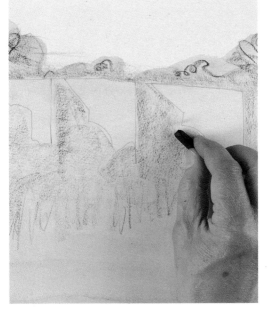

2 *A wash of Burnt Sienna is applied over the whole of the foreground and middle distance and areas of shadow, foliage, and vegetation are tentatively drawn with black conté crayon.*

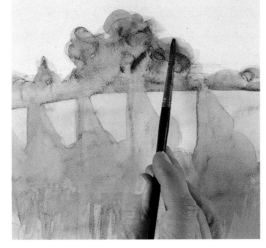

3 *The shadows of the arches and projecting buttresses are formed as a transparent wash of gray is overlaid onto the Burnt Sienna ground.*

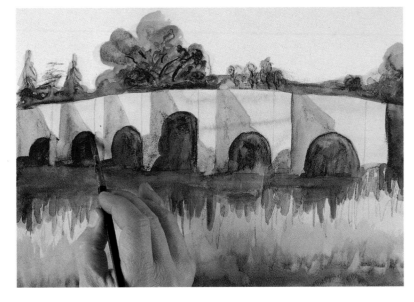

4 *Darker shadows are added to the arches under the bridge, the trees, and river.*

5 *Texture is added to the grasses on the riverbank. A pale wash is applied for both the sky and the stonework of the bridge.*

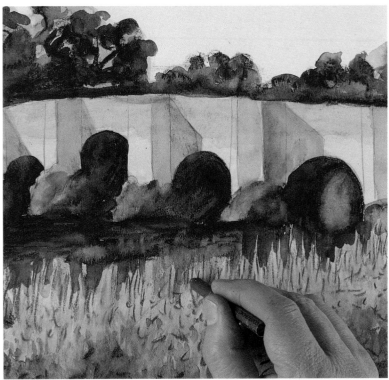

Artist · Alice Englander

82

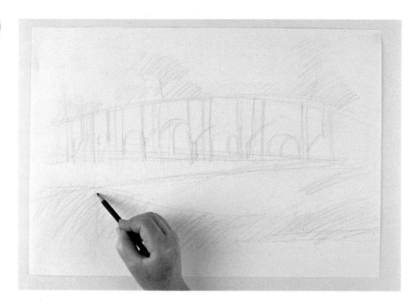

1 *An underdrawing of the bridge and surrounding foliage is produced with a crayon of a neutral tint on heavyweight cartridge paper.*

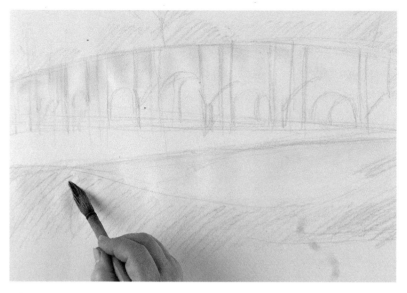

2 *Pale washes of watercolor are applied wet-in-wet with a large Chinese brush.*

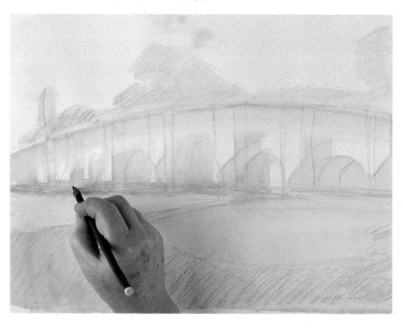

3 *Here the artist uses a finer Chinese brush to add a mid-tone of watercolor to the arch of the bridge.*

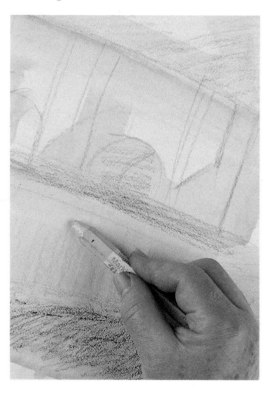

4 *A yellow wax crayon is used as a base color for the grass on the riverbank.*

PURPLE CRAYON

LEMON YELLOW
WATERCOLOR

VIRIDIAN
WATERCOLOR

BLUE CRAYON

BLACK LUMBER
CRAYON

5 *Here the artist has used a heavy wax lumber crayon. This produces a denser granular atmospheric tone on the bridge and distant trees. Further drawing is done on the stonework and under the arches of the bridge with the lumber crayon.*

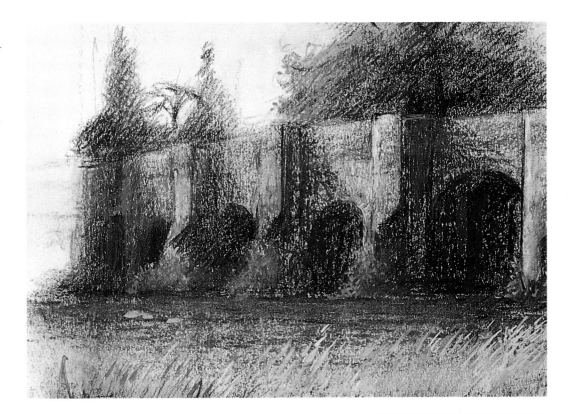

6 *Reeds and grasses on the riverbank are drawn with a No. 1 sable brush.*

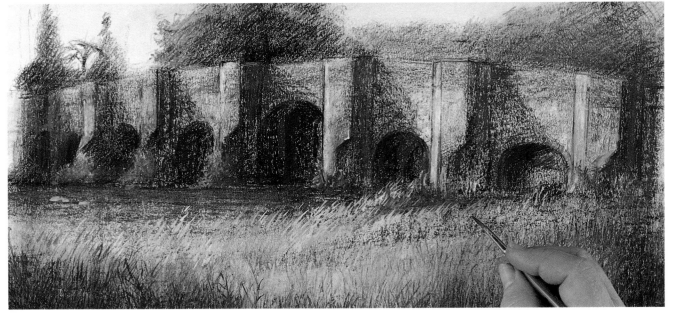

Artist · Gerald Woods

84

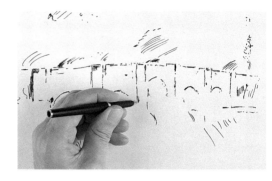

1 *The main proportions of the bridge and stonework are drawn with a fountain pen filled with water-soluble black ink. A few random strokes of the pen also suggest distant foliage and grass on the riverbank.*

2 *Shading is introduced alongside supporting buttresses and surrounding vegetation.*

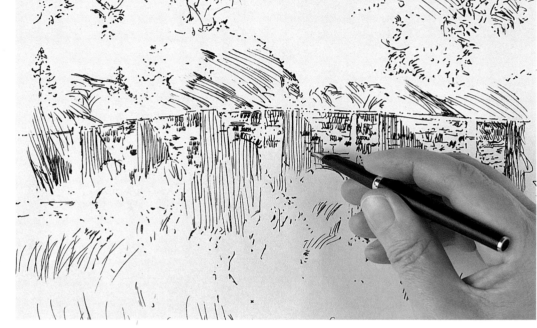

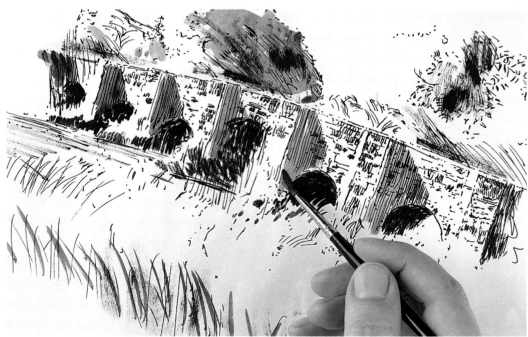

3 *Applied with a No. 3 sable brush, a diluted wash of Indian ink provides half-tones and shadows. A more solid black forms the intense shadows under the arches.*

FOUNTAIN PEN INK WASH OCHER CRAYON PURPLE CRAYON

4 *The drawing is more fully developed, using successive strokes of the pen and dry brushwork. After some parts of the drawing have been marked off, spatter is added with an old toothbrush and ink.*

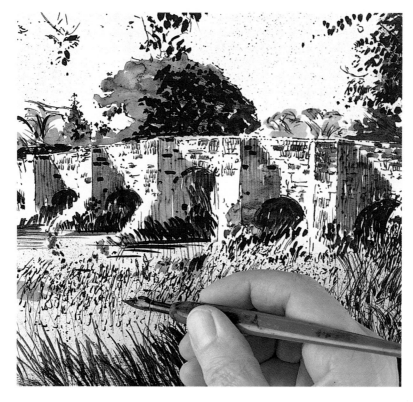

5 *A tint of ocher is drawn sparingly on the riverbank and on part of the bridge.*

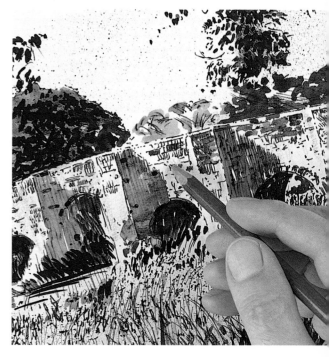

6 *A tint of purple crayon is added to the sky and is blended with other colors.*

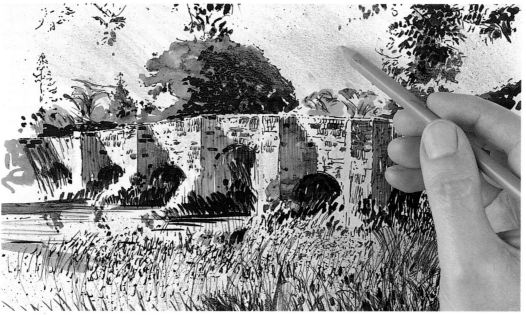

Landscape · *Critique*

86

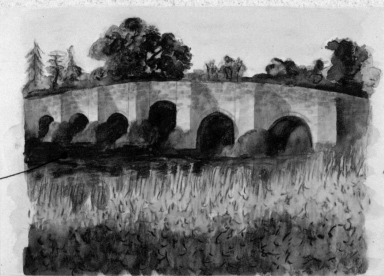

composition is helped by strong tonal contrasts

ROLAND Man-made structures in the landscape, such as this bridge, need to be drawn as if they are growing out of the ground on which they stand.

This drawing demonstrates how black and a second colored tint can be used effectively to produce greater depth as well as an interaction of the warm and cool values that control the design. It is a forceful composition, with strong tonal contrast suggesting the material substance of the stone bridge.

Bridge and landscape well integrated

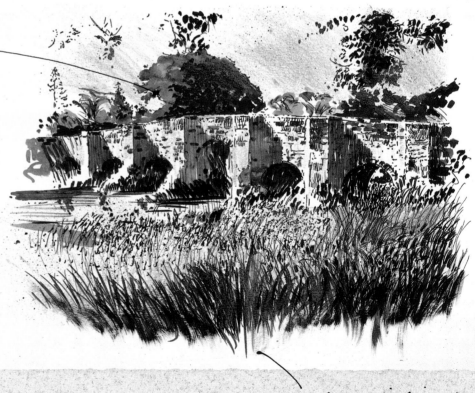

GERALD In this graphic rendering of the subject, the artist has combined pen and ink, wash, dry brushwork, and spatter to create a unified sense of the place and its particular quality of light. The integration of the bridge and the landscape works well, and there is enough variety in the marks to suggest texture and character in the surrounding vegetation.

Compositionally, it is perhaps too symmetrical, and the drawing could have been made more dramatic by extending either the sky or foreground and by providing more contrast.

composition too symmetrical

Elements
harmonize
well

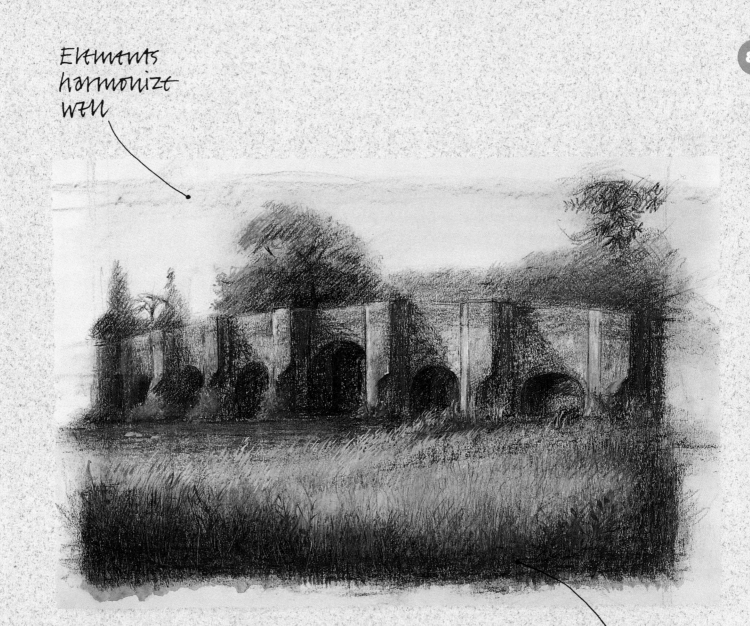

Good use of
contrasting
textures

ALICE The artist has avoided the potential trap of producing a picturesque rendering of this subject. It is a drawing in which all the elements work together in harmony. Everything necessary to the idea is included without the addition of extraneous detail. There is an interesting contrast between the solidity of the bridge and the almost gossamer-like quality of the wild grasses on the riverbank.

MATERIALS
AND
TECHNIQUES

Choosing Pastels

Soft pastels are quite simply sticks of molded pigment mixed to a binder to form a "paste." Generally, gum tragacanth is used as a binder but there are also a number of other equally suitable binding agents. The sticks are extremely fragile and are supported by an outer layer of tissue paper, which can be peeled back gradually as the work progresses.

One important advantage that pastels have over painting media such as oil and gouache is that, whereas paints can dry to either a lighter or darker tone, pastels do not undergo any such change.

The enormous color range available in pastels is made possible by reducing the stronger primary, secondary, and tertiary colors with a white base filler to produce an extensive sanicle of delicate tints. When selecting your own color palette, there are a number of points worth considering. Think about the kind of subjects to which you are drawn: landscapes, portraits, or flower studies, for instance. All require a basic range of colors, but you might need a number of neutral tints, in addition, to express light and shade. Your preferred subject may demand a dominant hue. Remember that almost every subtle nuance of color in your drawing will require a separate stick of pastel. It sometimes happens that a carefully placed color can provide a keynote to the entire work. The color and tone of the paper support that you choose will also influence the degree of brightness and contrast in the finished work.

The crumbly texture of soft pastels produces very different marks to those made with colored chalks or wax crayons. Used forcefully, a stick of soft pastel can be diminished rapidly, and the beginner might initially find them difficult to handle. The quality of soft pastels varies considerably; the less expensive ranges, for example, might be made from synthetic pigments and a high proportion of white filler.

Hard pastels contain a higher proportion of binder and are more tightly compressed. They produce a much sharper line and are used primarily for the initial structure when building up a pastel drawing. The pastels are sharpened either by breaking the stick, leaving a sharp point on each corner, or by wearing down one tip of the pastel on a pad

Soft pastels

Stiff brush

of sandpaper. The pigment deposited from hard pastels is less likely to be absorbed into the grain of the paper than soft pastel pigment and, as a consequence, is much easier to remove – preferably with a stiff painting brush.

Your initial palette might well consist of, say, six hard pastels – four primaries and a stick each of black and white – and 35 soft pastels, chosen individually rather than as a boxed set. Try to include a scale of warm and cool neutral tints in your selection, and include a few special colors such as Carmine Red or Olive Green. Ideally, you will need to have a light, middle, and dark tone of each color, which means that for a basic palette of 12 colors you will need 30 pastels. Manufacturers generally grade pastels according to the strength of each color. A permanent deep red, for instance, might be produced as a pale tint in No. 1 grade and a more intense shade in No. 10 grade. Some manufacturers prefer to denote the amount of white filler used in reduction in percentage decimal points. Confronted by a huge range of colors in an art store, however, I tend to select by sight – or rather, the colors select me!

PASTEL PENCILS

Pastel pencils are used when finer detail is required, since they can be sharpened to a fine point. They have the advantage of being protected by the outer wood casing, which helps to prevent breaks. If you are used to drawing with a pencil, you might be tempted to use them alone, not in conjunction with sticks of soft pastel. This would be a mistake, in my view, since you would never be able to experience the freedom of expression that comes from the broader application of colored pigment.

OIL PASTELS

Oil pastels are a comparatively recent addition to pastel technique. The main difference is that they require an oil-based binder. With their consequent high grease content, the drawn strokes from oil pastels are less granular, but more transparent, than those made by soft chalk pastels. The colors are generally stronger, more intense, and darker in tone. They should not be used in conjunction with chalk pastels because of their mutual antipathy. Once deposited on the paper support, oil pastels can be further diluted with white spirit to produce a colored glaze effect.

Oil pastels

White spirit

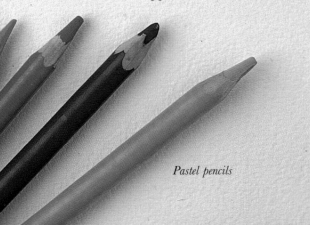

Pastel pencils

Surfaces and Supports

Pastels demand a paper that has a raised surface texture, or "tooth." Whereas watercolors, gouache, and acrylics are absorbed into the paper itself, pastel stays on the surface. The action of drawing forces the pigment to be compacted into the minute hollows and ridges on the textured paper, an effect that is seen clearly under a magnifying glass.

Degas sometimes used tracing paper as support – mainly because he was able to place one sheet over another, continually correcting the drawing. These sheets were later glued to Bristol board. When using other papers, he would first soak them in turpentine so that the pastel pigment, when applied, would adhere more readily to the surface.

Apart from the texture of the paper surface, you also need to give some consideration to the color and tone. Would your subject, for instance, benefit from a warm or cool base color, or a pale or dark tone? Again, Degas often treated the base color of the paper as an integral part of the subject he was drawing. As I write, I am looking at a reproduction of a pastel of Ellen Andrée drawn by Degas. On the base color of green-gray, he has drawn the main outline of the figure in charcoal, which is overlaid with just three pastel colors – olive green, white/pink, and a rich plum. The total effect is of a color harmony.

TONED PAPERS

Ingres, Canson, and Fabriano papers are all suitable for pastels. Ingres paper is sometimes produced as a "laid" paper, which means that the surface texture of close parallel lines is produced by the wire mesh of the mold. The range of color and tone of these papers is extensive, but your choice will be determined to some extent by the subject. Light-toned papers, for example, are best suited to those subjects that demand a progression from mid- to dark tones. Middle-toned papers are most popular with beginners because they tend to enhance the paler tints of pastel color. The rich color and texture of a paper, however, cannot detract from any weakness in the drawing itself. Dark-toned papers are difficult to use and are reserved mainly for certain subjects such as interiors, where there might need to be greater contrast between light and dark tones. As a general rule, I would say that the color,

A selection of Ingres papers

tone, and texture of the paper should not impose too much on the drawing itself.

There are some colored papers that have been given a surface very similar to that of fine sandpaper. These are produced in a range of pale and dark tones. I find that I am very sensitive to the tactile quality of paper, however, and although such papers are excellent technically, I dislike working with the kind of surface that produces a very mechanical-looking drawn line. Large sheets of fine sandpaper can, of course, be given a base color with gouache or acrylics.

Crushed pastel pigment

TONING PAPER

Watercolor papers made from 100% cotton are sufficiently absorbent to allow an even tone to be laid on the surface. You can do this in a number of ways: for example, crushed pastel pigment can be taken up on a damp cloth and rubbed into the surface of the paper. Watercolor and gouache can also be diluted to produce a light or dark stain that can be brushed onto the paper. You may also like to experiment with other substances such as shellac or cold tea!

Tubes of gouache and watercolor

WHITE PAPER

If you prefer to work directly on watercolor paper, you will need to bear in mind the fact that pastel colors will appear to be slightly darker. If I am working with pastel on watercolor paper, I tend to combine it with charcoal, as I find that this helps me to get the tonal balance right.

Cloth for rubbing pigment into the surface

CARDBOARD, MILLBOARD, AND CARPET UNDERLAY

Henri de Toulouse-Lautrec (1864–1901) and Edouard Vuillard (1868–1940) both used beige cardboard for pastels, gouache, and even oils. The paper used for underlaying carpets, which is thick and often has an interesting color and texture, is also very suitable for pastels. It often happens that when you are working on materials that cost very little, you feel less inhibited about making mistakes and, as a consequence, the drawing is often livelier and less constrained.

Additional Equipment

DRAWING BOARDS

If you intend to work both in the studio and out of doors, then you will probably need two boards: a heavy, wooden commercial board and a lightweight board (plywood, hardboard, or masonite) for sketching. Try to ensure that both boards are about 14 inches wider on all sides than the paper. It is advisable to use some sheets of old newsprint as padding between the paper and the board to produce a more tensile surface to work on, and to prevent pastels from breaking on an otherwise hard surface.

TABLES AND EASELS

Most pastellists prefer the sturdy support of a wooden table to an easel. There are exceptions, of course – an easel is far more useful when doing life studies or portraits. If you prefer an easel, make sure that all the joints are tight, as a sudden knock or too much vibration when drawing can very easily displace the fine pigment at a critical stage.

PASTEL ERASERS

Kneadable erasers are particularly useful when working with pastels since, as the name suggests, they can be kneaded into any shape or point to enable the artists to lift out the surface pigment of any part of the drawing to be corrected. Never rub or burnish the surface of a pastel drawing – this will simply produce a greasy smudge, and destroy the unique character of the chalk stroke.

Before using an eraser, brush away any loose particles of pigment with a hog's hair brush of the type used for oil painting. The same brush can also be used to make slight tonal adjustments before the drawing is finally fixed. Unwanted areas of pigment can also be gently scraped away with a flat blade. Make sure that the blade is absolutely flat against the surface of the paper.

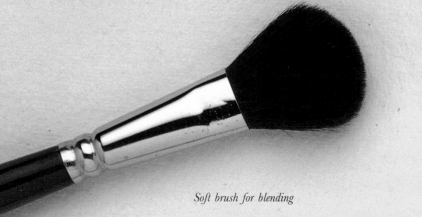

Soft brush for blending

Emery boards

Scalpel

Kneadable eraser

Torchons

TORCHONS (PAPER STUMPS)

These can be used both for erasing the top layer of pigment, and for blending pigments together. The paper stumps are made in different sizes, but you can just as easily make your own from sheets of tightly rolled blotting paper.

BLENDING BRUSHES

Several large, soft, mop-haired blending brushes are useful, especially when working on a larger scale. Finer sable brushes can be used for small areas of the drawing, where you need to soften the effect without removing the pigment.

SHARPENING PASTELS

Use ordinary emery boards, or an emery board containing parallel sheets of fine and coarse emery paper as a base to sharpen pastels, by rubbing the stick across the surface. Alternatively, shave the edge to a point with a scalpel or craft knife.

Fixing Techniques

Artists who work frequently in pastel tend to regard fixatives as a necessary evil. This is due in part to the fact that fixative does tend to spoil slightly the dry, fresh color that distinguishes pastel from other media. There is a tendency for color to darken as the pigment absorbs the viscous spray. The problem can be overcome to some extent by "staggering" the process of spraying. A light spraying of fixative at each stage of the drawing will ensure that the pigment is stabilized without seriously affecting the brilliance of the color. This way, if there is any change in color after the fixative has dried, it can be corrected before the next stage.

Excessive spraying is common, and this, unfortunately, does the most damage to a pastel drawing, since the pigment is flattened or spread, by the force of the spray, into a paste-like consistency. It is better to under-spray than to saturate the paper. If you are using a fairly absorbent paper, it will help if you also spray the drawing from the back.

For convenience, fixative is available in aerosol spray cans. Alternatively, the fixative can be atomized through a folding spray diffuser (available from art supply shops). This offers a greater degree of control, since the flow is directed by blowing directly into the mouthpiece of the diffuser.

Cats are wise creatures – whenever I attempt to spray fixative on a drawing, my black cat departs with alacrity from the room! The fact is that the fumes are unpleasant and can be harmful to anyone with respiratory problems. Spraying should be carried out where there is plenty of ventilation.

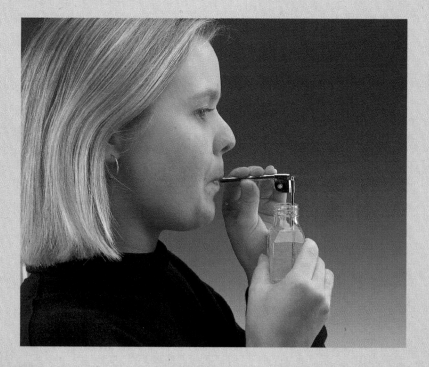

Using a mouth diffuser is an altermative to an aerosol spray.

Mouth diffuser

SPRAYING PROCEDURE

Fix the drawing to a board or an easel, or lay it flat. First, make sure that the drawing is reasonably stable and that there are no loose particles of pigment. Keep the spray at least 12 inches from the surface, and use a sweeping action to direct the spray back and forth across the drawing in a continuous movement, to prevent the spray from becoming concentrated in any one area. Always test the spray on a sheet of scrap paper first, to make sure that the nozzle is not clogged.

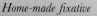
Home-made fixative

MAKING YOUR OWN FIXATIVE

There are numerous recipes for making fixative – the most suitable for pastel is based on casein, which is a glue derived from milk. Hilaire Hiler, author of the standard work *Notes on The Technique of Painting*, recommends the following recipe: Mix $^3/_4$ oz. of cascin with an alkaline solution of $^1/_6$ oz. borax and enough distilled water to make a paste. After a few hours this becomes a syrupy mixture that should be thinned with $1^3/_4$ pt. of water. Add 1 pt. of pure grain alcohol, and, after the solution has clarified, it can be stored in an airtight bottle ready for use. (Ammonia may be substituted for borax.) Apply home-made fixative with a spray diffuser.

A basic, non-toxic fixative that is fairly reliable is non-fat milk; caseinogen is the soluble form of casein as it occurs in milk.

The aerosol is held firmly and used with a sweeping action at a distance of approximately 12 inches.

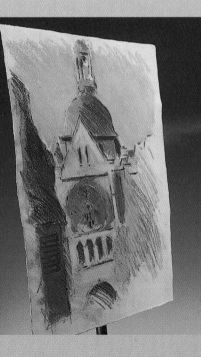

If you decide against fixing your pastels, then you should seal them behind glass in a frame. Make sure that you clean the glass of the frame with a damp cloth to avoid static electricity build-up, which would attract pigment particles to the underside of the glass.

Basic Strokes

Before I start work I sometimes like to stroll down to the seashore to see what has been washed up by the morning tide. Quite often, I come across a web of different-colored fishing nets caught up on the rock. In a way, this reminded me how, in pastel drawing, one builds up color with a web of cumulative drawn strokes, rather than by applying it in solid areas. Look, for example, at a Degas study of a nude bathing, and you will see how he seemingly carves out the form with vigorous intersecting strokes of pastel. Before you can draw with conviction, you will need to gain confidence in handling pastels, so that the marks you make have the recognizable quality of being your own. If you happened to have bought a new box of pastels, take one stick from the box and break it in half. Then, pick up a broken fragment and begin to make arcs, spirals, thin lines, and thick lines, with the kind of flowing gesture that comes from a supple writer. This kind of exploratory mark-making will enable you to gain the kind of control needed for more applied studies.

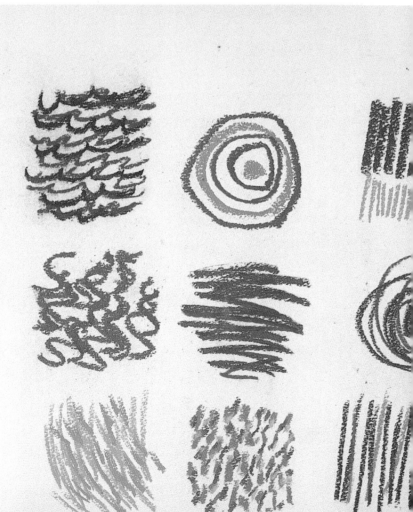

ABOVE *Practicing a basic, direct stroke with chalk pastels on a dark-toned Ingres paper.*

Notice how the grain of the paper influences the quality of the line.

TOP RIGHT *More experimenting, this time with three tones of one color on a dark paper.*

The type of paper used will, in part, determine the granular quality of the stroke. On a smooth paper, for instance, the pastel stroke will be more dense. On a rough paper, the stroke will be broken into a halftone by the "tooth." A laid paper will break the color with a series of fine, white, parallel lines.

Try drawing on different papers with hard and soft pastels. Begin with a single color, then try to build up webs of color in two or three layers of broad cross-hatchings. When using the cross-hatching technique, vary the space between lines. The closer the lines are together, the darker the tone will be. Try also interweaving complementary or discordant colors, or colors of the same hue, on light- and dark-toned papers. You will begin to see how colors blend optically as each hue, while retaining its own identity, also appears to blend with other colors in close juxta-position. Color produced in this way is more kinetic than flat areas of color – which is why Degas's figure studies always seem to be in movement.

Hard pastels will generally produce better results when using this technique, especially when used on an HP drawing paper.

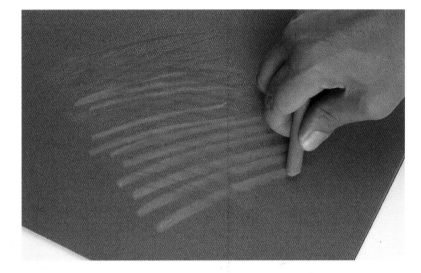

TOP RIGHT *A lighter tone of orange is hatched over the red, producing an optical blending of the two colors.*

RIGHT *A cobalt blue is hatched over the red and orange, creating the effect of movement.*

LEFT *Drawing random calligraphic squiggles is a good way to loosen up, so that your drawing action is less stilted.*

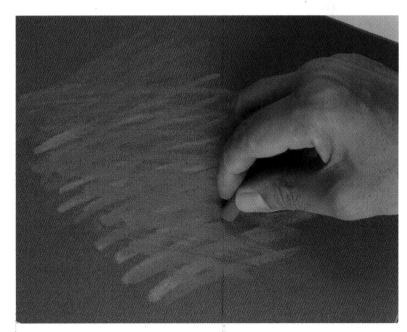

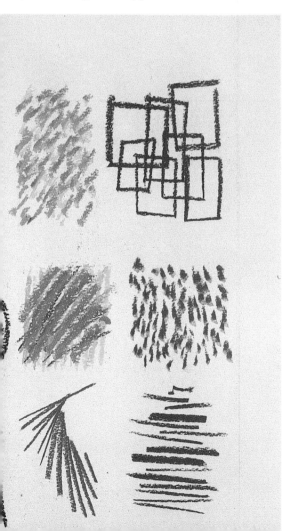

Building Up Solid Color

100 **M**ost pastel drawings combine the kind of linear strokes we have already practiced, with solid or semi-opaque areas of pure and blended color. To produce a large area of color, it is best to use the length of the pastel laid flat on the surface of the paper. To create a continuous tone, the pastel is literally dragged over the surface, depositing a layer of color that is broken only by the texture of the paper. Further layers can be added by applying more pressure until the right tone has been established in relation to the rest of the drawing. Again, experiment with hard and soft pastels and different papers in order to discover the combination that suits your own intentions.

Without proper control, pastels can be twisted and turned on paper to produce a rather mechanical pattern; resist, if you can, the temptation to incorporate any slick marks into your drawing. Always try to make the medium work in the service of an idea.

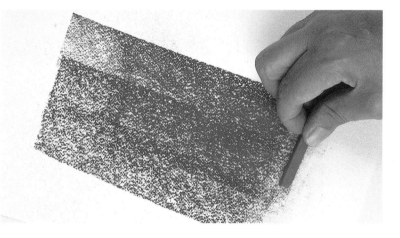

2 *A layer of solid red applied over the ultramarine intensifies the tone, as the two colors are blended together.*

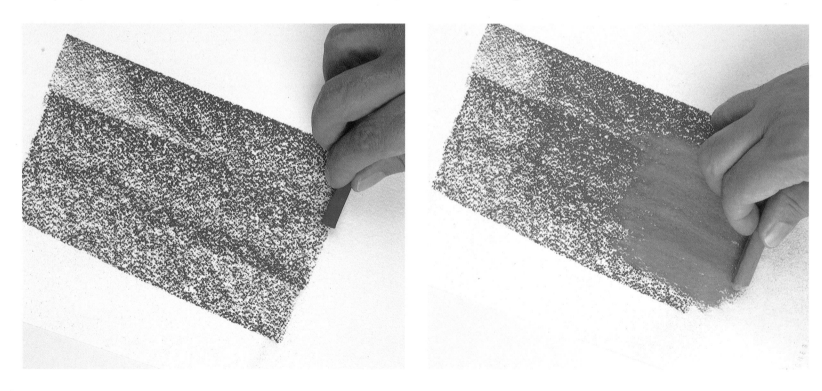

1 *Using the length of a stick of ultramarine chalk pastel to produce a continuous tone that is broken only by the grain of the paper.*

3 *A more intense blending of color is achieved by applying more pressure – the first two colors are almost cancelled out by a layer of Burnt Sienna.*

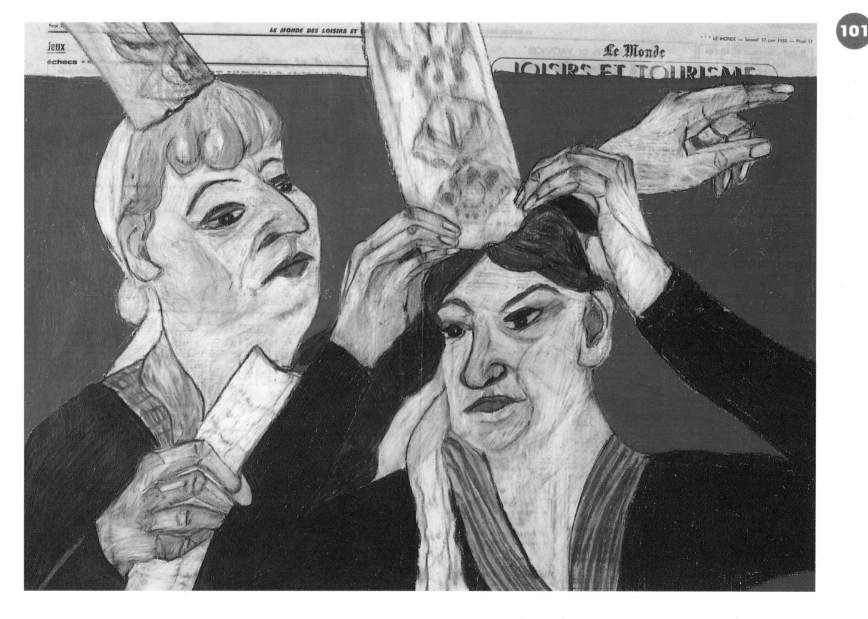

ABOVE *Illustration for a story by Cecilia Hunkeler. The two old ladies in traditional Breton costume are drawn in solid layers of oil pastel, working directly onto a double-page spread of a French newspaper.*

Blending, Merging, and Feathering

102

One of the most attractive features of the medium of pastel drawing is that colors can be blended and fused together easily to produce the most beautiful gradations. Pastel colors, once put down, retain their luminosity and do not sink like other media. In certain conditions, the light is refracted by the surface of the pigment so that the drawing appears to stand in relief. Adjacent colors can be blended together with a fingertip, or with torchons, brushes, soft cloth, or tissue. Additionally, you can moisten the pigment by steaming it (as Degas did) before blending.

Of course, the blending of colors should only be done as an integral part of the overall drawing. In a landscape drawing, for example, you might want to suggest recession and aerial perspective by blending colors in the middle-distance and sky. When working on a still life, you might need to blend the color to suggest the form of curved or rounded objects. There are few occasions when you would use blended color alone – a seascape,

LEFT *A drawing of a life model using a feathering technique to suggest the fleeting quality of the light.*

LEFT *Using a soft brush to blend color in a part of the drawing where the pigment has become too heavy.*

RIGHT *Blending color by gently burnishing with a finger – this is the most direct way of fusing colors together.*

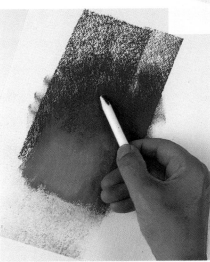

LEFT *A torchon can be used for blending local areas of color on a large drawing, especially in portraiture.*

perhaps, or a sky study – but, generally, blended color should be harnessed in some way by broken linear strokes.

MERGING

The effect of three-dimensional modeling is achieved by blending colors from a light tone to a mid-tone and then towards a dark tone in relation to the source of light. The eye responds to a variety of soft and hard forms, and in the best pastel drawings there is a balance between softly blended color, hard and soft edges, and a descriptive line that pulls everything together. The degree to which the linear element is either overstated or understated is determined by the nature of the subject. If, for instance, you wanted to say something about the intensity of light in a landscape seen at midday, you might ruin the whole effect if you allow for too much vigorous linear description.

Blending is a form of mixing color on the surface, and while this might produce interesting results with two or three colors, the technique becomes unworkable if too many colors are used; the colors become dirty and the paper will no longer retain the pigment.

For large areas of color – the sea, sky, or a field, foreground or background – it is best to use a finger or a soft rag to gently merge one color into another. For figure studies, where the drawing is prominent, I would tend to use a soft brush, so that, as the colors merge, part of the underlying contours is revealed. A torchon is used for blending color in small areas – when modeling the features of a portrait, for instance, or the intricate shapes of a flower study.

FEATHERING

Feathering color simply means drawing strokes rapidly, applying very little pressure. It is a technique that can be used to relieve the monotony of a flat, underlying tone, or to bring an overall unity to a drawing when the various disparate elements don't seem to jell together. Essentially, it is a means of modifying tones that are too light or dark. An area of a drawing that is too cool in tone, for example, might be feathered with a tint of red to correct the balance.

Oil Pastels

104 Oil pastels are really a species of oil paint. Because the pigment is bound in a greasy, oil-based substance, they are more malleable than chalk pastels, but the mark they produce is entirely different in character. They are generally more robust and less likely to break than chalk pastels, though in warm temperatures they can become too soft and sticky to handle. The color clings to the support in layers and is richer and deeper in tone. When burnished with a soft cloth, the color develops a sheen. The drawn stroke is less granular than that of chalk pastel, but the blending of color can be more luminous.

BLENDING OIL PASTELS

To blend one color with another, push the pigment with a fingertip into an adjacent color, so that they merge unevenly to produce a third color. Variations in pressure and temperature can result in a delightful "scumbled" effect. It is also possible to blend colors with a brush or soft cloth using a little white spirit. Try using this technique to produce wash-like effects in local parts of your drawing, such as the sky, or the general recession of color in a landscape or seascape. White spirit should be used with care, however, since it can weaken and dilute the drawn strokes in such a way that the work becomes too flat.

IMPASTO

If you are using oil pastels in an expressionistic way, building up an *impasto*, make sure that you have an adequate support. A fine, sand-based paper will anchor a number of layers of pigment to the surface. Alternatively, use cardboard or hardboard that has been primed with two coats of acrylic gesso.

LEFT *An exercise in overlaying color by applying varying pressure – using solid tints and hatched strokes.*

RIGHT *Sgraffito exercise – a scraping tool is drawn through the upper layer of ultramarine to reveal the base tint of pink.*

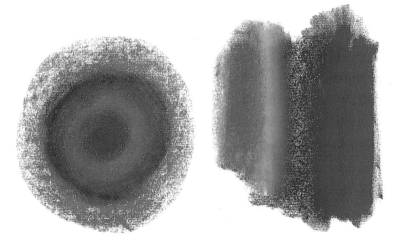

ABOVE *Exercise in merging and blending oil pastels.*

SGRAFFITO

Sgraffito is a scratching technique. It involves laying a flat color onto a paper support using a light or dark tone, then covering the first color with a second color that is darker or lighter in tone. Then the drawing is scraped or scratched out using a blunt tool, such as an old pen nib, so that the base color is revealed.

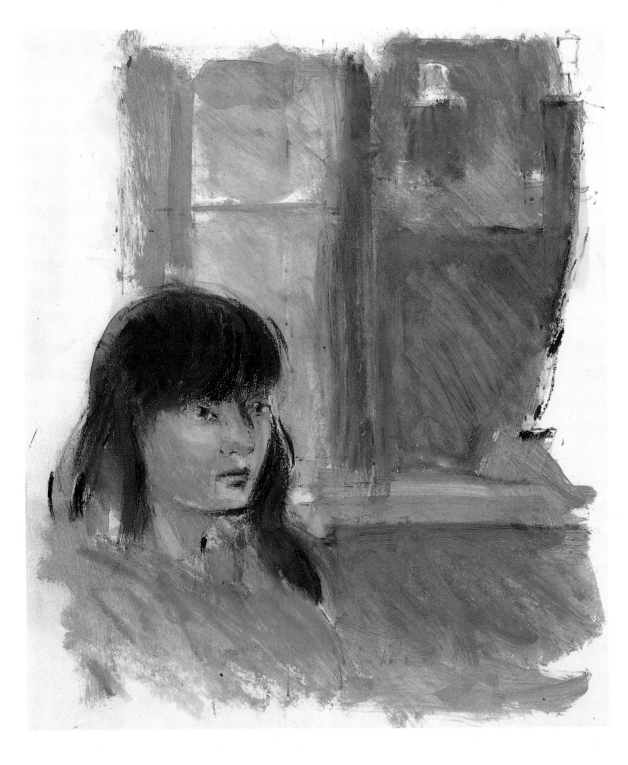

LEFT *A portrait using oil pastels that have been diluted in some areas with a brush and white spirit to produce a soft, semi-transparent tint, rather than an overall opaque tone.*

Depicting Mood and Atmosphere

106

> *See this layered sandstone among the short mountain grass. Place your right hand on it, palm downward. See where the sun rises and where it stands at noon. Direct your middle finger midway between them. Spread your fingers, not widely. You now hold this place in your hand.*
>
> from *Black Mountain* by Raymond Williams

The work of certain writers, painters, poets, photographers, and even musicians is often inextricably linked with a particular place or region. By close association you learn to uncover the spirit of a place, and to be cognizant of different levels of feeling. Turner's paintings varied dramatically in mood and atmosphere; from storms at sea and over the Alps to the calm and brilliant scenes of the Venice lagoon and hazy views of English castles seen at sunrise.

What do we mean when we say that a drawing or painting is atmospheric? "Atmosphere" contains a duality of meaning; the particle-laden body whose transparency is dependent on variable atmospheric pressure, and the pervading mood of a place which in turn evokes certain feelings and emotions. Additionally, the mood and atmosphere of the work might also be dependent on the state of mind of the person producing it. Whereas I might depict a fishing harbor as a scene that reflects a kind of tranquil sadness, another artist might view the same scene in a more joyful and exuberant frame of mind.

We use color by association to suggest mood, sometimes contrasting bright complementary colors with more somber hues, or cooler colors to express quietude. One must be cautious, however, in confining color values to such convenient categories.

ATMOSPHERE AND LANDSCAPE

When drawing a landscape or an architectural subject, we sometimes need to be patient, waiting for that time of day when the conditions of light will enhance the mood and atmosphere of the subject. Mountainous regions, for instance, are best seen in mist or after rain, when distances are difficult to define and contours less sharp. It might be necessary to rise at first light or wait until dusk to heighten the drama of the subject. In attempting to evoke the atmosphere of a place, you need to be more attentive to the influence of light than to the representation of detail. Light waves are conditioned by the way that they react to various substances – water, mist, cloud, stone and so on. Even under direct sunlight, the actual intensity of the light varies considerably from one part of the landscape to another. At sunset or sunrise there is a scattering of light caused by the molecules of air and by the presence of dust and moisture in the atmosphere. And when the sun is overhead at noon, the light waves have a shorter distance to travel than at dusk or early morning.

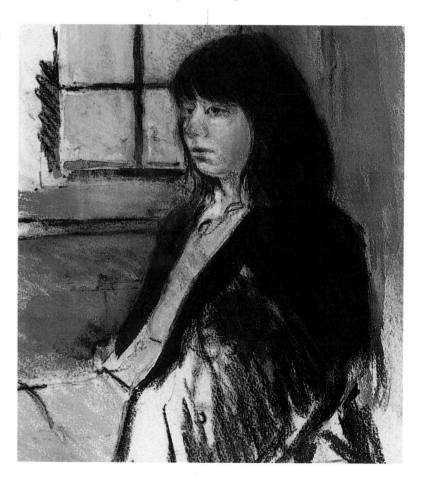

RIGHT *Stores in the Rue de la Ste Catherine, Dieppe, France. An intimate study in winter of this small square, which has changed little since it was painted by Walter Sickert in 1900.*

INTERIOR MOODS

When working on interior subjects, one can work with the available light source from doors and windows, or under artificial light, which can be controlled to some extent. Vuillard produced his most atmospheric pastels in the intimate surroundings of his own home. Start, then, with those subjects you know and love best, and remember, although this may sound like a truism, you are more likely to be aware of the mood and atmosphere of your own surroundings than you would be in unfamiliar territory.

LEFT *The mood of this drawing is largely determined by the low level of the available light source from the window.*

RIGHT *Spanish landscape. A study of the rooftops in a white village seen around dusk, a time when contrasts are softer and colors more muted.*

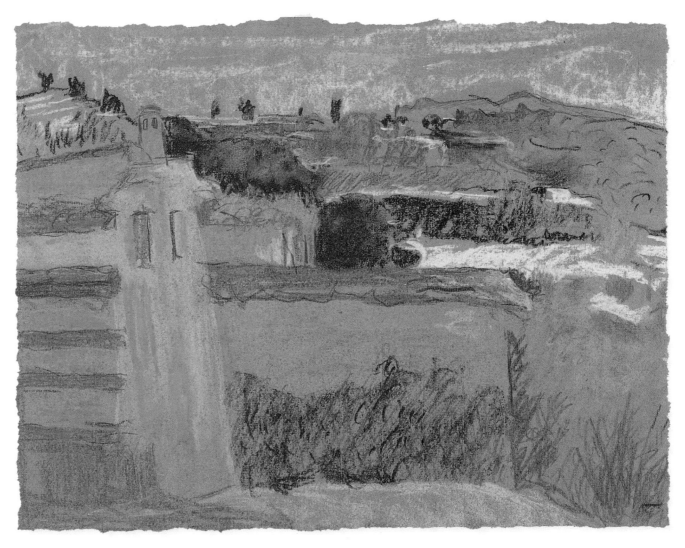

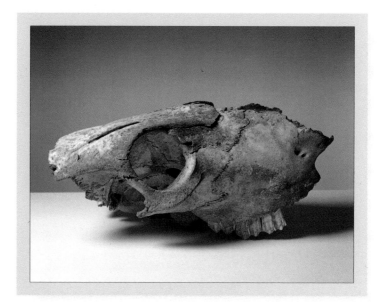

Nature Study

ANIMAL SKULL

One of the most difficult aspects of working in pastels is learning to control tone. This has something to do with the fact that pastels have no depth or transparency — they reflect the light, and even the darkest colors seem light in comparison with other media. The first project, then, is really an exercise in restraint, learning to use just a few colors to convey form in terms of tonal contrast.

Finding often comes before making, but it is only by concentrating on what we have found that we are able to extend our awareness of the visible world. In this instance, a weathered animal skull found in a corner of a damp field provides an ideal subject for a still-life drawing.

It is important to approach the subject without fixed ideas about what the end result will look like; in other words, we should be curious and be ruled by what we see. We sometimes overlook the fact that memory plays an important part in drawing from observation. As memory is an imperfect function, it requires a great deal of concentration to register the detail and form of even the simplest object.

The artist might decide to treat the drawing in a purely abstract way, as a series of irregular interlocking shapes seen against the flat tones of the background. The contour of the skull, however, needs to be suggested – otherwise it would be deprived of its identity. At the same time, the artist must be able to suggest the textural quality of the bone structure, which might determine whether or not oil pastels should be used instead of chalk pastels. Alternatively, you might consider combining chalk pastels with another medium such as pen-and-ink, or charcoal, so that there is a fusion of flat, blended color with selective linear detail.

By working in an almost monochromatic way, with a few light, medium, and dark tints, you will find it easier to control tonal contrast. When you are then confronted with a more complex subject – a landscape or interior, for instance – you will be better able to think in terms of an overall tonal scheme.

Artist • Helen Armstrong

| BLACK | GRAY | YELLOW OCHER | OLIVE GREEN | YELLOW OCHER TINT | LIGHT CHROME GREEN | DARK CHROME GREEN | PRUSSIAN BLUE |

1 *The outline of the main form of the skull is drawn in Olive Green pastel on a green-gray Fabriano paper.*

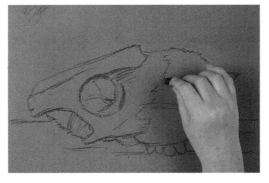

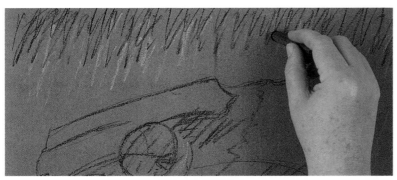

2 *The main areas of contrast are roughly sketched in with gray, olive, and black.*

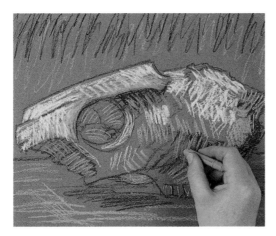

3 *The base colors of the skull – light ocher, light Chrome Green, gray with flecks of Yellow Ocher, and light Sienna – are applied with rapid short strokes.*

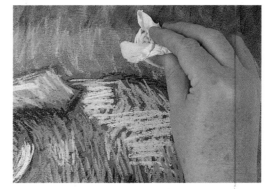

4 *Using a white chalk, patches of light are added to the foreground and to the top of the skull. The background is smudged with a tissue, and touches of Prussian Blue are added to all the areas of shadow, along with touches of gray and light ocher. Gray chalk pastel is also used for the reflected light on the underside and inside parts of the skull.*

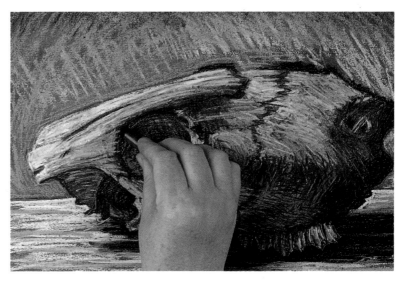

5 *The brittle and sharp edges of bone are drawn with Olive Green and dark Chrome Green. The highlights were toned down with gray in the foreground and gray and light ocher on top of the skull. The tonal balance was created using Olive Green and black.*

Artist • Cecilia Hunkeler

1 *The outline of the skull is drawn with a mid-green wax crayon on a pale gray Canson paper.*

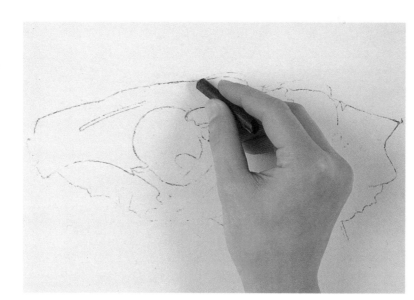

2 *A pale Sap Green pastel is added to the weathered surfaces of the bone, and this is partly overworked in white. A darker gray is drawn in the recesses and reduced with a damp brush. White is also scribbled into the foreground area.*

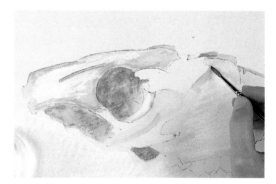

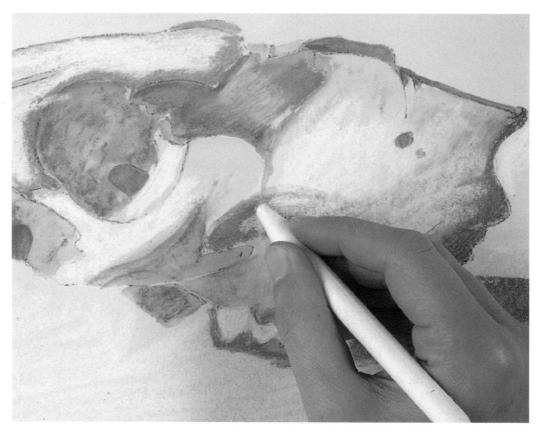

3 *The various facets of the bone structure are rendered with a variety of textures, created by blending and burnishing white, green, and gray tints of chalk pastels.*

CHROME
YELLOW

MID
GRAY

PALE
SAP
GREEN

DARK
CHROME
GREEN

BLACK

4 *Some of the surfaces are scraped back and reworked, and a darker green added to delineate fissures in the bone.*

6 *The background is filled with a soft tone of gray wash, made up of merging tones of white, gray, and touches of yellow and green. All the internal facets of the skull are resolved tonally, and shadows generally heightened.*

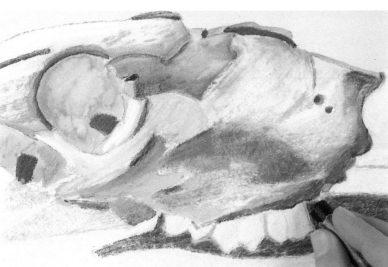

5 *The shadows at the base of the skull are drawn in charcoal and immediately fixed before adding dark tones of green to concave areas of the bone structure.*

Artist • Sophie Mason

1 *The main outline of the skull is drawn onto white cartridge paper using a 2B pencil.*

2 *A pale olive tint is laid as a base color over the main form of the skull, and the background is darkened with a mid-gray tone.*

3 *The pale olive tint is intensified and extended to the foreground. A light Cobalt Blue is introduced to suggest light (rather than white).*

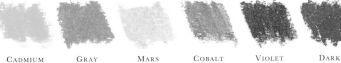

CADMIUM YELLOW | GRAY | MARS VIOLET LIGHT | COBALT BLUE LIGHT | VIOLET | DARK GRAY | PALE OLIVE | HOOKER'S GREEN | BLACK (PENCIL)

4 *A darker tone of Olive Green is added to shadows on the skull to give it more form and depth. The darker recesses are drawn in gray.*

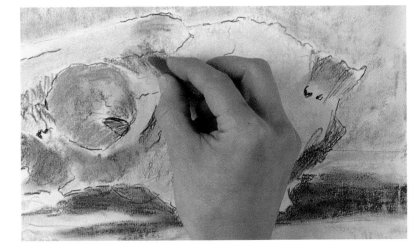

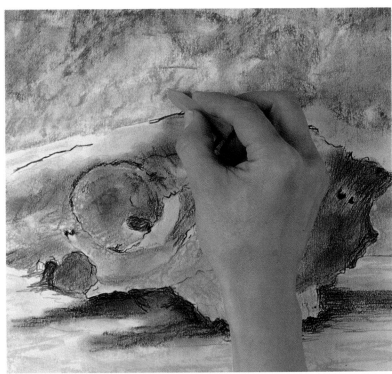

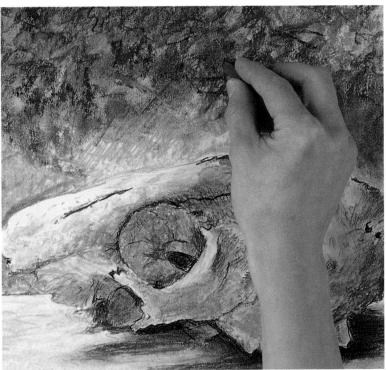

5 *The tonal contrast of the drawing is developed, adding more dark gray to the background and working around the contour of the skull with a light violet tint. More violet-purple and black soft pencil tones are applied to sharpen the edges of the skull, and to emphasize the brittleness of the bone structure.*

6 *Hooker's Green and dark gray are added to the background to increase tonal contrast with the foreground. Cadmium Yellow and dark olive are blended into areas of the skull, and a pale yellow tint is used to lighten the foreground. The balance of color and tone is resolved in the final stage.*

Nature Study · *Critique*

116

convincing rendering of surface textures

HELEN The artist has got as close as she can to the subject and, in doing so, has concentrated on making a careful analysis of the form, surface color, and texture of the weathered bone structure. She has used contrasting tones to invest the subject with a sense of drama. By employing a technique using short strokes, the surface is built up of hatched lines, making the drawing more vibrant. A darker, flat tone in the background would have produced more contrast and heightened the texture of the skull.

Dark-toned paper makes the lighter tones more luminous

CECILIA One gets the feeling that the artist has gained a great deal from controlling just a few colors and tones in such a confined area. Additionally, there has been a real attempt to explore the nature of the brittle texture and weathered surface of the skull. When representing both concave and convex surfaces, a careful modulation of tone is necessary to create the sense of depth and recession. By carefully blending chalk pastels one can achieve a gradual progression from light passages to dark.

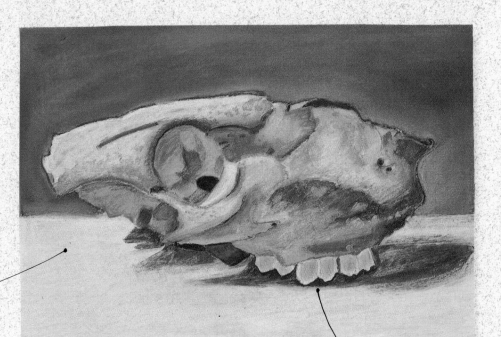

A good example of tonal control using a few colors

shadow at the base of the skull could be more intense

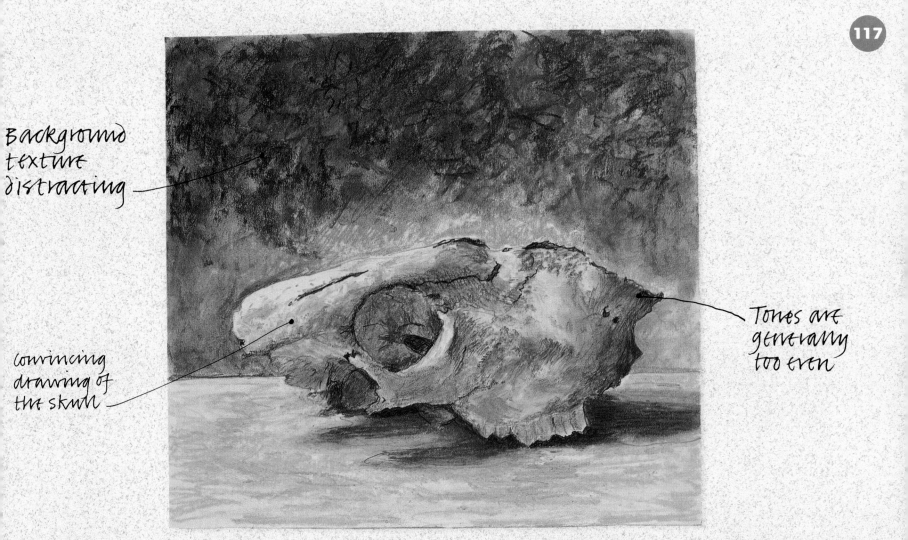

Background texture distracting

convincing drawing of the skull

Tones are generally too even

SOPHIE Although quite well composed, the tones in this drawing are too regular. The skull itself is well drawn, and the artist has managed to represent the very brittle texture of the bone convincingly. However, I find that the broad texture used in the background does not contribute much to the overall tonal scheme of the drawing. The real interest for the artist was in exploring the surface marks and textures of the skull itself and, bearing this in mind, she felt that she should have worked on a larger scale.

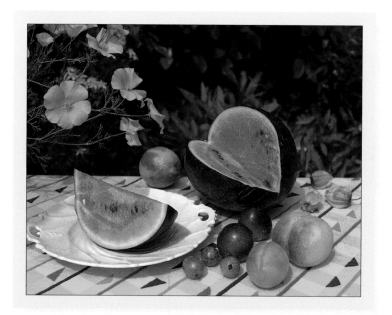

Still life

SUMMER FRUIT

After the restrained color and tone of the skull drawing, this project allows for a more profligate use of pure color. On the face of it, this still life of bright fruits would appear to be a fairly straightforward undertaking, since essentially it presents little more than an arrangement of elementary shapes. But the image could easily appear trite, unless careful consideration is given to color, contrast, and composition.

Sometimes it is necessary to exaggerate or heighten color contrasts in order to fully convey the inherent qualities of the subject – the juicy ripeness of the watermelon, for instance, or the bloom on the skin of the plums and peaches. The color of the fruit is complementary to the background foliage, and the yellow tablecloth divides the picture plane tonally.

How can you suggest the succulence of the fruit when working with dry chalk pastels? Should you use oil pastels instead, or perhaps mixed media? These are the kinds of questions you need to ask yourself before starting the drawing. Try a few initial experiments using some of the techniques described in the first part of the book. If you were using oil pastels, for instance, you could achieve greater transparency of color by burnishing the pigment with a finger moistened with white spirit. Alternatively, the surface can be scraped with a flat blade.

You may find that you need to work on the drawing in more than one session. If so, try to retain the spontaneity established with the first strokes. You might pace yourself by concentrating on the contours of the fruit and flowers in the first session, then by establishing the broad masses of color in the second session, before finalizing details in the last session.

Ultimately, the success of the drawing will depend on just how much you are prepared to invest in trying to uncover the specific values of each individual object, and the collective values of composition and color harmony.

Artist · Helen Armstrong

YELLOW OCHER CADMIUM ORANGE GRAY RED SCARLET YELLOW DARK GREEN COBALT GREEN LEMON BLUE

119

1 Oil pastels have been used for this project. The main outlines of the still-life group are drawn on a light gray Fabriano paper with pencil. Tints of mid- and dark green are scribbled into the background and on the gooseberries, lemon, and flower stalks.

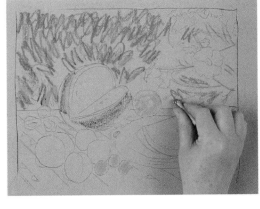

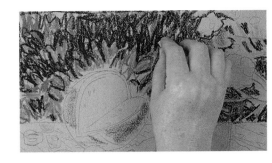

2 Parts of the background are blocked in with a soft black oil pastel.

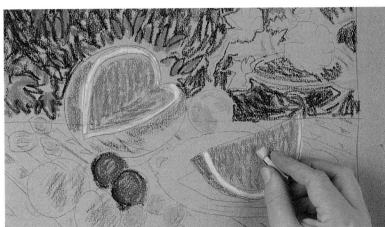

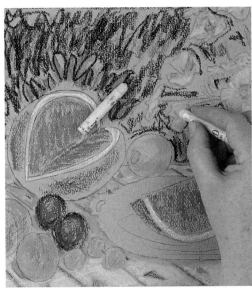

4 Yellows are now brought into the drawing – a Sennelier 20 and 22 on the tablecloth and flowers. A touch of orange is also added to the flower pods. Yellow Ocher is used to provide a darker tone on the peaches and for shadows on the cloth and lemon.

3 The reds are established at this stage – a pinkish red on the melon and peaches, a pink-brown on the plums, and pink for the pattern on the cloth. White and Lemon Yellow are fused together on the edges of the melon.

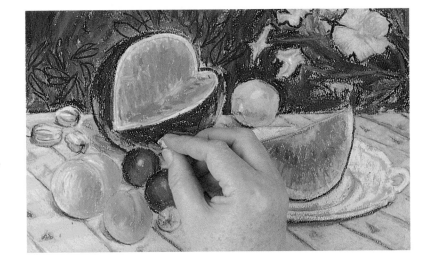

5 White (with a touch of lemon yellow) is used for the plate, and gray added to shadows. Traces of the background paper are allowed to show through. White highlights are added to the fruit. Black, Dark Green, and Dark Brown are fused together in the background to produce the dull tone of the leaves. Tones are now generally refined and moderated by adding light and dark touches of color, and by scraping back some areas and redrawing others.

Artist • Cecilia Hunkeler

120

1 *The outlines of the still-life group are drawn in a red wax crayon on a sheet of pale gray Canson paper.*

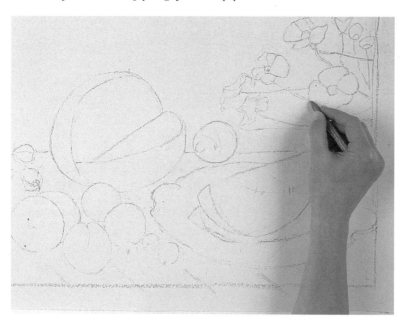

2 *The flowers, lemon, edges of the melon, and the tablecloth are drawn in Cadmium Yellow, which in turn is softened with a wet brush.*

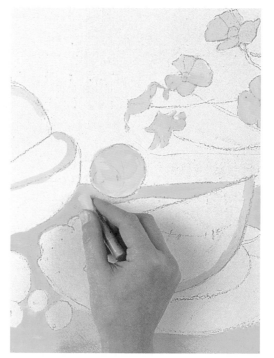

3 *Permanent Green Deep is worked into the background and on part of the fruit, and then reduced with a wet brush. Cadmium Orange is drawn on the peaches, plums, and melon, with touches of Scarlet Lake added before blending with a wet brush.*

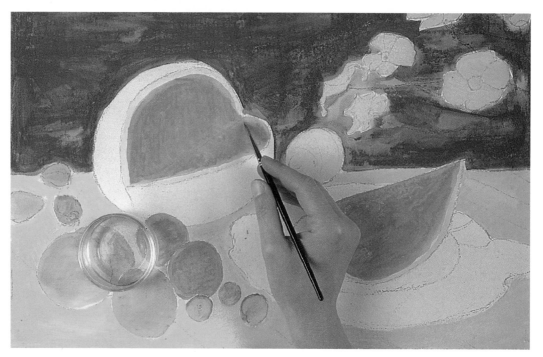

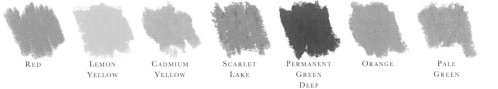

| RED | LEMON YELLOW | CADMIUM YELLOW | SCARLET LAKE | PERMANENT GREEN DEEP | ORANGE | PALE GREEN |

4 *A dark green tone is worked over the skin of the melon, and the red flesh is blended using a torchon, to produce a softer tone. The color of the other fruits is also intensified at this stage.*

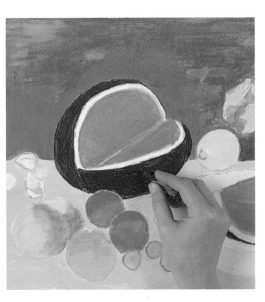

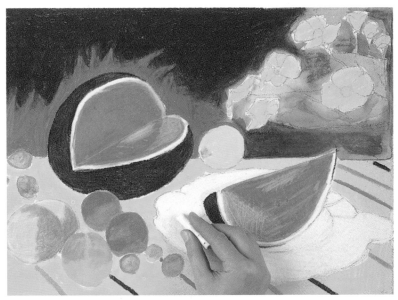

5 *The background is reworked, fusing together dark and light tones of green. Color on the fruit is scraped back and redrawn, and colored stripes are added to the tablecloth. A white chalk is worked over the plate.*

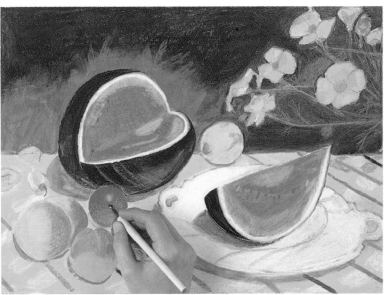

6 *The pitted texture of the fruit is rendered with the point of a scraping tool, using a stippling technique that exposes the paler tone beneath the top layer of color. Some white is worked into the flesh of the melon. The plate is resolved tonally and the flowers in the background redrawn.*

Artist • Sophie Mason

122

1 *A Raw Sienna pastel is used to mark out the main shapes of the still life, particularly in relation to the horizon line of the table.*

2 *Cadmium Yellow and Cadmium Orange are roughly scumbled into the foreground with a suggestion of the pattern on the tablecloth.*

3 *Cadmium Red is used for the melon, peaches, and plums to give body to the main shapes in the arrangement and to provide contrast to the background. The flowers in the background are roughed in with Cadmium Orange.*

CADMIUM
YELLOW

CADMIUM
ORANGE

YELLOW
OCHER

RAW
SIENNA

PERMANENT
RED
LIGHT

CRIMSON

PALE
OLIVE
GREEN

DARK
OLIVE
GREEN

MID
GRAY

BURNT
UMBER

6B
PENCIL

4 *Burnt Umber is applied to the skin of the melon, and the background is darkened with Raw Umber.*

5 *Raw Umber and Burnt Umber are used to strengthen the background tone and to provide more definition to the flowers. Permanent red and light red are blended onto the peaches, melon, and plums. The outer shapes of the melon and plate are more carefully defined using graphite pencil and Burnt Umber.*

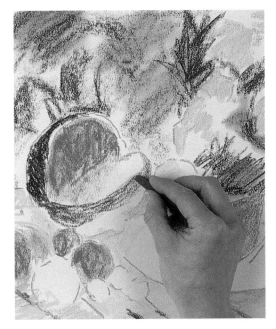

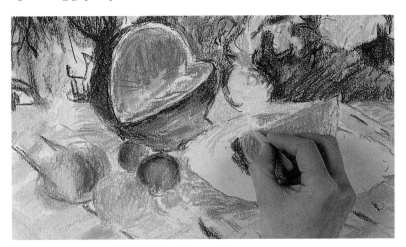

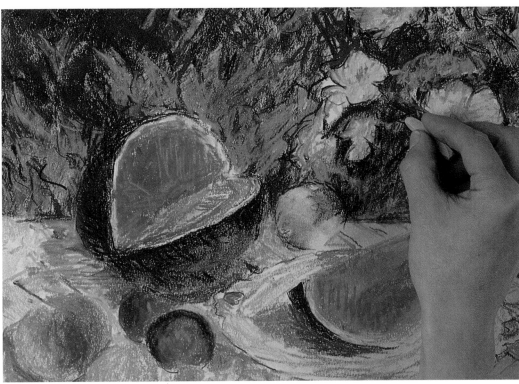

6 *Dark olive and pale olive are added to the background foliage to bring forward the shapes of leaves and to relate the background to the foreground. More gray is added to the plate.*
Greater definition is given to the flowers with Raw Umber and black pencil. Color reflected from the fruit is added to shadows using Cadmium Yellow and Yellow Ocher.

Still life · *Critique*

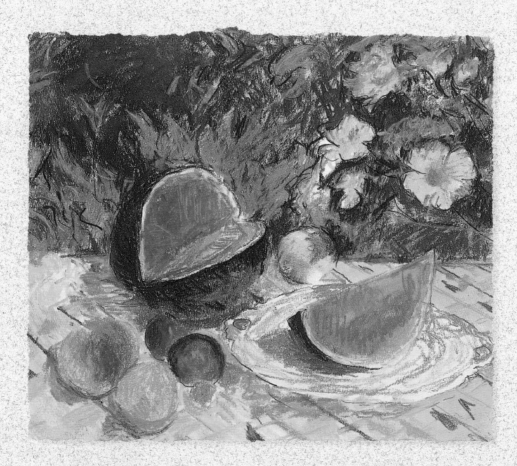

SOPHIE One senses that the artist enjoyed working with the brilliant colors demanded by this subject. The drawing works well in terms of color and tone, and in the rich variety of marks made with chalk pastels. This is a drawing that bears the imprint of an artist who works quickly, using short strokes of pastel, rather than slowly building up layers of color. Working in this way there are inevitably gains and losses, and in this instance some shapes have been more carefully defined than others.

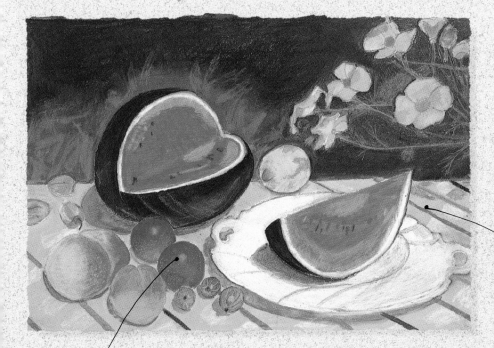

CECILIA The intensity of the color and the range of textures – from smooth to coarse-grained fruit skins – has been dealt with convincingly and, one senses, with enthusiasm! Contrasts of tone have also been handled well, although it is possible that the background could have been made darker, and the leaf forms made more distinct, without detracting too much from the strong color and shapes of the fruit. When so many elements in a drawing compete for attention, it is sometimes better to change the composition or point of focus.

contrasts of tone generally handled well – background could have been darker

Texture of the fruit skin rendered convincingly

The oil pastel impasto adds a tactile quality

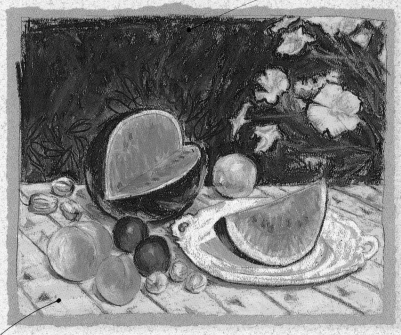

HELEN The decision to use oil pastels rather than chalk pastels clearly paid off in this drawing. The clarity of strong shapes and the rich impasto of color lends a tactile quality to the work. The artist decided early on to try to retain the lucidity of the drawing and this has meant sacrificing something of the delicacy of the flowers. The fruit has a sumptuousness that is heightened by the dark tone of the background color. When drawing objects such as plates or cups and saucers seen in perspective, it is important to make sure that the ellipse is drawn convincingly.

Dark tone of paper enriches color values

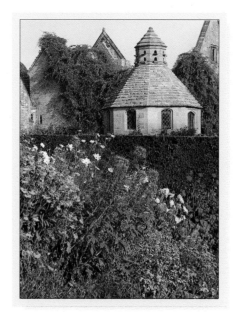

Garden Scene

DOVECOTE AND FLOWERS

Artists have long been inspired by gardens both formal and informal. Claude Monet, of course, is the supreme example – his garden at Giverny became the source of some of his finest work, including the series of paintings of waterlilies growing beneath a bridge. He realised that he could orchestrate color using difference species of plants and flowers to create an approximation of preconceived color schemes.

The subject selected for this project is an old garden attached to an English manor house, now largely destroyed by fire. The dovecote remains intact and its mellow stone provides an interesting contrast to the rich color and gossamer-like quality of the abundance of flowers in the foreground.

Composition can be critical in dealing with this kind of subject, since you have to try simultaneously to express the dynamism of growth and the solidity of the stonework. Too much concen-

tration on isolated details might lose the sense of actuality and liveliness. Working with pastels, you are less likely to get bogged down with the precise details of individual flower heads and will be able to concentrate instead on treating everything in terms of planes and color masses. Contrast, too, plays an important part: the intensity of the color of the flowers is heightened by seeing them against the darker tone of the hedge, for example, and the dovecote is defined by the darker tones of adjacent foliage.

Of course, you are continually having to make adjustments to the color and tone of a drawing as it progresses from one stage to another. A flat tone that appears dark when first laid might seem much too light when other colors have been added. The rich, red tone of a flower head might sink into a neutral background tone, whereas a sharply contrasting, complementary dark green would make it appear even richer.

Artist · Helen Armstrong

BLACK BURNT SIENNA DEEP YELLOW LIGHT YELLOW GOLD OCHER PRUSSIAN BLUE BLUE VIOLET PERMANENT ROSE MADDER LAKE DEEP

1 The basic composition is drawn sparingly in graphite pencil on a dark ocher sugar paper. White and Cobalt Blue are blended together in the sky.

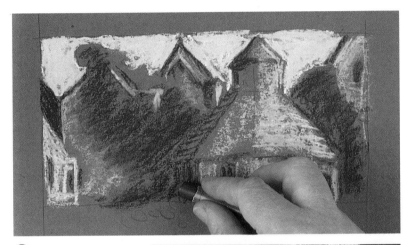

2 The stonework of the buildings is drawn in a light Yellow Ocher, and the tone of the paper, which is darker, is allowed to show through in areas of shadow. Prussian Blue is used as an undertone for the foliage.

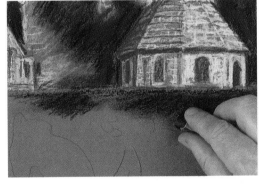

3 More detail is added to the stonework, using a light Yellow Ocher for lighter tones and Olive Green for shadows. Olive Green, Chrome Green Deep, and black are fused together on background foliage.

4 At this stage, the artist decided that the top half of the drawing had become too detailed. She therefore took the surface pigment off with a tissue, blurring the details. Greens were then rubbed into the foreground, followed by the sharper linear strokes for stalks and leaves using Olive Green, Chrome Green Light, and Chrome Green Deep. A Pthalo Green is also used. The flower heads are picked out in white, permanent rose, red violet, blue violet, scarlet, Madder Lake Deep, and Burnt Sienna.

127

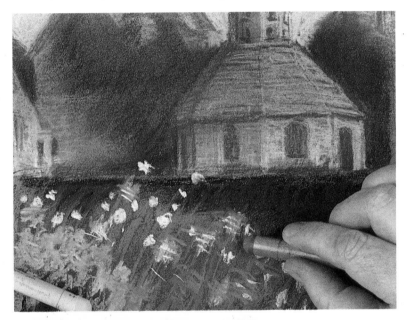

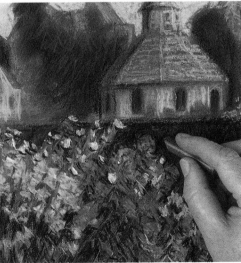

5 A black chalk is now used to bring the drawing together as a single statement, working in tones between stalks in the foreground and adding detail to buildings in the background. Finally, the orange roses are highlighted with Gold Ocher and Burnt Sienna.

SCARLET CHROME GREEN DEEP OLIVE GREEN CHROME GREEN LIGHT GRAY COBALT BLUE YELLOW OCHER YELLOW OCHER TINT

Artist • Cecilia Hunkeler

1 *An outline drawing of the main shapes is made with a mid-green wax crayon on a sheet of off-white cartridge paper.*

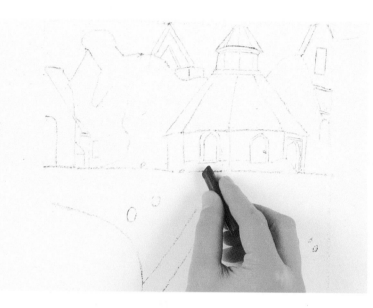

3 *A stippling technique is used for the flowers using pink, Geranium Red, vermilion, Lemon Yellow, Yellow Ocher and Violet Dark.*

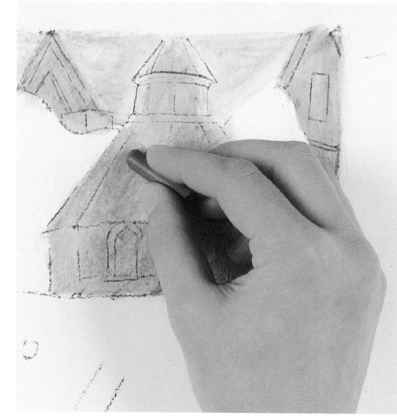

2 *A mid-gray pastel is worked roughly over the sky and blended with Burnt Sienna and a touch of yellow on the dovecote and other buildings.*

| MID GREEN | MID GRAY | LEMON YELLOW | YELLOW OCHER | VERMILION | VIOLET DARK | BURNT SIENNA | BLACK |

4 *A thin layer of Permanent Green Light is applied over the whole of the garden area, and this is reduced to a transparent tone with a moist sable brush, which allows previous colors to show through.*

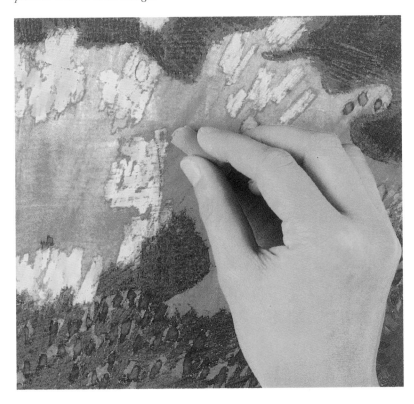

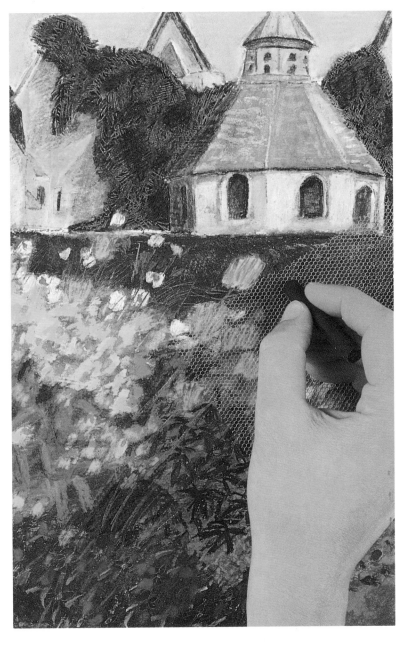

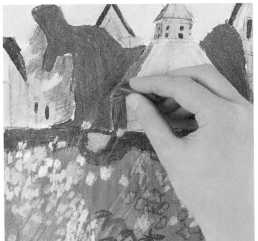

5 *More flowers and leaves are stippled in, and the darker recesses of the buildings are drawn in Burnt Sienna blended with black.*

6 *In the final stage, the textural quality of the drawing has been enriched by a combination of scraping out leaf shapes with a steel nib, and by forcing color through a piece of gauze mesh. The drawing is resolved in terms of color and tone and without a conspicuous outline.*

Artist • Sophie Mason

130

❶ *A green-brown
Ingres pastel paper was
selected for this subject
in relation to the
overall color scheme.
The dovecote and the
main position of the
flowers are briefly
stated in Olive Green
pastel pencil.*

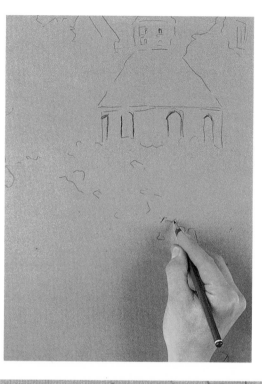

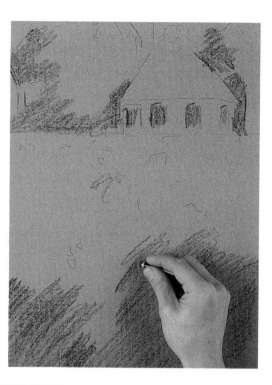

❷ *A dark gray crayon
(water-soluble) is spread
over the foreground and
in the darker areas of the
background.*

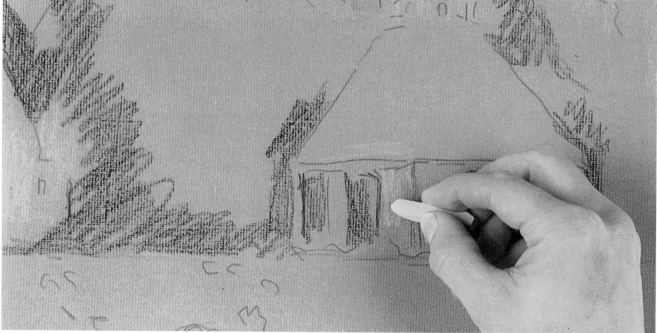

❸ *Touches of pale olive
are added to the dovecote
and foreground.*

| CADMIUM YELLOW | CADMIUM ORANGE | VERMILION | PALE OLIVE | OLIVE GREEN | PERMANENT GREEN | HOOKER'S GREEN | DARK GRAY | 4B PENCIL |

4 *Permanent Green is overlaid on the areas of foliage in the background and carried through to other parts of the garden. Touches of gray are added in other areas.*

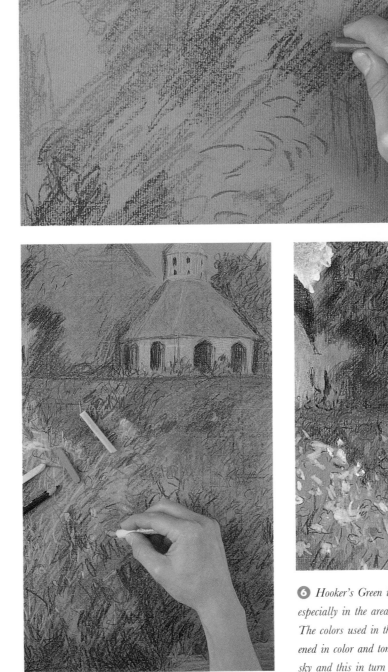

5 *The flowers are stippled in with various colors, including Cadmium Yellow (oil pastel), Permanent Red, Cadmium Orange, vermilion, and pink (chalk). A soft pencil is also used to bring more definition to the drawing.*

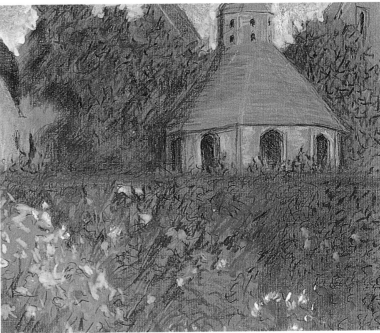

6 *Hooker's Green is introduced to produce more depth, especially in the area immediately behind the dovecote. The colors used in the previous stage are again strengthened in color and tone. White oil pastel is used in the sky and this in turn is moderated with gray.*

Garden Scene • *Critique*

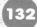

The general mood well interpreted

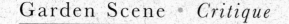

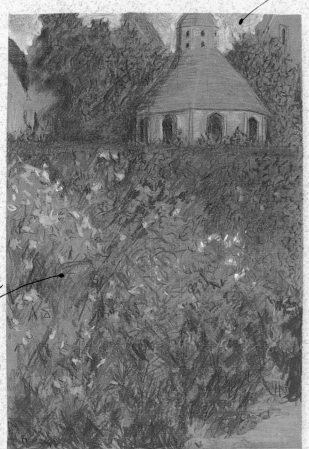

There is little tonal progression from light to dark – from the path to the distant buildings

HELEN Halfway through this drawing, the artist realized her mistake in developing the top part of the composition at the expense of the rest of the drawing. You should always consider the drawing as a whole and not concentrate too much on one area. In this project, the artist's primary interest lay in the way that the bright color of the flowers contrasted with the dark tone of the hedge. The early attention to architectural details detracted from this, which is why she wiped the surface pigment away in order to simplify the background. One must always be prepared to spoil things a little in order to gain ground. In this instance, you can see how, in the final stage of the drawing, the artist has managed to resolve the tonal balance of the drawing in a way that draws attention to the garden flowers, rather than focusing on background detail.

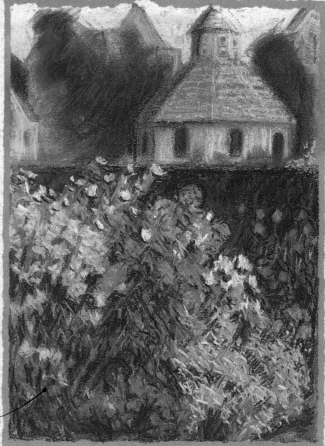

SOPHIE The artist herself felt that the choice of such a dark-toned pastel paper was a mistake – although I would disagree, since I feel it allows the richness of color to become more evident in the final stage of the drawing. I like the general mood, atmosphere, and sense of place that comes across. The flowers are shown *en masse* without any fussy detail, and this works well in contrast to the solidity of the stone dovecote in the background. I do feel, however, that tonally everthing is too even. Could the tone beyond the dovecote have been made darker? Or the path and flowers in the immediate foreground lighter in tone?

Everything has been resolved in terms of tonal balance

133

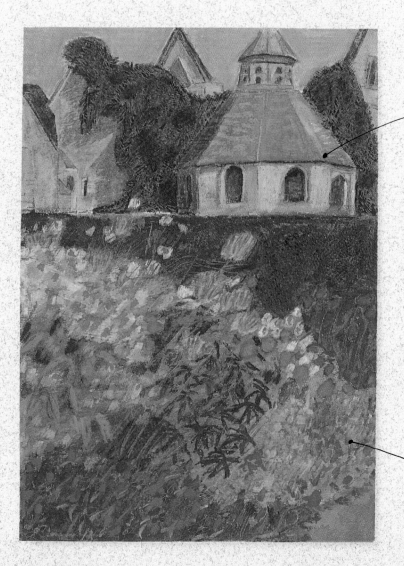

The sky should have been extended to show the complete shape of the dovecote tower

Intelligent combination of oil and chalk pastels to give a variety of texture

CECILIA The artist has gone to considerable lengths to recreate the textural contrasts of weathered stone and the delicacy of the flowers, creeper, and hedge. She has used a combination of oil and chalk pastels, to work and rework some parts of the drawing and rebuilt it in her own terms. Contrasts of color and tone work without being too boldly defined. Compositionally, it might have been interesting to extend the path in the foreground.

All three artists have cropped off the top of the tower of the dovecote, which I feel is unnecessary. Preliminary thumbnail sketches can help to avoid this kind of problem.

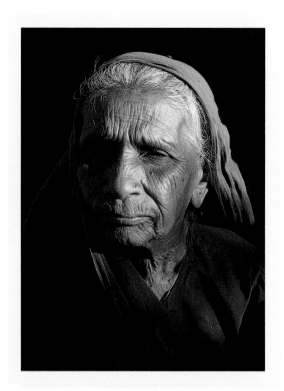

Portrait

SRI LANKAN WOMAN

When an artist produces a portrait that is pleasing to the sitter and their family and friends, it is usually claimed that he or she has captured a "likeness." But a "likeness" is difficult to define since it is dependent on a variety of intentions, both on the part of the artist and his or her subject. Most people refer to a "likeness" as being in some way emulative of the silky sheen of a photographic print; yet such portraits, although technically sound, are often lacking in conviction. The artist who is anxious to please the sitter frequently neglects other values. A good portrait, I believe, goes beyond external appearances to suggest something of the inner life of the sitter.

The old Sri Lankan woman selected for this portrait, for instance, has spent a lifetime working in tea plantations. Her life experiences appear to be etched into her weathered features. Her expression is proud – a spirit unbroken, defiant. One senses a fine intelligence, that this old lady is a fount of wisdom, and is ready to pass it on to a younger generation. All these qualities should be apparent in any subsequent portrait.

Technically, it could be treated almost monochromatically, using just three or four tones of pastel of the same hue. The tones are strongly contrasted, and the merging of light areas into dark needs to be handled carefully. Before starting the drawing in pastel, however, it is a good idea to make a series of thumbnail sketches in order to work out all the compositional variations and the main divisions of light and shade.

You might also consider using a toned paper, or staining the surface yourself with a tint that relates to your intended overall color scheme.

Artist : Helen Armstrong

| BLACK | GRAY | VANDYKE BROWN | BROWN | YELLOW OCHER | PALE ORANGE | PINK | PRUSSIAN BLUE | GOLDEN YELLOW |

1 *Oil pastels are used for this portrait. The outlines are drawn with a pale tint of Vandyke Brown on a black Fabriano paper.*

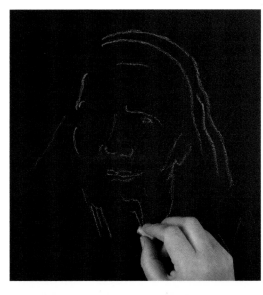

2 *The main areas of contrasting light and dark tones are drawn with short strokes of Burnt Sienna, Yellow Ocher, gray, Vandyke Brown, and white.*

135

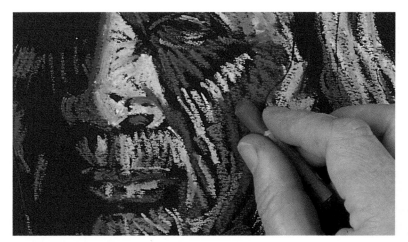

3 *The sari is drawn with Prussian Blue and dark gray. Touches of Vandyke Brown lend warmth to the gray. The flat edge of a blade is used to scrape away excess color.*

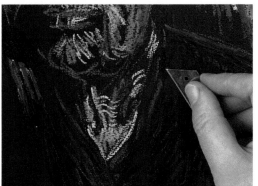

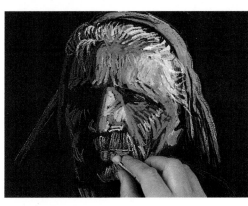

4 *The hair is drawn first with light gray, dark gray, Vandyke Brown, and white, then with strokes of pink, Yellow Ocher, and pale orange. Some areas are scraped back so that more color can be applied.*

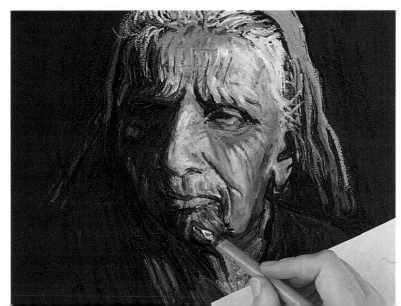

5 *Work now concentrates on the face, building up color on the forehead with short strokes, then scratching through the pigment to reveal the black paper, to denote all the lines and wrinkles. All the tones are now moderated, and the sari is redrawn after scraping away the first drawing. Parts of the drawing are masked with paper when working on small areas of detail.*

Artist • Cecilia Hunkeler

136

① *The main features of the head are rendered in wax crayon on a dark-toned Canson paper.*

② *A basic tint of Yellow Ocher is worked into the face, with the exception of the eye sockets and mouth. Short strokes of pale gray describe the hair uncovered by the veil.*

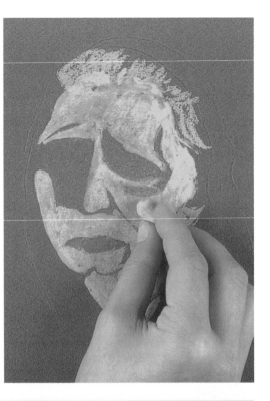

③ *Black, Prussian Blue, and viridian chalks are fused together to create a dark tone for the dress. Black is also added to the shadows created by the sitter's veil. The veil itself is drawn in a light brown blended with dark gray, which in turn is softened with a wet brush.*

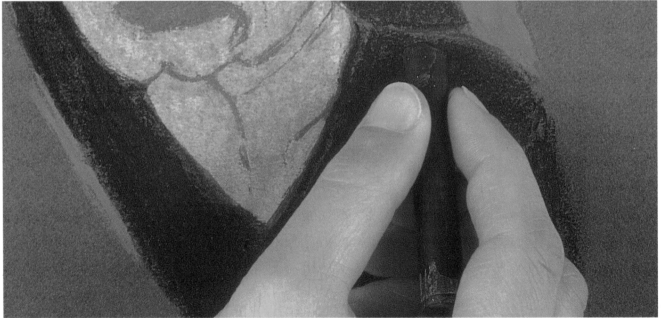

| BURNT SIENNA | PALE BROWN | INDIAN RED | PALE GRAY | RAW UMBER | YELLOW OCHER | VIRIDIAN | COBALT BLUE | PRUSSIAN BLUE | BLACK |

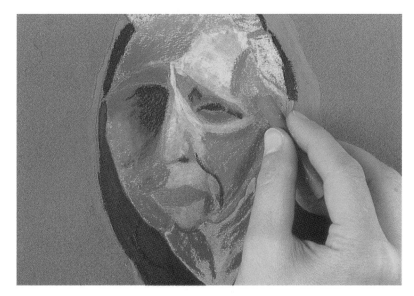

4 *The modeling of the face is now developed in contrasting warm tints of Burnt Sienna, Indian Red, Yellow Ocher, Raw Umber, and white. The sleeves and folds of the dress are defined with black chalk.*

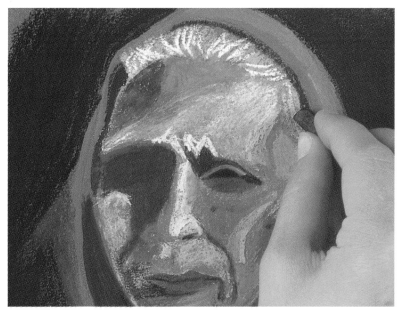

5 *A background tone of black chalk used at full strength is applied to provide contrast and to make the color in the face appear more concentrated. A white chalk is burnished into the lighter planes of the forehead, nose, and cheekbone.*

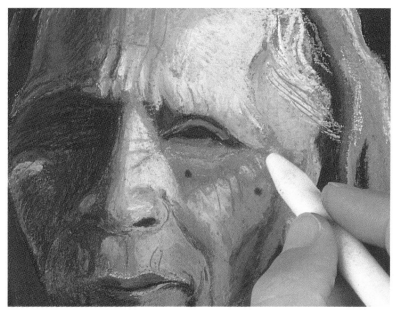

6 *All the tints are now blended with a torchon. Details such as creases and folds of skin are heightened with a black wax pencil. Finally, all the tones are carefully modulated from light to dark.*

Artist · Sophie Mason

1 *The main contours of the face are lightly drawn on white cartridge paper with pencil, and Burnt Umber and black pastel pencils.*

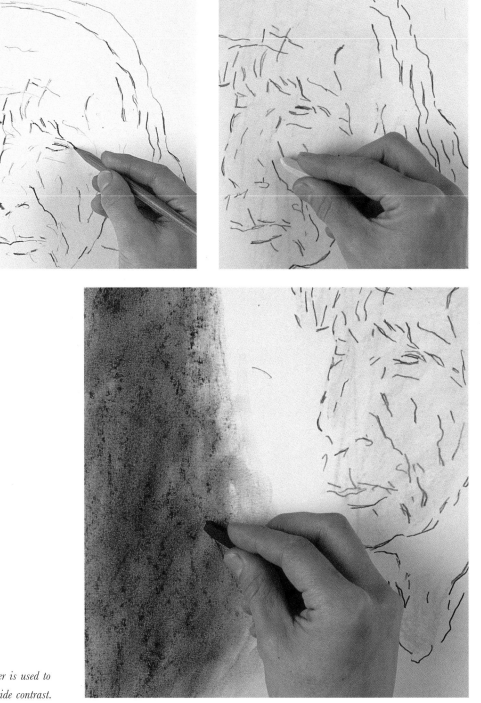

2 *A pale tint of Naples Yellow is spread over the face as a background tone for the colors to follow.*

3 *The flat side of a stick of Raw Umber is used to create a dark background tone and to provide contrast.*

INDIAN RED	NAPLES YELLOW	YELLOW OCHER	MARS VIOLET LIGHT	PERMANENT RED	RAW SIENNA LIGHT	BURNT UMBER	COBALT BLUE	PRUSSIAN BLUE	BLACK

139

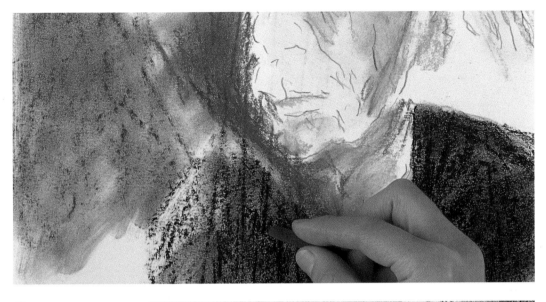

4 *The flat side of a stick of Prussian Blue is used to spread a tint over the woman's clothing. Raw Sienna is added to highlight those areas of the face that are turned towards the light. A Permanent Red is used on the ear, chin, and neck and carried through to other areas. Indian Red and Burnt Umber are blended on the left side of the face to suggest shadow and recession. A mauve violet is added to the scarf.*

5 *Yellow Ocher is introduced on the right side of the face to make it darker in tone. Burnt Umber pastel and a black pencil are used to define creases and lines in the face and to provide more definition generally.*

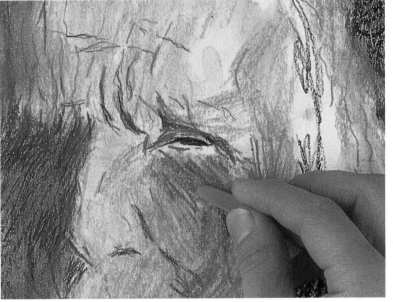

6 *The drawing is brought to a conclusion with a great deal of linear work using pastels and pastel pencils – mainly Burnt Umber, Raw Umber, black, and touches of Cobalt Blue.*

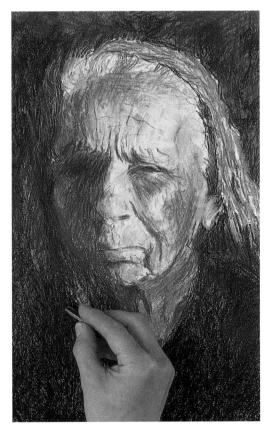

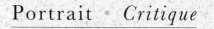

Portrait · *Critique*

140

Linear treatment works well

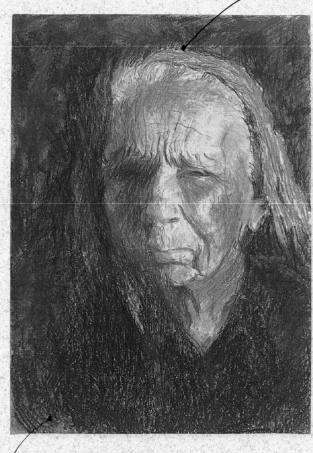

subtle handling of dark tones

HELEN This is a good example of the way that an impasto technique can be used effectively. Layers of color have been built up, scraped down, and redrawn, lending an almost sculptural quality to the drawing. A dark, near-black background always compresses color values, but it is important to get the balance right. Here I feel that the cotton sari could have been a shade lighter in relation to the dark background

Good example of impasto technique

The cotton sari is too dark and too opaque

SOPHIE This was a difficult subject to translate in terms of the medium because of the strongly contrasting tones. The artist has overcome this to some extent by treating everything in a strictly linear way, so that tones accrue in a cumulative web of thin pastel strokes. When seen from a distance, everything in the drawing seems to jell together. The darker tones of the left-hand side of the drawing are handled with subtlety. When building up a drawing in this way it is important not to lose sight of the main forms, which can be lost under the weight of too much pigment.

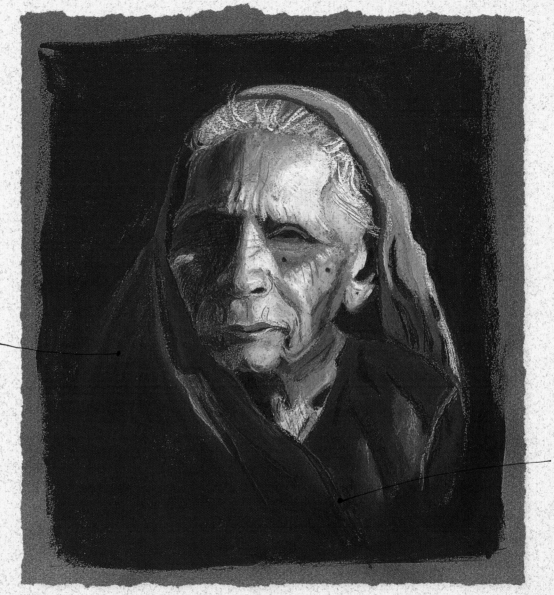

careful use
of a restricted
palette to
model the form

surface
pigment
too heavy
in some
places

CECILIA The commanding presence of the subject comes across in this drawing. By deliberately limiting both color and tone, the artist has been better able to control the modeling of the form. She has clearly been fascinated by the wrinkled, folded flesh of the old lady's face and has tended to exaggerate those qualities. But the handling of the veil and the woman's sari is perhaps rather too heavy – the surface pigment could have been reduced with a soft brush in this instance.

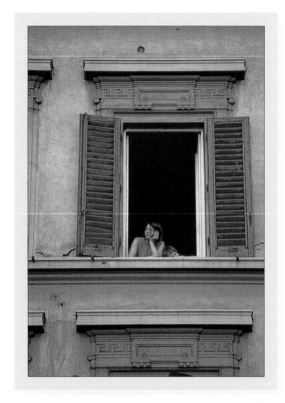

Townscape

A WINDOW IN NAPLES

In almost any town or city in Italy in the course of a single day, the population, young and old, acts out scenes that convey joy, despair, hope, fear, anger, and disappointment to the observer. The street life becomes the backdrop for an alfresco opera in which everyone plays a leading part. Family ties remain strong even in the most impoverished conditions. Children, in particular, hold a special place in Italian life. No Italian street scene would be complete without a few children in it.

There is a sense of the theater in this view of a tenement in Naples. The window in this street scene is rather like an old picture frame: the crumbling moldings and stucco with open shutters serve to isolate the diminutive figures of the two children. Both children seem bored, waiting for something to stir their interest. Compositionally, it presents an interesting subject, and, in terms of color, the somber hues of the building are relieved only by the pale carmine red of the girl's dress.

You might begin drawing with a base tint of Raw Sienna, perhaps dilute oil paint or gouache. Layers of chalk pastel of the same hue might be needed to suggest the texture of the stucco. The architectural detail could be rendered with pastel pencils or sepia ink, and a broad reed pen. Alternatively, you could use oil pastels throughout to produce a soft, unfocused drawing.

Artist • Helen Armstrong

| BURNT UMBER | BURNT SIENNA | OLIVE GREEN | GRAY | PERMANENT RED LIGHT | GOLD OCHER | LEMON YELLOW | CARMINE | MADDER LAKE DEEP |

143

1 *The main outlines are drawn in pencil on a beige Fabriano paper. Base tints of light yellow, Yellow Ocher, Burnt Sienna, Lemon Yellow, and deep yellow are blended with tissue into the paper's grain.*

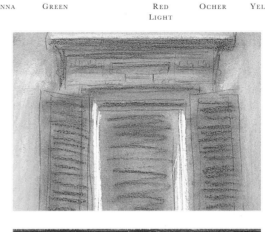

2 *The shadows are indicated with Burnt Umber rubbed in with tissue.*

3 *Lighter tones are overlaid on the top ledges of window frames and walls to suggest the chalky texture of the crumbling stucco. Colors used at this stage are lemon yellow, Yellow Ocher, and Gold Ocher.*

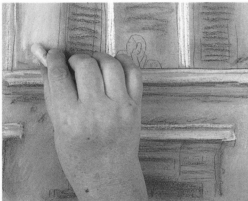

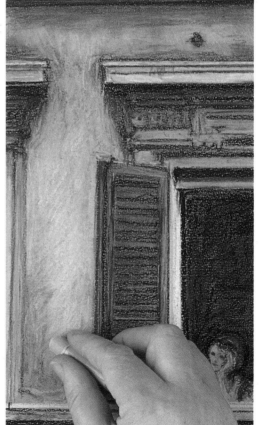

5 *The tone of the stucco is made lighter at this stage by using a light yellow. Details are generally given a sharper definition and shadows made more intense. Burnt Umber and Olive Green are used to suggest stains on the stucco walls. Finally, the artist uses short strokes of Yellow Ocher to level out the tones of the façade.*

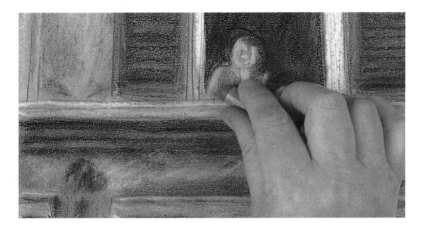

4 *Carmine and Madder Lake are used for the girl's dress, and Gold Ocher and pale Burnt Sienna for flesh tones. Black and dark brown are used for deeper shadows and for heightening details. Color is burnished with a finger to indicate the stucco walls.*

Artist · Cecilia Hunkeler

144

① *The windows, shutters, and the outlines of the main architectural detail are drawn in red crayon onto pale gray Canson paper.*

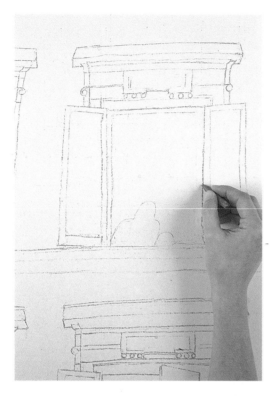

② *A base color of Yellow Ocher is painted in gouache over most of the wall surface. This in turn is overlaid with patches of white, Yellow Ocher, and Raw Umber oil pastels. The shutter and darker recesses are painted in Burnt Sienna gouache.*

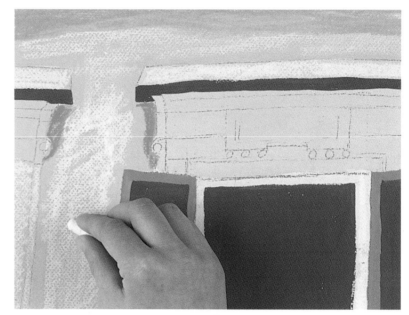

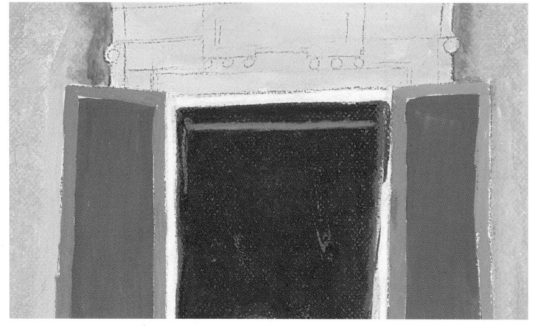

③ *The overall tone of the wall surface is made lighter by blending white chalk into the existing yellowish color.*

ROSE
MADDER

VERMILION

YELLOW
OCHER

RAW
UMBER

BURNT
SIENNA

VANDYKE
BROWN

BLACK

145

4 *Vandyke Brown oil pastel is drawn through a gauze mesh to add texture to the tone behind the children at the window. The same tone is added to the underside of ledges and cornices. The shape of the girl's dress is drawn in a tint of Rose Madder.*

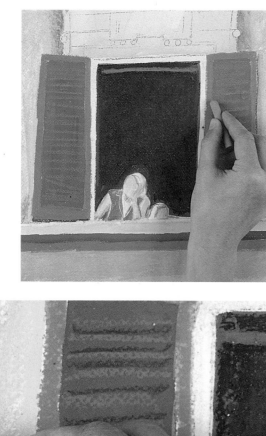

6 *In the final stage, the patterns on decorative moldings above the windows are scraped out of existing color, and more colors are blended into the surface. The top window is redrawn and details such as the struts of the shutters are more precisely defined. Finally, more color is worked, burnished, and scraped on the wall surface to produce a stucco effect.*

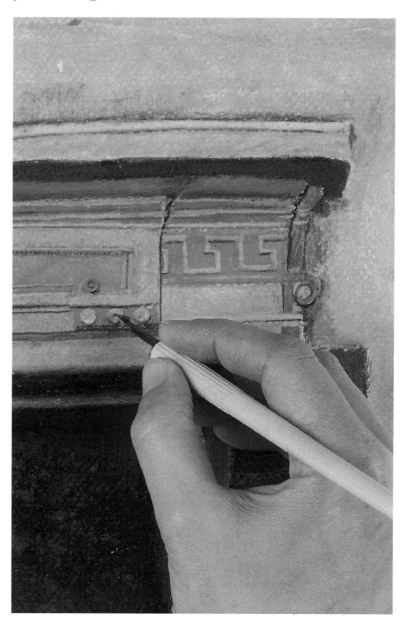

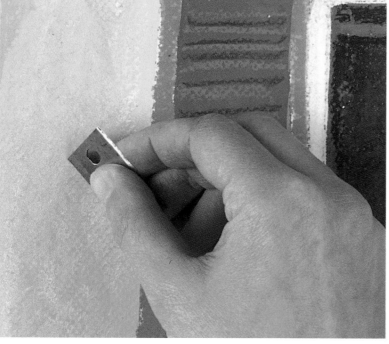

5 *More tints of light and dark ocher are added to the wall surface and then scraped and reworked, to represent the texture caused by weathering and decay. A Burnt Sienna oil pastel is worked into the window recess behind the children to make it less dark.*

Artist • Sophie Mason

1 *A warm, light brown paper was selected in relation to the overall color scheme. The main lines of the building – lintels, shutters, and window – are drawn in with a Brown Umber pastel pencil.*

2 *The lightest tone on the stucco is drawn with a Naples Yellow crayon (water-soluble).*

3 *Yellow Ocher and Raw Sienna are roughly blended with a finger over the main area of the building.*

| CADMIUM YELLOW | NAPLES YELLOW | RAW SIENNA LIGHT | YELLOW OCHER | RAW SIENNA | VERMILION | BURNT UMBER | BLACK |

4 *The shutters are drawn with Burnt Umber, and the same color is used for areas of shadow. The dark recess of the window is drawn in black, isolating the figures of the children.*

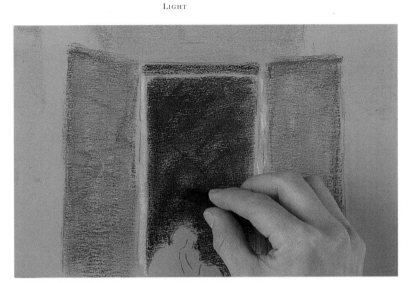

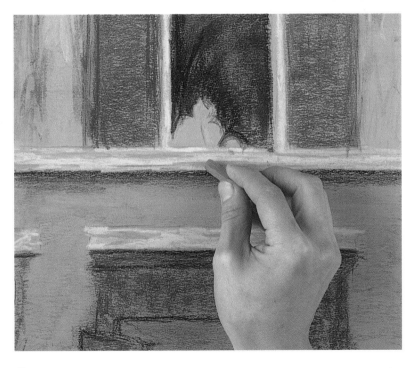

5 *Some variety is given to the texture of the wall with pale Cadmium Yellow, which is blended with colors applied previously. Black and Burnt Umber are used to provide more definition. Touches of Permanent Red Light and ocher are used to highlight the children's faces and arms.*

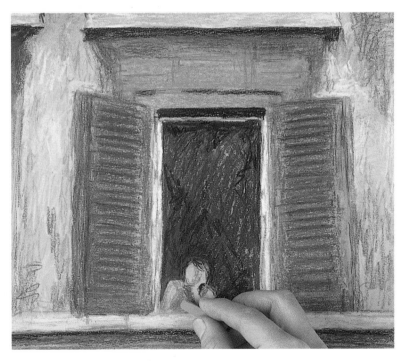

6 *Vermilion is used on the girl's dress. Most of the work in the final stage is expended on the texture of the wall. The slats of the shutters are carefully drawn using a Violet Dark crayon. Finally, part of the color is softened with a brush and water.*

Townscape · *Critique*

The freshness of the early stages slightly lost in the final stage

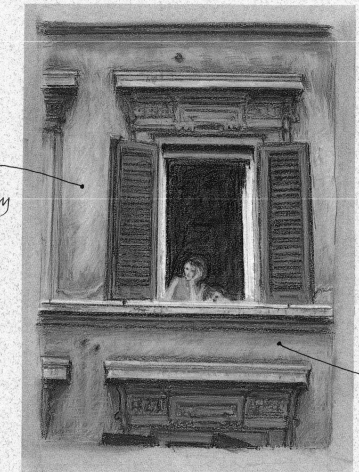

Balance between color, tonal values, and descriptive detail is successfully achieved

HELEN The early stages of this project worked well when the color was softly rubbed in. The freshness of these early stages was slightly lost when architectural detail was superimposed. Nevertheless, the texture of the crumbling stucco has been handled well. The darkest tone ought to be the recess of the room seen through the open window. Otherwise, the tonal balance is about right.

Because pastels are opaque, one can easily work and blend pale colors over dark and sometimes allow parts of a dark ground color to show through and enrich the drawing.

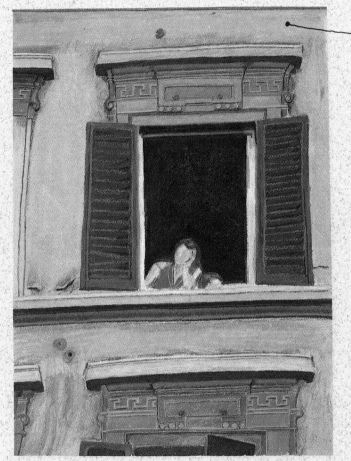

convincing rendering of the surface qualities of decaying stuccos

SOPHIE Everything is understated in this drawing. I feel that more attention could have been given to architectural detail, and to contrasting color and tone. In other words, more resolution is required to invest the drawing with interest. As it stands, the drawing looks like a detail from a much larger study. Perhaps the artist might have derived more interest from the subject by moving closer to the window, or, conversely, by viewing the subject from a greater distance.

More attention to architectural detail needed

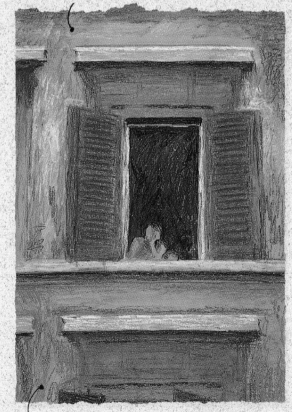

Judicious use of mixed media

CECILIA The artist has enjoyed the challenge of trying to produce a convincing drawing of the surface qualities of decaying stucco. The scraping technique is particularly effective in this instance, conveying the illusion of recessed patterns in the moldings above the windows. When working with a scraping technique for oil pastels, it is a good idea to work to a larger scale, in order to be able to exercise more control. Chalk and oil pastels have been successfully combined to produce a bas-relief effect.

The drawing of the children is carefully understated in relation to the wealth of surrounding texture. This is a good example of the way that materials can be harnessed to serve the intentions of the artist.

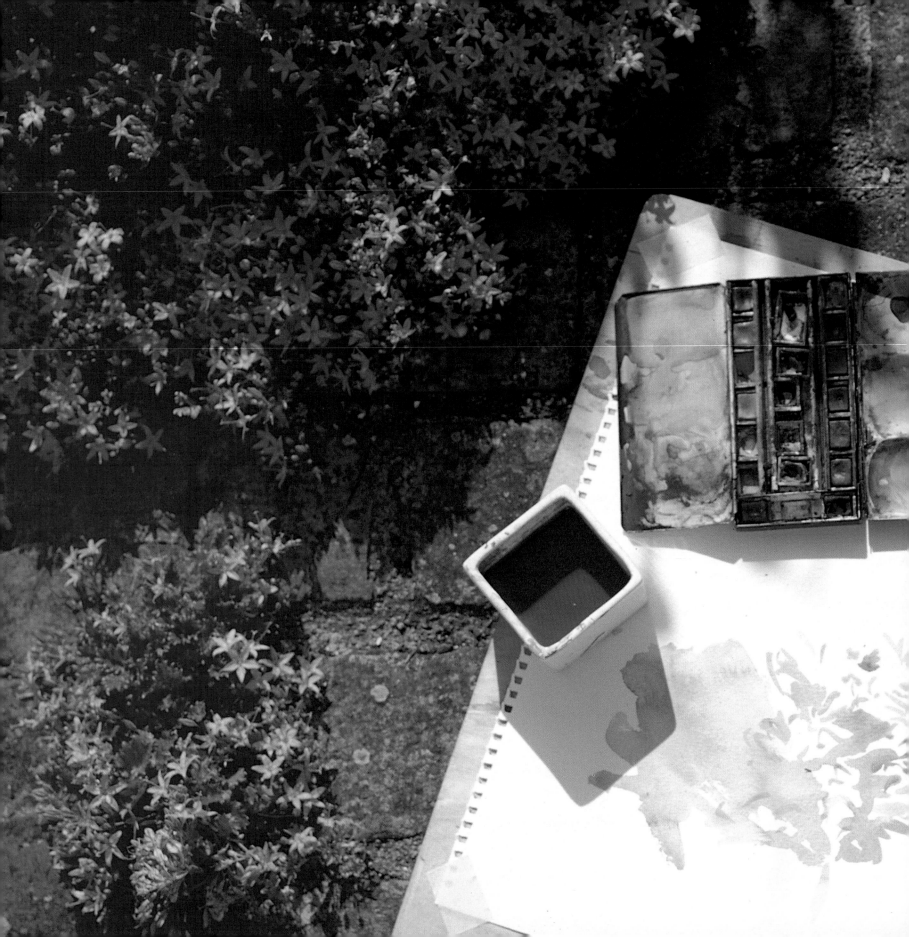

MATERIALS
AND
TECHNIQUES

Paints

152

In the manufacture of watercolors the pigment is first separated into individual particles. Gum arabic, which comes from the acacia tree, is one of the most important additives, since it binds the pigment together and is also water-soluble. Because most pigments do not blend easily into aqueous solutions, other wetting agents are required, such as oxgall, and detergents to aid the process of dispersion. Sugar and glycerine are also added to prevent the colors from drying out completely.

Most manufacturers have jealously guarded their recipes and only one has been prepared to publish his formulae. The London supplier Robert Ackermann was able not only to offer sixty-eight prepared watercolors for sale in 1801, but also published the recipe for those who wished to prepare their own colors. Ackermann's recipe involved four separate stages of manufacture and included gum arabic, sugar candy, distilled water, honey and distilled vinegar in varying proportions. But he warned those who wanted to prepare their own colors that, "the time, the trouble, the expense of attending their preparation will never compensate the small saving gained by it."

Watercolors are usually bought as a preselected range of colors in the form of semimoist cakes or pans, contained in a metal box. The compartmentalized lid of the box acts as a mixing palette when the box is opened out flat. Half-pans are small cakes of color held in a plastic container ³/₄ inch square. You may, however, prefer to buy an empty color box and select your own colors – in which case, you can mix half-pans with full-pans of color. The full-pans are likely to be colors you will use most frequently – blues, yellows and reds – while your half-pans might be restricted to colors that are used sparingly, such as violet, Lamp Black or crimson.

Some artists prefer the convenience of having tubes of watercolor or bottles of liquid watercolor. Much depends on the kind of work you are doing. If, for example, you are painting a landscape, then you might want to be able to see all your colors at a single glance without having to squeeze them out of individual tubes. On the other hand, you might consider it an advantage to be able to squeeze out just enough color for your purpose.

When selecting your own colors, you will no doubt add some of the more unusual hues to the basic set of primary, secondary and tertiary colors. You might also be guided in your choice of palette by the colors used by the great watercolorists. Turner, for instance, used several Chrome Yellows, Cobalt Blue, Indian Red, Madder, Yellow Ocher, Vermilion, Venetian Red and Raw Sienna.

Tubes contain watercolor pigment in a more liquid form. The texture of the paint is generally more consistent than pan colors.

A selection of half- and full-pan watercolors. You will need full pans for the colors used most frequently.

The choice of colors will not, of course, in itself turn you into a good colorist – but it can be a contributing factor. It is important to choose watercolors of a good quality. Poor-quality watercolors usually contain too much white filler. You will only be able to reproduce rich, granular washes by using artists' quality paints.

Most manufacturers offer some guidance as to the permanence or fugitiveness of their colors. Alizarin Green is fugitive, and Prussian Blue is liable to fade. Vermilion darkens in bright light, and colors with a dye content, such as Alizarin Crimson, are difficult to remove.

You will discover that certain colors are better used in small patches than as large flat washes. Colors such as French Ultramarine, for instance, tend to granulate either alone or when mixed with other colors. The behavior of different pigments will become more apparent with practice. Certain effects achieved by mixing color may be unexpected and can either enhance a painting or ruin it altogether.

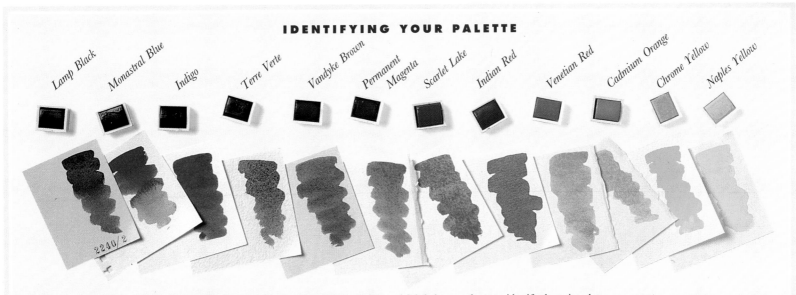

IDENTIFYING YOUR PALETTE

Lamp Black | Monastral Blue | Indigo | Terre Verte | Vandyke Brown | Permanent Magenta | Scarlet Lake | Indian Red | Venetian Red | Cadmium Orange | Chrome Yellow | Naples Yellow

Beginners are encouraged to make swatches and label them so they can identify the paints later.

Paper

A sized white paper is the support normally used for water-color painting. The artist today is faced with a wide choice of papers from the United States, England, France, Italy and Japan.

My own preference is for paper that is not too heavily sized, and without a pronounced "tooth."

Strathmore, Arches, Saunders Waterford, Whatman and *Fabriano* are all fine papers that bring out the best characteristics of transparent watercolor glazes. In the first instance, however, any white paper that is heavy enough to withstand stretching, washing out and re-working, and does not buckle when wet, is ideal. Inexperienced artists should initially avoid expensive papers with a pronounced "tooth," which might tend to flatter the work, and avoid toned papers for the same reason.

Watercolor papers are classified by weight and surface texture.

● CP (cold-pressed) has a semirough surface of medium grain that accepts washes without too much absorption.

● HP (hot-pressed) papers have a much smoother surface with a fine grain with sufficient texture to retain a wash. It is an ideal paper for working in pencil and wash or for fine brushwork.

● ROUGH paper has a coarse surface, achieved by drying the sheets between rough felts without pressing. This paper is most suited to strong, broadly painted washes. It is generally unsuited to pen and ink or soft pencil, which tends to smudge.

WEIGHT

At one time, the thickness of paper was determined by the weight of a ream (500 sheets) of that particular paper in a given size. Today, however, it is expressed as the weight of a square meter of a single sheet of paper given in grams – gsm. An average weight for a watercolor paper would be about 300 gsm / 140 lb. The heaviest is about 638 gsm / 300 lb.

SIZING

Watercolor papers are generally sized. Unsized papers, known as waterleaf, are generally unsuitable since they absorb the color and tend to "bleed." The "right" side of the paper is determined by the maker's name, which appears as a watermark reading in the right direction when held up to the light.

Paint Additives

GUM ARABIC/WATERCOLOR MEDIUM

This is a mixture of gum arabic and acetic acid, which acts as a binder and extender. It is particularly useful when working on top of several layered washes to prevent the color from sinking. Watercolor glazes are enhanced by the addition of gum arabic.

ABOVE *Diluted gum arabic. It can be mixed in varying proportions with watercolor pigment.*

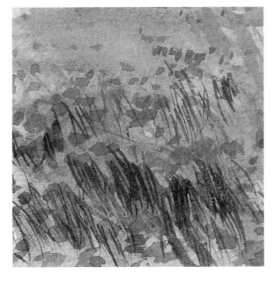

RIGHT *An example of a brighter color mixed with gum and laid over layered washes – notice how the color retains its tonal strength.*

OXGALL LIQUID

This additive is generally available in different-sized containers. It is generally used to improve the wetting and flow of watercolor paint. To improve the acceptance of watercolor on various papers, the liquid oxgall is diluted with water and used as a primer. It can also be mixed directly with the paint to produce a smoother flow of color. Additionally, it can be used as a flat wash (with a touch of color) over a finished painting to bring colors together tonally.

PREPARED SIZE

You may find a particularly attractive paper to work on which is too absorbent for watercolor. Prepared size is used to make the paper less absorbent. It should be warmed gently before use so that it is free flowing and can be brushed directly onto the paper and left to dry. Prepared size can also be useful as a base for wet-in-wet painting to prevent the color from spreading too much.

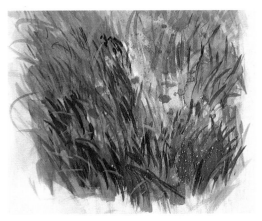

LEFT *Colors applied wet-in-wet onto paper that has been sized by hand.*

VARNISH

If a watercolor is to be framed under glass, it is not really necessary to varnish the surface. There are, however, a number of paper varnishes made from synthetic resin dissolved in turpentine, which the manufacturers claim do not affect the color or tone of the painting.

RICE STARCH

Nineteenth-century watercolorists sometimes added fine powdered rice starch to the color mix to produce a dry, pastel-like quality. In an age of aerosol sprays, rice starch is becoming increasingly difficult to find.

Brushes

efore you discover the kinds of brushes most suited to your needs, you will most likely need to experiment with different types of brushes.

To produce a broad wash as a single statement, for instance, you will need to use a flat brush, a mop or a one-stroke brush. Larger brushes retain more color so that a sheet of paper can be covered quickly and evenly. When out sketching, you will find that a medium-sized sable brush – No. 6 or No. 8 – will generally suffice for both washes and more detailed work. Chinese brushes are essentially calligraphy brushes, but you may like the sensitive line they produce.

Chinese brushes.

¼ inch Prolene.

¼ inch Sable/Synthetic.

1 inch Sable/Synthetic.

One-stroke brushes and a domed flat wash brush for broad washes.

A broad wash brush designed for covering large areas with watercolor.

Prolene Series 51.

Series 7 sable brushes.

Round brushes for broad strokes and washes.

Dalon 66.

Prolene 14.

Series 16 sable brushes.

Prolene brushes.

Holding Brushes

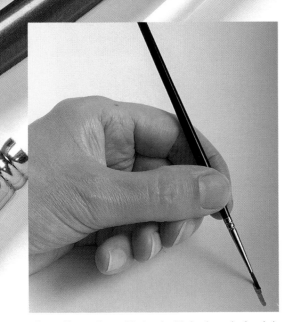

Controlling a fine sable brush. Notice how the brush is cradled for support between forefinger and thumb.

Just as a person's signature is highly personal, a painter will handle everything in terms of his or her own brushwork. You will sometimes hear artists and art critics talking about the "handling" of a painting. That has to do with the individuality of the artist's touch. We recognize the difference between, say, a watercolor by Richard Parks Bonington and one by James Abbot McNeill Whistler by the difference in handling. The brush is an extension of the artist's eye – revealing the most tentative trace of the artist's feelings.

In order to gain graphic control of the hand, the painter William Coldstream worked as an assistant sign-writer. The painting of letterforms is an excellent way of learning brush control.

For detailed work, the sable brush is usually cradled between the first and second fingers with pressure applied by the thumb. In my experience, the broader the brush, the farther down the handle it is held. Try holding the brush at the very tip of the handle, so that the smallest movement is amplified. Practice making strokes upward and downward, slowly and very rapidly, until you feel you have brush control.

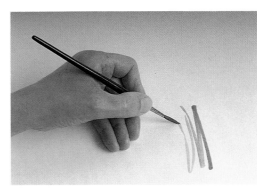

Practicing line control with a No. 4 sable brush.

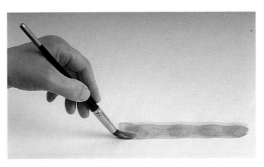

A round brush is held loosely to produce a broad wash.

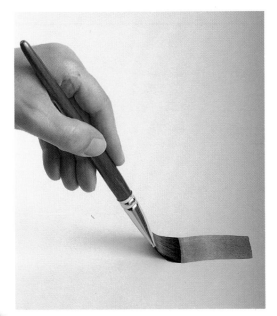

A broad one-stroke brush is used to lay a wash. It is held farther down the handle to ensure greater control.

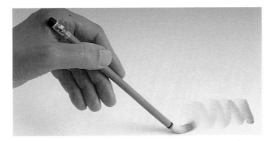

A Chinese brush is held at the top of the handle for a more fluid movement.

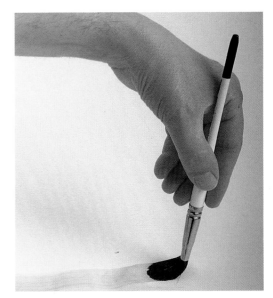

A backstroke with a mop produces a pale wash.

Maintaining Equipment

158

BRUSHES

Sable brushes are expensive, and it should be an unbroken rule to clean them each time after use. The life of a sable brush will depend on the way it is used as well as how thoroughly it is cleaned. Try to keep brushes for different functions; a sable brush can take quite a lot of punishment, but try not to use it for any kind of scrubbing action. That will loosen hairs in the ferrule and spoil the shape of the brush.

TO CLEAN A BRUSH

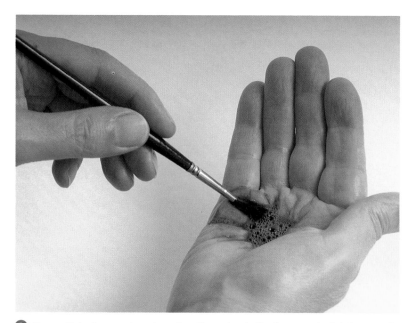

❶ *Pour a little detergent into the palm of your hand. Gently rotate the bristles to soak up the detergent.*

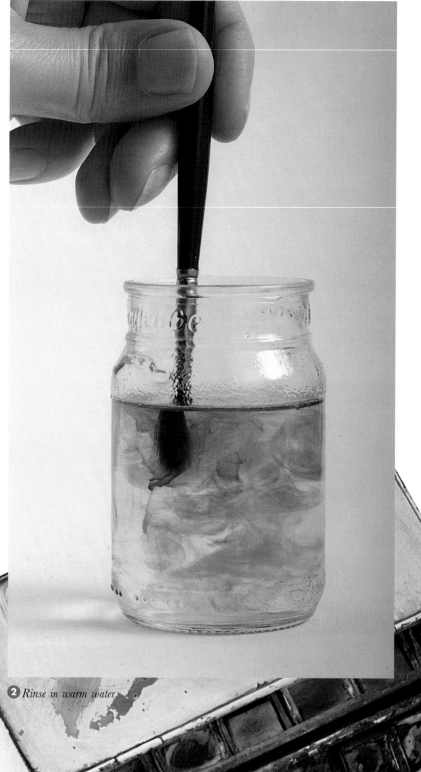

❷ *Rinse in warm water.*

PROTECTING YOUR BRUSHES

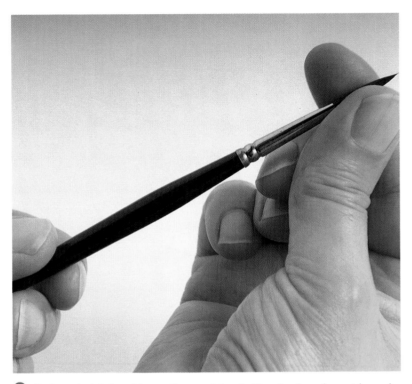

3 *Reshape the bristles with your finger and thumb. Store brushes when not in use in a cylinder or on a protective backing cardboard (as illustrated right).*

PAINTBOX AND PALETTE

Clean all mixing palettes after use and, more important, allow pans of watercolor to dry out before closing the box. That might prove difficult when you are traveling; if so, open the box when you return to your studio so that the colors can dry.

When using tubes of color try to get into the habit of screwing the cap back on the tube *immediately* after use.

OTHER MATERIALS

A roll of paper towel always comes in useful whether you are working inside or out.

Keep two jars for mixing and rinsing color and make sure they have screwtops that are watertight.

Good-quality paintbrushes are expensive to buy, but will give long service if looked after properly. One of the most common causes of damage is the inadequate protection of the brush hairs during transit. Avoid this by either retaining the plastic cap that comes with the brush, or buy a specially designed rigid tube. A very simple and inexpensive alternative is to make your own. Cut a stout piece of cardboard taller than your largest brush. Cut four semicircular indents in the sides, as shown in the illustration above. Place two thick elastic bands around the cardboard in the indents. Then slide your brushes through the elastic bands.

Washes

160 One of the main prerequisites for becoming a good watercolor painter is the ability to lay a good wash. By that, I mean being able to cover a relatively large sheet of paper with an evenly laid tone of diluted color.

For the beginner, this is often the most daunting aspect of watercolor painting. There is no need for anxiety, however, provided that you take account of the following factors. First, the quality and surface texture of the paper are important – whether it has too much size content or too little, whether it is too smooth or too coarse. Second, the angle of your sketchbook or drawing board and the angle of the brush to the paper can assist the flow of color. Third, the amount of color loaded in your brush and the size of the brush in relation to the area to be covered makes a difference. Finally, the deftness and speed at which you work and (if you are working outside) the heat of the day, the wind or a damp atmosphere affect the evaporation of color. You can apply washes freely as Turner did, without precise boundaries, or you can develop a blocking-in technique as John Sell Cotman did, by dividing the subject into simple shapes or blocks of color. Freshness of color is one of the main characteristics of watercolor, and this is lost to some extent if too many washes are superimposed on one another.

MIXING A WASH

Being a painter is sometimes like being a good cook – the mixing of the ingredients can greatly influence the finished result.

Though I would not personally worry about the kind of water used for producing a wash, there are some painters who believe that distilled water or even rain water will produce a better wash than hard water from a faucet. There is some truth in this, since hard water has a tendency to curdle the paint.

Unless you find it too cumbersome, you should always have two jars of water – one for mixing color, the other for rinsing your brushes. That will ensure cleaner results and you will need a change of water less often.

It is always better to mix more of a tint than you will actually need; the time taken to mix a fresh tint can spoil your concentration, and it will be difficult to match the first mixture exactly.

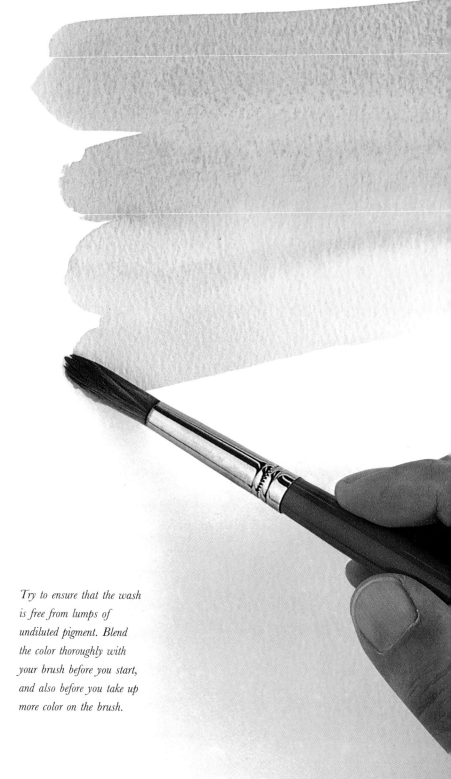

Try to ensure that the wash is free from lumps of undiluted pigment. Blend the color thoroughly with your brush before you start, and also before you take up more color on the brush.

STRETCHING PAPER

You will need a drawing board, or a similar firm support that is larger than the size of the watercolor paper. The paper is fastened to the board with gummed tape (gum-strip). This is coated on one side with a water-soluble glue that becomes tacky when moistened with a sponge.

First, immerse the paper completely in a tray filled with a few inches of cold water – a photographer's developing tray is ideal.

1 Allow the paper to soak so that there are no dry patches, then lift it out of the tray and drain off any excess water.

2 Next, place the paper centrally on your board and, with a finger, squeegee the edges so that they are just damp.

3 Cut the gum-strip into four pieces – longer than the four sides of the paper itself. Wet the tape with a damp sponge.

4 Press the tape firmly into position along each edge of the paper so that it covers an equal width of board and paper.

The paper should then be allowed to dry out – you can assist the drying after 15-20 minutes with a hairdryer.

Watercolor papers of 300 gsm / 140 lb and heavier papers do not require stretching.

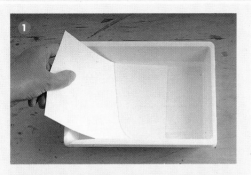

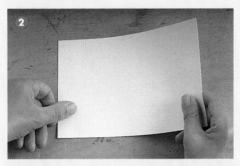

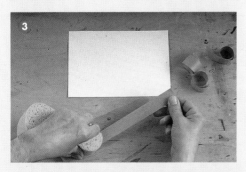

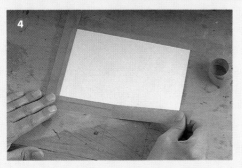

Laying Washes

A flat wash made with a 1½ inch flat brush and Fabriano (ROUGH) paper.

LAYING A FLAT WASH

If you are laying a flat wash on dry paper, mix a sufficient quantity of paint in your mixing tray and fully load the brush. Tilt your board or sketchbook toward you at a slight angle. Make your first stroke across the top of the paper. As the color begins to collect at the bottom of the stroke, pick it up with your brush and continue in this way with successive strokes, allowing a slight overlap where they join. Work toward the bottom of your sheet of paper, or the area you wish to cover, and remove excess paint by squeezing out your brush and lifting the residue so that the wash is even in tone.

An alternative method is to dampen the surface of the paper first – this is particularly desirable on papers that are heavily sized. Having dampened the paper, make sure that the surface is mat and not too wet. Any excess water should be blotted off before laying the wash. Tilt the board and proceed as before. A flat wash laid onto damp paper is softer and more diffused than a wash on dry paper.

WASHING OUT

This is a way of reversing out white shapes from previously laid washes of color. When the wash is dry, take a fine sable brush dipped in clean water, and soften the color where you wish to remove it. Blot off the color carefully with tissue.

You may need to repeat this operation until the paper appears as a clean white shape.

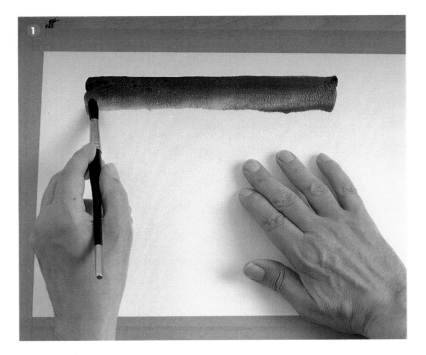

GRADUATED WASHES

A graduated wash starts with the color at full strength and then, by dilution, the tone becomes paler until it is just a trace darker than the paper itself. Again, as with a flat wash, you can work either on dry or damp paper.

① Mix the full tint and with a broad brush make the first stroke horizontally across the top of the paper.

② Then, pick up a little water on the brush and dilute each stroke.

③ Continue until you have achieved a satisfactory gradation of tone.

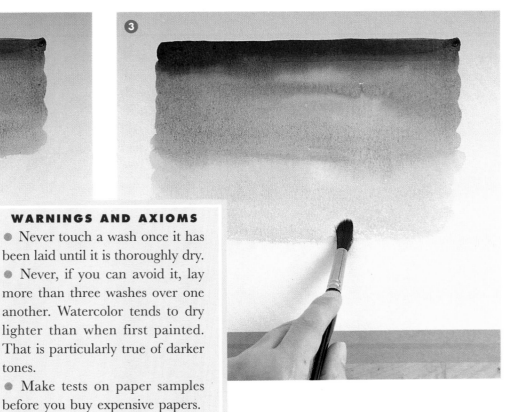

WARNINGS AND AXIOMS

● Never touch a wash once it has been laid until it is thoroughly dry.

● Never, if you can avoid it, lay more than three washes over one another. Watercolor tends to dry lighter than when first painted. That is particularly true of darker tones.

● Make tests on paper samples before you buy expensive papers.

● Change damping water often.

Wet-in-Wet

164 elacroix said that, "One always has to spoil a picture a lit-tle bit in order to finish it." Wet-in-wet is one of those tech-niques that is unpredictable and difficult to control. If you are the kind of artist who enjoys risk-taking, however, then the uncer-tain outcome of allowing washes to merge into one another while wet will appeal to you.

When working wet-in-wet you can dampen the paper first, by sponging either the whole sheet or local areas of the painting such as the background or the sky. While the paper is still damp, float one or more washes onto the surface. The pigment will immediately be absorbed as it spreads, coagulating and forming rivulets of varying intensity. You can assist the flow by tilting your drawing board upright so that the colors run down, blending randomly with one another. A degree of control can be exercised by systematically blotting off patches of color with tissue or cotton batting. More color can be added before the first washes have dried out completely.

All techniques serve one purpose – to enable you to convey the particular qualities of some phenomenon you have witnessed yourself. There is no particular virtue in using the wet-in-wet technique for its own sake. The application of this technique is best suited to strongly atmospheric images – a landscape emerg-ing from early morning mist, a turbulent sky or a seascape are all examples that come to mind.

RIGHT *An exercise using a large brush to make loosely painted slabs of color on a dampened sheet of paper.*

BELOW *A rapidly executed sketch painted directly from the subject. Washes have been applied wet-in-wet onto RIVES HP paper.*

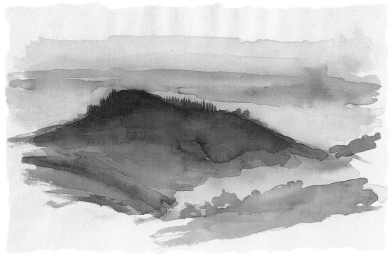

LEFT AND RIGHT *Two studies of a hillside in Tuscany painted directly from observation early in the morning when the mist rises from the valley.*

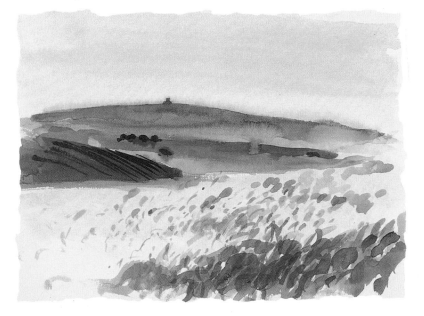

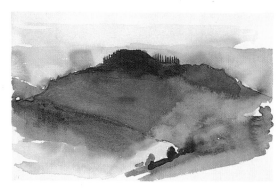

Dry Brush

The dry brush technique is essentially a means of providing texture in watercolor painting. It is also a way of lending graphic expression to what might be an otherwise static painting. When painting a landscape scene, for instance, you may feel the need to suggest rhythm and movement – particularly with the rendering of crops, grassland, trees and foliage.

In order to gain confidence in using this technique, you should make a few mark-making trials on scrap paper. You will need a textured paper – rough or CP (cold-pressed). The brush should be starved of water before lifting pigment from your palette. Hold the brush lightly and make rapid strokes across the paper in a kind of sweeping action. The combination of dry pigment and the textured surface of the paper will produce a broken, granular stroke, which makes a pleasing contrast to flat washes.

Try different colors and vary the amount of water used. You could also experiment with different kinds of brushes.

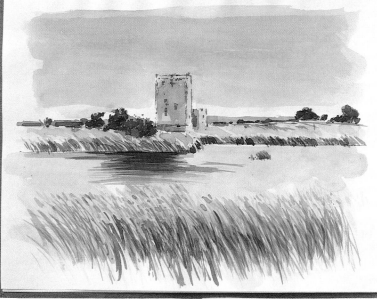

ABOVE *Threave Castle, Scotland. Dry brush strokes have been used mainly in the foreground for reeds and grasses.*

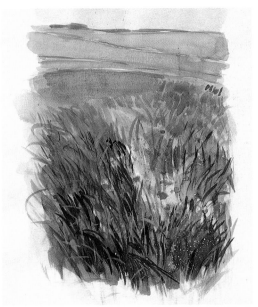

ABOVE *Poppy field. Strong directional strokes of dry color evoke the wavelike quality of crops and grassland.*

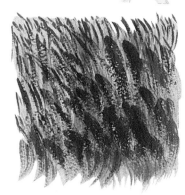

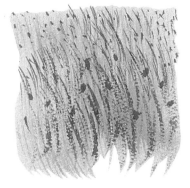

LEFT *Four variations of the dry brush technique. Notice how the color is more opaque, and how the texture influences the quality of the marks made. To avoid making the color too muddy, use short, sharp strokes.*

Brush Drawing • *Basic Exercises*

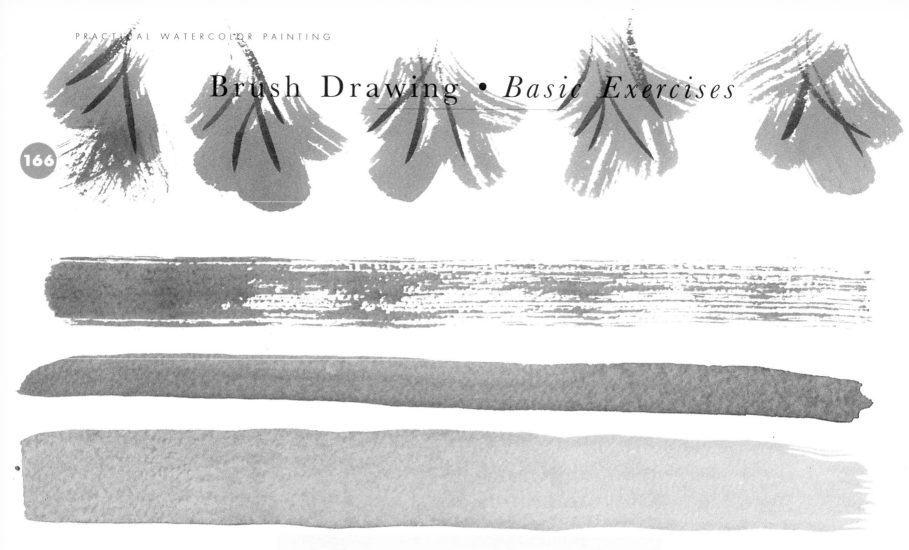

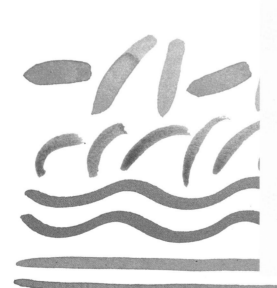

This is the purest form of watercolor painting. To draw directly with a brush can be an immensely satisfying form of graphic expression. Drawings made with a brush and watercolor are often less self-conscious than those made with pen or pencil. That probably has something to do with the fact that the softness of the image lends a fluency to the drawing that is difficult to obtain in any other medium.

Almost any mark you make with a brush is a statement about form and shape as well as about color and tone. Most important, you should first discover what kind of marks can be made with different types of brushes. Try to work in terms of the medium, rather than trying to conceal the unique character of brushmarks by overworking the drawing.

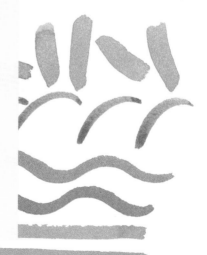

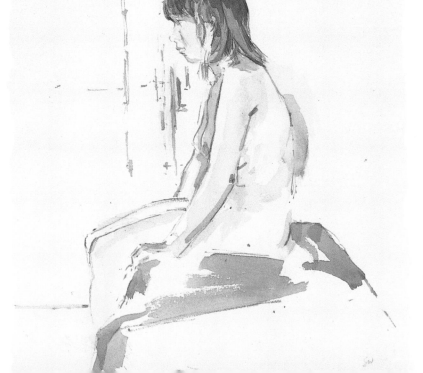

LEFT *A portrait study made with a No. 5 sable brush. The underlying drawing has been made from direct observation using a pale wash of Alizarin Crimson and Lamp Black. When dry, other washes have been rapidly overlaid wet-in-wet.*

LEFT *A study drawn with a No. 4 sable in a life class. Tentative washes have been added to suggest modeling of the form.*

ABOVE *A direct study of an olive tree made as a notation for future reference. This sketch was completed in 10 minutes using a No. 8 sable brush.*

Pencil and Wash

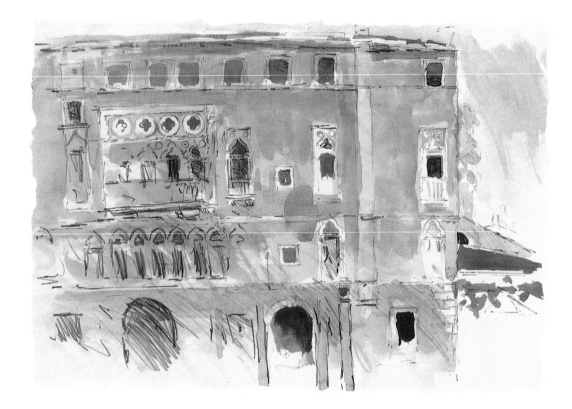

LEFT *This page from a Venetian sketchbook shows the right kind of balance between pencil and color.*

RIGHT *Another sketchbook page on which drawn pencil marks and color work well together.*

The earliest watercolors were really tinted drawings – washes of pale color were laid over pencil studies as a kind of embellishment to heighten the drawing.

Quite often the tinted drawings were preliminary studies for engravings. A number of early English watercolorists, Turner and Cotman included, were employed to add watercolor to ready-made prints.

Line and wash – the classic watercolor technique – came into its own when wealthy 18th-century patrons commissioned picturesque studies of scenery along the "Grand Tour" of Europe.

John Cozens (1752-97) was one of the first watercolorists to use line and wash to depict the Italian landscape. By the beginning of the 19th century, watercolor painting was considered to be an art in its own right. Turner, much influenced by Cozens, traveled to the Continent in 1802 as far as the Swiss Alps. There followed a series of watercolor paintings recording a journey down the Rhine, and in 1819, at the age of forty-four, Turner visited

Italy for the first time and produced some of his finest watercolors. The tradition of classic watercolor established by the early English watercolorists has continued to the present day – alongside computer-aided photography and video-recorders! My own view is that you cannot truly know a place until you have drawn it. When I sit before a scene trying to register line for line, tone for tone, I gain an understanding of the subject that is indelibly stored in my memory.

For pencil and wash I prefer to use a paper made from 100% cotton – Saunders or Fabriano are ideal. The soft surface of these papers is very receptive to both pencil and watercolor. A paper that is too heavily textured tends to break up the pencil marks; too smooth a paper produces unsatisfactory washes.

The balance between line and wash is critical – there is no point in simply filling in a previously drawn pencil outline with washes. The pencil drawing might provide an underlying structure, but it is also an integral part of the whole painting.

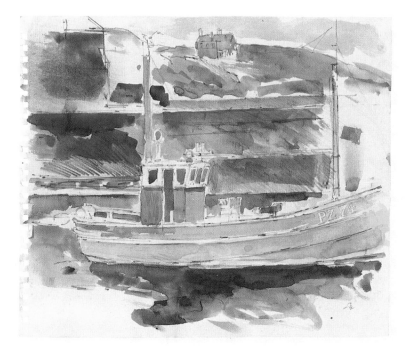

I find a medium-soft pencil, such as 2B or 3B, ideal to produce the right tonal balance between line and wash.

Perhaps the most difficult aspect of this technique for the beginner is to learn how to be selective. When you start to draw, you need to be conscious of the fact that the drawing is only a part of the total image – you must allow for the fact that subsequent washes of color will work alongside the pencil drawing, rather than displace or color it. In other words, both line and wash should be used descriptively to produce a single image without any separation of technique.

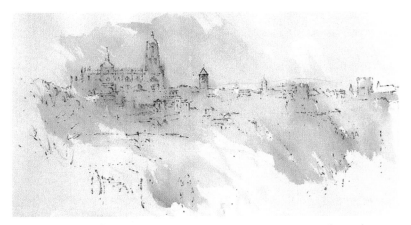

ABOVE *The city of Segovia drawn from a distance in pale pencil tones with delicate washes that do not cancel out the drawing.*

RIGHT *A tentative use of the pencil in this painting allows colored washes to work independently.*

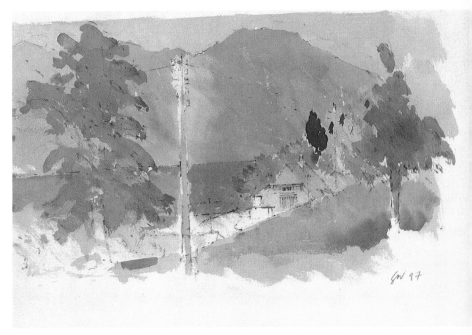

THE
PROJECTS

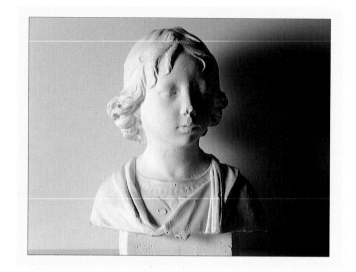

Light and Shadow

ANTIQUE HEAD

We tend to see most things in terms of contrasts, which can be strong and sharply defined or more subtle and barely perceived. In addition, with a graduated scale of tone from light to dark, we also need to perceive color that is modulated in warm or cool hues. Color and tone need to be harnessed together to produce a satisfactory painting. When working in watercolor, it is fairly easy to produce bold washes of primary color, but to produce a more subtle range of tone requires much more control.

For this project, a white cast of an antique head is seen against a white background. The aim of this project is twofold – to gain experience of controlling pale washes of color to render the subtle tones of light and shade and to learn to mix a wider range of warm and cool tints without adding body color (gouache).

From a basic set of watercolors, you will be surprised just how many shades of gray you can mix. Traces of Umber, Ocher and Cadmium Red produce warm tints; the blues – Cerulean, Cobalt and Monastral with a hint of Lamp Black – produce cooler tints. It would be a useful background exercise to make your own chart of warm and cool tints – perhaps twenty of each with notes to remind you of the color combinations used in mixing each tint.

In a painting of this kind, the white surface of the paper itself plays an important part, as does the quality of light falling on the antique head. Because the head is cast in white, and the background is also white, the local color is neither warm nor cool. If, however, the light is a cold light, the resulting shadows will tend to be warm. Conversely, if the light source is warm then the shadows will be cool.

All of this may seem confusing at first but, with practice, you will begin to understand how color as color and light as light are combined in the adumbrated washes used to build up a painting. The more you paint from direct observation, the more you will begin to see shades of tone and hues of color that previously would have gone unnoticed.

Artist • Ian Potts

PAYNE'S GRAY

HOOKER'S GREEN

VIRIDIAN

INDIGO

COBALT BLUE

173

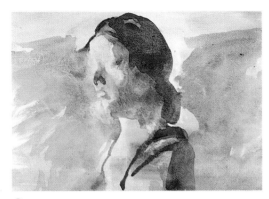

❶ *The artist uses an unstretched sheet of Bockingford*
CP 300 gsm / 140 lb paper. The surface of the paper
is dampened slightly and a background wash of
Viridian mixed with a little Hooker's Green is laid in a
very controlled movement with tissue. The wash follows
the contours of the head. When dry, a stronger wash of
the same color begins to define the features of the head
and areas of shadow. Further adjustments are made by
dabbing off some of the washes with a paper towel.

❷ *The modeling of the form continues with a No. 8*
sable loaded with a mix of Indigo and a touch of
Payne's Gray to produce a darker hue.

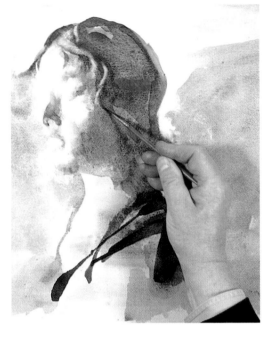

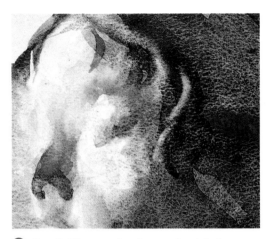

❸ *(Detail) The paper is redampened and further*
washes are laid and lifted, in successive layers, until
the balance of tone seems to be about right. The folds
in the hair are dealt with at this stage, to suggest a
sculptured low-relief.

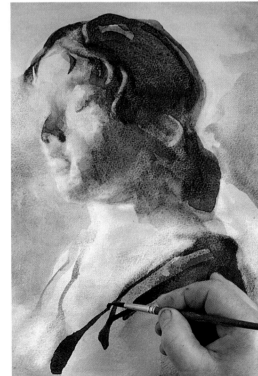

❹ *An inky blue-black*
wash provides the darkest
tone in the painting and
intensifies the contrast
even further.

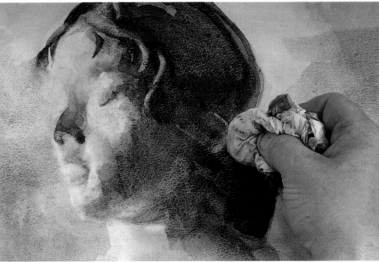

❺ *Certain passages of the painting are blotted off with*
a paper towel while the color is still wet.

Artist • Anthony Colbert

174

1 *A wash of pale Indigo is laid as a base color for the painting, using a Hake 3 inch, and allowed to dry. The wash is then repeated over the background, isolating the shape of the antique head.*

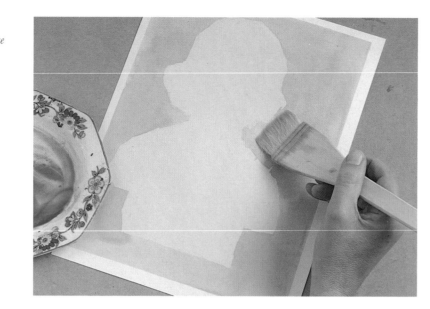

2 *Pale shades are blocked in using the same color loaded onto a No. 8 sable brush.*

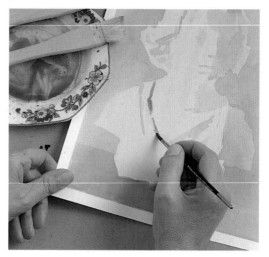

3 *The area of the cast shadow is dampened and a stronger mix of Indigo with a little Alizarin Crimson is brushed in.*

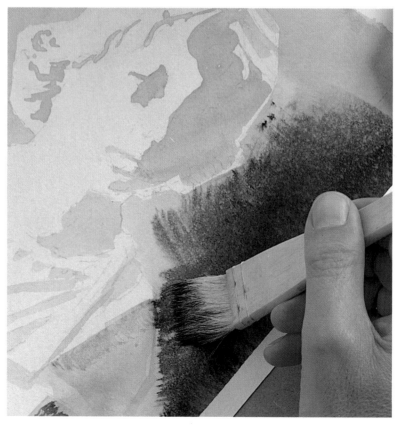

NAPLES YELLOW ALIZARIN CRIMSON INDIGO

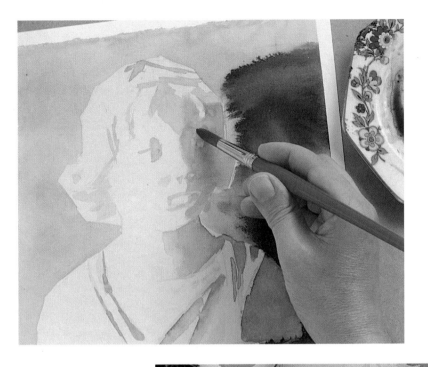

4 *Darker tones continue to be blocked in using the same mix but with a hint of Naples Yellow and Alizarin Crimson.*

6 *The tonal modulation is completed with a final dark wash of Indigo.*

5 *The same process continues – highlights are lifted from original washes with a clean, damp brush as necessary.*

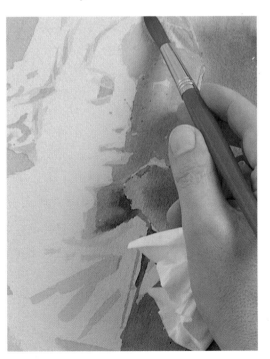

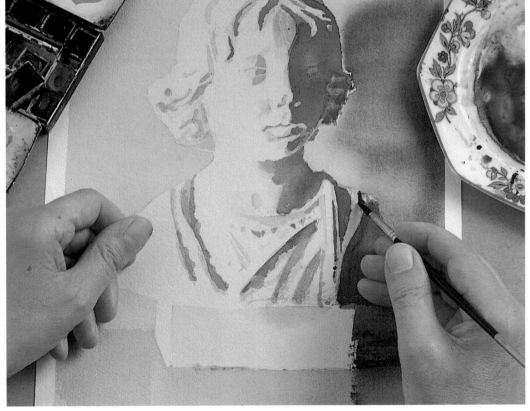

Artist • Deborah Jameson

1 *A Saunders hot-pressed paper has been selected for this project. The basic proportions of the antique cast are tentatively stated with a soft pencil.*

2 *The drawing is further developed to establish tonal values.*

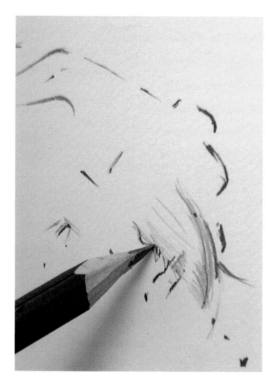

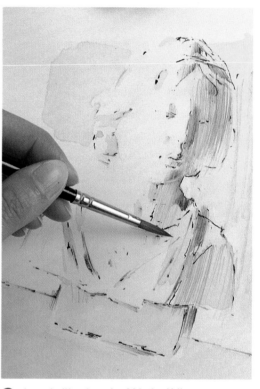

3 *A much-diluted wash of Naples Yellow serves to heighten the contrast as it is laid over the drawing.*

NAPLES YELLOW

PAYNE'S GRAY

LAMP BLACK

4 *The folds of the form are picked up in Naples Yellow.*

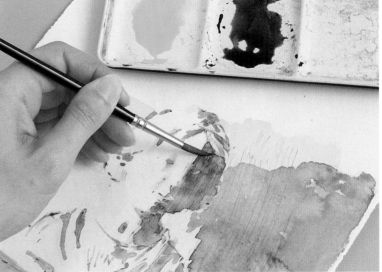

5 *A granular wash of Lamp Black follows the form of the head and provides further contrast.*

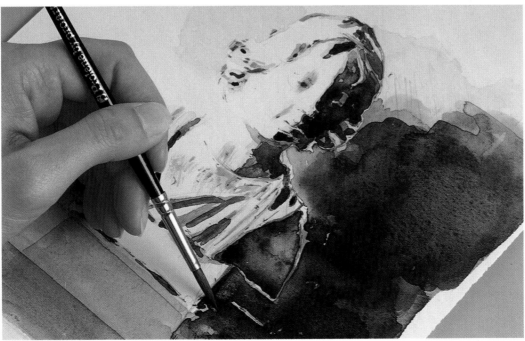

6 *The darkest tones are produced by over laying a wash of Payne's Gray, which also adds a hint of blue to the areas of shadow.*

Light and Shadow • *Critique*

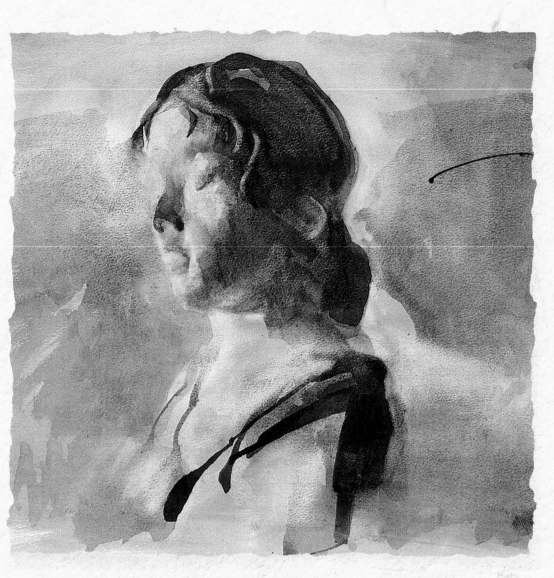

Overall colour too blue

IAN This painting demonstrates just how much can be achieved with a few carefully coordinated washes that are closely related in tone and color.

The artist has resisted the temptation to overwork the painting by the addition of too much sharply defined detail. As in all the best watercolors, the painting retains the sense of suspended fluidity.

The color is perhaps a little too blue – a more restrained gray-blue wash might have worked better.

final stage overworked

DEBORAH The color in this painting is of a warmer hue than the others — although, in the final stage, a near blue-black balances the warmth of the Naples Yellow. The artist has made good use of the white surface of the hot-pressed paper as an integral part of the image. My own feeling, however, is that it worked best at the second stage of development, when only a single wash of Naples Yellow had been added to the pencil drawing.

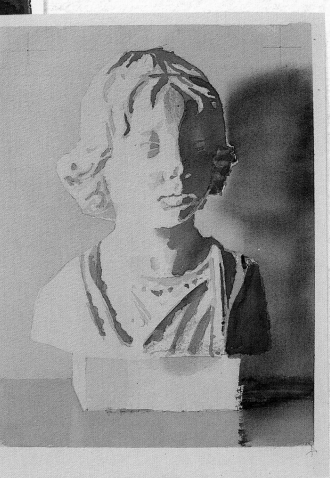

ANTHONY This painting makes good use of a range of soft and hard washes to create the illusion of a three-dimensional sculptural form.

It is clear that a considerable amount of premeditation on the part of the artist has been necessary to establish how best to employ washes with economy while at the same time suggesting modeling and graduation of tone from light to shadow. Again, it is perhaps too blue — and the white surface of the paper might have been used to better advantage.

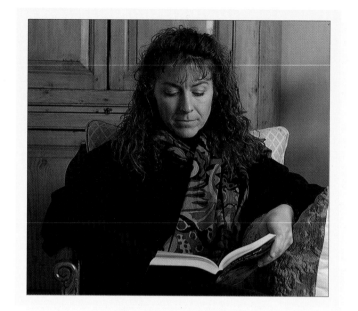

Portrait

GIRL READING

The experience gained from the first project can now be used to advantage in painting a portrait. Watercolor is a most suitable medium for portrait painting, since the best portraits are usually those which employ a few colors and closely related tones – paintings by Rembrandt (1606-69), for instance, are almost entirely monochromatic, relying as they do on dramatic tonal contrast. Bright primary colors tend to distract and dilute the tonal unity that necessarily directs our attention toward the expression of the person portrayed.

To talk of producing a "likeness" of someone refers not just to external appearances but also to the way that the particular expression and demeanor of the sitter can hint at character and personality. A good portrait must be more than mere imitative photorealism – it should, by sheer force of statement, uncover the emotional state of the sitter. In this respect, a rapidly executed drawing or watercolor can sometimes be far more revealing than a prolonged study in oil painting.

Most people when sitting for a portrait will present a particular stance or gesture that betrays an aspect of their personality. The eyes, ears, nose and mouth are the primary organs of the senses and often provide a key to intrinsic character. The process of selection is all important – one needs to ask oneself, "what are the essential features that are unique to the person who is sitting before me and how can I best express those qualities, in terms of the medium I am using?"

Before starting a portrait, therefore, one should consider different viewpoints – profile, full-face or three-quarter. Is the subject best seen from a high or low vantage point? Should one stand two or six yards distant? Consider also the lighting and try to keep the background simple and free from extraneous detail.

Artist ▪ Ian Potts

YELLOW OCHER RAW UMBER VANDYKE BROWN COBALT BLUE ALIZARIN CRIMSON

181

① *Having first dampened the paper, the lightest tones of the painting are laid with tissue, wet-in-wet. When dry, the main form of the figure is blocked in with a wash of Cobalt Blue, which contrasts with the warmer tones of the background.*

Painting onto damp paper allows the features of the portrait to remain in soft focus.

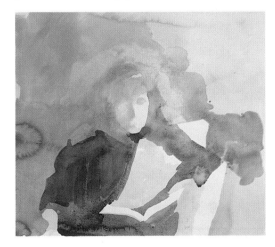

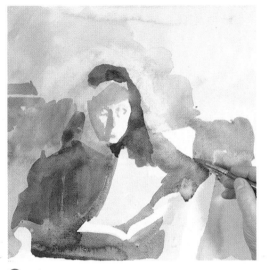

② *The darker tones of the hair are added with a wash mixed from Cobalt Blue and Vandyke Brown – producing a near black. The flesh tone is also heightened with a wash containing traces of Yellow Ocher and Raw Umber – the same color that is overlaid in the background.*

③ *Using a No. 6 sable brush, details such as the pattern on the scarf are established. Other details are tentatively suggested with a few strokes of the brush – avoiding overstatement.*

④ *(Detail) Notice how the edge of the face is defined by a single wash of color.*

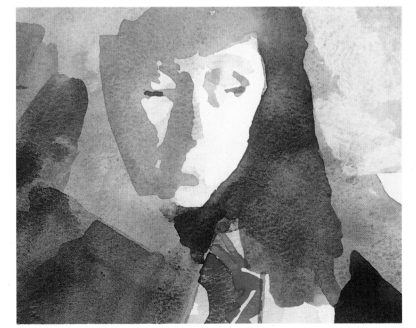

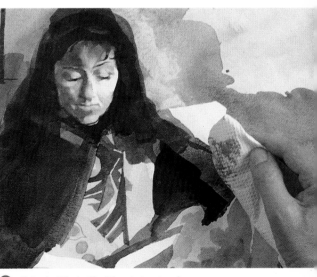

⑤ *Color is lifted off with a paper towel.*

Artist • Anthony Colbert

2 *An underpainting is established using washes of Burnt Sienna, Cadmium Red and Burnt Umber in varying strengths.*

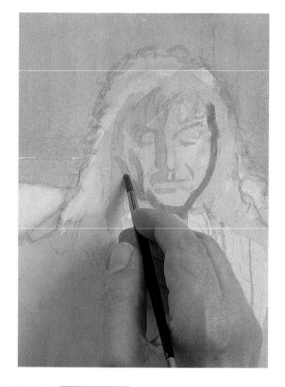

1 *A light wash mixed from Yellow Ocher and Cadmium Red is laid over the whole area and allowed to dry. The main features of the portrait are lightly penciled in.*

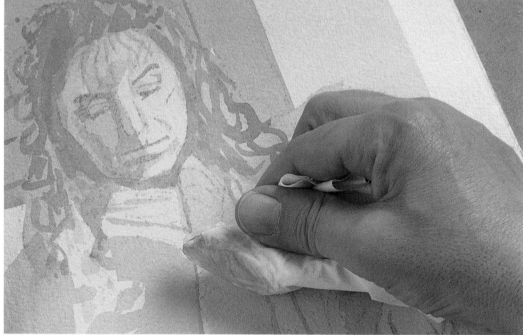

3 *Some highlights are lifted out and other washes darkened to provide tonal balance.*

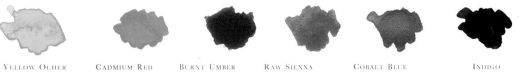

YELLOW OCHER CADMIUM RED BURNT UMBER RAW SIENNA COBALT BLUE INDIGO

4 *The bright primary colors of the scarf are painted in.*

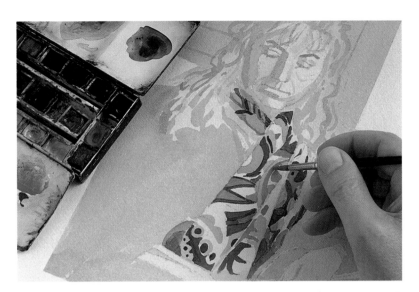

5 *The hair and details on the face and hands are painted with Burnt Sienna. The same color is used for the details of paneling behind the figure. A strong wash of Indigo is applied to the coat and scarf.*

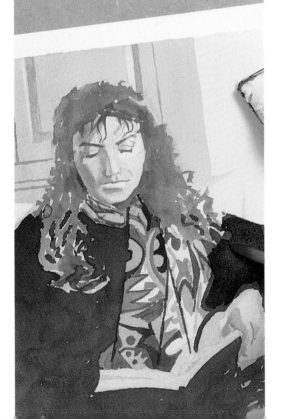

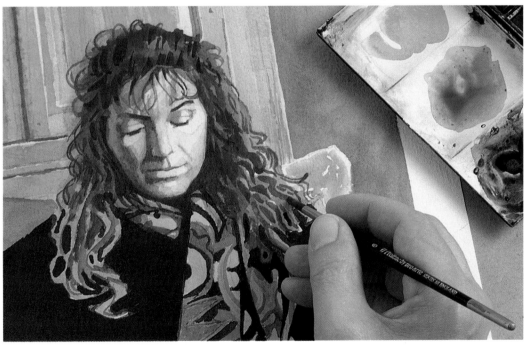

6 *Using a No. 4 sable, fine details are added – the face is modeled with darker browns and flesh tints made from Yellow Ocher warmed with Cadmium Red. Cast shadows are produced with a mix of Burnt Umber and Indigo. In the hair, the light areas are painted with Burnt Sienna, the darker tones with Burnt Umber.*

A second wash is added to the coat and the wall is painted green to complement the warmer colors in the rest of the painting.

Artist • Deborah Jameson

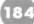

1 *Having selected a profile view of the model, a preliminary drawing registers the main features of the pose.*

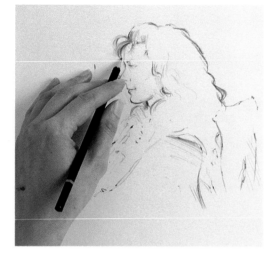

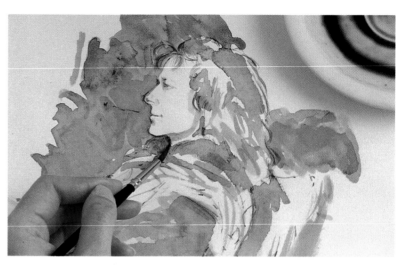

2 *A wash of Payne's Gray follows the contours of the profile and works well as an underpainting for the washes to follow.*

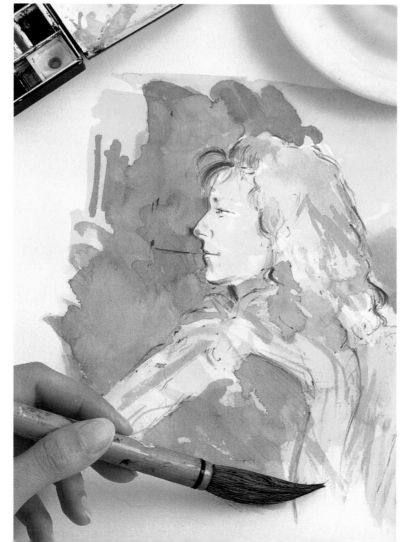

3 *Using a broader Chinese brush, a wash of Naples Yellow neutralizes the Payne's Gray and provides the first flesh tint.*

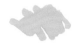

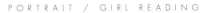

NAPLES YELLOW PAYNE'S GRAY VANDYKE BROWN ALIZARIN CRIMSON BURNT SIENNA

4 *The main features are delineated with a No. 3 sable brush loaded with Burnt Sienna. The details of the scarf and chair are picked up.*

5 *The fine detail of the portrait is rendered with a fine sable brush loaded with Vandyke Brown applied almost dry. The color is heightened generally by delicate tints overlaid on the existing painting.*

185

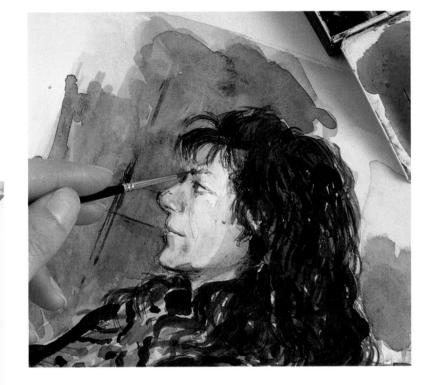

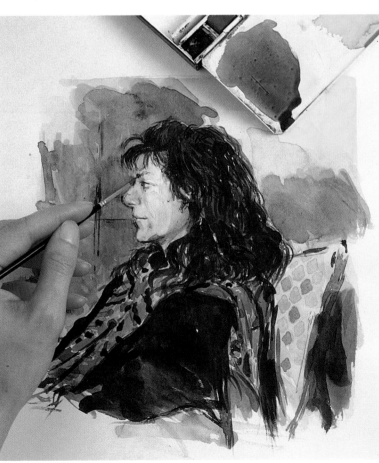

6 *The drawing is refined with a fine sable brush.*

Portrait • *Critique*

186

The artist should have given more consideration to the viewpoint before starting work.

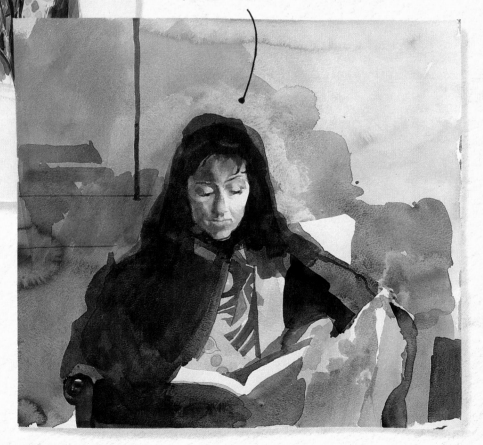

DEBORAH The artist has chosen a profile view of the model and this can be quite difficult to deal with in terms of the medium, since one must try to avoid creating an image that is too flat. The composition of this study is too symmetrical – it would have been better to include more of the foreground.

The delicacy of washes used on the features of the head are sensitive to the subject and work well on a hot-pressed paper.

The quality of light in the early stages has been lost to some extent

IAN In the early stages of this painting, we saw how the artist was concerned with basic abstract interlocking shapes of color. It is well composed – notice, for instance, how a single vertical stroke of Burnt Umber on the left-hand side serves to balance the loosely ranged washes on the right. There is also an interesting interplay between hard-edged and soft washes of color.

The quality of light in the early stages has to some extent been lost – though not to any great detriment to the painting as a whole.

187

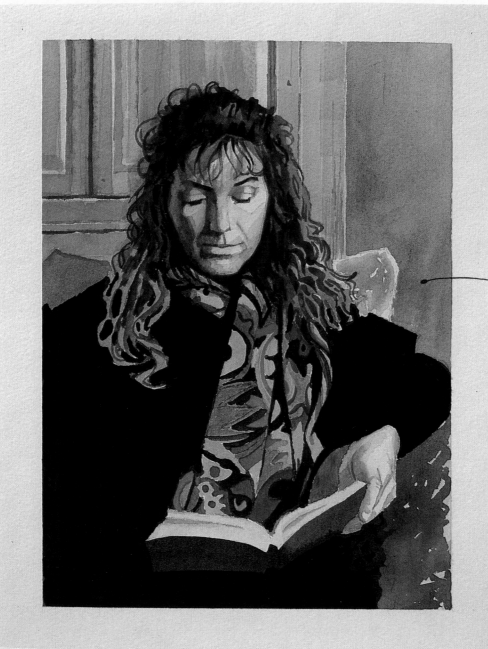

This painting has been overworked in the final stage

ANTHONY. This version of the portrait began as a monochromatic study in warm tints of Chrome and Ocher. It worked well in my view, in the penultimate stage – before the heavier tones were added to provide more definition. It is in the nature of watercolor painting that there are gains and losses at each stage. One might argue, for instance, that the addition of a darker tone to the coat enriches the color of the scarf and the introduction of a green wash in the background complements the warmth of the wood paneling.

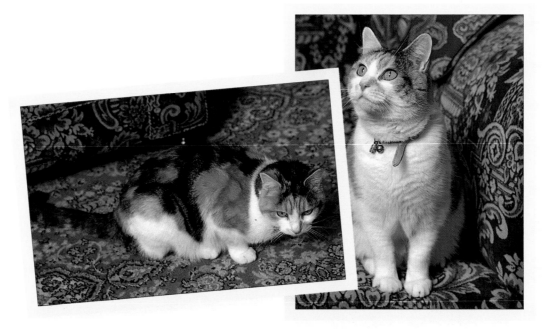

Animal Study

"FLORENCE"

Domestic animals have always been a source of interest to artists. The Egyptians, especially, produced magnificent murals depicting many varieties of birdlife.

Watercolor was used by Albrecht Dürer to make animal studies – who can forget his wonderfully controlled watercolor painting of a hare, painted in 1502. My favorite paintings of cats are the watercolors produced by Gwen John (1876-1939) and, more recently, by the Scottish painter Elizabeth Blackadder.

Cats are vain creatures and they love to pose – but unfortunately not always at the exact time you want to paint them! There are essentially two ways of dealing with their unpredictable behavior – either you can take into account that the cat is likely to move every few seconds and produce a kind of collage of rapid studies noting the movement itself or, alternatively, you can wait until they are more docile or asleep!

The cat we used in this project was quite indifferent to our attention but nevertheless tolerated our presence. Remember, even when you are painting an animal that is perfectly still, you should nevertheless try to paint it in such a way that suggests it is capable of movement.

Artist • Ian Potts

YELLOW OCHER

PAYNES'S GRAY

VIRIDIAN

VANDYKE BROWN

BURNT SIENNA

1 *The paper is dampened and a succession of warm and cool washes are laid roughly following the form of the cat. The artist exercises control over each stage by laying the color with tissue, allowing some areas to dry and blotting off other areas where the color is too heavy. This process continues until the right tonal balance is achieved.*

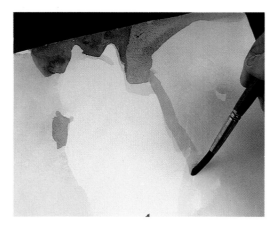

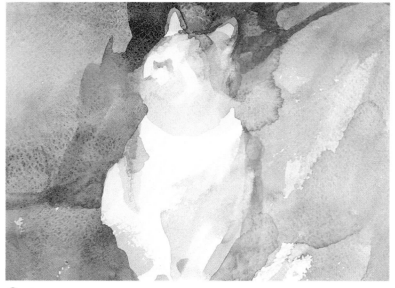

2 *A No. 8 sable brush is loaded with a wash mixed from Vandyke Brown and Viridian – this lends more definition to the contour of the cat, and begins to suggest modeling of the form.*

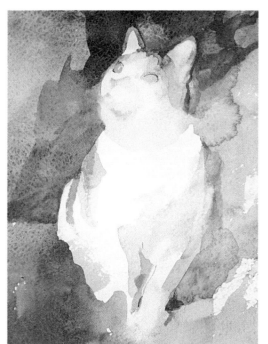

3 *Greater definition is given to the head of the cat using a finer sable brush.*

4 *The final detail – the characteristic white whiskers are added using white body color sparingly on a No. 1 sable brush.*

Artist • Anthony Colbert

190

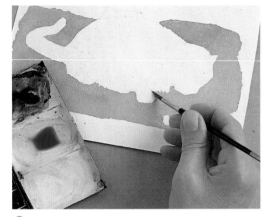

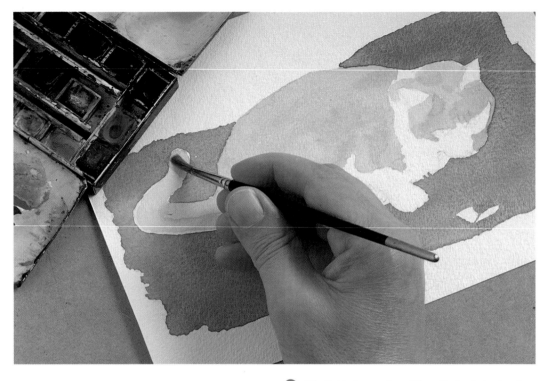

❶ *A heavily textured 300 gsm / 140 lb Bockingford CP paper was used. The whites are masked out and a rich mix of Cadmium red with a touch of Ultramarine is used to isolate the form of the cat and provide a base color for the carpet.*

❷ *The light ginger color of the cat's fur is produced with a wash of Yellow Ocher and Burnt Sienna.*

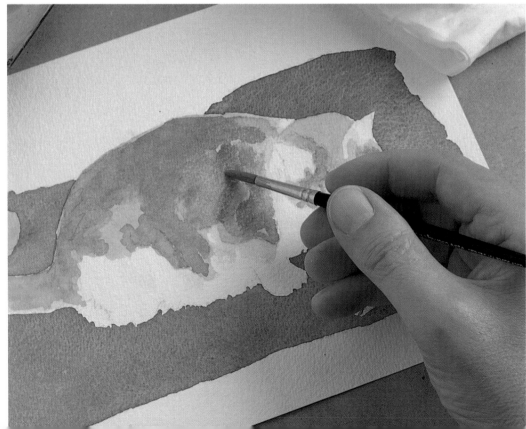

❸ *The surface of the paper is dampened and darker ginger markings of the fur painted with Burnt Sienna.*

YELLOW OCHER

CADMIUM RED

BURNT SIENNA

PAYNE'S GRAY

FRENCH ULTRAMARINE BLUE

4 *Even darker markings are produced with a wash of Payne's Gray. Soft edges are diffused with a damp brush.*

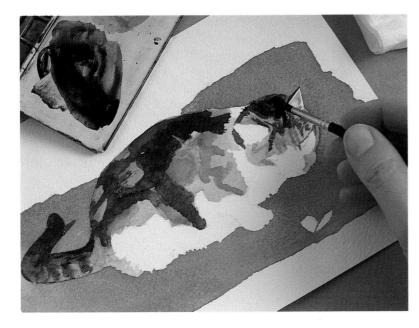

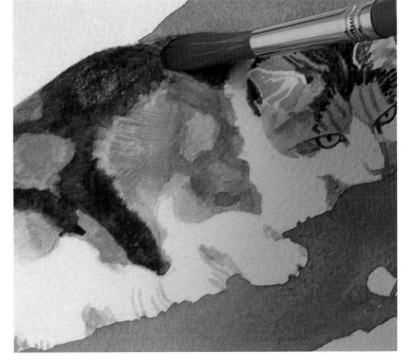

5 *With a dry No. 10 bristle brush, fur markings are added with a dry mix of Burnt Sienna and Yellow Ocher. The edges of the fur are softened with a clean, damp brush.*

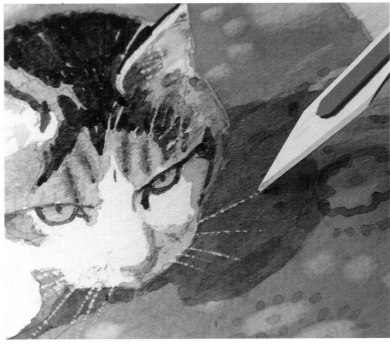

6 *The decoration on the carpet is lifted out with a damp bristle brush and allowed to dry. Pale blue carpet decoration and cast shadows are added. Finally, the cat's whiskers are scratched out with a scalpel blade.*

Artist • Deborah Jameson

192

1 *A rapid sketch is made directly onto a Saunders rough paper using a 3B pencil. A few washes of blue-black help to establish the form of the cat.*

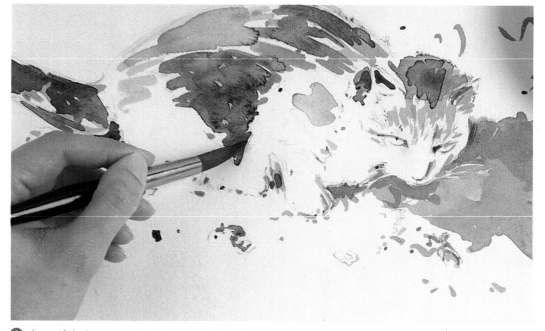

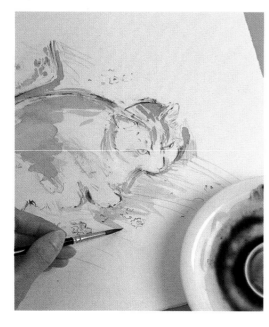

2 *Areas of shadow are rendered with further layered washes of the same blue-black.*

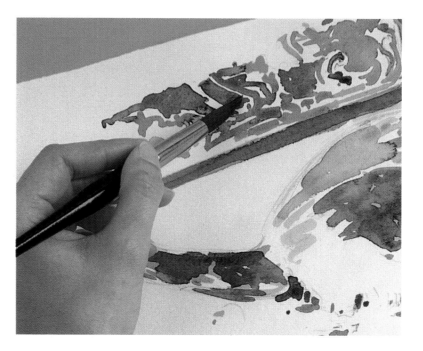

3 *Blue-black is also used to pick out the detail of the chair cover.*

YELLOW OCHER INDIAN RED CADMIUM RED PAYNE'S GRAY INDIGO

193

4 *The red pattern of the carpet is introduced with a wash of Cadmium Red and Indian Red mixed in equal proportions.*

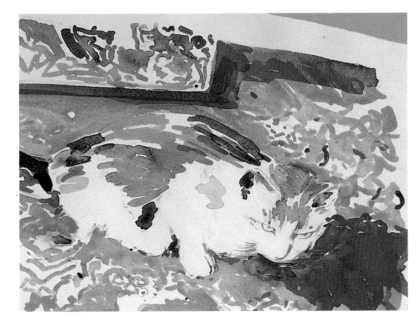

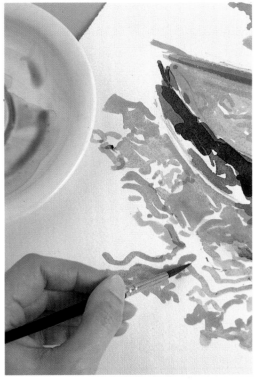

5 *The detail shows how the pattern of the carpet is hinted at with a few deft strokes of color.*

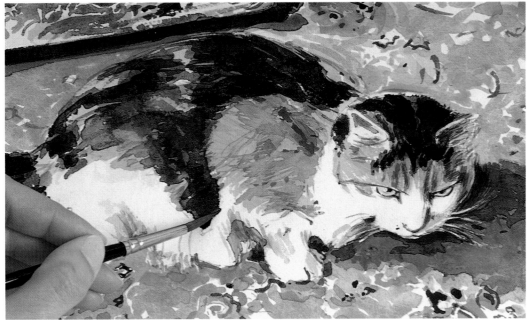

6 *The tonal balance is adjusted by further washes. Dry brushwork produces details such as the animal's fur and picks up here and there the intricacy of the patterned carpet and chair.*

Each layer of color is allowed to dry thoroughly between each stage.

Animal Study · *Critique*

194

DEBORAH This is a fairly lucid handling of the subject, with all the elements gelling together quite well. The artist has managed to render detail without allowing the image to become stilted – the animal looks capable of movement, rather than being just a slavish Natural History illustration.

The animal is not too stilted – it looks capable of movement

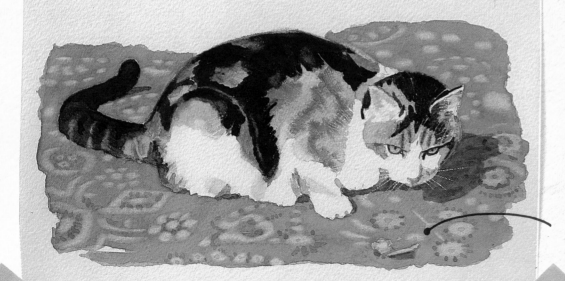

ANTHONY This study is distinguished by the richness of the washes used. The textural qualities of the cat's fur have been handled well in terms of the medium used – a combination of wet-in-wet, broad dry brushwork and fine detail.

In the final stage of the painting, the added pattern of the carpet tends to distract a bit too much from the main form of the cat. That could have been handled in a more selective way, or perhaps by making the tone of the carpet slightly darker.

Tone of carpet could be slightly darker

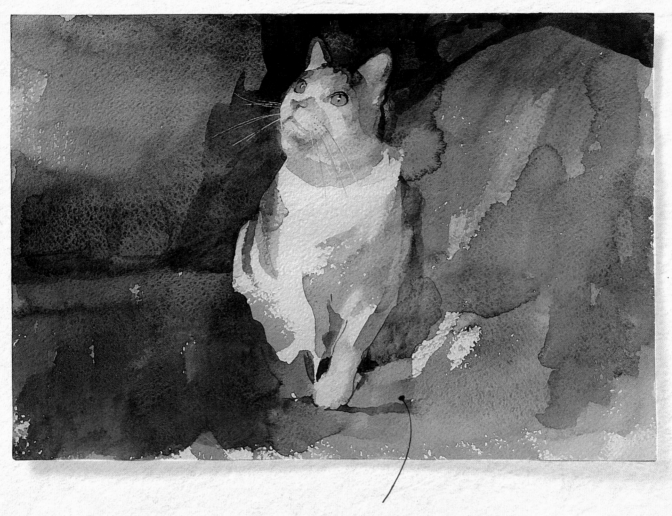

The main form has been lost to some extent

IAN A considerable amount of risk-taking has been involved in producing this painting – the artist's technique of applying and lifting off washes in successive strokes demands concentration on maintaining a balance between lost and found shapes and a predetermined knowledge of the effect that one wash will have when laid over another. There have been some gains and losses in this painting – in the early stages it worked quite well in an overall way. In the final stage, however, the head of the cat is quite convincing, but the main form of the rest of the animal seems to have been lost.

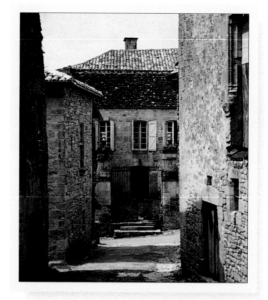

Townscape

RURAL FRANCE

An air of indolence pervades these backstreets of a small town in the Lot region of southwest France. The buildings are all built from locally quarried stone, which seems to generate the heat of a hundred summers or more. And it is the time of day when most inhabitants are to be found in cool, shuttered rooms, and only watercolorists and sleeping dogs are out in the streets! The very lack of human presence stirs the interest; as our field of vision narrows, we begin to focus on details such as doors and windows, and the lure of the unsuspected makes us want to walk around corners and explore alleyways. The iron gate, slightly ajar, beckons us towards the darker recesses of the house in front of us.

Ancient towns and villages rarely conformed to a grid-like plan, but rather grew together as a random sequence of spaces and enclosures. The problem for the artist confronted by such a scene is somehow to convey the sense of place by bringing together textures, juxtaposed planes, color and contrast, and by exploring the character and individuality of each building. The honeyed hues of the stone can be contrasted with cooler areas of shadow. Everything needs to be broken down into simple planes of light and shadow, and the verticals of the building linked and joined by horizontal paths of light and shade. Details need to be registered selectively – the texture of a wall hinted at, perhaps, or the particular shape of a window described precisely. Where houses are grouped closely together, it may be difficult to find a suitable vantage point, but it is always worthwhile to view the subject from different levels and distances before settling down to paint.

Artist • Ian Potts

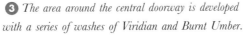

INDIAN RED RAW UMBER BURNT UMBER VANDYKE BROWN VIRIDIAN INDIGO PAYNE'S GRAY

1 *Using a swab of moist tissue, a wash of Indian Red is laid over the whole area of the paper with the exception of the sky and a patch of light in the middle distance.*

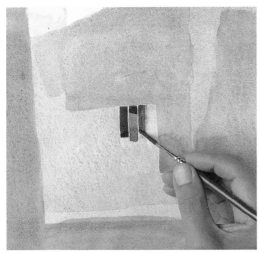

2 *Further washes of Indian Red added to the central building and to the wall on the right. A wash mixed from Raw Umber and Viridian is brushed broadly over the building on the extreme left, and to shadow in the foreground. A few slats of Payne's Gray are overlaid on the doorway of the central building.*

3 *The area around the central doorway is developed with a series of washes of Viridian and Burnt Umber.*

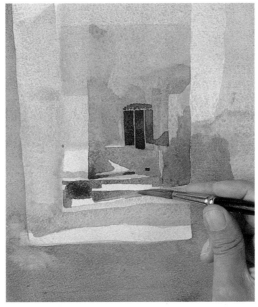

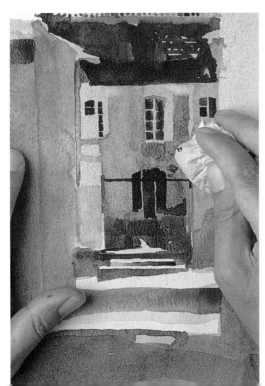

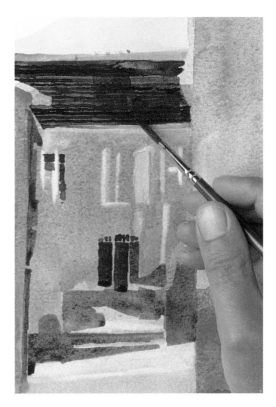

4 *The shapes of the window frames and shutters are lifted out of the first wash using a wet Q-Tip. Darker washes of Indigo are added to the roof using a No.6 sable brush.*

5 *Further washes are added and immediately softened with a wet tissue. Details such as the gate are suggested as well as the darker recesses of window.*

Artist • Anthony Colbert

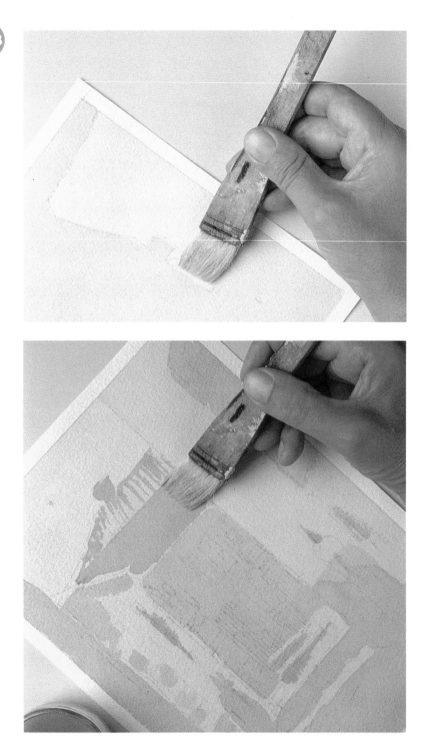

❶ *An overall wash, mixed from varying proportions of red and blue, with a touch of Naples Yellow and Raw Sienna is laid using a Hake brush. When dry, the windows and shutters are masked out, and the wash is repeated except in the area of the sky.*

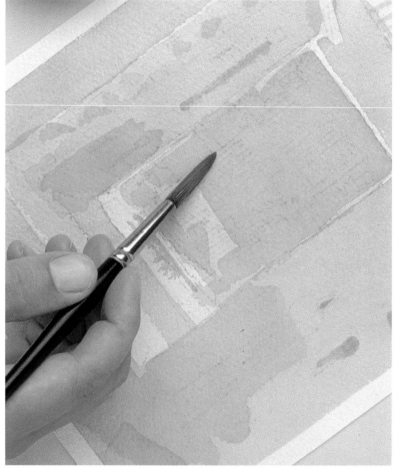

❸ *A warmer wash, mixed from Naples Yellow and Raw Sienna with a touch of red, is laid on areas of walls in sunlight.*

❷ *The same wash is strengthened in the areas of shadow and on parts of the building structure.*

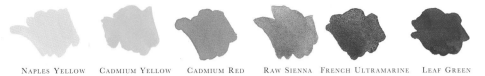

NAPLES YELLOW CADMIUM YELLOW CADMIUM RED RAW SIENNA FRENCH ULTRAMARINE LEAF GREEN

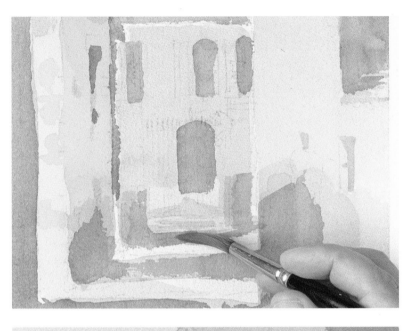

4 *The original wash is again strengthened to indicate dark shadows and shaded areas. Suggestions of windows and steps are blocked in. A Cadmium Red wash is overlaid on the second wall on the left and the same wash stippled on roof tiles.*

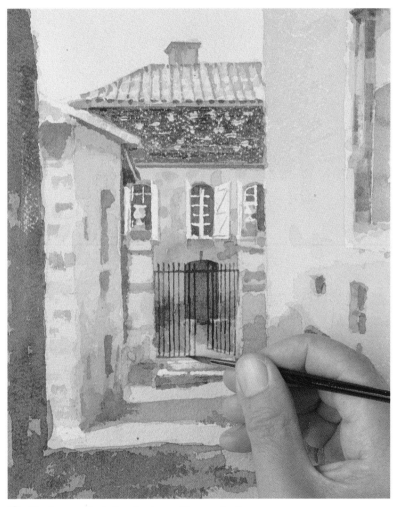

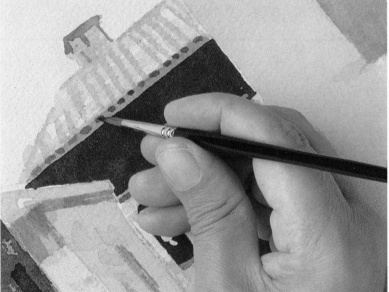

5 *Using a 1-inch Dalon brush, windows are darkened, as is the main entrance to the central building. Masking fluid is removed at this stage from windows and shutters. A No.4 sable brush is used to dot in shaded ends of pantiles.*

6 *The forecourt is darkened using a dilute wash of the original applied color with a Hake brush in a one-stroke action, so that the pigment settles downwards. Details such as railings are added, as well as greenery. A texture is scraped on the roof tiles with a flat blade.*

Artist • Deborah Jameson

200

1 *The main divisions of the composition are tentatively registered with a soft pencil. A pale wash of French Ultramarine with a touch of Carmine Red is laid over the sky and in recesses of the buildings.*

2 *A warmer pale wash mixed from Sahara Yellow and Naples Yellow is laid over most of the surface area except the sky, windows and shutters, and patches of light between buildings. A 2-inch Hake brush is used to produce an even tone.*

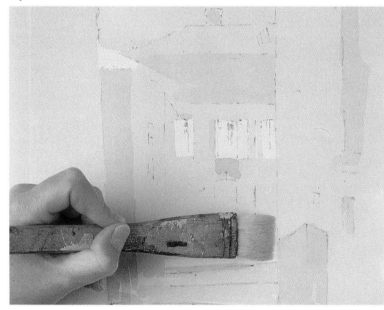

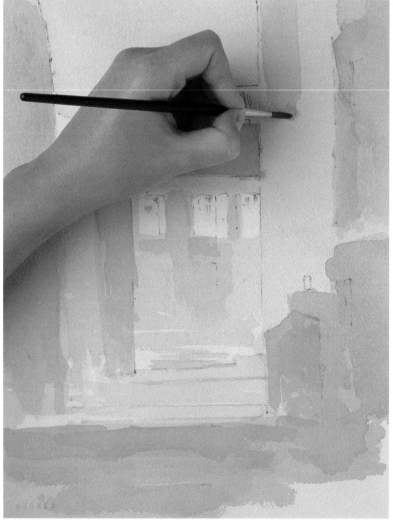

3 *The warmer hues of the stone walls are suggested with washes of Gamboge Yellow and Chrome Yellow using a No.5 sable brush.*

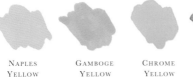

| NAPLES YELLOW | GAMBOGE YELLOW | CHROME YELLOW | YELLOW OCHER | CARMINE RED | ULTRAMARINE | VIRIDIAN | AUBERGINE |

4 *Areas of shadow are strengthened with a wash mixed from Aubergine, Lamp Black, and mauve.*

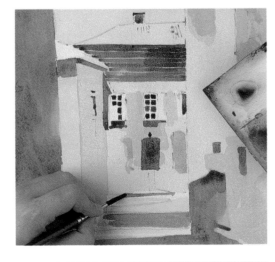

6 *Greater contrast is created by adding a dark wash mixed from Terre Verte, Lamp Black, and Viridian. This is added to the wall on the left, areas of shadow on paths, and in recesses of door and windows. Texture is added to walls using a stippling technique. Details such as the iron gate are picked out using a fine No.1 sable brush.*

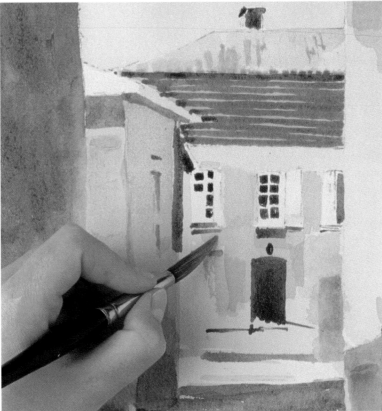

5 *The warm tones of the stone walls are enriched with a wash of Yellow Ocher using No.8 sable brush.*

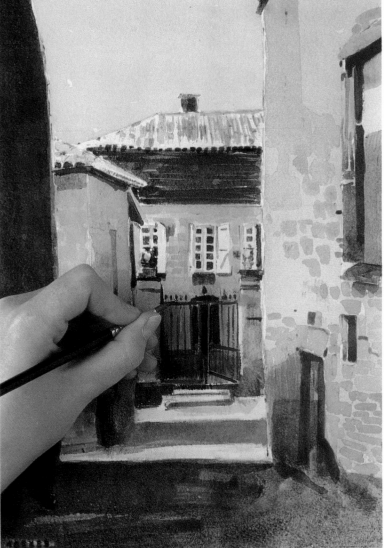

Townscape • *Critique*

Fine detail handled well

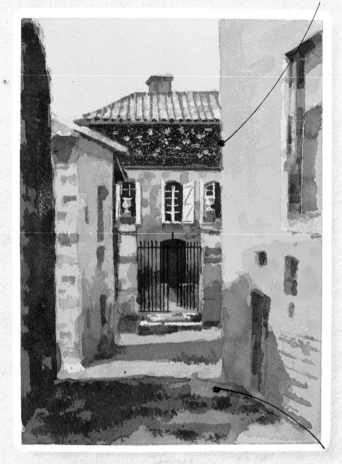

DEBORAH The contrast between light and shadow, cool and warm hues work well in this painting. Compositionally, however, it is perhaps too symmetrical. This might have been resolved by the artist standing further back or moving to the extreme left or right alleyway. The washes have tended to become too opaque in certain areas, such as the façade of the central building.

Washes are too opaque

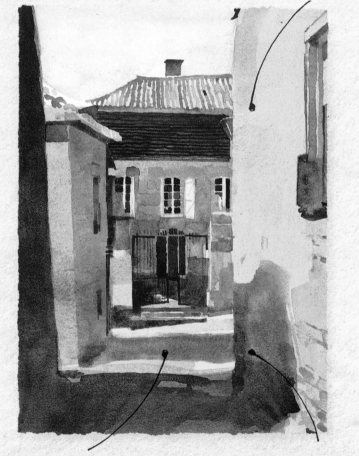

ANTHONY The artist has obviously decided to use colors in a "high key" to evoke the brilliance of the day. The interaction between broadly-stated washes and selected fine detail is handled well, as is the treatment of surfaces in terms of texture, such as the roof pantiles and the irregular stonework of the buildings.

Tonally, the work is rather too even; some might feel that more contrast could have been created by intensifying shadows, particularly in the foreground.

Needs more contrast

Contrasts work well

Composition is too symmetrical

worked better at
earlier stage

color of stone
too red

washes are
well handled

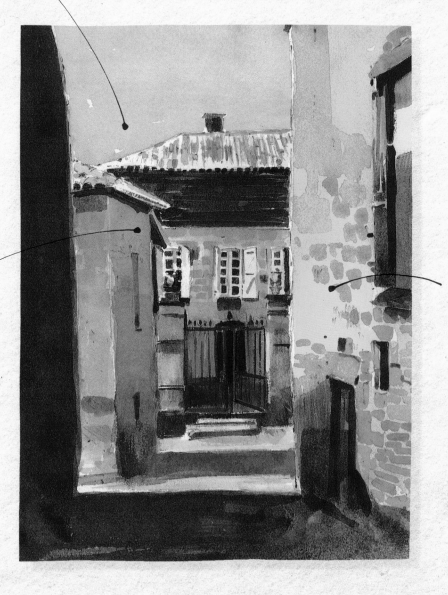

IAN The broad treatment of washes is handled confidently and convincingly in terms of the subject. The artist has, in my view, struck the right balance between planar relationships and selected descriptive detail.

The color of the stone is perhaps too red and tones too even. My own feeling is that everything worked better earlier. Of course, it is easy to say this with hindsight, but difficult to recapture the freshness of a painting in its earlier stages.

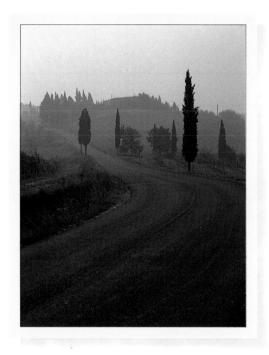

Change of Scene

ITALIAN LANDSCAPE

The traveling artist needs to take account of the fact that, in the process of searching for a suitable subject, he or she is likely to have to do a lot of walking and climbing to different levels. A certain amount of preparation beforehand can therefore help to ease the burden of carrying around too much cumbersome equipment. Everything needs to be kept to a minimum – a lightweight shoulderbag might contain a box of watercolors, pencils and brushes (in a protective tube), plastic waterpots (2), waterbottles, paper towels and a spiral-bound sketchbook or a variety of water-color papers clipped to a supporting sheet of hardboard. Protective clothing is also necessary especially if you find it difficult to judge the weather pattern in another country. It is one thing to be walking around for a subject to paint but, having found it, you might be sitting still for two or three hours at a time. Climate has a bearing on everything and, in my experience, it is rare to find conditions that are perfect for painting. It may be too hot,

too cold, windy or wet and, having found your subject, you may have chosen the wrong time of day. In mountainous regions such as Switzerland, for instance, one side of the valley might be in shadow for most of the day.

The subject selected for this project is the gentle, undulating countryside of Tuscany in central Italy. It is a scene that represents the classical ideal in landscape painting and one that is relatively unchanged since the time of Simone Martini (c.1285–1344) and Piero della Francesca (c.1410/20–92). Cypress trees provide dark sentinels that punctuate the predominantly horizontal forms of this wine-growing area. The artists worked early in the morning, at that time of day when the mist has cleared and the sun has not yet risen above the hills. The whole scene is invested with a sense of mystery as buildings and distant forms are not clearly defined. The narrow road leads the eye from the foreground toward barely perceived farm buildings on a distant hill.

Artist ▪ Ian Potts

NAPLES YELLOW BURNT SIENNA ALIZARIN CRIMSON VANDYKE BROWN HOOKER'S GREEN COBALT FRENCH ULTRAMARINE BLUE

205

❶ *A Bockingford spiral-bound sketchbook has been used vertically rather than horizontally to make the composition more interesting.*

A much-diluted warm ocher-brown wash has been laid over the whole page with tissue and allowed to dry. Further colors have been applied wet-in-wet and merging from blue-gray on the horizon to purple-gray in the foreground. Details on the horizon have been added using a much finer sable brush.

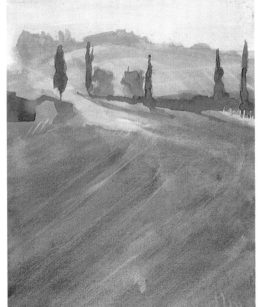

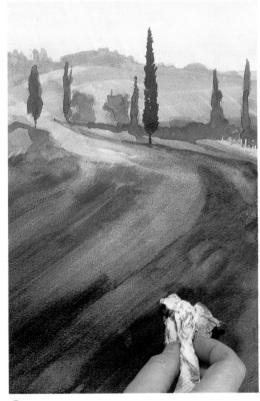

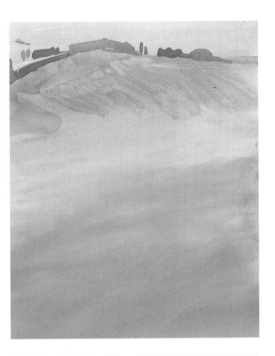

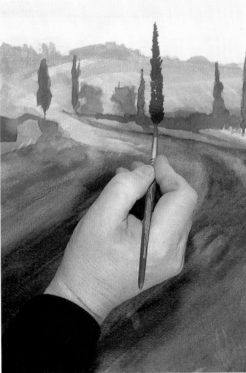

❸ *Tonal contrasts are further heightened with richer washes of the previous colors used. Color is applied with tissue to broader areas, such as the road surface, and with a No. 8 sable brush for more sharply defined forms such as trees, grass and shadows. The painting has now more depth tonally.*

❷ *Tonal contrasts are now firmly established – a line of cypress trees in the middle-distance is painted in as the strongest tone with a mix of green-brown. Colors in the foreground are intensified by a sequence of layered washes – mauve-gray made from Alizarin Crimson, Ultramarine and a touch of Burnt Sienna. A blue-green wash made from Cerulean Blue and Hooker's Green is overlaid on the grass verges.*

❹ *The darkest tone of the painting – a near black – is mixed from Alizarin Crimson, Vandyke Brown and Ultramarine. This is painted over the cypress trees in the middle-distance and on the road surface in the foreground. Those parts of the color that appear too heavy tonally are blotted off again while the color is still wet.*

Artist • Anthony Colbert

❶ *A base wash of Alizarin Crimson mixed with Raw Sienna covers the whole area. When dry, a second wash of the same mix follows the contours on the horizon and continues covering the middle-distance and foreground.*

❷ *A very pale wash of Prussian Blue helps to intensify the tone of the hills, buildings and trees.*

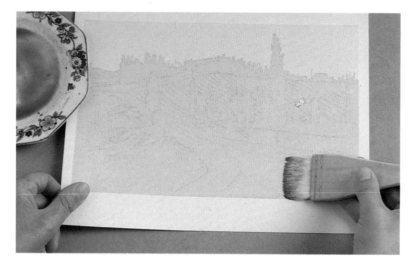

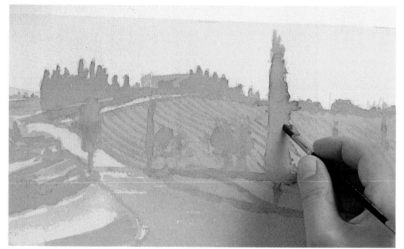

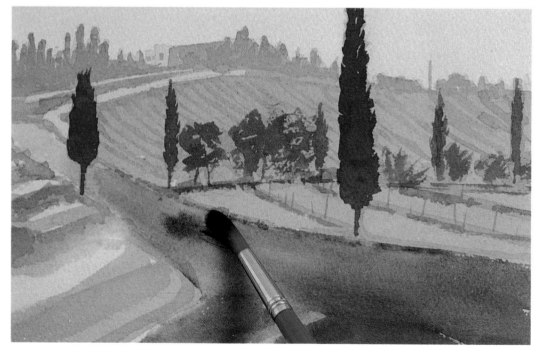

❸ *A stronger wash of Indigo with Yellow Ocher and Burnt Sienna is laid on trees and establishes shadows and furrows in the fields.*

The paper is dampened and the track and verges are picked out with a wash of Indigo and Cobalt Blue. The same wash fades into the foreground of the road.

 NAPLES YELLOW YELLOW OCHER BURNT SIENNA BURNT UMBER INDIGO ALIZARIN CRIMSON PRUSSIAN BLACK

4 *The color around the verge is lifted and softened to take a wash of Burnt Sienna. Trees in the middle-distance are made darker. Flowers and stones in the foreground are masked out.*

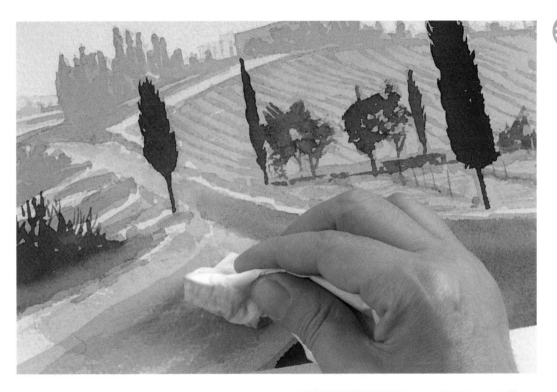

5 *The dark cypress tree is brought up to full strength. Damp and dry brushstrokes are used in the foreground along the verge. Masking fluid is removed and flowers and stones painted in with Naples Yellow, Burnt Umber and Burnt Sienna.*

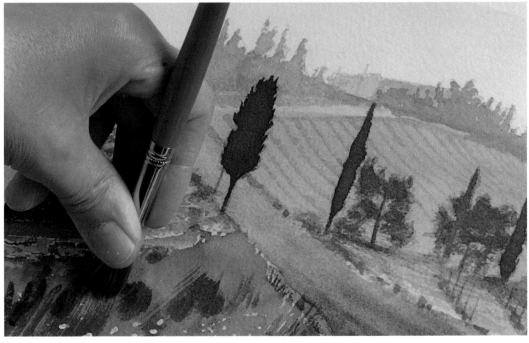

6 *This detail shows how the bristles of a Prolene 20 brush are flayed between finger and thumb to drag color across scrubland.*

Artist • Deborah Jameson

208

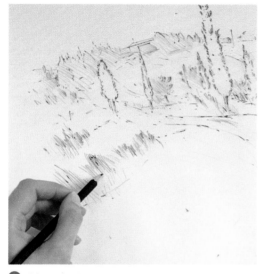

❶ *The main forms of the landscape are drawn with a soft pencil on a hot-pressed sheet of watercolor paper.*

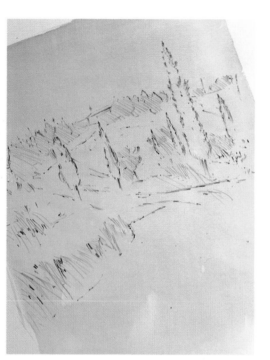

❷ *A warm wash mixed from Cadmium Orange and Naples Yellow is brushed over the whole area of the composition with a large Chinese brush.*

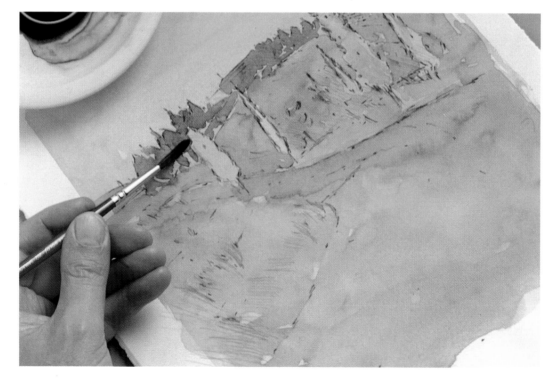

❸ *A wash of Payne's Gray is applied at this stage to produce an even tone that is without contrast.*

NAPLES YELLOW

BURNT SIENNA

PAYNE'S GRAY

CADMIUM ORANGE

FRENCH
ULTRAMARINE BLUE

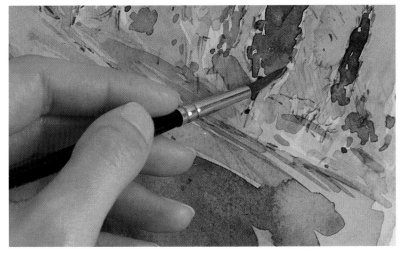

4 *The landscape forms are heightened with a wash mixed from Burnt Sienna and Naples Yellow. A green-brown wash is also applied to the cypress trees in the middle-distance.*

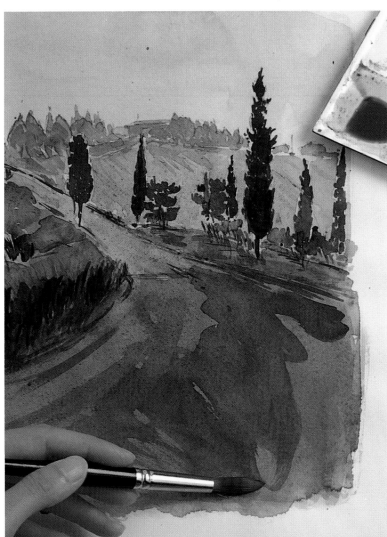

5 *A rich, olive-colored wash is made from Payne's Gray, Yellow Ocher and Prussian Blue. This is used fairly solidly on the trees and as a wash on the landscape.*

A Change of Scene • *Critique*

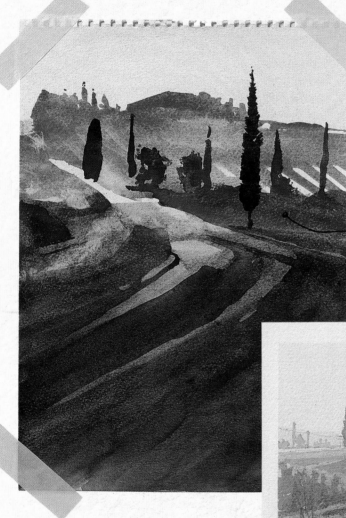

IAN The early stages of this painting revealed exquisite qualities of light – the radiance of which has been lost to some extent in the final painting.

One has the feeling that the artist felt constrained by the size of the paper on which he was working – his technique of laying on color in broad washes might perhaps have worked better on a larger format.

In purely abstract terms, this painting works very well – it is a bit like looking at a detail from a larger painting.

Radiance of light in early stages has been lost

Good feeling for light

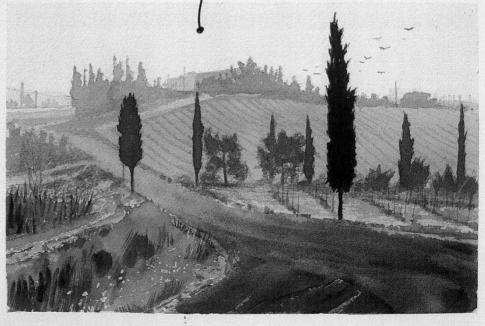

ANTHONY This painting demonstrates a mature handling of the medium – the quality of diffused sunlight is particularly effective. One has the impression of a heat-haze in the distance – dust-laden, rather than dull and misty.

It is also a well-composed painting in which the cypress trees seem to punctuate the landscape at intervals that are critical to the visual balance of the painting.

Good composition

Good tonal control

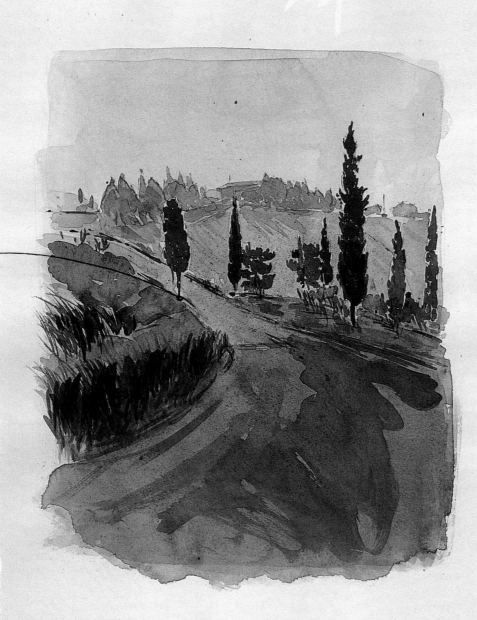

There could
have been
more
graduated
tones

DEBORAH This painting also conveys a feeling of diffused sunlight, although the brushwork is more loosely handled.

The choice of a few washes that are closely related in tone and color works to advantage for this subject. There could have been even more graduation of tone from light to dark and from sky to foreground.

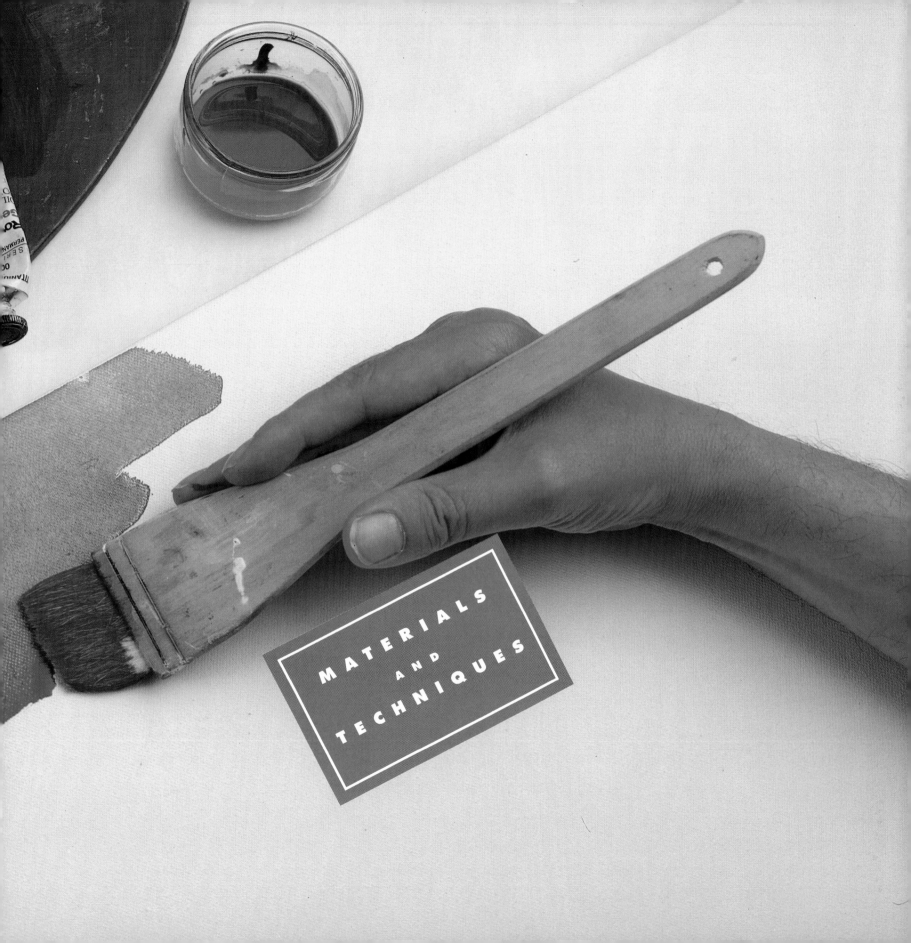

MATERIALS
AND
TECHNIQUES

Canvas and Other Supports

A support is the name given to the various supporting surfaces on which all oil paintings are carried out. The primary function of a support is to provide a stable and solid surface that will readily receive whatever technique or medium you intend using. Wood panels, stretched canvas, hardboard (Masonite), canvas board, compressed fiberboard, cardboard, and metal are all supports.

When considering which type of support would be most suitable for your own purposes, focus on factors such as weight, size and cost, as well as surface qualities of different kinds of materials.

WOOD PANELS

Historically these are the oldest type of supports, although they were largely replaced by stretched canvas during the Renaissance. Many varieties of wood are suitable; however, hard woods such as mahogany are more stable than softer woods, which are liable to warp.

All wood panels should be cut from well-seasoned wood and be free from cracks or knots. Thin panels can be given additional strength by screwing battens to the reverse side. If well-seasoned wood is difficult to obtain, you could salvage old furniture, particularly door panels.

The weight of a large wooden panel could prove to be a problem for the landscape painter, although small panels are eminently suitable for painting directly from nature.

HARDBOARD

Hardboard (or Masonite) is mid-brown or dark brown in color and is made from wood-pulp compressed into thin sheets. This type of board is perhaps the most widely used support for oil painting, because it is inexpensive, lightweight, and strong. Many people make the mistake of using the textured side of the board, probably because it is akin to the texture of canvas. The somewhat

Supports for oil painting include, from top to bottom, stretched linen canvas, canvas board, cardboard, hardboard, and sanded plywood.

mechanical "tooth" is very pronounced, however, and will dominate the painting unless a thick impasto is applied. The smooth side is preferable, but should be sanded slightly to make the surface more receptive to primer.

PAPER AND CARDBOARD

Rembrandt van Rijn, Eugène Delacroix and Paul Cézanne all occasionally used paper as a support. A good-quality rough-surface watercolor paper is ideal, and can be given additional stability by being stuck down onto board. A thin coating of gesso primer painted on both sides of the paper will counteract its absorbency. One note of caution is that unsized and unprimed cardboard tends to attract fungus and mildew unless stored in dry conditions, or framed and sealed behind glass.

OIL SKETCHING PAPER

This is a commercially produced paper that comes already primed and has a canvaslike texture. It is useful for landscape and figure studies, although some people are put off by the rather mechanical texture of the surface.

CANVAS

This is the traditional support for oil painting and the one most favored by professional artists. Fine and coarse weaves of cloth offer a variety of surfaces. The characteristic "tooth" of the canvas is, when primed, particularly responsive to oil paint.

A stretched canvas is light and easy to transport and can, if necessary, be taken off the stretcher and rolled up for storage.

The finest canvas is made from linen, which has a fine weave and is less liable to shrink or stretch than other materials. Cotton canvas is more economical but is generally softer and more prone to distortion. A professionally prepared cotton canvas, however, is adequate for most purposes, and less expensive than linen.

STRETCHING A CANVAS

The drumlike tautness of canvas is achieved by stretching it over a wooden frame called a stretcher. If you are a skilled woodworker and have adequate mitering equipment, you may prefer to make your own stretchers. The mitered corners of each length must be slotted and the edges beveled so that they do not press against the stretched canvas. Ready-made stretcher pieces can be bought in standard sizes and very quickly put together.

1 *Cut the canvas with an overlap of 2 inches all around the assembled stretcher. Make sure that the stretcher is completely square, and that all the bevels are on the same side.*

2 *Tack the center of one side firmly in position with a tack hammer. You could also use a staple gun if preferred.*

3 *Stretch the canvas taut and tack the opposite side in the center. Continue working in this way from one side to the other and left and right of the center.*

4 *Fold the remaining flaps neatly over at each corner of the stretcher as shown above.*

5 *Tack down each corner. Finally, knock the wooden wedges (which are supplied with stretchers) into the gaps on each miter, two to each corner.*

Hardboard can be
primed with gesso
primer. The first coat
will normally dry in
30 minutes. A second
and third coat can be
applied after finely
sanding the surface
slightly at each stage.

Priming

As its name suggests, primer is the first coating of paint applied to the support. Besides providing a ground on which to paint, the main function of a primer is to prevent the color from sinking into the support. If, for instance, you were to paint directly onto an unprimed canvas, the oil that binds the pigment would be rapidly absorbed, leaving a residue of color that is difficult to control with a brush. Oil paint has a tendency to darken with age, but a coat of white primer will help to ensure that the tone and brilliance of the color is retained.

SIZING

Before the canvas or support is primed it should be given a coating of size. The best size is made from rabbit-skin glue, available in crystal form from artists' materials stores. The sheets of glue or crystals should be dissolved in warm water and stirred until liquid. (When cold, it should be the consistency of soft jelly.) The size is applied while still warm, and allowed to dry thoroughly before priming. To prevent the canvas from sticking to the stretcher, insert pieces of cardboard during the drying process. Some artists prefer to use the natural color of the cloth as a ground for painting and do not therefore add a coat of primer.

Hardboard and other water-resistant materials do not generally need to be sized before priming.

WHICH PRIMER?

Traditionally, the main priming pigment for oil painting is white lead, to which glue size and boiled linseed oil is added. The toxic nature of white lead, however, has proved to be a health risk. Titanium White or Zinc White are generally used now.

The introduction of ready-mixed acrylic grounds has made life easier for those artists who do not wish to spend a lot of time on preparation. Acrylic gesso dries rapidly and provides a fine, matt, white surface that is very receptive to brush marks.

If you are applying two or three coats of primer to your support, allow each coat to dry thoroughly, and sandpaper any uneven patches. Gesso primer can be given a final polish with a damp rag.

MAKING PRIMER

If you prefer to make your own primer, the following recipe might prove useful:

Mix equal quantities of chalk whiting powder and Titanium White together with five parts rabbit-skin glue and one part linseed oil. Blend the powders together on a glass slab with a palette knife, leaving a depression in the middle. Pour in half of the glue while it is still warm, then the oil, and follow with the rest of the glue. Mix to the consistency of double cream. Dilute this paste further with a little hot water and brush directly onto the canvas. This will produce a ground that is slightly porous. If desired, the surface can be sealed with a weak solution of gelatin and water, to which a touch of Titanium White has been added.

A number of alternative recipes for primers will be found in standard textbooks, such as those by Stephenson and Mayer, available in art supply stores.

LINSEED OIL

RABBITSKIN GLUE

CHALK WHITING POWDER

WINSOR & NEWTON
Artists' Oil Colour
Titanium White

644
Permanence AA
Series 1

Blanc de Titane
Titanweiss
Bianco de Titanio
Bianco di titanio

37 ml ℮
1.25 U.S.fl.oz.

Brushes and Painting Knives

I have known painters whose attachment to their brushes borders on the superstitious! There is the feeling that, if a particular brush has served one well, it would be tempting providence to replace it with another. In my experience, a brush needs to be "broken-in" by regular use before it will render exactly the marks I want to make. Sable brushes improve with age if they are cleaned properly after use.

The best brushes are still handmade and it is really a false economy to buy cheaper mass-produced brushes. Brushes used for oil painting are made from hog's hair and sable. In addition, there are an increasing number of brushes made from synthetic materials such as nylon. A good-quality brush will hold its shape when paint is applied to the canvas. The bristles should be neither too limp nor too springy but should respond sensitively to the direct action of mark-making.

Oil painting brushes have a wooden handle about 12 inches long. In terms of size of the brush head, No. 1 is the finest, and 12/14 the broadest.

Hog's hair brushes are made in three main shapes. Flat brushes have a wedge-shaped square tip. They are used mainly for blocking in large areas of color, particularly in the first stages of a painting. Round brushes taper toward the tip and are used for more linear brush strokes. The filbert shape, which actually resembles the rounded tip of a finger, is also used to apply color broadly. Sable or "soft" brushes are used primarily for finer detail. They are also manufactured as flats, rounds and filberts.

No. 11 hog's hair round brush.

Painting knives with thin flexible steel blades.

No. 10 hog's hair long flat brush.

No. 6 hog's hair short flat brush.

No. 9 hog's hair short filbert.

No. 3 hog's hair short flat brush.

No. 8 pure sable brush.

No. 10 round sable brush.

CLEANING BRUSHES

Cleaning your brushes and palette should become a ritual after each painting session. I find it particularly satisfying (even if the day's work has gone badly) to clean and prepare everything so that I can start afresh the next day.

The brushes should be first rinsed in turpentine substitute or gasoline and carefully wiped on a soft rag. Each brush is then degreased by activating the bristles in dish-washing liquid cupped in the palm of your hand. Rinse the brush thoroughly in warm water, squeeze out excess water and reshape the bristles with thumb and forefinger.

PAINTING KNIVES

These flexible knives are either flat or trowel-shaped and are also known as palette knives.

They are useful mainly for mixing and blending color on a palette or painting table. Moreover, they are particularly useful for scraping out or scraping back unwanted passages in a painting.

Although some artists use a knife as a painting instrument, my own feeling is that a knife is not as sensitive as a brush, and I do not much like the smooth slabs of paint it deposits on the canvas. Having said that, however, there are some fine passages of "knife-work" in the landscape paintings of John Constable.

Easels

It is perfectly possible to work on oil paintings without an easel; indeed, some artists prefer working in a less formal way on an old table. Nevertheless, for the professional artist or serious amateur, a studio easel is a worthwhile investment. A well-made studio easel will hold your canvas or board in a rigid position, the height can be adjusted for a standing or sitting position, and the easel can be moved to any position to catch the best light.

A studio easel is usually constructed from a rigid H-shaped vertical frame set into a base that is moved on castors. The canvas rests on a shelf, which sometimes incorporates a compartment for brushes and colors. A sliding block holds the canvas firmly in position at the top.

The canvas is moved up and down by means of an adjustable ratchet, which may also be tilted backward or forward from the vertical to give greater flexibility. Some easels adjust so that the canvas can lie horizontally for watercolor work.

RADIAL EASELS

This is the type of easel most commonly used in art schools, especially in the life-painting studio. The upright column is held by a large locking wing-nut connected to three short tripod legs. By loosening the wing-nut, the column can be tilted backwards or forward. The canvas rests on an adjustable shelf and is held at the top by a sliding block.

SKETCHING EASELS

These folding easels are made primarily for landscape painting. They combine lightness, strength and simplicity. Made either from beechwood or a lightweight metal such as aluminum, they can accommodate a canvas height of 34 inches. There is no reason why this type of easel should not also be used in the studio, provided that the spiked tripod legs are supported by blocks or an old carpet or rug.

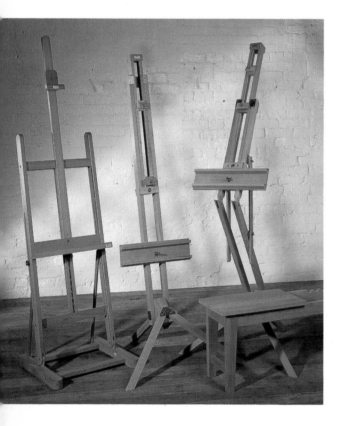

LEFT *Studio easels. The self-assembly easel (far left) has an adjustable lower shelf. The beechwood radial easel (center) tilts to provide different working positions. The tilting radial easel (right) has a central pivotal joint so the canvas can be fixed in any position.*
RIGHT *Sketching easels. The lightweight beechwood easel (right) can be tilted to any angle. A more robust version is shown in the center. Two lightweight metal folding easels (far left) with telescopic legs.*

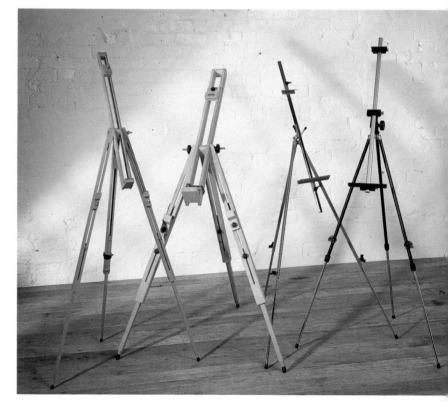

Photographs courtesy of Winsor & Newton

Palettes

The kidney-shaped wooden palette has become a kind of professional symbol for the oil painter. Strangely enough, very few painters in my experience actually use the traditional wooden palette for mixing their color — most prefer to use a glass slab or sheet of plastic on a painting table. Much depends on the kind of painting you are doing. The concentration needed for portrait painting, for instance, might be unduly disturbed by constantly having to turn away from the model to mix color on a table, whereas a palette enables the artist to have all the colors he or she is using readily at hand.

Wooden palettes are usually made from mahogany. The weight of the palette is critical, since it should be comfortable to hold for hours at a time. The oval thumb hole should be sanded so that it does not cut into the skin. Containers known as "dippers" can be clipped onto the edge of the palette for oil, turpentine, or varnish. Oblong wooden palettes will fit more readily into a painting box. White plastic palettes make it somewhat easier to judge color values, especially when working on a white canvas, but the surface is less sympathetic to work on than wood. Expendable parchment palettes, which are produced as tear-off pads of 50 sheets, are convenient since you can simply dispose of unwanted color at the end of each painting session — although you may waste quite a lot of paint that way.

This selection of palettes includes birch, plywood, throwaway vegetable parchment, traditional curved mahogany, and chinaware (for glazes).

Paint Additives

All oil paints produced in tubes contain a certain amount of linseed or poppy oil, and you need to consider this before further dilution. There are painters who prefer to use oil colors straight out of the tube, thus retaining the essential richness of the colored pigment. In practice, however, most painters discover that they need to reduce the consistency of oil paint in order to achieve full expression in the character of individual brushmarks.

There is a general rule that you should work from thin to fat, though some artists enjoy working in a thick impasto throughout.

There are mainly three ways of reducing the consistency of oil paint: with more oil, with varnish, or with an evaporative essence such as gasoline or turpentine. The most common painting medium is a mixture of distilled turpentine and linseed oil.

For those who, like myself, are allergic to turpentine, oil of spike lavender (available from artists' materials stores) is a suitable alternative – but it is slower to dry.

WHITE SPIRIT

Sometimes known as turpentine substitute, this tends to dull the color, and should be used mainly for cleaning purposes.

LINSEED AND POPPY OIL

This strong and reliable medium is chemically processed in different ways. Cold pressed linseed oil is a slightly yellow oil that is extracted without heat. It increases gloss and transparency while reducing the pigment.

Stand oil (prepared by heating linseed oil or drying it in the sun) is a pale, viscous oil that will retard drying and improve color flow when used in conjunction with turpentine.

Drying linseed oil is of a darker color and will increase the drying rate of oil colors. Sun-bleached poppy oil is a pale, non-yellowing oil useful when painting with whites and pale yellows.

There are numerous commercially formulated painting media, many of which are excellent. As a general rule, however, it is best to use only those that provide some indication of the ingredients used in their manufacture.

VARNISH

Varnishes are used either with other media as part of the painting process or as a protective film for the finished painting. Copal Varnish has been used for many years with oil as a painting medium. It is highly viscous and difficult to handle – it also has a tendency to darken. Damar Varnish is a spirit-based varnish made from the resin of the Damar fir tree dissolved in turpentine. It can be used as a final varnish for the completed painting, producing a waxlike sheen rather than a high gloss. It can also be added to oil and turpentine to produce a painting medium that enriches the color. Mastic is yellowish in color, and has the advantage of drying quickly to produce a high gloss finish. It tends to darken with age and is subject to blooming.

The whole point of giving a painting a final coat of varnish is to protect it from dirt and discoloration. If in turn the varnish becomes dirty, it can be removed with alcohol, and the painting revarnished. That is a slightly risky process, however, since some of the paint might also be removed – especially if varnish has also been used as part of the painting medium.

A coat of varnish will not enhance a bad painting, and might easily spoil a good one.

Before applying varnish, make sure that the pigment in the painting is really hard and free from moisture. The temperature should be even, and the room free from dust.

Warm the painted surface first, using a hairdryer or fan heater. Lay the board or canvas on a flat surface. Pour enough varnish into a dish to cover the whole painting. Using a broad, soft brush, apply the varnish lightly and rapidly under a good light.

A CAUTIONARY NOTE

Observe the correct drying times for all media and varnish.

Linseed oil can take from three to four days to dry, stand oil up to eight days, mastic and copal thirty-six hours.

Oil Paints

224 Colored pigments from which oil paints are made are either mineral or organic in origin. Among the natural pigments are the earth colors: yellow, Yellow Ocher, Terre Verte and Ultramarine. Organic animal and vegetable pigments include Carmine, Sepia, the Madders (from the plant of that name), Gamboge, Indigo and Sap Green.

Artificial chemical compounds are the basis for other colors, such as Prussian Blue, Cobalt Blue and Viridian.

Oil paint is made from finely ground pigment held in a binding medium (oil), which enables it to be spread evenly and adhere to a prepared surface. The oil that binds the pigment does not evaporate but reacts to oxygen in the air and, as it dries slowly, it becomes a solid linoxyn. It is only when the oil and pigment are bound together in liquid form that they are soluble. Today, oil paints are sold in air-tight tubes, and if you leave the screw-cap off for any length of time, you will find that the paint will solidify inside the tube. Before the introduction of collapsible tubes, artists had to grind colors afresh for each painting session.

In the manufacture of oil paint there are two basic operations. The raw lumps of pigment must be refined into individual particles and then dispersed in the liquid medium (linseed oil). Large mixing machines known as triple rolling mills are used for the dispersion process. Most colors will pass through the mill several times before they achieve the correct color.

CHOOSING COLORS

Some colors, such as Ultramarine, are still hand-ground on a granite slab with a cone-shaped block of marble or glass called a muller. There are a number of factors to be taken into consideration when choosing colors – the suitability of the

Traditionally, oil paint was freshly mixed for each painting session.

color itself for your purposes, the body, density, speed of drying, and the degree of permanence.

Most artists have a predilection for certain colors – whether it be a special color such as Carmine or Naples Yellow, or a range of colors of the same hue. The landscape painter might use an entirely different range of colors from someone who paints seascapes or portraits. For most purposes, however, a basic range of ten to twelve colors will do. Titian, one of the greatest colorists, is said to have observed that a painter needs only three colors in his or her palette!

Technical analysis of Constable's palette at the Tate Gallery in London, England, shows that he used Vermilion, Emerald Green, Chrome Yellow, and Madder. Further examination of his painting of Flatford Mill reveals that he also used Prussian Blue, Yellow Ocher, Raw, and Burnt Sienna.

Artists' color suppliers of repute now provide information in their catalogues concerning the ingredients of their oil paints, as well as the degree of permanence of each color.

WHITES

All the whites are dense and will give added density to transparent colors. Titanium White is used both as a primer, and as a painting pigment. Flake White is made from white lead and is suitable for building up an impasto. Zinc White is fairly intense, but is subject to cracking when dry.

Most artists lay their palette out in the same order every time they paint so they can find the colors easily even when absorbed in their work.

BLUES

Cobalt – a clear mid-blue – tends to look transparent even when applied thickly. Cerulean Blue, a greener blue, is dense and very opaque. Ultramarine is a brilliant, slightly red/blue; it is semi-transparent and should be used with care in relation to other colors. Prussian Blue has a powerful green/blue stain that is very intense. Monastral Blue is a more recent transparent blue, which is permanent and less cold than Prussian Blue.

GREENS

Viridian and Terre Verte are transparent greens – the latter was often used for underpainting by the Old Masters. Cadmium Green is a blend of Cadmium Yellow and Viridian. Cobalt Green is an opaque blue-green pigment; it is weak, with poor tinting strength. Emerald Green is useful for strong opaque tints; it turns black when used with Cadmium Yellow or Vermilion.

BROWNS AND BLACKS

Raw Sienna, which is sometimes considered to be a yellow, is transparent. Burnt Sienna is a red-brown that is permanent. Raw and Burnt Umber are both earth colors – the first is cool, the second warm.

Ivory Black is the most commonly used black, it is very intense and opaque. Lamp Black is slower to dry, but warmer in tone than Ivory Black.

VIOLETS

Cobalt Violet is a transparent color that does not have very much covering power. Ultramarine Violet is a mid-tone with a tinge of blue.

YELLOWS

Lemon Yellow is a pale, transparent yellow that has a tinge of green. Chrome Yellow is an opaque yellow with a good covering power. It is supplied in different tones – Chrome Yellow Deep and Chrome Yellow Light. It is not permanent and is poisonous. Cadmium Yellow is more permanent and again is produced in different tones. Indian Yellow is a brilliant transparent yellow. Naples Yellow is opaque, being a blend of Cadmium White, red, and Yellow Ocher.

REDS

Cadmium Reds range in color from a bright yellowish red to a deep red tinged with blue. They have a good degree of permanence and excellent covering power. Alizarin Crimson is an intense red with a hint of crimson – used in low concentrations it can become fugitive. Vermilion is a brilliant, very opaque red. Madder is a delicate crimson color that is used mainly as a tint for other colors. Indian Red has a purple-brown tone – it is opaque with a good covering power. Venetian Red is a rich, dark red; it is opaque and permanent. Carmine is a very pure, transparent pinkish red, but is less permanent than other reds.

Modern oil paints are sold in air-tight metal tubes.

Brush Techniques

The first marks made on the canvas are as important as the last – there is little point in trying to finish a painting that has started badly or with the wrong intentions. Delacroix felt that the first marks on canvas revealed everything that was essentially significant to the rest of the painting, "The life of the work," he said, "is already to be seen everywhere, and nothing in the development of this theme, in appearance so vague, will depart in the least from the artist's conception: it has scarcely opened to the light, and already it is complete."

The work of a painter is often distinguished by the character of the brushstrokes made on the painting surface. We call this the "handling" of the medium, that part which is most personal to the actual execution of the work. Vincent van Gogh's paintings, for example, are characterized by his use of thick, expressive strokes, which stand in relief on the surface of the canvas. When we look at a painting by Edgar Degas, however, we are more conscious of the quality of the drawn line, particularly in his figure studies.

There is no single method of painting that can be described as the "right" way – the importance lies with the product, not with the method of production. There are, however, ways of handling materials that ought to be explored and practiced by any artist seriously intent on finding a personal means of expression through the medium of oil painting.

The novice painter starts with high expectations, and is all too often put off by early failure. Think about what happens when, having bought all the necessary materials, you tackle the first painting – say a still life. The wedges of color are squeezed out onto the palette looking fresh and untested; a hog's hair brush is dipped into the oil medium, and the coarse bristles take up a little color; the first brushstrokes are made in response to the subject – but the paint isn't behaving as expected – there seems to be a disconnection between what was intended and the quality of the marks that actually appear on the canvas. When things go wrong technically, the concentration tends to go adrift. What usually happens is that you go on hoping that something significant will emerge from the layers of pigment that begin to accrue on the canvas. But by this time, you are no longer in control, and things might get considerably worse before they get better.

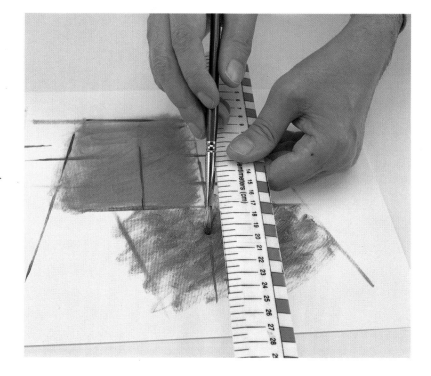

Of course, the difficulties encountered should be seen in a positive light, rather than as a cause of despair. A lack of confidence in handling techniques can be remedied to some extent by a process of familiarization through simple exercises.

First of all, you will need to learn how to control your brushes. If you have ever witnessed a signwriter at work (a rare sight these days!), you will have noticed how the hand moves slowly, but at a constant speed, to follow the curvature of the letterforms. It is a kind of swift, pivotal action from the wrist, which can be practiced by painting spirals and full circles.

Using different actions and different types of brushes you will be able to produce a rich variety of brushmarks and textures – from thin transparent glazes to a dry impasto. For the following exercises, you can use primed hardboard or even cardboard.

USING A MAHLSTICK

A mahlstick is useful as a means of support for the painting hand when adding fine detail to a painting. It allows you to get close

OPPOSITE *A ruler can be used as a brush guide for making straight lines.*

RIGHT *A long hog's hair flat brush is used to practice the pivotal wrist action that helps good brush control.*

BELOW *Scumbling color with a broad house-painter's brush.*

FAR RIGHT *Scumbled color is used to evoke the effect of a storm-lashed coast in this seascape.*

to the painting without smudging it. A piece of ash dowel or bamboo has one end covered with a ball-shaped pad of chamois leather which rests on the canvas, while the end of the dowel or bamboo is supported by the free hand.

DRAWING STRAIGHT LINES

A decorator's yardstick or meter stick is useful as an aid to drawing uprights and horizontals – particularly in architectural subjects. The loaded brush can be run along the edge of the stick as it is held about half an inch from the surface.

SCUMBLING

The scumbling technique involves dragging one dry, opaque layer of paint lightly over another layer of a different color, in such a way that parts of the first layer are still visible through the broken texture of the scumbling. This kind of irregular and unpredictable texture can be seen in the work of many artists, from Joseph Mallord William Turner to Pierre Bonnard. The paint to be scumbled should be brushed out on the palette first until almost

ABOVE *A hog's hair flat brush is used to produce a brushstroke that bears the imprint of the brush shape.*

dry. Since the bristles of the brush tend to be splayed out of shape during this process, it is advisable to use a hog's hair brush rather than a sable which might easily be damaged. The more pronounced the "tooth" of the canvas, the better the effect of scumbling will be.

IMPASTO

When paint is so thick that it stands in low-relief bearing the imprint of the brush that has been used, it is "impastoed." Thick, solid areas of paint are sometimes found under glazes in work by Rembrandt, Turner, Gustave Courbet and others. The paint is best applied without much medium being added. It can be scraped back while still wet, and reworked if necessary.

GLAZING AND STAINING

Glazing is the process of applying transparent layers of oil paint

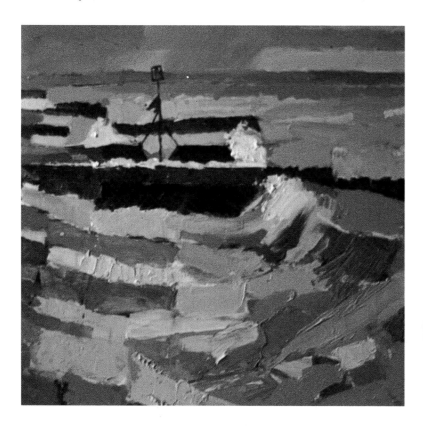

LEFT *In this seascape detail, a heavy impasto has been laid with a painting knife to suggest the layered formation of advancing waves.*

RIGHT *A broad filbert brush is used to produce a bold impasto.*

over a solid color, so that the color and tone is distinctly modified. If, for example, a transparent glaze of Carmine Red were to be brushed over Ultramarine, it would produce a rich purple color. Much depends on the thickness of the glaze, and the intensity of the pigment in the solid color.

When working on a white ground, the glazes can be built up like watercolor. But few artists work entirely in oil glazes since each coat of paint must be dry before applying the next. Glazes are best used in conjunction with other techniques such as underpainting, scumbling, and impasto. Some artists like to stain parts of the canvas with a wash of dilute color, in contrast to passages in the same painting that are built up with impasto. It is a matter for experiment to determine the right approach.

ABOVE *In this mixed-media painting of a Spanish church, dilute oil paint has been stained over the drawn detail with a soft rag to produce a transparent film of color.*

LEFT *The rich colors of rusting plate iron on a freight wagon provided the inspiration for this painting, which combines collage with broad brush-strokes of "dry" color.*

BELOW *A medium filbert is used to produce a dilute stain of color.*

Painting *Alla Prima*

*A*lla Prima comes from the Italian, meaning "at first." When we talk of a painting that has been produced *alla prima*, we are describing the technique of completing the picture in one session. This method of painting has been popular since the nineteenth century and coincided with the fashion for painters to venture out of the studio to paint directly from nature.

It is a way of working that reached its apotheosis with the French Impressionists, who made it a basic tenet of their painting philosophy. There may be a number of practical reasons why a

painting must be completed in one session – the model sitting for a portrait may not be available for a second sitting, or you might have only a few hours to paint a particular landscape view.

To paint a subject *alla prima*, then, is to respond to your first impression – and in doing so, the painting is likely to be far more spontaneous and authentic than a painting produced from reference in a studio. We know that the authenticity of Cézanne's landscape paintings was due to his direct contact with nature. It is this aspect of painting that has most appeal for those who feel at one with their subject – when confronted by the actual experience of real fields, hills, valleys, rivers, and oceans. There is also something to be said for the idea of producing a portrait or life study in a single sitting; a rapid and direct response can often be more telling than a painting that has been labored over numerous sittings. The whole process of painting *alla prima* is of course rather "hit or miss" and it can go disastrously wrong, but when things do go well the results are particularly rewarding.

RIGHT *This small portrait was painted in one short sitting of about an hour.* BELOW *Life study produced in a single sitting of two hours. The painting technique combines washes of oil paint with a heavier impasto.* FAR RIGHT *This garden scene was hurriedly painted between showers of rain in about three hours.*

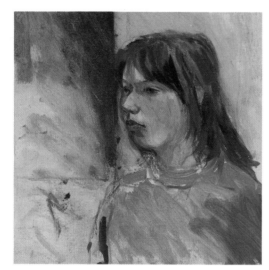

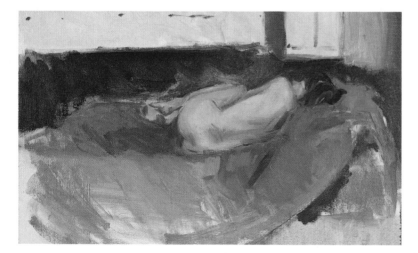

Wet-in-Wet

LEFT *Working boats tend to move from one berth to another without warning. This painting on board was rapidly executed in one sitting of 45 minutes in a failing light.* BELOW *This study of a farm wood-store was painted directly onto a small canvas as a single statement.* BELOW, RIGHT *This small life study was produced in a single sitting at a two-hour life class.*

Anyone producing an *alla prima* painting must of necessity work wet-in-wet; provided that the pigment can be kept moist, it is not necessary to complete the painting in one session. The drying times of oil paints are such that you apply fresh moist color into, on top of, and alongside existing wet color.

It is not a technique that allows for precise linear detail since the merging and blending of color tends to soften outlines. It is, of course, possible to vary the consistency of the paint, but you need to think in terms of broad blocks of color rather than sharply delineated forms. It is difficult to correct color values when working wet-in-wet; it is sometimes necessary to scrape off the color with a palette knife, before reworking a particular passage of the painting. Alternatively, if the impasto is too thick, you can try blotting off the surface with paper towels.

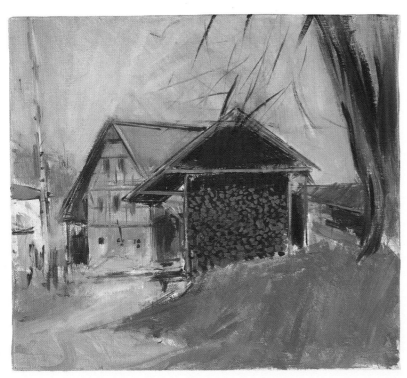

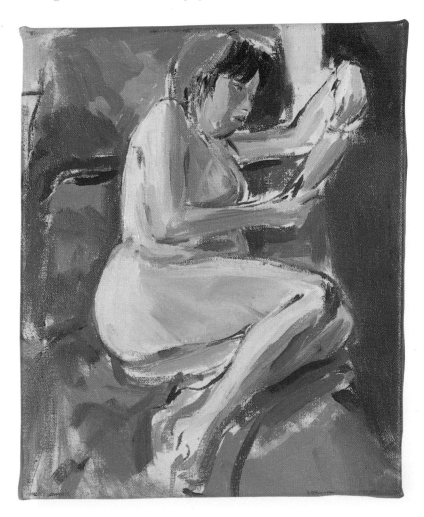

Contrast and Harmony in Color

232

There are basically two ways of achieving color harmony in a painting. First, by using closely related colors, that is to say, colors that are found together on the color circle. A landscape, for instance, might be painted in a harmony of ochers, siennas, and chromes. Second, harmony can be attained by carefully contrasting complementaries. Turner, for example, often used to create very subtle harmonies of warm and cool colors in his paintings of landscapes and seascapes.

There is a small painted panel by Walter Sickert called *The Red Shop* that I like very much. It is a painting of a shop in Dieppe. The shopfront itself is painted in a brilliant shade of Vermilion, but the color is given much greater intensity by the surrounding drab ochers, brown and Umber.

A bright color produces an after-image of its complementary, which will affect colors seen in juxtaposition. Colors cannot be considered in isolation, and you must be constantly making adjustments to both color and tonality, as part of the painting process.

A painting that has little or no contrast can often appear flat and dull. The contrast may be very subtle, as in the work of Vuillard, for instance. Conversely, the contrasts can be extremely violent as we see in certain paintings by van Gogh or in Fauvist paintings such as those by Matisse. Cézanne used contrasts to give his painting greater vibrancy – the repetitive strokes of green that represent the needles of umbrella pines seem to be in continuous movement against the contours of the land mass and sky. When artists talk about the quality of the light they are not only

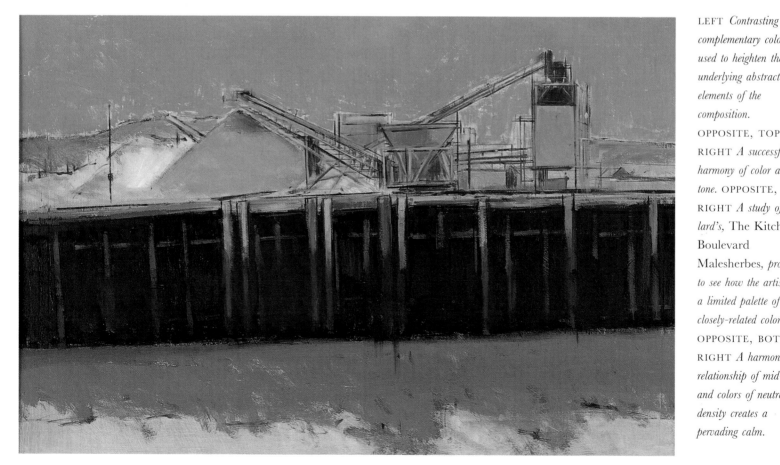

LEFT *Contrasting complementary colors used to heighten the underlying abstract elements of the composition.* OPPOSITE, TOP RIGHT *A successful harmony of color and tone.* OPPOSITE, FAR RIGHT *A study of Vuillard's*, The Kitchen, Boulevard Malesherbes, *produced to see how the artist used a limited palette of closely-related colors.* OPPOSITE, BOTTOM RIGHT *A harmonious relationship of mid-tones and colors of neutral density creates a pervading calm.*

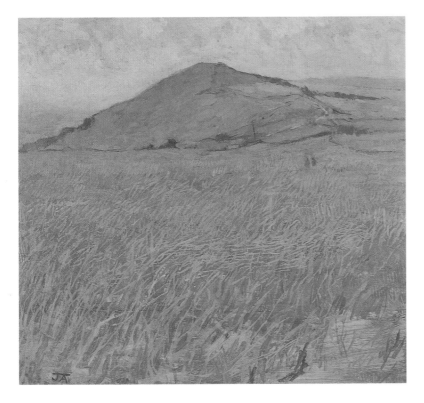

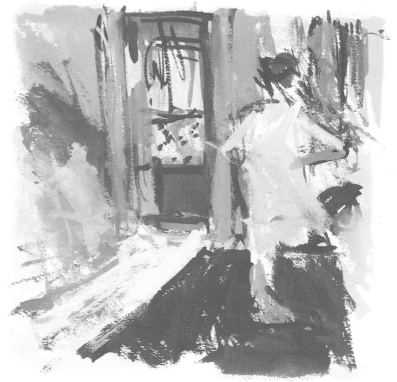

referring to the clear bright atmosphere of a sunny day! They are concerned with the way that certain conditions of light enable them to see scales of color and tone that they must try to capture to produce contrast and harmony in their paintings.

The seeming complexity of contrast and color will become less bewildering with practice – not just in the handling of materials and techniques, but also when searching for suitable subjects to paint. You have to learn to look with these things in mind.

In the small working port of Newhaven, on the south coast of England, a few miles from where I live, I can always be sure that if I walk from the Customs House to the harbor entrance, I will find a series of subjects that are sufficiently stimulating in terms of contrast and color. The fishing trawlers painted in bright primary colors contrast with the darker tones of the sludge-covered landing stages and the surrounding murky water.

The important thing is to allow yourself to be open to possibilities, and to respond before the sensation fades.

Rhythm and Movement

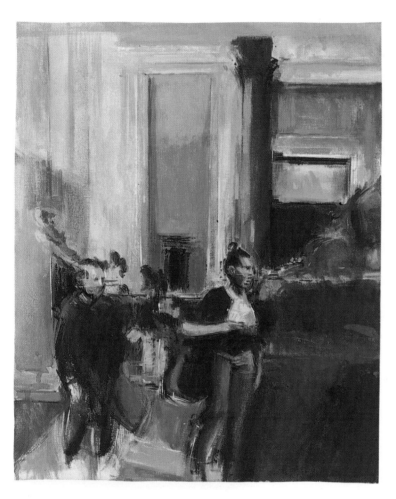

ABOVE, LEFT *Tourists hurrying through the Eygptian galleries of the British Museum seem insignificant in relation to the sculpture.*
LEFT *This painting attempts to arrest the movements of the conductor Christof Penderecki.*

Our perception of the world has changed dramatically in the latter part of the twentieth century. More often than not our experience of landscape is a fleeting glance from the window of a car or train traveling at high speed. But more than that, the whole pace of life has changed to such an extent that we tend to scan rapidly rather than pause for any length of time. And yet, all of our sensory experience comes from movement – without movement there is no life. In drawing and painting, we use line to express movement because line transports the eye more rapidly than blocks of color or flat shapes. The futurist painters, led by the Italian Umberto Boccioni, attempted to render movement in their paintings with unequal success. In their manifesto of 1910, they proclaimed, "Universal dynamism must be rendered in painting as a dynamic sensation . . . motion and light destroy the materiality of bodies."

It is difficult to take account of movement while painting from direct observation – and nature is never still, everything is in constant movement, however imperceptible. Horizontal and vertical lines can be used to give an air of stability. Diagonals, because they are off balance, are symbols of motion and suggest continual movement.

I have recently been working on a series of paintings based on the Egyptian Rooms at the British Museum in London. I was interested in the visual dichotomy between the stillness and monumentality of the wonderful artifacts, and the movement of groups of tourists hurrying past. I made some rapid sketches, and also took some reference photographs using a fast shutter speed to arrest the movement. From the drawings and color prints I was able to reconstruct the image on canvas, starting with an underpainting in Sepia.

Some marks were lost and others gained, and it was important to maintain the balance between stillness and movement. It is always easier to start a painting than to know when it is finished. I sometimes leave a painting around for a month or so until I am sure there is nothing to be added or taken away. Sometimes it is a case of making a particular tone lighter or darker. On occasion I have been known to take the most drastic of moves and have started a painting again.

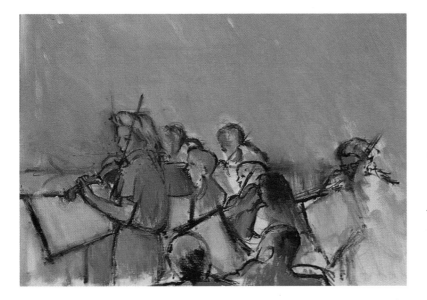

LEFT *Because musicians are constantly moving, the artist must react by making rapid judgments visually.* BELOW LEFT *There is an interesting relationship in this painting between the static form of the scuplture and the blurred figure in movement.*

BELOW RIGHT *The vertical structure of walls and pillars provide visual equivalents to the single moving figure.*

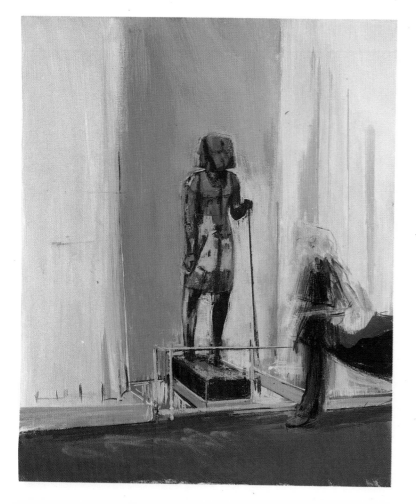

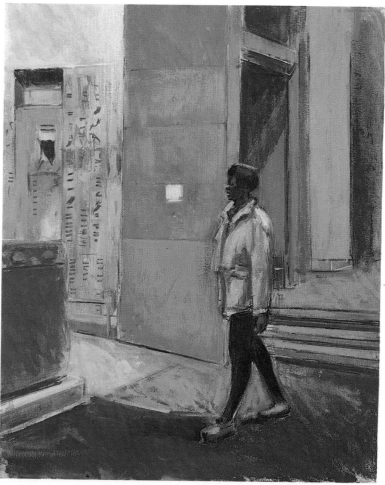

Form and Structure

When we talk about structure in painting, we refer both to the underlying organization of space, using divisions such as the Golden Section, and to the visible elements of the painting concerned with substance and stability. "Construction," said the poet Charles Baudelaire, "is the framework, so to speak, the surest guarantee of the mysterious life of the works of the mind."

I have always been interested in the way that artifacts and architectural structures can add dynamism to an otherwise dull scene. On most days, if I walk down to the seafront where I live, I can watch the wooden structures called "groins" being bolted together from rough-cut planks of wood. The groins provide stability, preventing the shingle beach from being shifted away by the tides. The artist is ruled by what he or she sees, and while, as a conservationist, you might object to a structure such as an electric pylon being placed in a landscape, as an artist, you might find that such a structure provides the essential link to your composition. I find that industrial landscapes often take on a grandeur that is missing in more conventional landscape subjects. I am interested both in the structural aspect of composition theory, and subjects that combine artificial structures with natural forms.

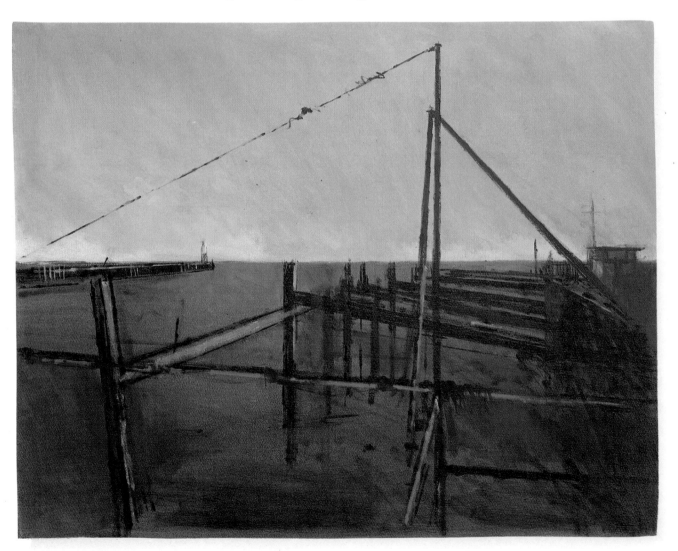

LEFT *The wooden structures of the entrance to Newhaven harbor in Sussex, England define the space of ocean and sky.*

OPPOSITE RIGHT *Industrial artifacts, such as this sand and gravel hopper, can often provide more visual interest than conventional landscape subjects.*

RIGHT *In this painting a steel cable revealed at low tide provides a visual link that the eye follows from the foreground to the boats in the middle-distance.*

BELOW RIGHT *The structural elements in this industrial harbor scene have been carefully selected to produce an interesting composition.*

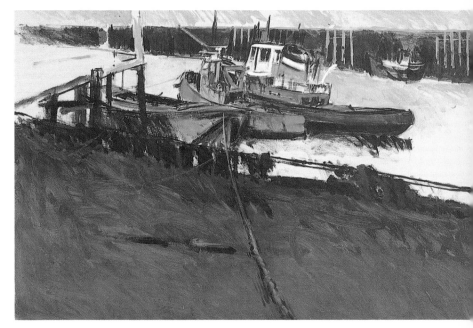

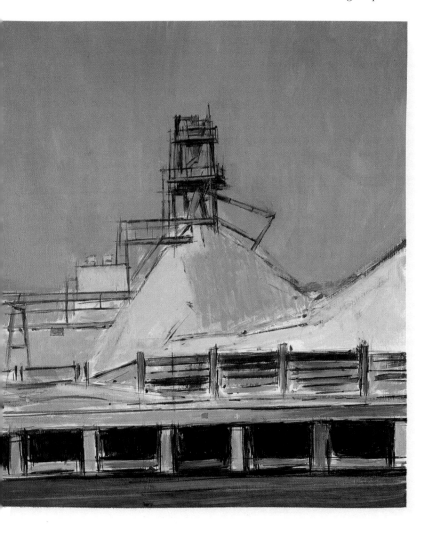

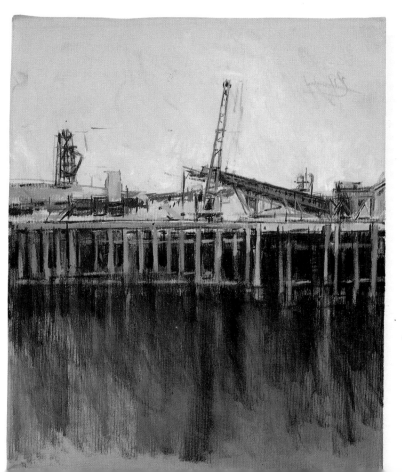

Painting from Drawing

238 There are painters who subscribe to the view that one's work should be carried out in the presence of the subject or motif – what we commonly call "painting from nature." There is a lot to commend this point of view; spontaneity and purity of vision are among the qualities we associate with painting directly from the subject. But as Walter Sickert once said, "Do you suppose that nature is going to sit still and wait until you have got what is there?" He reinforces his argument by suggesting that all interesting things that happen in nature are anyway of momentary significance. He cites the fact that Jean François Millet made notes on scraps of paper while watching people working in the fields. Very few paintings are literal transcripts from nature, and some of the greatest masterpieces were produced by a combination of memory, imagination, and varying sources of reference.

The drawings produced as reference for painting are not intended for exhibition. They are, however, of great interest because they show the working of the artist's mind – the first thoughts on the subject. What matters most is that your drawing should have sufficient information for you to be able to develop your painting with conviction. Some artists like to add notes to the drawing to remind themselves of color values. Thus one might find descriptions such as "mid-slate," "buff," or "brick red" added as footnotes.

Remember that you will have to interpret your drawing in a much broader way with a brush. Most reference drawings are produced "sight-size" – the scale to which you draw naturally, depending on your distance from the subject. That means that the drawing will have to be enlarged in proportion to the size of the canvas or board.

SQUARING UP

It is important that the proportion of the drawing and canvas are the same. A drawing on a piece of paper sized $9^{1}/_{3}$ x $11^{1}/_{5}$ inches, for example, is in direct proportion at a ratio of 2:5 to a canvas sized 24 x 28 inches. To check the proportion of the drawing against the canvas, draw a diagonal line on the drawing from the bottom left-hand corner to the top right-hand corner. Now draw a similar diagonal on the canvas and place the drawing to fit the bottom left-hand corner of the canvas. Lay a rule or straight-edge along the diagonal – if the top edge of the rule intersects the top right-hand corner of the canvas, it is in proportion.

A grid of squares is overlaid on the original drawing. The same number of squares are measured onto the canvas. It is then possible to match the content of each square of the drawing to the corresponding square on the canvas – so that the original

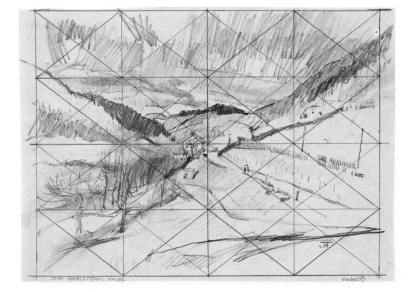

drawing is enlarged. The drawing on the canvas, resulting from this particular method of squaring up, will almost certainly look very stilted, but it will provide a firm basis for making a start on the underpainting.

SICKERT'S METHOD

Instead of scaling up the drawing onto canvas, Sickert preferred to use a thin sheet of paper the same size as the canvas. To transfer the drawing to canvas, he first painted some old newspaper with black oil paint. The painted side of the newspaper was placed in contact with the canvas, and the enlarged drawing placed on top. All the lines were then traced through with a hard pencil, which forced a deposit of the black pigment onto the canvas underneath it – in much the same way as carbon paper.

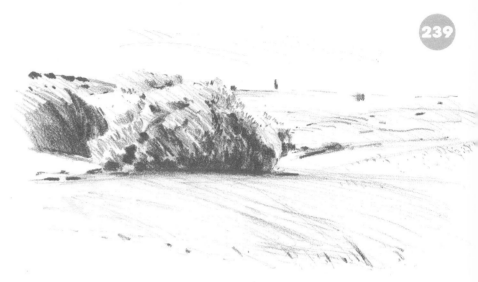

OPPOSITE FAR LEFT *A landscape drawing that has been squared-up prior to transferring to canvas.*

OPPOSITE LEFT *A landscape drawing has been divided by a grid of 16 squares. The corresponding squares are scaled up in direct proportion to the dimensions of the canvas.*

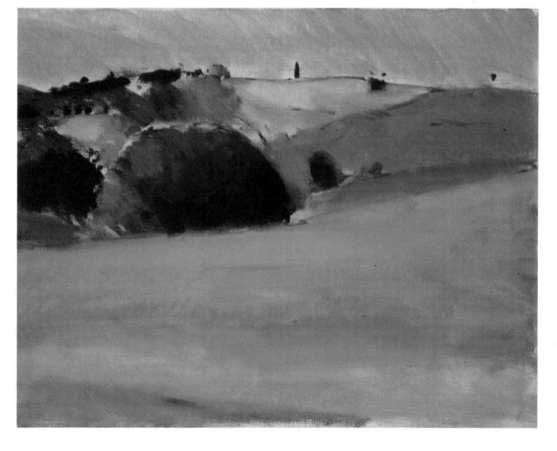

ABOVE *It sometimes happens that a landscape view seen momentarily on a journey can be drawn quickly and used later as reference for a painting.*

LEFT *This painting was made in the studio from the sketch, the artist having committed color to memory.*

Painting from Photographs

240 Despite the fact that artists of the caliber of Degas, Bonnard and Vuillard used photographs for their paintings in the early part of this century, many artists today remain skeptical about such a practice. There are, of course, obvious dangers in that the painting can be nothing more than a slavish copy of purely photographic values. Sickert, who also used photographs as reference, once suggested that, rather like alcohol, photography should be allowed only to those who can do without it!

Photographs are most useful as a stabilized source of reference. This is particularly important when we need to record a situation where, for instance, figures are in constant movement, or where one is working against time itself. The English artist Paul Nash (1889–1946), who was forced by illness to rely increasingly on photographic reference, also spoke of the "peculiar power of the camera to discover beauty." The viewfinder on a camera is in fact a very useful compositional aid.

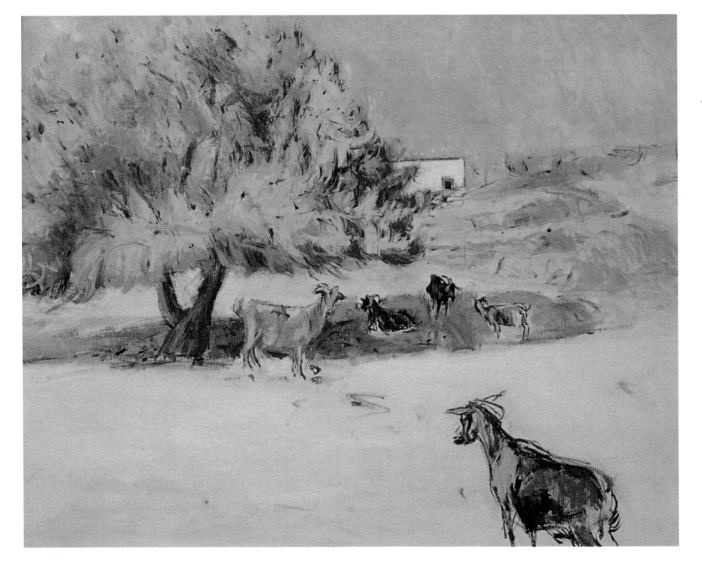

This painting of a goatherd was inspired by a visit to a small island near Patmos, Greece. A few rapid sketches and photographs were the only sources of reference. During the course of painting, radical adjustments were made to color and tone to produce a more brilliant suggestion of the light.

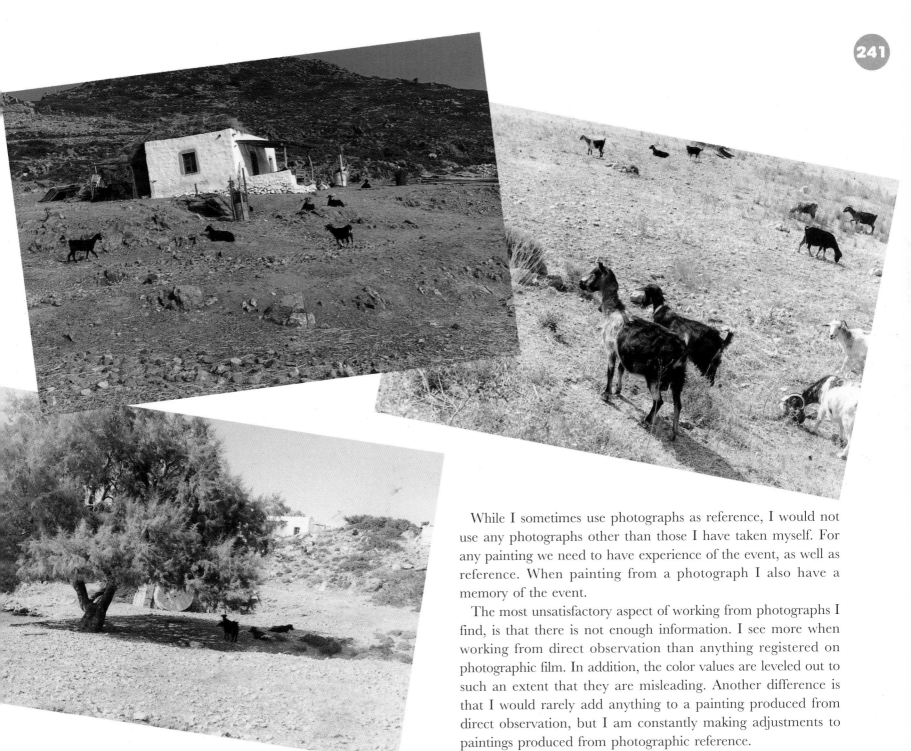

While I sometimes use photographs as reference, I would not use any photographs other than those I have taken myself. For any painting we need to have experience of the event, as well as reference. When painting from a photograph I also have a memory of the event.

The most unsatisfactory aspect of working from photographs I find, is that there is not enough information. I see more when working from direct observation than anything registered on photographic film. In addition, the color values are leveled out to such an extent that they are misleading. Another difference is that I would rarely add anything to a painting produced from direct observation, but I am constantly making adjustments to paintings produced from photographic reference.

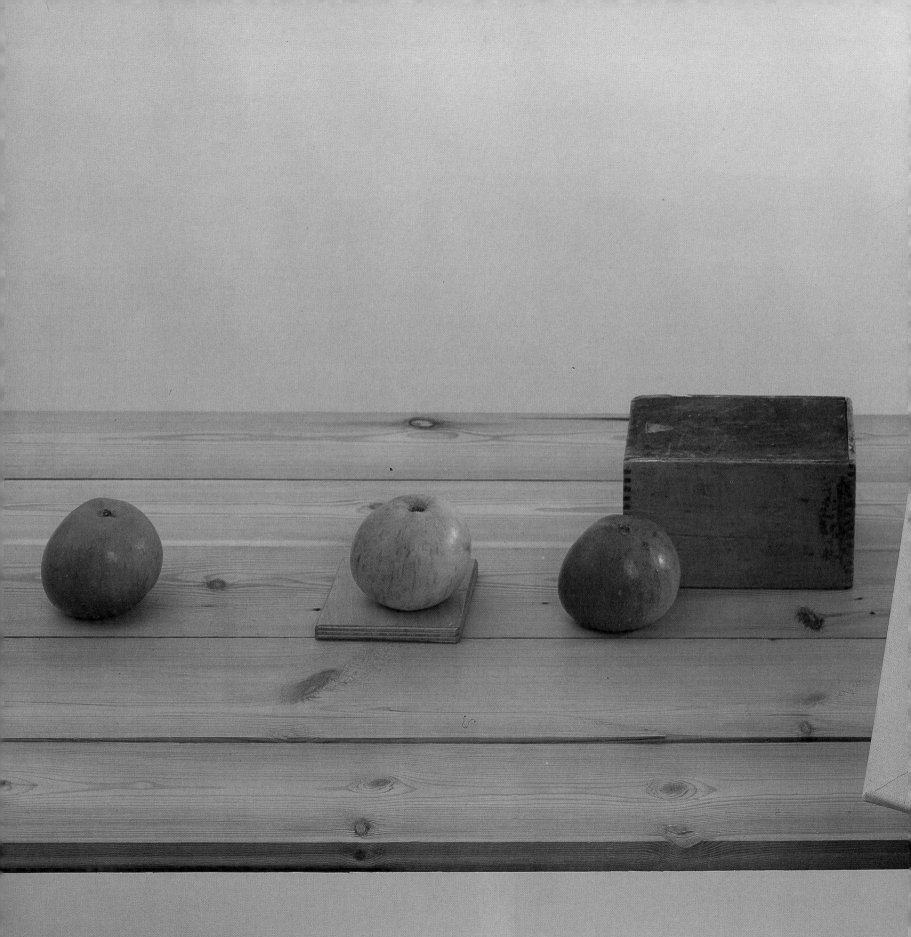

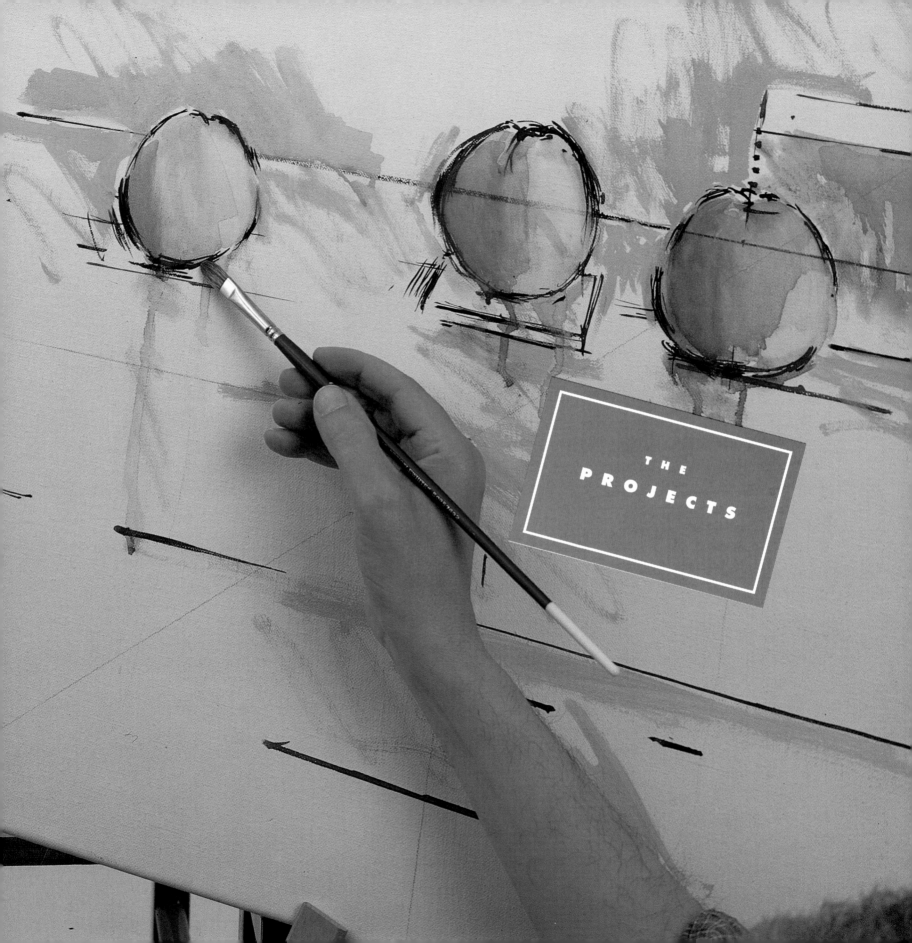

THE
PROJECTS

Glazes and Impasto

VASE OF FLOWERS

How can you interpret the delicacy of flowers in terms of oil painting? There are essentially two approaches to the subject. You can use a combination of thin glazes and fine brushwork, or simply try to say something about tonal and color values using the paint with a broad brush and a rich impasto. If, however, you are concerned with fine detail, then it might be as well to work in another medium, such as watercolor or tempera.

Although there is a long tradition of flower painting, it is not often that one sees really good contemporary examples of the genre. All too often, flower painting is seen as a kind of therapeutic hobby rather than as a subject to be invested with serious visual analysis. As with all still-life subjects, you have the freedom to select and group objects to suit your purposes, and to control the lighting in which they are seen.

It is important to try to retain the vigor and vibrancy of the subject, from the first marks made on canvas to the finished painting. If the painting becomes too labored at any stage, it should be scraped back and the forms restated. The artist must sometimes perform rather like a tightrope walker and a dancer at the same time, to harness exuberant shapes and color within a disciplined structure. The speed and energy of the brushstroke can contribute to the liveliness of the work.

Artist · Robert Williams

LAMP BLACK · PURPLE LAKE · RAW UMBER · OLIVE GREEN · CADMIUM YELLOW · YELLOW OCHER

❶ *A rough underpainting is made on primed board with a No. 3 hog's hair brush and Lamp Black. A mid-gray defines the undertone of the vase.*

❷ *The background is blocked in with a dark red-brown mixed from Purple Lake and Raw Umber.*

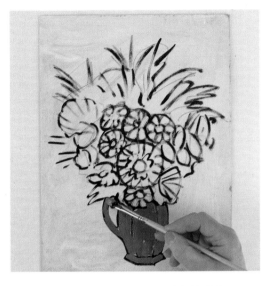

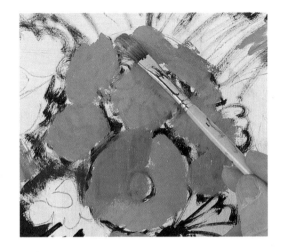

❸ *Various tones of red and Yellow Ocher are used as an undertone on the flowerheads.*

❹ *An Olive Green is applied broadly to delineate leaf shapes. Further colors are added to the flowers.*

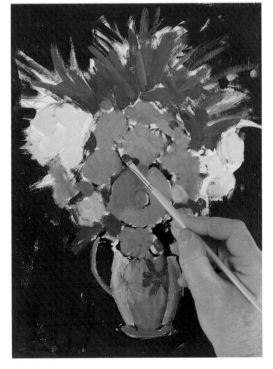

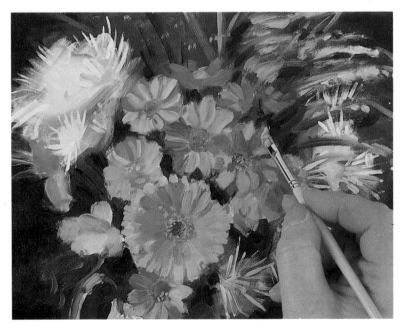

❺ *Individual petals and fronds are now finely detailed using the edge of a No. 3 hog's hair brush.*

Artist • Sophie Mason

1 *The main outline of the composition is drawn in oil pastel onto primed board. The drawing is tentatively stated to allow for the painting to be developed in terms of color and tone.*

2 *A rich crimson glaze is brushed over the whole area using a No. 2 short hog's hair brush.*

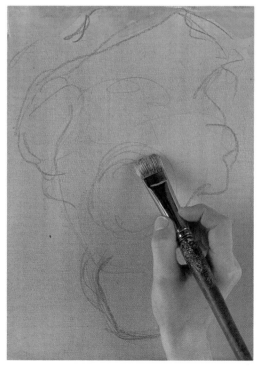

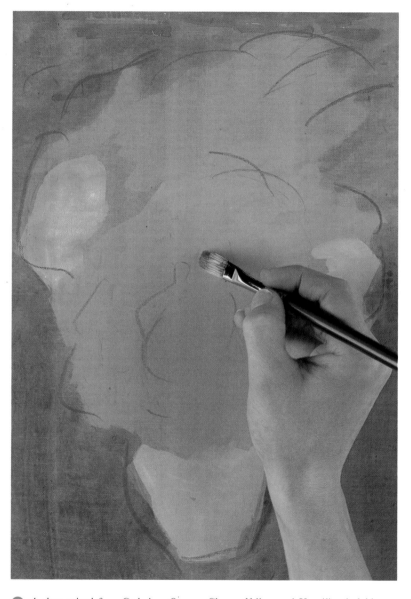

3 *A glaze mixed from Cadmium Orange, Chrome Yellow and Vermilion is laid on a base color for the flowers. A second glaze of white mixed with Cadmium Yellow is overlaid on the pot and background.*

4 *The background is made considerably darker with a color mixed from violet, crimson, and black to produce greater contrast. More specific areas of color are painted fairly thickly using a No. 8 short hog's hair brush.*

5 *Work continues on the flowerheads using contrasting colors and glazes.*

6 *Final details are added to flowers and ferns using a fine sable brush. Oil pastels are also used to produce a variety of tone and contrasting texture.*

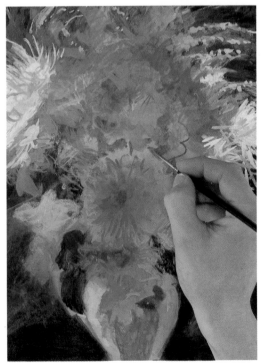

Artist · John Armstrong

1 *The primed board is first stained with Indian Red and, when dry, sandpapered slightly. The general rhythm of the composition is noted with a few strokes of Raw Umber using a No. 4 one-stroke brush.*

2 *The base color is blocked in using a No. 4 one stroke brush. Some color is wiped off with a tissue.*

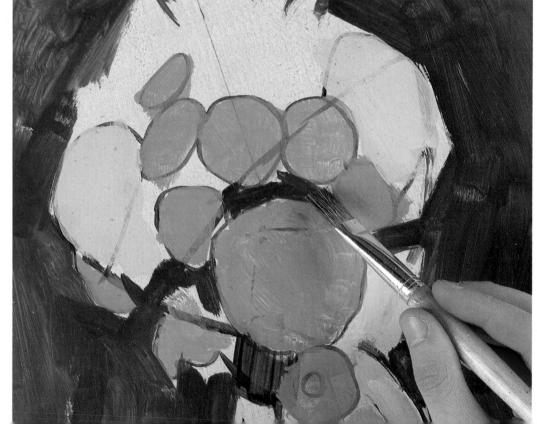

3 *The background is painted in a dark magenta using a No. 7 hog's hair brush. Basic tones are added to the flowerhead and vase. Everything is scraped down slightly.*

INDIAN RED

MAGENTA

RAW UMBER

CHROME YELLOW

OLIVE GREEN

249

4 *The basic geometry of the interlocking shapes is considered. Details are added to petals, grasses, and ferns, and also to the vase.*

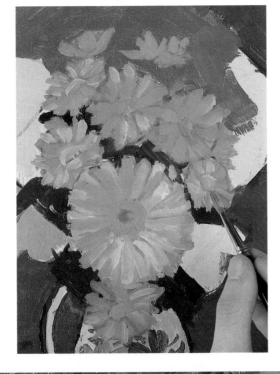

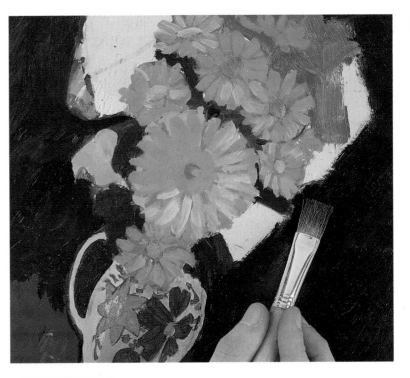

5 *A darker glaze is overlaid on the background with a No. 8 hog's hair brush. Details are picked out using a fine sable brush.*

6 *The white flowers are painted deftly with Titanium White and a No. 6 sable brush. Finally, the tone and color of the table is adjusted in relation to the feel of the painting.*

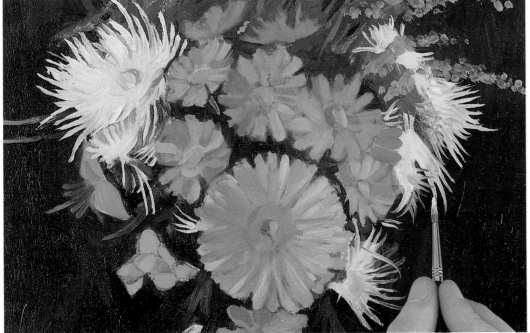

Glazes and Impasto • *Critique*

250

Background color could be less opaque

ROBERT The symmetry and balance which are critical to a flower study have been given due consideration here. The artist has suggested the delicacy of fronds and petal shapes without being too pedantic. The deftness and liveliness of the brushstrokes suggest movement – flower studies can become too stilted, if one attempts to register every detail. More attention could have been given to the background.

Background tone could be more translucent

JOHN The artist has successfully used both hog's hair and fine sable brushes to produce a variety of brushmarks to render the variegated character of flowers and ferns. The background color could have been more translucent perhaps, so that the contours of the flowerheads are less sharply defined.

SOPHIE One is immediately attracted to the verve and sheer exuberance of this study – it demonstrates how a "still-life" painting can be full of movement. Compositionally, it successfully fills the dimensions of the canvas in such a way that one feels that every element counts. Detail has been sacrificed for exploring the richness of color saturation. Some might feel that too much detail has been left out, especially in the central area of the painting.

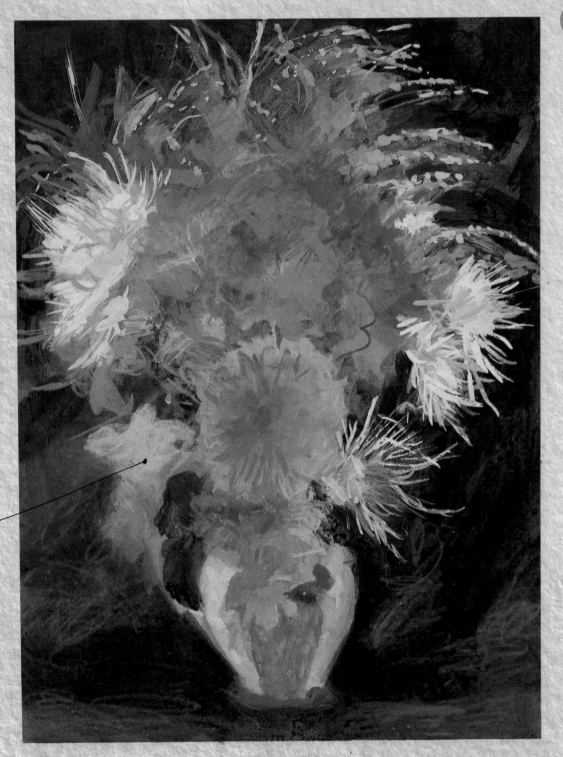

Interesting balance between the opaque color and selected linear detail

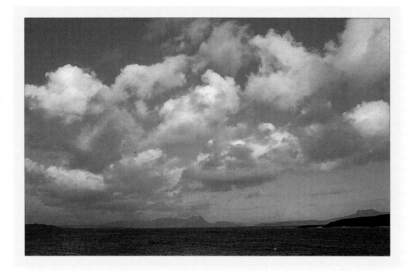

Sky Study

CLOUDS

In many landscape paintings the sky is often treated as a featureless flat block of color and yet, more than any other element, it can greatly influence the whole mood or drama of a painting. The sky has a structure which is elusive and constantly changing – ponderous clusters of cumulus clouds might break, accumulate, and disperse altogether within a short space of time.

The English painter John Constable (1776–1837) once said, "the landscape painter who does not make his skies a very material part of his composition neglects to avail himself of one of his greatest aids." Indeed, he felt that the sky was the keynote in his painting that often determined the mood or sentiment of his final composition.

It is precisely because clouds are unfamiliar shapes which are constantly changing that we need to observe them with a greater degree of concentration. Clouds have their own vaporous forms which can be seen to recede in perspective; it is not difficult to observe how their size seemingly reduces in scale towards the distance. Most painters find it useful to make rapid notations using a pencil and sketchbook. The sketches can be kept for reference. In drawing clouds, you need to take account of the duality of translucence and semi-opacity, which in turn has to be translated in terms of glazes and impasto. Some painters prefer to work on a colored ground so that it is easier to deal with the properties of color, tone, and structure of cloud compositions.

Artist · Robert Williams

COBALT BLUE ULTRAMARINE ALIZARIN CRIMSON PRUSSIAN BLUE LAMP BLACK GRAY

1 *The complexity of the cloud formation, seen in perspective, is first resolved in terms of a pencil drawing on primed hardboard.*

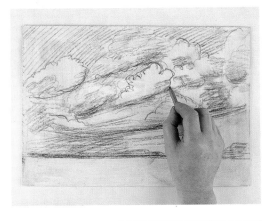

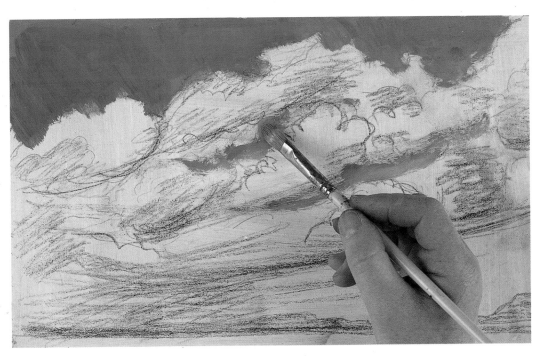

2 *The clouds are defined by a pale tone of blue mixed from Cobalt Blue, Titanium White and a hint of Ultramarine.*

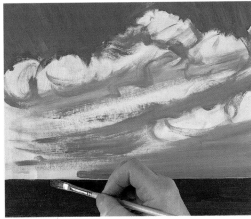

3 *A strong contrasting tone for the ocean is brushed in with a No. 4 hog's hair brush and a mixture of Prussian Blue and Lamp Black.*

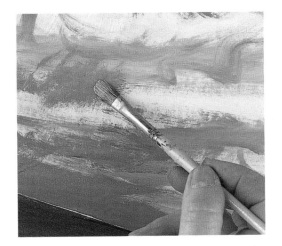

4 *The undersides of the clouds are feathered and scumbled with a pale purple mixed from Alizarin Crimson, Ultramarine and Titanium White.*

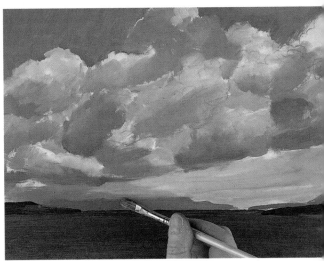

5 *The painting is now resolved in terms of aerial perspective – with the headland in the distance barely discernible as a pale warm gray. The clouds are not fully resolved in terms of contrast, color, and texture. The tone of the ocean is modified in relation to other colors.*

Artist · Sophie Mason

254

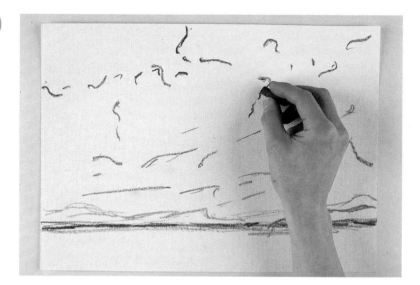

2 *A glaze mixed from Ultramarine and turquoise is laid over the whole area with a No. 10 short hog's hair brush. It is important to get some color onto the canvas quickly. As soon as the first colors are laid, a whole new set of propositions occur.*

1 *The outline shapes of clouds, headland, and ocean are drawn in oil pastel onto a primed board.*

3 *Passages of Ultramarine are applied thinly to the sky and ocean using a No. 6 hog's hair brush.*

ULTRAMARINE TURQUOISE WARM GRAY PINK

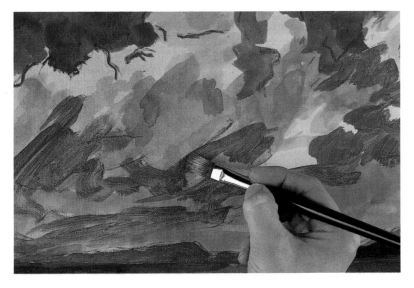

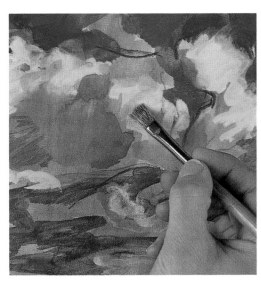

5 *A pink-gray tone is painted selectively on the clouds and lighter passages are restated.*

4 *Further thin glazes of contrasting blues are added to the sky. The headland and the underside of the clouds are painted in a neutral warm gray.*

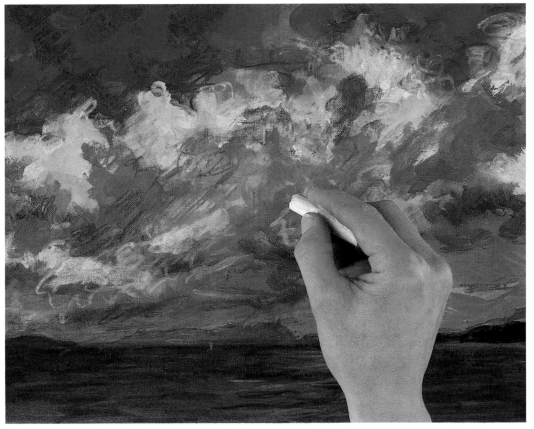

6 *Finally, oil pastels are used to create the fluffy texture of the clouds, and to express their movement.*

Artist • John Armstrong

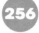

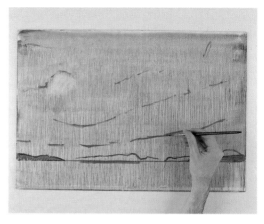

1 *The primed board has been stained with dilute blue with just a tinge of red and allowed to dry. The main outlines are drawn in Cobalt Blue, using a No. 4 sable brush.*

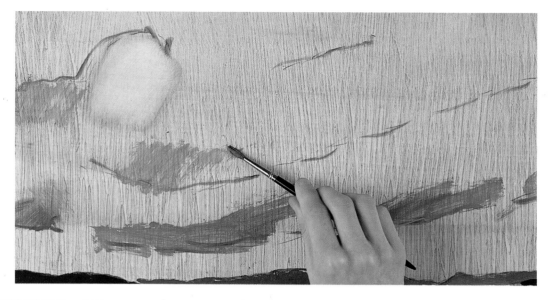

2 *The dark tone of the ocean is mixed from Cobalt Blue, Payne's Gray, and Burnt Sienna and blocked in with a No. 8 hog's hair brush. Further tones of mid-gray are added to the headland and the under-side of the clouds using a No. 4 sable brush.*

3 *Dark and light tones of Cobalt Blue are added to the sky. Part of the color is scraped away before beginning the next stage.*

COBALT BLUE PAYNE'S GRAY BURNT SIENNA LIGHT GRAY WARM GRAY

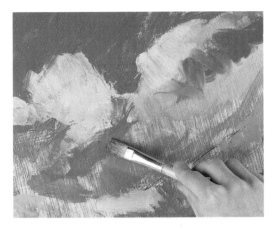

4 *The underside of the clouds is scumbled with light and dark gray. The color is rubbed with a finger afterward.*

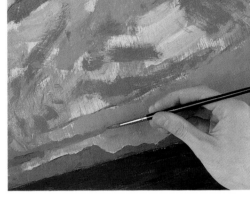

5 *Clouds are repainted using a No. 4 sable brush and a soft rag. The tone is made paler on the horizon.*

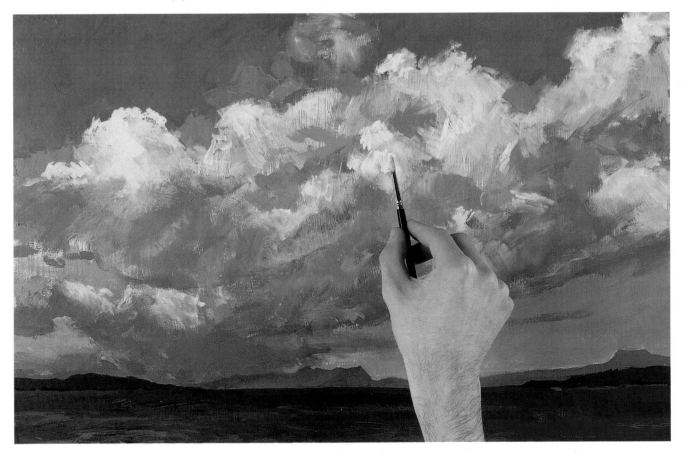

6 *A warm gray has been glazed over the ocean and the white of the clouds painted thickly with a No. 4 sable brush. Even in the final stage, the brush-work is kept free to retain the spontaneity of the first stages.*

Sky Study · *Critique*

Painting works better in early stages

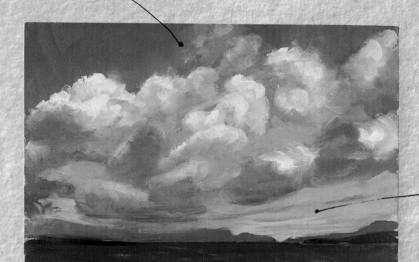

ROBERT The strata of clouds in the top left-hand part of the painting have been handled convincingly, but the underside of the clouds as they recede towards the horizon are less plausible. I much preferred this painting when seen at stage 5 – the brushwork at that point was freer and the forms softer.

works well in terms of light and aerial perspective

JOHN This painting demonstrates an effective use of aerial perspective to suggest depth and recession. In terms of handling, it is, I feel, the most successful study of the three. Cloud studies can be notoriously difficult to register in terms of brushmarks. Here the artist has convincingly represented the nebulous strata of advancing clouds using a No. 8 chisel-edged brush to scumble the basic shape, later introducing finer strokes with a No. 4 sable.

Good example of aerial perspective

Paint and
pastels combined

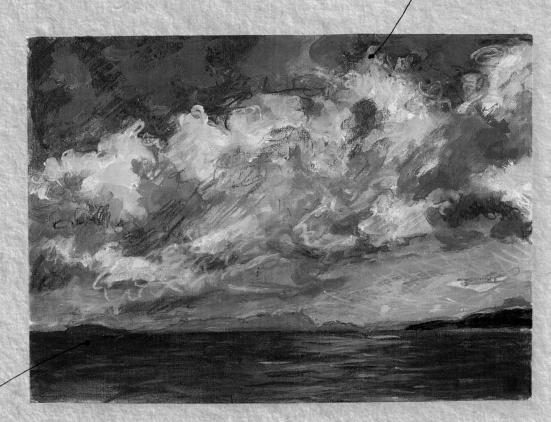

Symbolic
rather than
realistic

SOPHIE The conventions of aerial perspective and tonal recession are less apparent in this study. The artist, I would suggest, has been concerned more with symbolism than with the illusions of three dimensions. Essentially, she has tried to capture something of the process of trans-mutation – allowing for the constantly shifting patterns of light and shade created by moving clouds.

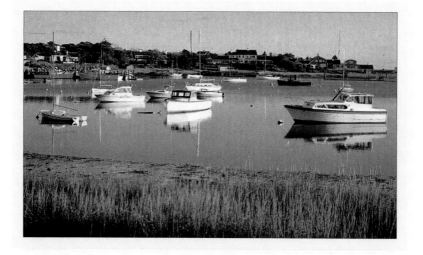

Travel

BOATS AT ANCHOR

A flotilla of pleasure craft at anchor in the still waters of a New England inlet provides a suitable vehicle for testing an artist's ability to bring all the diverse elements together into a meaningful composition. Still water produces mirror-images that add another dimension to the painting by accentuation.

The shapes of boats are deceptive and sometimes difficult to draw. Seen from varying angles, the structure is further complicated by the curve around the hull and from prow to stern. In addition, there are cabins, rigging, and masts to take into account.

When drawing or painting this kind of subject, selection is all important; the harbor may be full of boats, but the particular dis-position of these elements in your composition is what counts. You do not have to register everything; if it helps your composition to leave out one or more boats altogether, then there is no particular virtue in keeping them in simply because they are there. It is worth remembering that the artistic values of a painting are independent of the subject – one does not need to be interested in sailing, or even to like boats, to find them useful in constructing a satisfying and enjoyable picture.

You must learn to translate what you experience when confronted by nature – to convey something of the immediacy of the sub-ject, and of the shifting values of light and shade.

Artist · Robert Williams

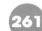

CADMIUM GREEN LAMP BLACK YELLOW OCHER FRENCH ULTRAMARINE INDIAN RED COOL GRAY

① *The composition and basic tonal pattern is resolved in an underdrawing made with a soft graphite pencil on primed board.*

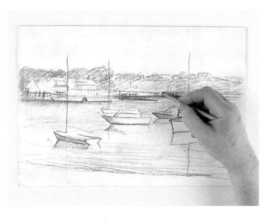

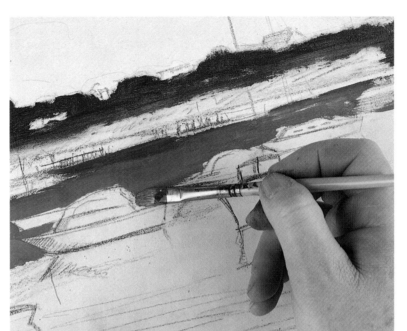

② *The tree line on the horizon is blocked in with a green-black mixed from Lamp Black and Yellow Ocher. A warm blue based on French Ultramarine isolates the boat shapes.*

261

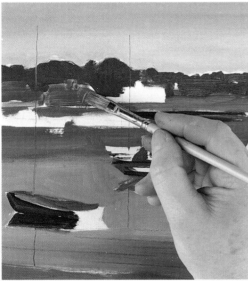

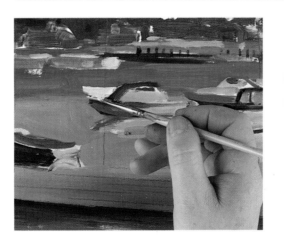

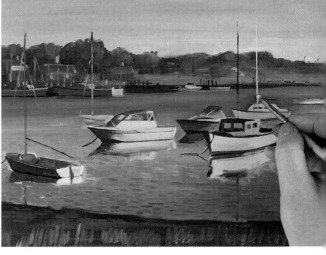

③ *Further blues are applied as thin glazes and Indian Red added to the shoreline. Work continues on the shoreline, foreground, and shadows on the boats.*

④ *Mid-tones of warm and cool grays, white and Yellow Ocher provide tonal contrast.*

⑤ *Details on the boats, such as masts and cabins, are highlighted using the edge of a flat hog's hair brush. Reflections and the effect of dappled water are expressed by stippling, and tones are finally modified in relation to each other.*

Artist · Sophie Mason

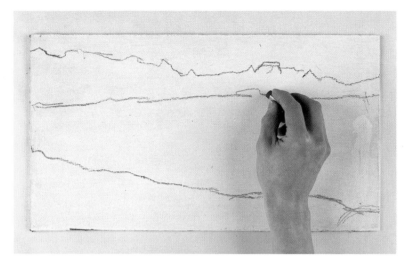

1 *The mainland and harbor are defined with oil pastels on primed board.*

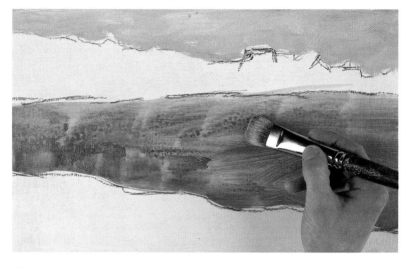

2 *Glazes of lilac and gray are overlaid with a No. 10 short hog's hair brush*

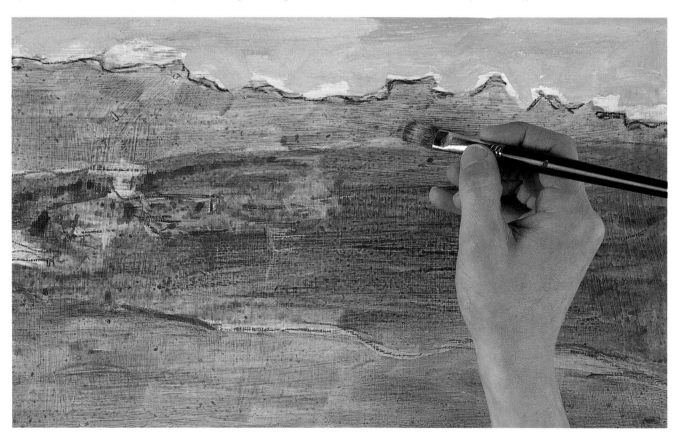

3 *The mainland is glazed with a color mixed from Yellow Ocher and Olive Green.*

YELLOW OCHER OLIVE GREEN LILAC WARM GRAY ULTRAMARINE VIOLET BLACK

5 The tone of the sky is darkened considerably using a color mixed from black, violet, and Ultramarine. Olive Green and Yellow Ocher are added to the mainland. The boat shapes are established using a mixture of Ocher and white, and darker tones are overlaid on the water.

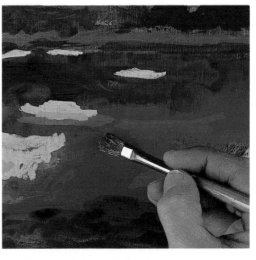

4 The shapes of the boats are drawn over the dried blue glaze using yellow oil pastel.

6 Final details are added using oil pastels on grasses in the foreground and for added texture to the sky.

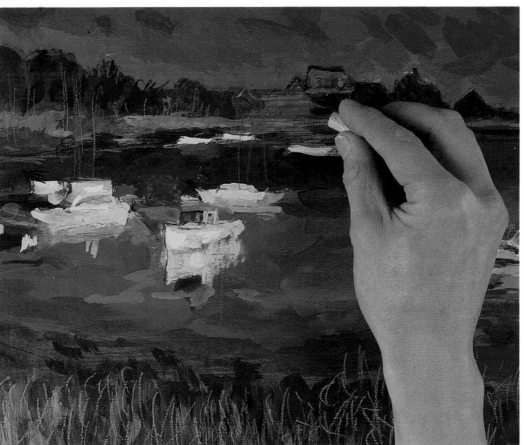

Artist · John Armstrong

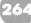

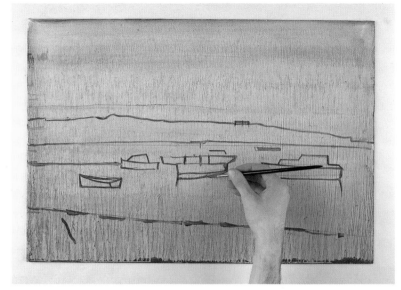

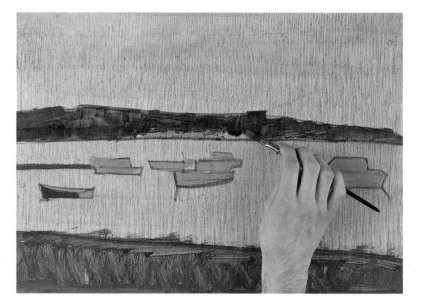

❶ *A thin wash of Payne's Gray is applied to the primed board and allowed to dry. The main outlines are drawn in a color mixed from Terre Verte and Burnt Umber using a No. 4 sable brush.*

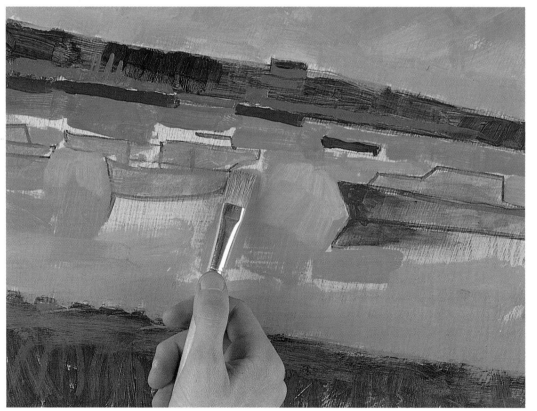

❷ *The middle-distance is blocked in with a deep olive using a No. 6 flat nylon brush. The basic shapes of the boats are painted in mid-gray. The foreground is added using a green made of Yellow Ocher and deep olive.*

❸ *The sky and water are painted in mid-blue, which is scraped back. If the artist feels a painting has become unworkable, it is necessary to scrape off the pigment and restate the drawing.*

PAYNE'S GRAY COBALT BLUE TERRE VERTE BURNT UMBER YELLOW OCHER OLIVE GREEN MID-GRAY

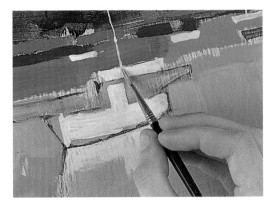

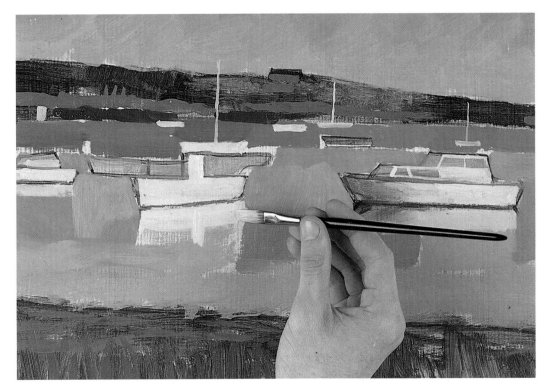

4 *Further tones of Ocher and Payne's Gray are added to the distant harbor. Details such as masts on the boats are painted in white using a No. 4, short-handled sable brush.*

5 *The sky is made lighter on the horizon. Reflections of the boats are painted with a No. 6 flat nylon brush and then smudged slightly.*

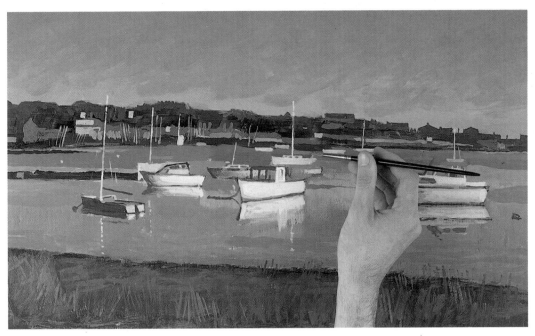

6 *The foreground is glazed in brown and reeds are added with a short handled No. 4 sable brush using a dry brush technique. Final details are added to the boats and to their images reflected in the water.*

Travel · *Critique*

SOPHIE The color and pervading mood of this painting is quite different from the others. The sky, for instance, appears menacing rather than radiant. The light is concentrated on the boats so that they appear to be spotlit in an almost theatrical way.

To achieve this kind of subtlety of color, one needs to be aware of contrasts between warm and cool hues of color, and how they influence each other.

Good sense of place and atmosphere

Boats well lit

Everything is too symmetrical

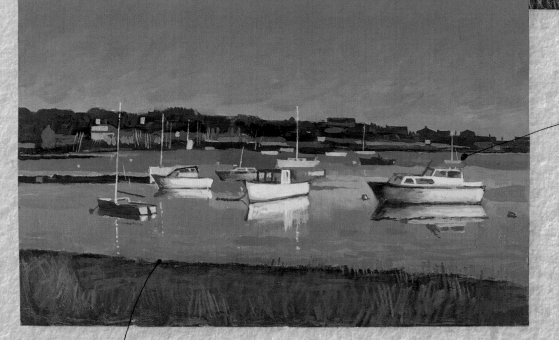

JOHN The radiance of light in this painting has been handled well in terms of the medium. Compositionally, the disposition of various elements might seem too evenly balanced, although I feel that perhaps the subject demands this kind of equilibrium. The color and tone of the sky are reflected on the surface of the water, but I feel that there are subtle differences that the artist has failed to observe and record.

Needs to be more contrast in color and tone between sea and sky

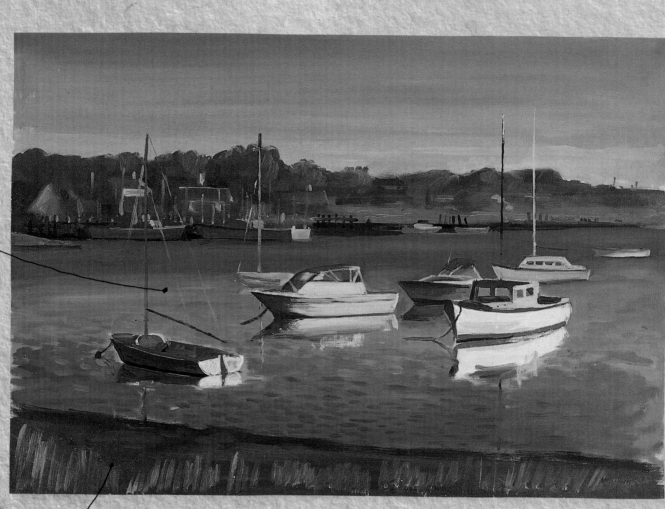

convincing
handling
of water
and reflection

Good
composition

ROBERT I am immediately struck by the handling of water and reflections in this study – in this sense it is more convincing than the others. By varying the consistency of the paint from thin washes or glazes to a thicker impasto the painting could have become more atmospheric.

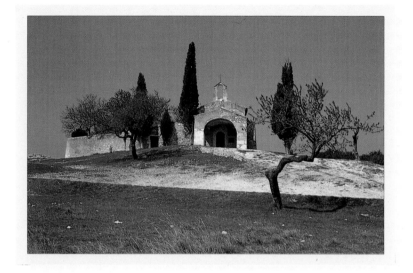

A Change of Scene

PROVENÇAL CHAPEL

The Alpilles form a limestone ridge between Avignon and Arles in France – this is van Gogh country. The outcrops of white rock sharply contrast with the sky, olive groves, and cypress trees. The twelfth-century chapel of St. Sixte is situated a few miles from the small town of Eygalières. It is built on high ground on the site where once stood a pagan temple dedicated to the spirit of the local spring water.

It is always difficult, I feel, to paint in a location that is closely identified with the work of a well-known artist. You tend to view the subject through the eyes of that artist. This project is concerned with very basic compositional problems – the chapel and surrounding walls and trees are fairly simple forms seen in an elevated position. Therefore, the viewpoint can be critical. You need to walk around the chapel to view it from different angles before deciding on the viewpoint that best brings out the right balance of horizontal and vertical forms.

It is also a subject which, seen under direct sunlight, produces stark contrasts. Therefore, choosing the right time of day can also enhance the subject, greatly influencing the color and tonality of the painting. The subject seen at midday, for example, would correspondingly require colors to be mixed in a fairly high key – light excludes color. Brilliant sunlight tends not only to emphasize contrasts, but also to reduce the contrast between local colors. Generally, you should avoid contradictory effects of light and color.

Artist • Robert Williams

PRUSSIAN BLUE LAMP BLACK FRENCH ULTRAMARINE ALIZARIN CRIMSON RAW UMBER YELLOW OCHER CHROME YELLOW

269

❶ *All the compositional details are first resolved by producing an under-drawing on primed board with a graphite pencil. The darkest tones – the cypress trees and shadows – are painted with a mixture of Prussian Blue and Lamp Black, using a hog's hair brush.*

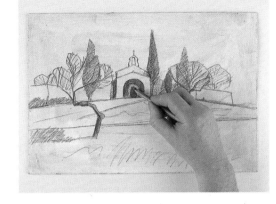

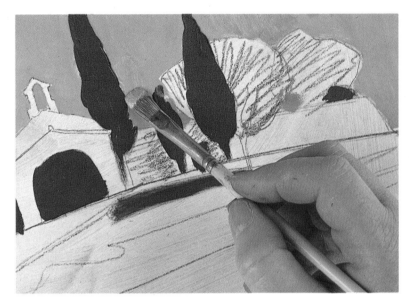

❷ *A pale warm tone of blue mixed from French Ultramarine, Titanium White, and a hint of Alizarin Crimson is blocked into the sky.*

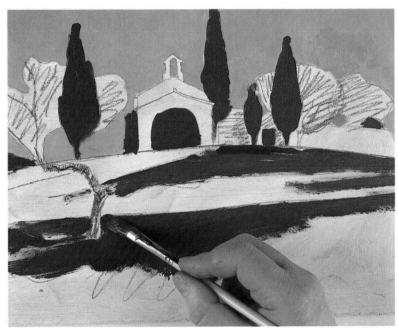

❸ *A band of strongly contrasting tone of green-brown, mixed from Raw Umber with a touch of Lamp Black and Yellow Ocher, is painted in the foreground.*

❹ *An Olive Green mixed from Chrome Yellow and Lamp Black is added to the foreground area in front of the church. The painting is now resolved in an almost monochromatic way, blending colors of the same hue. Textural details are accentuated in the grass, trees, and stonework, producing a harmonious tonal quality.*

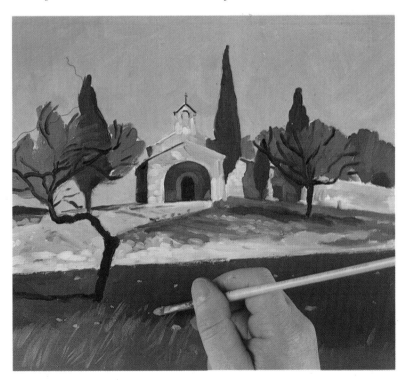

Artist • Sophie Mason

270

① *The trees, landscape, and church are drawn with Viridian and Yellow Ocher oil pastels onto ready-primed canvas board. The space around and between objects is also considered.*

② *Thin glazes of blue and Olive Green are overlaid on the sky and foreground using a No. 8 hog's hair brush. Here the artist is trying to establish middle tones.*

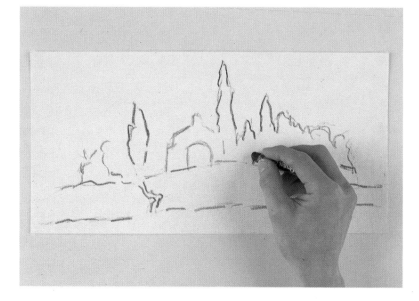

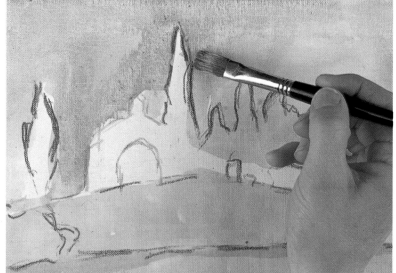

③ *Darker glazes of green are added to trees and foreground.*

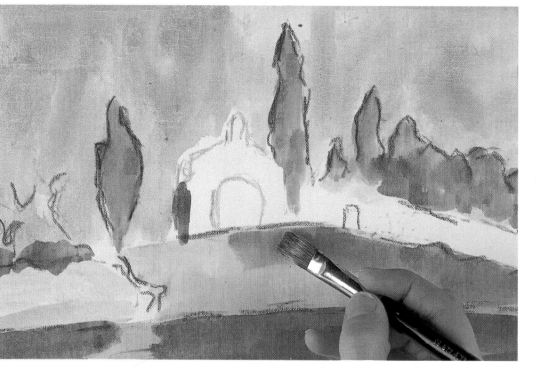

VIRIDIAN YELLOW OCHER OLIVE GREEN COBALT BLUE FRENCH ULTRAMARINE RAW UMBER

4 *The tone of the sky is made darker with Cobalt Blue and French Ultramarine, and a warm gray is added to the church and adjacent walls. A dark Umber is painted in the recess of the doorway.*

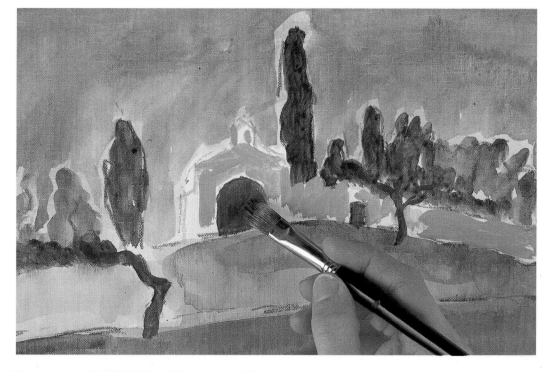

6 *The outcrop of limestone in the middle-distance is radically altered to a much lighter tone. Final details are added to the sky, church, and trees.*

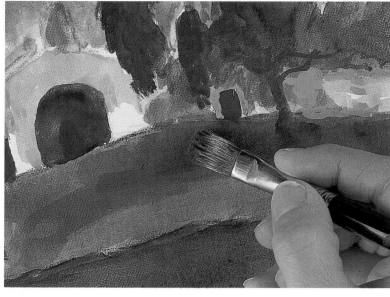

5 *The tones in the middle-distance and foreground are darkened with shades of Olive Green.*

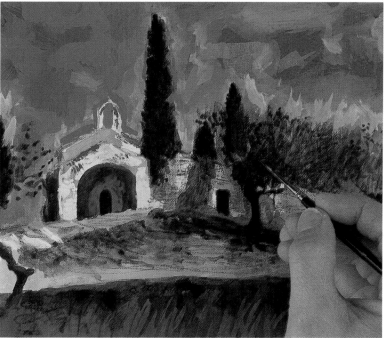

Artist • John Armstrong

272

1 *The primed board is stained with Payne's Gray and Cobalt Blue, and allowed to dry.*

2 *The main composition is drawn in Raw Umber using a No. 4 sable brush.*

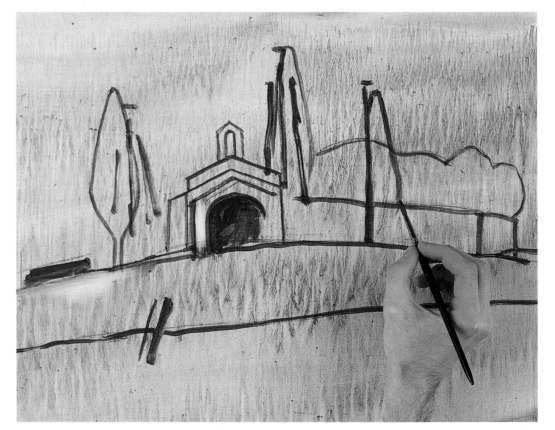

3 *A deep olive color is overlaid on the foreground and trees, using a No. 6 hog's hair brush.*

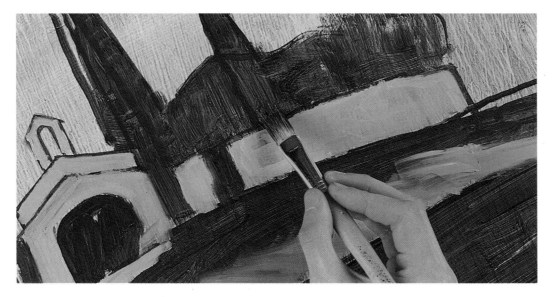

PAYNE'S GRAY COBALT BLUE RAW UMBER OLIVE GREEN YELLOW OCHER TERRE VERTE BURNT SIENNA

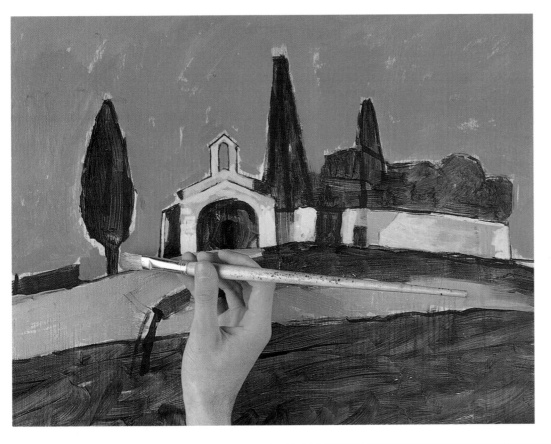

4 *The sky is roughly blocked in with blue, and dry scraped down with a flat blade.*

5 *The white wall adjacent to the chapel is painted, details are added to trees, and the grass area in the foreground made lighter in tone.*

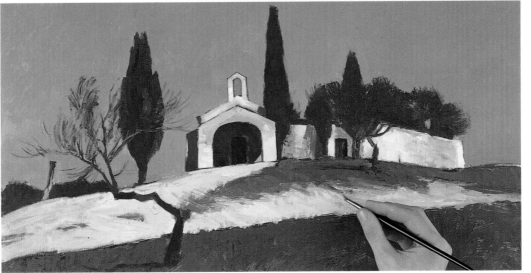

6 *The sky is painted again and the tone of the ground in the middle-distance made much lighter. Final details are added to the chapel, and a palette knife is used to apply more color in the foreground.*

A Change of Scene · *Critique*

274

ROBERT The tree on the left-hand side of the middle-distance provides a balance to the whole composition, which has been well considered. The coloration of the painting is a kind of harmony of middle tones, which is particularly suited to the subject. My only reservation is that I do not feel that the artist has managed to capture the clarity of Provençal light.

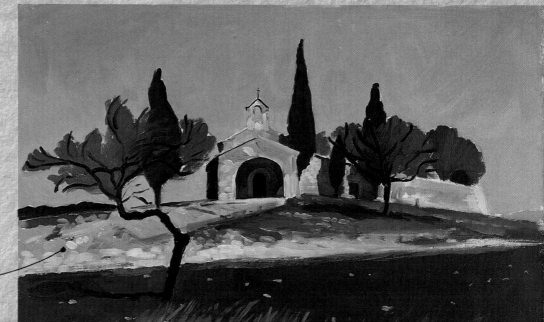

color harmony is suited to subject

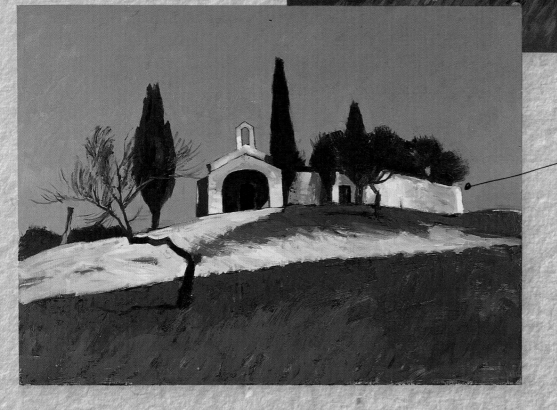

Good underlying design

JOHN The light has been concentrated on the chapel and the outcrop of limestone, so that all attention is focused directly on the main elements of the composition. It is the underlying abstract values in this painting that make it work as a series of interlocking shapes. The sky seems dull and too opaque. It might have been better to use a thin glaze of blue with a hint of Alizarin Crimson.

Sky handled
particularly well

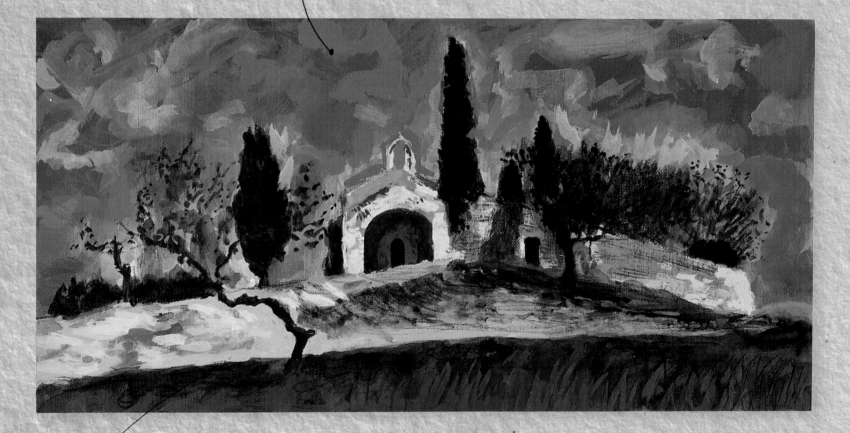

composition
could be
improved

SOPHIE There is nothing static about this painting and I feel
that the artist has come very close to the spirit of the place. It
has a strong rhythmic quality that recalls van Gogh's paintings of
cornfields (which were painted in the same locality). In my view,
however, there is an underlying structural weakness in the compo-
sition; elements within it appear to be much too compressed. I feel
that the main interest for the artist has been in the painting of the sky.

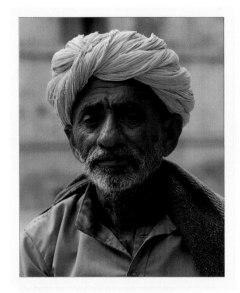

Portrait

MAN IN A TURBAN

In his journal of 1850, Delacroix noted that, "the warmer the light tones are the more nature exaggerates the contrast with gray: witness the half-tints in the Arabs and in people of coppery complexion." You feel he could almost have been describing the subject chosen for this portrait.

We tend to see things in terms of contrast – the brilliant lemon yellow of the turban against the background and the leathery tone of the face. We normally think of portrait painting as an interior subject, where the pose, lighting and viewpoint can be carefully planned. In this instance, however, the subject is seen in direct sunlight, which produces sharp contrasts and saturated color.

A good portrait will reveal something of the personality of the subject. The face of our elderly Indian market trader, for instance, is deeply furrowed and bears the imprint of a hard-working life. His expression betrays a stoicism and an amused perplexity that anyone should want to paint his portrait!

Artist · Robert Williams

CADMIUM YELLOW

BURNT UMBER

RAW SIENNA

MID-GRAY

MID-GREEN

LAMP BLACK

277

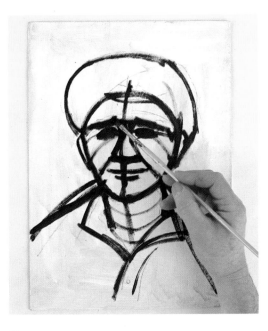

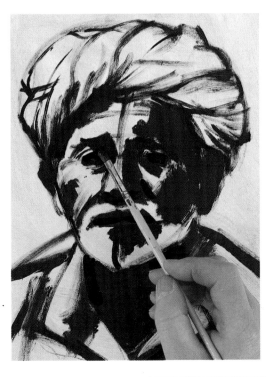

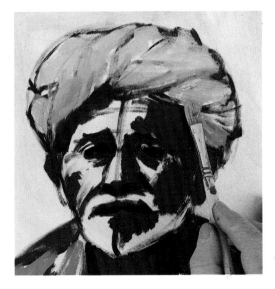

❶ *An underdrawing is produced on primed hardboard using a No. 6 flat hog's hair brush and Lamp Black.*

❷ *The drawing is further developed in terms of strongly contrasting areas of tone.*

❸ *The turban is painted with Cadmium Yellow and a green-gray is added to the shirt.*

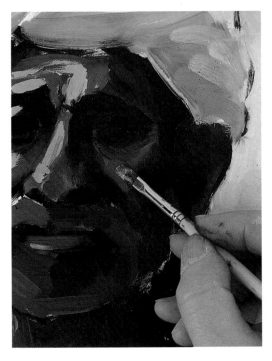

❹ *The background is blocked in with a pale ocher. A mid-brown mixed from Burnt Umber, Raw Sienna, and Flake White is painted over the face and while still wet, paler tones of the same color are used as highlights on the forehead, nose, and cheekbone. The beard is defined as a dark gray.*

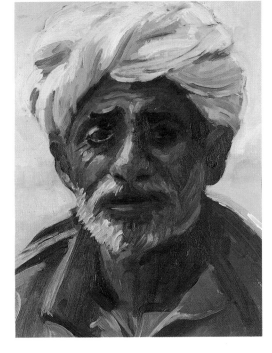

❺ *The texture of the beard is accentuated by using alternate strokes of white and gray. Everything in the final stage is resolved in terms of modeling and tonal values.*

Artist • Sophie Mason

278

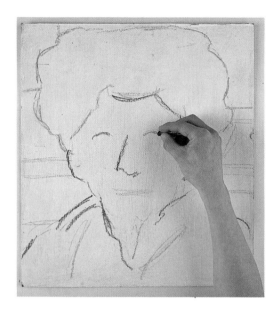

① *The main outlines of the portrait are drawn in oil pastel onto a primed board.*

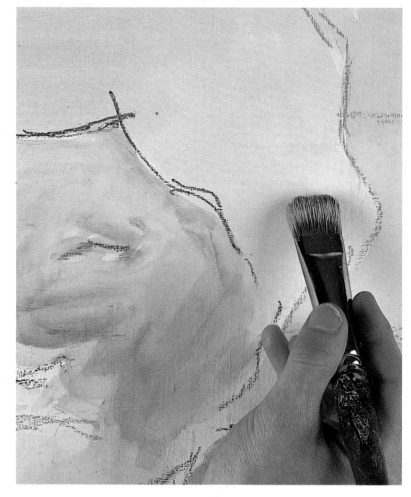

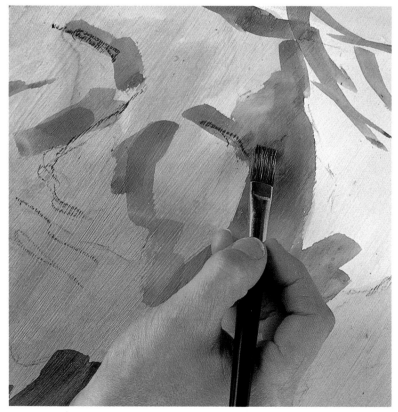

② *Glazes of Cadmium Yellow, Vermilion, and crimson are overlaid on the turban, face and background. A neutral gray glaze is painted on the shirt using a No. 10 short hog's hair brush.*

③ *Details are broadly established with a thin glaze of Raw Umber. In addition, the artist indicates where light and shade fall on the head to suggest the modeling of the face.*

CADMIUM YELLOW VERMILION CRIMSON COOL GRAY RAW UMBER BURNT UMBER

4 *Tones are further modulated generally, using thin broad strokes of gray on the beard and shirt, Burnt Umber and crimson on the face, and darker chrome on the turban.*

5 *Sharper tonal contrasts are established overall. Brushstrokes are still very free at this stage.*

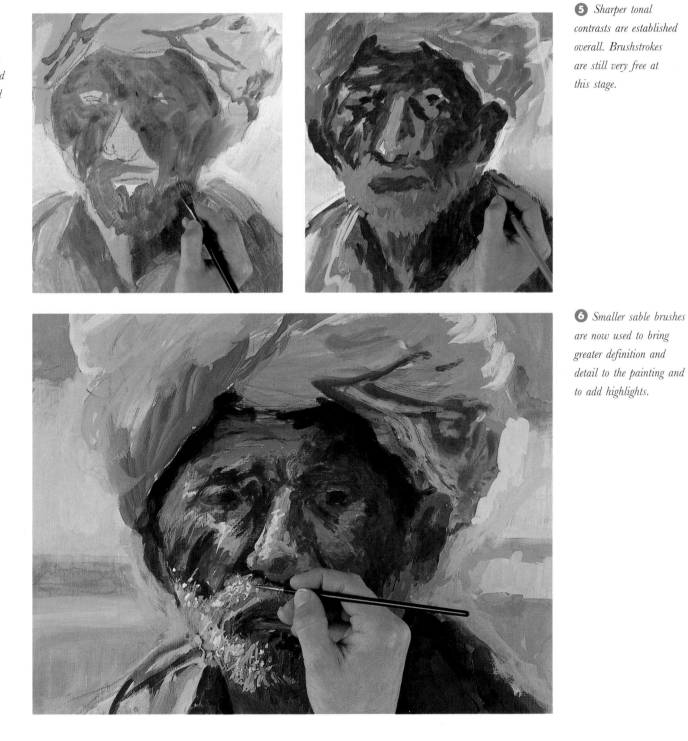

6 *Smaller sable brushes are now used to bring greater definition and detail to the painting and to add highlights.*

Artist · John Armstrong

❶ *The primed board is stained with Raw Sienna and allowed to dry. The main proportions are marked in brown using a No. 4 sable brush.*

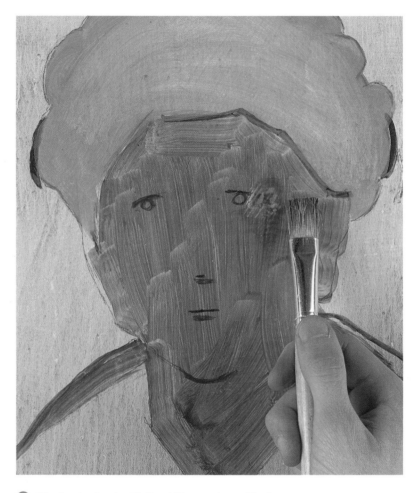

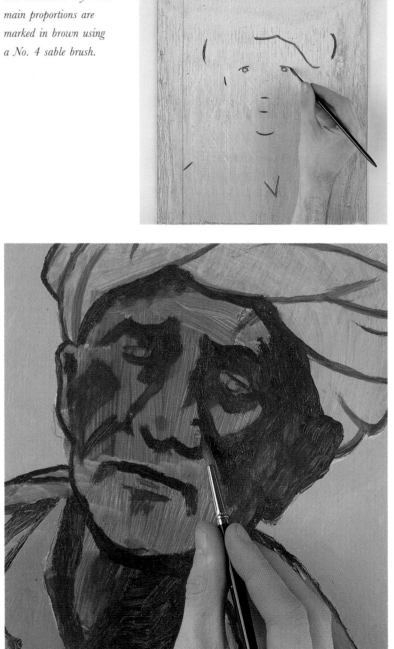

❷ *The face is glazed with Burnt Sienna using a No. 8 hog's hair brush. The shape of the turban is blocked in with Yellow Ocher.*

❸ *The folds in the turban are painted in brown. Darker tones are added to the face and a warmer tone painted over the background. The shirt is painted a neutral color mixed from Terre Verte, brown, Yellow Ocher, and white.*

RAW SIENNA BURNT SIENNA YELLOW OCHER TERRE VERTE WARM GRAY

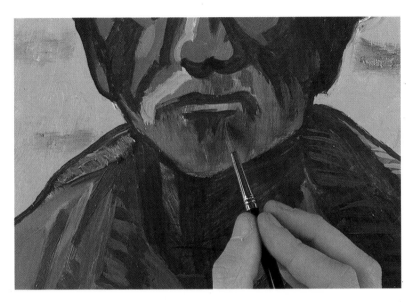

4 *The modeling of tones on the face is continued using warm grays.*

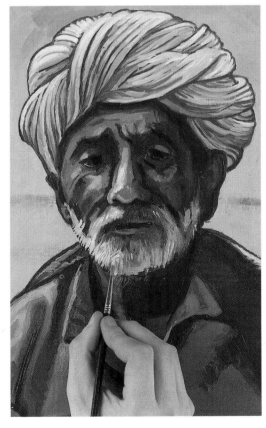

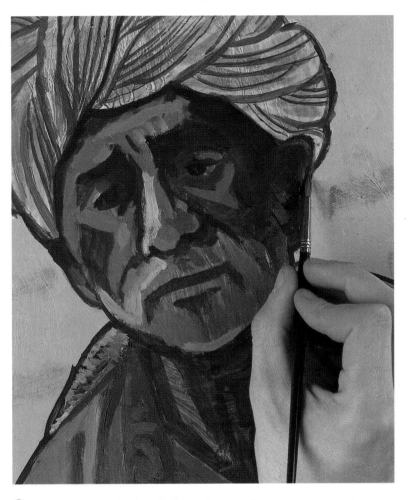

5 *Lighter tones are painted on the face and more work done on the turban, using a No. 8 sable brush.*

6 *Highlights are added to the turban and warmer whites to the nose and beard.*

Portrait · *Critique*

ROBERT The artist here demonstrates his ability to deal with the intensity of light. My only criticism is that the buttery impasto technique, which works well to suggest modeling, might have been contrasted with thinner glazes of color in certain passages of the painting.

confident handling of intensity of light

skillful handling of color values

SOPHIE In this painting the artist has somehow managed to get close to the subject so that right away I am riveted by the immediacy and character of the man. The technique of using alternating broad swathes of color with finer brushstrokes works well in this instance.

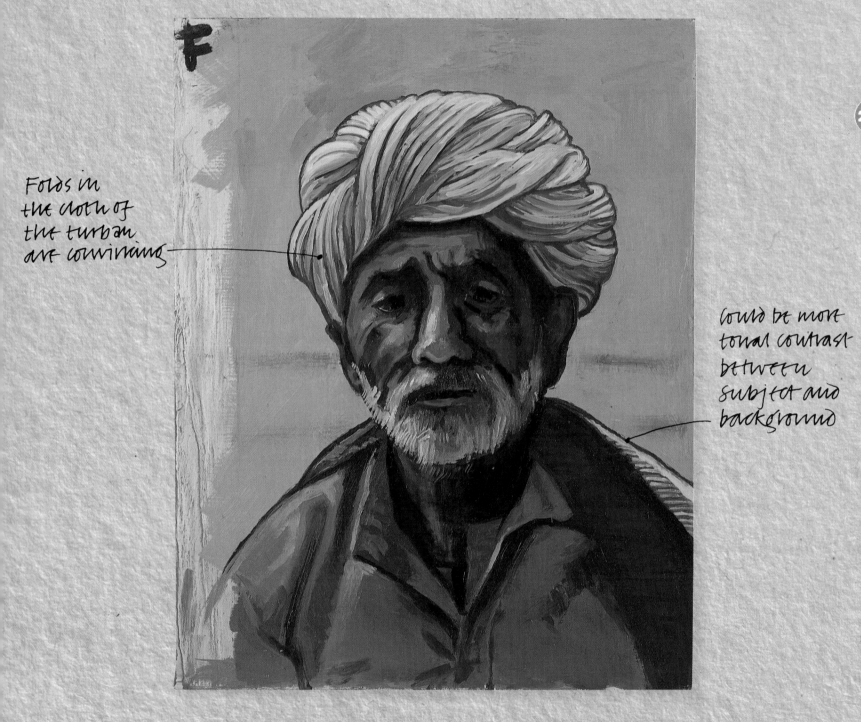

Folds in the cloth of the turban are convincing

Could be more tonal contrast between subject and background

JOHN My attention was first of all directed to the way that the artist has resolved the drawing of the turban! The folds and intertwining of the cloth have been made plausible. The expression on the face has been conveyed equally well. My only reservation is that there could have been more tonal contrast between the subject and his background and that somewhere between stage 2 and the final stage something of the freshness of vision has been lost.

Glossary

AERIAL PERSPECTIVE
Also called atmospheric perspective. The effect caused by the density of the atmosphere as objects recede in the distance. This results in colors and tones becoming muted and hazy, with a tendency towards blue in distant parts of the landscape.

ALLA PRIMA
Painting directly onto a support in a single session, without any preliminary underpainting or drawing.

AQUARELLE
Alternative generic name for watercolor. Also brand name for water-soluble colored pencils.

ATMOSPHERE
Relates to the suggestion of recession in a painting, achieved with changes of color and tone between the background and the foreground.

BINDER
The ingredient used in the manufacture of paints and pastels that holds the materials together, and helps them adhere to paper, board, or canvas.

BLENDING
The merging of colors or tones with a brush, torchon, or fingertip so that no sharp edges are visible.

BLOOM
A white or blue discoloration that can sometimes appear on the surface of a painting – most often when varnished.

BODY
Refers to the actual density of the pigment and its capacity in terms of coverage.

BURNISH
(a) To rub colors together with your fingers or a torchon to produce a glossy surface luster; (b) To take an impression from a woodblock, linotype, or monotype by continuous rotational rubbing movements with a spoon or brayer (special burnishing tool) on the back of printing paper.

CALLIGRAPHIC
A term that refers to a cursive linear mark.

CALLIGRAPHY
Handwritten letterforms used as an art form.

CHARCOAL
Charred sticks of willow or vine used for drawing.

CHIAROSCURO
Derived from the Italian "light-dark" and used to describe the effect of graduated shading.

COLD (OF COLOR)
All colors can be related to sensations of warmth or cold. Warm colors tend toward yellows, cold toward blues.

COLOR WHEEL
Twelve distinct colors – primary, secondary, and tertiary – arranged in equal progression around a circle.

COMPLEMENTARY COLORS
Complementary colors are found opposite from each other on the color wheel. A color is complementary to the one with which it contrasts most strongly, such as red with green.

COMPOSITION
The visually satisfactory arrangement of all the related elements in a drawing or painting.

CONTÉ
A hard French crayon named after the eighteenth-century scientist who invented it, Nicholas-Joseph Conté (1755–1805), and produced in a limited range of colors.

COPAL
A resin used in the manufacture of varnish.

CROSS-HATCHING
Layers of crisscrossed parallel lines produced with pen or pencil as a way of shading drawings.

DRAWING IN
The initial statement of the drawing prior to painting.

DRY BRUSH
A technique in which the paint or ink is usually undiluted and brushed lightly over the surface of the paper to produce a broken texture.

EASEL
A supportive stand for a drawing board or canvas. It is usually made of wood, though collapsible models are made from metal.

ESSENCE
An essential oil extracted from plants or animal substances; an example is lavender oil, which can be used as a solvent for oil paints and oil pastels.

FEATHERING
A pastel technique that involves using light, rapid strokes that have a kinetic effect on the drawing, imbuing it with a sense of movement.

FERRULE
The metal part of the brush that binds the hair to the wooden handle.

FIGURATIVE
A term that represents the artist's intention of producing drawings of recognizable objects rather than abstract interpretations.

FILBERT
A brush with bristles forming a flat, tapering shape.

FILLER
Usually, white pigment that is added to paints and pastels to extend the range of colored tints.

FIXATIVE
A thin, colorless varnish sprayed onto the surface of a drawing to make it stable, i.e., to prevent the pigment from coming off the paper or smudging.

FORESHORTENING
Perspective applied to a single object. If, for instance, a hand is pointed directly towards the viewer, it would be seen to be strongly foreshortened, since only the ends of the fingertips would be clearly visible.

FORM
The three-dimensional appearance of a shape.

FUGITIVE
A term used to describe colors that are liable to fade under strong light, or in the course of time.

GESSO
A priming agent for canvas and boards made from gypsum.

GLAZE
To modify the painting by applying one transparent film of color over another.

GOUACHE
An opaque, water-soluble paint also known as body color.

GRAIN
Refers to the direction of the fibers in machine-made papers. Handmade papers have no directional grains. The different surface qualities of watercolor paper is determined by the texture of the felts through which it is pressed or "couched." Hot-pressed paper is additionally pressed through heated rollers to produce a smooth surface.

GRAPHITE
A type of drawing pencil in which the lead is produced from a combination of carbon and clay.

GROUND
As in colored ground – usually the first color laid on the paper as a preliminary tone. Can also refer to colored paper used for drawing.

GUM ARABIC
In its purest form, the sap produced by acacia trees, used as a binding medium in pastels and watercolors.

HALF-TONE
A tone that is seen to be mid-way between black and white, or the strength between the darkest and lightest tone.

HUE
The color, rather than the tone, of a pigment or object.

IMPASTO
A heavy, paste-like application of paint or oil pastel, which produces a dominant texture.

INDIAN INK
An intense black ink available as a water-soluble or waterproof ink.

LOCAL COLOR
The actual color of an object, such as the red of an apple, rather than the color the object appears when it is modified by light or shadow.

MEDIUM
(a) The type of material used to produce a drawing or painting, e.g., charcoal, pastel, watercolor, oil, etc.; or (b) a substance blended with paint to thicken, thin, or dry the paint.

MERGING
The blending of two or more colors gradually so that there are subtle gradations from one hue to another without conspicuous seams or joins.

MODELING
The way in which the volume and solidity of an object is expressed through drawing in terms of light and shade.

MONOCHROME
Refers to a drawing or painting produced with a single color, gradations of color, or in black and white.

MONOTYPE
A single print made by painting with oil paint or printer's ink onto a slab of glass, and then transferring the image to paper by burnishing it from the back.

MULLER·
A heavy slab of marble with curved edges used for grinding colored pigment.

OPAQUE
Describes the density of paint. Not transparent.

PALETTE
A dish or tray made from wood, metal or china on which colors are mixed. Also refers to the range of colors selected individually by the artist.

PERSPECTIVE
A means of recreating objects when drawing or painting so that they give the illusion of having three dimensions, or appear to have depth, on a two-dimensional surface. Linear perspective makes use of parallel lines that converge on a vanishing point. Aerial perspective suggests distance by the use of tone.

PICTURE PLANE
The imaginary space or plane where a picture begins; in other words, the surface of the picture. Where perspective is applied, forms may appear to project or recede from the picture plane.

PIGMENT
The colored matter of paint or pastels originally derived from plants, animal, vegetable, and mineral products. It is generally synthesized chemically in paint manufacture.

RESIST
A term that refers to the use in watercolor painting of wax and masking fluid, which are both water resistant.

SCALE
The relative size of objects within the composition in proportion to each other.

SCUMBLE
To work a layer of opaque paint or pastel over an existing color in such a way that the color of the layer beneath is seen through the broken texture of the top layer.

SGRAFFITO
A technique used in oil pastel when the design is scratched through the top layer of color to reveal the lower layer.

SILVERPOINT
An ancient drawing technique using a silver-tipped instrument on a specially prepared paper to produce delicate tones of gray.

SIZE
A weak solution of any form of glue. In the manufacture of watercolor papers, a size is applied to impregnate the surface and control the degree of absorbency. The size usual for paper is traditionally made from gelatine with alum dissolved in alkalis.

SPATTER
A means of creating a texture of flecked particles of colored paint by dragging the bristles of the brush against the blunt edge of a knife.

STIPPLING
In pastel drawing, a technique of shading using closely spaced dots, or flecks of color.

SUPPORT
The surface on which a drawing or painting is made (canvas, paper, wood, etc.).

TINT
A color that is lighter in tone than its primary or parent color; usually obtained by adding white, or a diluting agent.

TONE
The term used to describe light and dark values in a drawing or painting; for example, pale blue is a different color from pale yellow, but both may have the same tone.

TOOTH
The degree of roughness caused by the raised texture of certain drawing papers, which enables the pastel or charcoal to adhere to the surface.

TORCHON
(Also tortillon or paper stump) A tightly furled stick of soft paper used for blending chalk pastels, pencil, conté, and charcoal.

UNDERPAINTING
The first laying in of the underlying drawing in thin transparent paint.

VANISHING POINT
In perspective, a point on the horizon line at which all the receding parallel lines appear to converge.

WASH
Diluted watercolor or ink applied to the paper in a way that allows it to spread (in a controlled or uncontrolled way) as a transparent film.

WATERCOLOR
A water-soluble paint made from pure colored pigment bound in gum and glycerine.

WET-IN-WET
A technique that allows colors to merge randomly while still wet.

Index